Symbol and Theology in Early Judaism

Other Fortress Press Books
By Jacob Neusner

The Foundations of Judaism: Method, Teleology, Doctrine
Vol. 1: *Midrash in Context:*
Exegesis in Formative Judaism
Vol. 2: *Messiah in Context:*
Israel's History and Destiny in Formative Judaism
Vol. 3: *Torah:*
From Scroll to Symbol in Formative Judaism
Foundations of Judaism (An Abridgment)
The Incarnation of God
The Character of Divinity in Formative Judaism
Judaism in the Beginning of Christianity
Judaism in the Matrix of Christianity
What is Midrash?
Writing with Scripture:
The Authority and Uses of the Hebrew Bible
in the Torah of Formative Judaism
A Midrash Reader

Edited by Jacob Neusner et al.

The Social World of Formative Christianity and Judaism:
Essays in Tribute to Howard Clark Kee
Judaic Perspectives on Ancient Israel

Symbol and Theology in Early Judaism

Jacob Neusner

FORTRESS PRESS MINNEAPOLIS

Scripture quotations from the Revised Standard Version of the Bible are copyright ©
1946, 1952, and 1971 by the Division of Christian Education of the National Council
of Churches. Scripture quotations from *Tanakh: A New Translation of the Holy
Scripture according to the Traditional Hebrew Text* are copyright © 1985 by the Jewish
Publication Society of America.

Photographs on p. 162 of the menorah of the Second Temple period found in the
Jewish Quarter of Jerusalem and on p. 161 of the Chancel Screen with menorah from
the ancient synagogue at Rehob in the Beit She'an region are used by permission of
the Department of Information and Public Affairs of the Hebrew University of
Jerusalem.

Photographs on p. 163 of the mosaic floor of the Byzantine synagogue near Kibbutz
Mirim and on p. 164 of the mosaic floor of the synagogue at Hamej Tiberias are used
by permission of Werner Braun, Jerusalem.

The photograph on p. 160 of the detail of the fresco above the Torah shrine from the
Dura-Europos synagogue is used by permission of the Yale University Art Gallery,
Dura Europos Collection.

Library of Congress Cataloging-in-Publication Data

Neusner, Jacob, 1932–
 Symbol and theology in early Judaism / Jacob Neusner.
 p. cm.
 Includes bibliographical references and index.
 ISBN 0-8006-2456-4 (alk. paper)
 1. Symbolism in rabbinical literature. 2. Lists in rabbinical
literature. 3. Jewish art and symbolism. 4. Midrash—Theology.
I. Title.
BM496.5.N4823 1991
296.3'09'015—dc20

90-29897
CIP

Manufactured in the U.S.A. AF 1-2456

95 94 93 92 91 1 2 3 4 5 6 7 8 9 10

For my friend and my president,

FRANCIS T. BORKOWSKI
PRESIDENT OF THE UNIVERSITY OF SOUTH FLORIDA

Who through music mastered the art of symbolic expression,
and in his presidency has brought harmony and rhythm
to a vast and varied campus-world

thereby making a difference, for good,
for the people of Florida's suncoast.

He brings honor to the profession of
academic administration
and shows what a good person can accomplish.

Contents

Preface

I express thanks to the Institute for Advanced Study, where I wrote this book, because for me IAS in its idyllic setting formed a paradise, but one without a snake. We the IAS members for 1989–1990 in everyday reality formed the true community of learning at that brief time, in that enchanted place, of which all of us dream. It was, for that year, each one's Brigadoon, everybody's Camelot, my *yeshiva shel maalah.* I was there. I do not have to go back. It is enough to remember. The members in my year, 1989–1990, formed an enchanted village, not so much a place but a time, a brief hour of tranquillity and reciprocal acceptance and shared illumination: a beautiful moment. We do not need, and perhaps cannot endure, perpetual perfection: the memory is enough. It was not locative, in Princeton in particular, it was Utopia in general. And there can be too much utopia—a nice place to visit.

At IAS you go into your office, close the door, and think great thoughts. But when you emerge, you always find another member with whom to share them, who is there to tell you things too (among them: your great thoughts are wrong). So with real pleasure I express my genuine appreciation for the institute's gifts to me: an endowment of peace and cordiality, generosity and collegiality among the members, and—above all—respect and appreciation for the shared enterprise of learning. I have learned not to take for granted acts of uncommon grace such as those carried out routinely and in a self-effacing way every day, also, by the members in my year and also one or two of the permanent staff of the Institute for Advanced Study.

During my year as member of the Institute for Advanced Study, I held a Senior Fellowship of the National Endowment for the Humanities, and I take much pride in offering to that agency in the support of humanistic learning my very hearty thanks for the recognition and material support that the fellowship afforded to me. I found the Endowment, particularly the Division of Fellowships and Seminars, always helpful and courteous in dealing with my application, and I express my admiration and appreciation to that thoroughly professional staff of public servants.

Brown University complemented that Fellowship with substantial funds to make it possible for me without financial loss to spend the entire academic year of 1989–90 in full-time research. In my twenty-two years at Brown University, now concluded, I always enjoyed the university's generous support for every research initiative that I undertook, and it was a welcome challenge to be worthy of the unusual opportunities accorded to me from 1968 through 1990 as a research scholar as well as a teacher at that university. I never took for granted the commitment of the university's scarce resources to my work, and now that I have taken early retirement in part to pursue my research interests, I express the thanks commensurate to the gift.

I made considerable use of the Firestone Library at Princeton University and the Speare Library at the Princeton Theological Seminary. I am glad to thank the librarians of those two inestimable collections, which turn this small town into as great a center for research in the field of religion as exists anywhere in the world.

Andrew Vaughn, a student at Princeton Theological Seminary, served as my research assistant for bibliography on synagogue art. His specific contributions are specified in context, as indicated in the table of contents and relevant chapter.

During the time that I worked on this book my final student at Brown University, Eli Ungar, wrote an honors thesis for his A.B. in Religious Studies on the "another matter" form in Pesiqta deRab Kahana. He stimulated my interest in the matter, and one of his discoveries, the high degree of formalization of the parsing of the verse to which recombinant theological signs are joined, plays an important role in my discussions in chapters 2 and 3. His honors thesis is published in J. Neusner ed., *Approaches to Ancient Judaism,* New Series, vol. 2 (South Florida Studies in the History of Judaism; Atlanta: Scholars Press, 1990), where his work stands entirely on its own. I would not have written this book if it were not for my engagement with his work and interests. While of what I know, most I learned from my colleagues, and some from my teachers, here is a student who taught me things I did not know and who stimulated my imagination to think about things I otherwise should never have conceived. It is a source of genuine satisfaction that my last undergraduate student at Brown University should have proved the best.

My colleague, Professor James F. Strange, University of South Florida, completely rechecked the tables in chapter 8. I am very grateful for his devotion to my research.

Professor William Scott Green discussed this work with me as it got under way and made many important observations and insightful sug-

gestions. I express my thanks to him for listening thoughtfully and responding critically and to the point. From the time he was my student at Dartmouth College, twenty-five years ago, to this day, he has made himself partner in all of my scholarly work, and if there is recognition coming to me for my contributions, then he shares in it.

<div align="right">

JACOB NEUSNER

</div>

Prologue

We understand a cultural and religious system as a whole only when
we can explain why this, not that. For the code of a system, which
requires deciphering, is embedded in the choices that it makes about
how things connect and combine. The key to the code must explain
what connects with one thing but not with another and how correct
connections bear meaning and incorrect ones gibberish. Ordinary
speech forms one such code, with rules of syntax and grammar that
govern the making of intelligible statements. This book shows how
Judaism in its formative age talked about God. The thesis is that at a
particular point, in the fifth and sixth centuries A.D., a mode of talking
about God took shape, both in synagogue art and in rabbinic writing,
that appealed not to propositional but to symbolic modes of discourse;
hence the title *Symbol and Theology in Early Judaism.*[1]

The distinction between propositional discourse and symbolic dis-
course in theology, critical to my analysis and argument, is not difficult
to explain. Within verbal communication, theological statements come
about in the form of propositions and yield syllogisms: God is, God does.
But there is also symbolic communication, by which theological dis-
course may also be made to take place. In symbolic discourse are con-
veyed and evoked attitudes and emotions rather than propositions: faith
as confidence in God rather than faith as the statement of truth about
God. This book describes how in Judaism a mode of communication, or
discourse, came about so that various symbols would be used to combine
and recombine to make normative theological statements.

In these pages I show that symbolic discourse took place not only in

1. As a matter of fact, this was the same period that marked the composition of the
Talmud of Babylonia, which, I plan to argue in due course, also inaugurated a mode of
discourse that had earlier not been conducted at all and, as a matter of fact, also
accomplished principal goals of a well-crafted theological statement. But it will require
several literary analyses before I can turn to the history of ideas—of the formation of the
Judaism of the dual Torah in its final and definitive statement in antiquity. For the kind
of analytical and synthetic project I have in mind, I point to J. Neusner, *Transformation
of Judaism: From Philosophy to Religion* (forthcoming). The planned work is *Transfor-
mation of Judaism*, vol. 2: *From Religion to Theology.*

the iconic but also in the literary medium. Both media were meant to serve to elicit right attitudes and approved emotions in the meeting with God, whether in synagogue worship or in Torah study among sages. These attitudes and emotions brought to expression within their mode of thought and expression propositions readily identified in intellectual form. As to the written form of symbolic discourse, I specify the literary forms that served, explain where we find them, and specify when, and in particular for what topics, symbolic discourse in the manipulation of symbols in verbal form began to assume importance.

In these ways I mean in detail to persuade the reader that symbolic discourse served—uniquely well, in my opinion—for theology. In that way I define the character—some might say, the phenomenology—of the theology of Judaism at the end of its formative age, in the sixth century: theology, as it was set forth through discourse yielding communication of not dialectical propositions but of well-composed dioramas or tableaux, not so much ideas that we are to affirm but attitudes that we are to nurture in our hearts.[2] While long available, symbolic discourse came to full and glorious expression in a single document, Song of Songs Rabbah, which portrayed God's love for Israel and Israel's love for God through the metaphor of the Song of Songs. There, above all, symbolic discourse proved to be the privileged, though not the only, medium of intelligible communication. First come signs, then speech, first the thunder and the thin voice of silence, and then, but only then, as Moses and Elijah had found out at Sinai that is Horeb, messages in the discourse of propositions and arguments and a different kind of dialogue from sound and silence. Then, and only then: "I am the Lord your God" and "What are you doing here, Elijah?" and the rest.

So my claim throughout is that at the end of its formative age, in the fifth and sixth centuries of the Common Era, the two Judaic systems of which we have evidence—one in the rabbinic writings culminating in the Talmud of Babylonia and associated Midrash compilations, the other

2. The issue I leave over and do not address is in two parts. First, I do not in these passages ask how to discover the syntax and grammar of the symbolic speech at hand: to decipher the principles of intelligible combination or, as I prefer, to decipher the semiotics of the recombinant theology of Judaism. That the same set of questions concerning the syntax and grammar of the symbolism of Christianity, its principles of recombinancy, is to be raised seems to me self-evident. The second involves the movement from symbolic discourse concerning theology, such as we shall find in the final writings of the formative age of Judaism, to that same mode of discourse concerning theology that we find in medieval continuators of these same writings, in Qabbalah for example, will then prove continuous and natural. But I leave it to specialists in Qabbalistic writings to make use of the findings of this book in ways they find compelling.

in the art of the synagogues of that period—undertook to express thought in not only propositional but also symbolic discourse. My argument derives from analysis of two distinct bodies of evidence. Sources for the literary representations of symbols are the canonical writings of the Judaism of the dual Torah, and the iconic evidence derives from ancient synagogues dating from the first to the seventh century. We shall see that symbolic, as distinct from propositional, discourse came to the fore in an important compilation of that end period in the formative era. At the same time iconographic communication, through a restricted vocabulary of symbolic representations, characterized the synagogues of the same time and place. What I demonstrate is that at a particular moment in the unfolding of Judaism in its formative age, the first through the seventh century, the symbolic mode of discourse took its place alongside the propositional, and in both literary and iconic form, within the same span of time, the fifth and sixth centuries, the Judaism of the rabbinic writings and that of the synagogues conveyed messages in a formerly uncommon medium of communication.

That is not to suggest that symbolic, as distinct from propositional, discourse can have surprised earlier Israelite artists—writers and iconographers alike—whatever particular Judaism compelled them to their art. Lists of names that bore meaning apart from any propositions associated with them, for example, formed a familiar medium of communication. Those names, correctly selected and ordered, communicated intelligible thought in symbolic, as distinct from propositional, signs. These symbols, whether represented in iconographical media or in verbal media, were relied upon to elicit, if not articulated right thoughts, then besought attitudes. The names—words out of all syntactic context, words not assembled to set forth syllogisms and prove propositions—communicated because they brought up attitudes and imparted their self-evident truth.

Names listed in catalogues but otherwise opaque in any denotative sense, such as Abel, Enoch, Noah, Abraham and Sarah, Isaac, Jacob, Moses, the people crossing the Red Sea, Rahab, Gideon, Barak, Samson, Jephthah, David, Samuel, properly selected and rightly ordered could be expected to communicate, conveying sense if not proposition. When joined with the words "by faith," the names just given indeed powerfully served the purposes of the author of Hebrews 11—and they did so as much as the arguments and propositions on the same matter, set forth in Romans and Thessalonians about salvation by faith, conveyed the meaning of the apostle Paul. Not only so, but standard lists of names of heroes, on their own convey the right attitude or even lead to the correct

conclusion, and that can be without regard to an associated, verbal proposition. As much as Washington and Lincoln and Eisenhower and Reagan for one party, or Jefferson and Wilson and Roosevelt for the other, communicate symbolically, as a kind of shorthand, for "what we stand for" in political contexts, so names rightly chosen and properly ordered bore meaning, if not explicit messages.

How does this symbolic communication take place, even alongside propositional discourse? To take a familiar example, for Ben Sira, the well-known catalogue of "famous men" of Sirach 44 makes a point that is never articulated—but does not have to be. The catalogue encompasses these names: Enoch, Noah, Abraham, Moses, Aaron, Phinehas son of Eleazar, Joshua son of Nun, Judges, Samuel, Nathan, David, Solomon, Elijah, Hezekiah, Josiah, Ezekiel, Zerubbabel, and, finally, *Simon the high priest son of Onias.* As the catalogue of Hebrews indicates, some of these names prove to be commonplace. They routinely appear, also on counterpart lists in rabbinic writings. But of others that is not true. The inclusion, in particular, of Simon the high priest and the positioning of that name at the end, in contrast to other such catalogues of names, is so jarring as to suggest that including him was the point of making the list. Ben Sira says much about the names he lists, but what he says merely by mentioning his ancestor's name, without an articulated proposition, proves to be his most eloquent and powerful medium of communication. Controlling the agenda governs communication, in which case one need not dictate what actually is said about the items that are on the agenda. Communication takes place on its own, without articulation in propositions. Then lists that omit that name, or Zerubbabel or Judges or Nathan, will represent other principles of selection and convey other meanings or attitudes. Then the ordering of lists that encompass Abraham, Moses, and David will clearly mean to convey some message other than the one Ben Sira's list so casually imparts. Symbolic discourse takes diverse forms; it may form the only medium of communication, or it may work within the infrastructure of articulated thought; it may appeal to iconic representations, or to verbal formulations, of symbols.

Critical to my proposition and argument here is that, in the rabbinic writings, certain words stand for opaque symbols, not for specific and determined propositions; they may denote, but, used for symbols, they only connote. And the connotations are conveyed through the manipulations of several such symbols, also in verbal form—hence, for instance, the lists of opaque symbols, such as, I maintain, Ben Sira and the author of Hebrews use to make points important to their compositions. While

we are used to symbolic speech in iconic form—alternating red and white stripes, a field of blue with fifty stars evoking deep feeling in citizens of the United States of America, for example—the conception that symbolic speech takes place in verbal form is less familiar. True, artists in fiction and poetry have for all times spoken to us in just that way. But that passages in rabbinic literature of late antiquity communicate in symbols in verbal form, rather than through the conventional representation of proposition, so far as I know has not been understood.

That is why I have to spell out with some care precisely what I mean by a symbol in verbal form in the literature under study here and in the religion that that literature adumbrates and recapitulates. For while everyone must realize that communication in Israelite life took place both through setting forth propositions through the syntax and grammar of syllogistic thought and expression and also through eliciting responses, for example, emotions and attitudes, through the rules of syntax and grammar of symbolic speech, we assume that rabbinic writing is wholly propositional, intellectual, critical, and rational in the ordinary senses of these words. But when "our sages of blessed memory" sought to communicate thought about God, they wrote in other ways, as well as in the familiar ones, and resorted to a discourse that in their other writings was quite uncommon. That allegation requires me also to explain at some length why I think that symbols may take the form as much of language as of iconic representation, not because the conception is a new one, but because, in the reading of this writing in particular, it is unfamiliar. For the writing before us I have to be able to define and identify the indicators that a word stands for a symbol in verbal form, that is to say, a word that is opaque except as it serves to convey meaning in a symbolic manner rather than standing entirely for itself and its own delimited, denotative, and pellucid meaning. The indicators must be such that readers will find no difficulty in making the same distinctions that seem to me self-evident and important.

My proposition in these pages is more than that the Judaism represented by the Mishnah, two Talmuds, and ten Midrash compilations—the Judaism of the dual Torah—engaged in not only propositional but also symbolic discourse. It is also that, at a very particular point, the literary evidence and the archaeological evidence converge, so that the kind of discourse that a particular document highlights turns out to have characterized the medium of discourse represented by synagogue iconography as well. To demonstrate that fact, we examine two quite separate bodies of evidence in ancient Judaism, literary and artistic, identifying what I maintain are symbols expressed through words in the literary

evidence, cataloguing the clearly symbolic utilization of artistic representations of objects, persons, and events in the iconic evidence.

How about deciphering the syntax and grammar of symbolic discourse in Judaism in its formative age? We shall see substantial evidence that a restricted symbolic vocabulary characterized both the literary and the archaeological sources of Judaism in late antiquity. The same few objects, but no others, repeatedly appear in iconic form; the same limited repertoire of symbolic representations[3] in literary form of certain persons, events, or actions, but no others, constantly makes up the probative lists. An inventory, based on the Hebrew Scriptures for instance, of the objects that can have been represented or of the scriptural heroes or miracles or objects that can have been invoked, vastly outweighs the incomparably shorter list of those iconic or verbal symbolic representations of the scriptural persons, events, objects, or actions which do appear. Ben Sira's list in comparison with counterpart lists in the rabbinic writings shows that fact. Drawing upon a limited vocabulary of only a few things that occur nearly everywhere, synagogues present iconic decorations that clearly are so selected as to convey messages or connote meanings. In the writings of the sages of the Judaism taking shape in that same period, recurrent allusions to a restricted catalogue of only certain events, persons, or actions alert us to the presence of an implicit symbolic repertoire.

While this book catalogues the literary and the iconic vocabulary that, in my view, stands for the symbolic structure of Judaism, I intend here only to lay out some of the rules that can point toward identifying the media for symbolic discourse. Beyond that point I cannot move, so I do not claim to know how the language of symbolic discourse is to be deciphered, understood, and even used. I mean to contribute only a clear account of the symbols that are used, showing when this mode of discourse became prominent. I cannot as yet lay out approaches to the interpretation of the symbolic discourse of Judaism, which seems to me a different problem from the one that engages my attention, drawn as it is from the history of religion rather than the semiotics of religion.

Still, even in these pages I trace what I should hope to find on a Rosetta stone, for I show that the symbolic vocabularies in iconic and in literary representation, respectively, differ not only in detail but in basic character. Each combines its components in its own way. It must follow that if we can decipher the speech of the one, that is to say, the principle

3. In chapter 1 I shall explain what I mean in suggesting that a person or an event may be represented as a symbol.

by which it chooses and combines this, not that, we cannot on that basis decipher the speech of the other. The former, the iconic, however it is to be interpreted, does not resort to combinations and recombinations to make its statement; in the aggregate, the same things occur in the same way everywhere. The latter, the literary representations of symbols, by contrast are to be compared to the words of a language. Through the infinite possibilities afforded by syntax and grammar the range of statements that can be made through these symbols, like the range of statements that can be made with a given repertoire of words, is scarcely subject to limitation. That limited result—the differentiation of symbolic discourse of synagogue iconography from literary expression—may prove helpful to those who pursue those questions of interpretation of symbolic discourse which I mean to help clarify but to leave so far unanswered. If I may persuade the reader that Judaism in its literature as much as in its iconography engaged in symbolic discourse, I shall have advanced the study of the symbolism of Judaism.

It remains to specify the two scholars whose heritage I explore in the argument set forth in these pages. The first is Max Kadushin; the second, Erwin R. Goodenough. The former discovered the indeterminacy of language in the rabbinic writings and led me to the thesis that words could serve for symbolic, as distinct from propositional, discourse. The latter opened the way to the interpretation of the iconic vocabulary of the synagogues.

The conception that theological words bear no determinate meaning and acquire sense principally in context is not original with me. It derives from Max Kadushin, and this book develops a conception that Kadushin formed. In his *Organic Thinking: A Study in Rabbinic Thought* (New York: Jewish Theological Seminary of America, 1938), Kadushin made the move from the philological to the philosophical reading of the vocabulary of rabbinic writings. This he did in his invention of the category "organic thinking," in which he stressed that through a variety of concrete expressions a given complex came to formulation. The clear implication is that we cannot accomplish the analysis of rabbinic thought by appeal to specific words, word studies, lexical analyses, or philology. To be sure, Kadushin's definition of what we do instead of philological study of conceptions proved hopelessly confused: "The complex of concepts as a whole enters into the constitution of every concept; and thus every concept is in constant, dynamic relationship with every other concept" (p. vi). That is an invitation to total confusion. But in emphasizing the "organismic" character of rabbinic thought, Kadushin did show that definite concepts or terms

interrelate and hence a clear definition of a concept cannot be attained through the study of specific words. Kadushin's error is quite specific:

> There can be no real amalgam of philosophy and religion, no sound philosophy of religion, for the reason that in any philosophical system all the ideas are related to one another in tight logical sequence whereas religious concepts are organismic, non-logical. A religious complex of concepts therefore cannot be made part and parcel of a philosophical system.

If the Mishnah stands for a religious, not only a philosophical, system, then Kadushin is wrong. But his basic initiative in distinguishing concepts from words that convey concepts assuredly opens the way toward a more appropriate medium for description, analysis, and interpretation of the ideas that, in a given rabbinic document, form a system and an orderly account of things.

In the second edition of *The Rabbinic Mind* (New York: Blaisdell Publishing Co., 1965), Kadushin formulated matters more successfully. He insisted that "rabbinic concepts" that are represented by single words or terms in fact are "connotative or suggestive. . . . This is to say that they are not definable and furthermore that they cannot be made parts of a nicely articulated logical system or arranged in a hierarchical order. Nevertheless, despite being simply connotative, these rabbinic terms are genuine concepts, general ideas, although neither scientific nor philosophic concepts, nor yet concepts referring to objects or relations in sensory experience" (p. vii). Here again, it is the negative aspect of his argument that I find useful: words are at best connotative, and, it must follow, the philological method in the study of ideas is misleading. In my language, it contradicts the character of the evidence that is studied. The point important in this book is that Kadushin set forth the conception that words may prove to lack determinate meaning and to gain specificity only in context, and he furthermore maintained, quite correctly, we shall see, that theological words in particular exhibit that quality. When therefore I maintain that some words are opaque and serve a variety of meanings, each dictated solely in context, I carry forward Kadushin's conception.

The importance of reading Judaism's art with Goodenough cannot be overstated. Goodenough frames issues as they should be addressed, because he treats the study of religion as a generalizing science, and he examines a particular case because it serves to exemplify matters of wider interest. Through the specific case of the symbolism of ancient Judaism and problems in its interpretation, Goodenough raises a press-

ing general question. It is how to make sense of the ways in which people use art to express their deepest yearnings. And how are we to make sense of that art in the study of the people who speak, without resorting to words, through it? The importance of Goodenough's work lies in his power to make the particular into something exemplary and suggestive, to show that, in detail, we confront the whole of human experience in some critical aspect. Goodenough asks when a symbol is symbolic. He wants to know how visual symbols speak beyond words and despite words. Goodenough studied ancient Jewish symbols because he wanted to explain how that happens and what we learn about the human imagination from the power of symbols to express things that words cannot or do not convey.

What I find important in Goodenough is his arguments concerning when a symbol is symbolic. Goodenough argues that the symbols under consideration were more than merely space fillers. Since this matter is crucial to his—and my—argument, let me give his reasons with appropriate emphasis. These are:

- First, they were all *living* symbols in surrounding culture.
- Second, the vocabulary of symbols is extremely limited, on all the artifacts not more than a score of designs appearing in sum, and thus highly selected.
- Third, the symbols were frequently not the work of an ornamental artist at all.
- Fourth, the Jewish and the "pagan" symbols are mixed on the same graves, so that if the *menorah* is accepted as "having value," then the peacock or wreath of victory ought also to have "had value."
- Fifth, the symbols are found in highly public places, such as synagogues and cemeteries, not merely on the private and personal possessions of individuals, such as amulets or charms.

When I set forth my reasons for maintaining that certain iconographic representations in the synagogue are symbolic and not merely ornamental, I draw upon Goodenough's arguments. In these pages, while I mean to make use of the legacy of both Kadushin and Goodenough in ways that will advance the study of the symbolic structure of Judaism, I have my own special point of reference. It concerns identifying literary, as much as iconographic, modes of symbolic discourse.

1

Locating Symbols

LOCATING SYMBOLS

Precisely what do I mean by "symbol," and how do I know that a sign or cognitive representation, whether verbal or artistic, is "symbolic"? An ostensive definition suffices for the purpose of this book, which does not pretend to make a contribution of any kind to the theoretical literature of symbolism. By symbol I mean a "thing"[1] that speaks beyond its own particularity, thus, "symbol" here signifies one thing that says many things. So while a symbol may denote, it always must connote. Within this simple definition a symbol is a thing that may or may not stand for itself but that must always stand for something more than itself.[2] Whether to soul or to heart or to mind, whether to intellect or to intuition, whether to change attitudes or to reshape emotions or to impart convictions or to express ideas, the symbol makes its statement by moving beyond the bounds of its own character.

Can the name of a person serve as a symbol? The "historical Moses," for instance, may denote an individual and stand for himself in all his particularity. But "Moses our rabbi" connotes something that transcends a particular person at a given moment; it is then (among diverse possibilities[3]) Moses in relationship to the Torah, so that "Moses our rabbi" connotes God's giving the Torah to Israel. What about an object? The

Covenant
Promise

1. I can think of no more neutral word than "thing," and all "things" can serve as symbols. But of course "signs" is available. I do not choose "signs," however, because to do so suggests a knowledge of the theoretical literature of semiotics that I do not possess.

2. But, as I shall argue shortly, a verbal symbol that denotes is less symbolic than an opaque verbal symbol, one that connotes but does not denote anything in particular. That observation will be central to my argument in this chapter and in the subsequent analysis of evidence.

3. The history of Judaism may be written through the account of Moses through the ages, beginning, after all, with his presence or absence in J, E, P, and D!

1

ram's horn denotes a particular object. But, represented on the floor or the wall of a synagogue, the ram's horn connotes (and may evoke) sentiments, intuitions, feelings, or propositions that vastly transcend the representation of the hardened excrescence on the head of the ram: the binding of Isaac, for one thing; Moriah and the Temple, for a second; the judgment of the New Year, for a third; the great trumpet that heralds the coming of the Messiah, for a fourth. In all of these cases the "thing" may or may not stand for itself. But to be symbolic, a "thing" must stand for something beyond itself—many things, that are far beyond itself, as a matter of fact.

What about events? A symbol, for example, may derive from and stand for an event, which, when represented however crudely, will bear self-evident implications that transcend what actually happened on that particular day on which the singular event took place. An event reduced to a sign, such as a battle, becomes symbolic when to the sign, for the battle, are attached meanings or consequences that extend far beyond what actually happened, or what took place on account of what happened, in the battle itself: the signs, here, mere names of places, such as Hastings or Agincourt, Gettysburg or Pearl Harbor or Midway, for instance. In the case of (a) Judaism, as I said, the *shofar*, or ram's horn, may signify the binding of Isaac, hence a singular event; the penitential season encompassing the New Year, hence a recurrent event; the altar of Moriah, hence the Temple in Jerusalem; and a variety of other things. It can stand, also, for Abraham and Isaac, for a symbol may be a person, and a person may be made symbolic, exemplifying in himself or herself an obvious attitude, virtue, or value. A gesture, such as kneeling, dancing, a motion of the hand or of the head, that evokes thought or attitude or feeling serves as a symbol, speaking, as it does, beyond its own contents; or it may have no contents to begin with: an action that bears meaning beyond the physical movement of torso or knee that on its own is inert, neutral, without implicit or self-evident meaning.

My ostensive definition, though minimalist, proves imperial, for it encompasses, as the medium for symbolic discourse, whatever can stand for something beyond itself, without limit as to how the thing is represented. The definition therefore does not limit itself as to the medium by which symbolic discourse may take place. That symbols reach us in iconic form hardly requires argument. But, as a matter of fact, I shall show that in the canonical writings of Judaism some words serve as signs, not as signifiers in their own right, so that symbolic discourse, as distinct from propositional and syllogistic discourse, is carried on. There are words that stand for signs in rabbinic writings. And that proposition

concerning the use of words for symbolic signification forms the burden of my representation of symbolic discourse in Judaism: which words, through what rhetoric, in what contexts, and how symbolic discourse takes place in canonical writings.

In these pages two media serve to represent symbols and to speak through combinations of symbols: iconic representation in synagogue art and verbal representation in rabbinic writings. As a matter of fact, we are entirely used to identifying symbols in iconic form: a crude drawing of a tree for astral ascent, for instance; a *menorah* for the seven levels of the heavenly ascent; a scroll for the Torah; a ram's horn for the *shofar* of Moriah, as I said; and a child on wood on a table for Isaac on the altar. And these iconic symbols—Torah, *shofar*, altar, *menorah*—bear a variety of meanings, some of them to be given in words, some in attitudes or approved emotions or evoked intuitions. In all cases, however, the represented object transcends its own details, for example, those imposed by the medium, verbal or iconic. But we are not used to the conception that, in the rabbinic writings, words serve as symbols, that is to say, symbols appear in verbal form. Quite what that allegation means and how it is to be demonstrated remain to be explained.

In these pages, then, what tells me when a "thing"—a sign whether portrayed iconographically or verbally—is symbolic? The answer to that question must come in two parts, for, as is already obvious, the Judaism in late antiquity studied here is represented by both literary and archaeological evidence. We have therefore to establish appropriate criteria for the symbolic status of "things," that is, for symbols, presented in each of the two media. But the same criteria must be met, in a systematic way, by symbolic representations in both media.

In speaking of symbolic discourse in Judaism, I do not claim here to decipher the symbolic structure of Judaism. I have in mind not a dictionary to interpret meanings of symbols but only a grammar to tell me when intelligible discourse is under way or is not under way. What I propose is not a catalogue of symbols but only an account of the media of symbolic discourse of Judaism: symbols so formed into combinations as to convey significance, meaning imparted to attitude or sentiment, if not articulated and propositional meanings delivered to intellect. Symbolic discourse through gesture or sound or visual media hardly is unfamiliar. But in writings of such unrelenting critical rationality as the rabbinic canonical ones, we may hardly take for granted the presence of symbolic discourse conveyed in verbal form. Let us start with the more familiar mode, the iconic, and establish the rules by which we shall describe the less familiar one.

SYMBOLS IN THE ICONIC MEDIUM

Signs in iconic representation of course are readily at hand. We have on the floors and the walls of synagogues ample representation of persons, objects, events, and gestures that in context surely are meant not only to denote but to connote and also to evoke: speaking through the eyes to the heart, if also to the intellect, significations that in no way require verbal articulation or explanation. Iconic representations of symbols not merely express, but speak beyond, themselves, transcending the thing or the moment that encapsulates them, addressing a world without end in space or time. Indeed, often crudely drawn, such signs scarcely represent a particular thing but principally evoke what that thing is meant to stand for.

Not only so, but a remarkably restricted vocabulary, made up of only a few symbolic "things" out of a vast available repertoire, served for the synagogues, particularly of the fifth and sixth centuries, to evoke whatever attitudes artists and their patrons wished to use to characterize public worship. From the obvious process of selection that has identified some few "things," it follows that, in order to identify as symbolic an iconic representation of a ram's horn or a candelabrum on the wall of a synagogue, or the representation of the altar with Isaac upon it on the floor, we hardly need to answer the question, When is a symbol symbolic? The conception that such things are mere ornament, as much as squiggly lines around the base of a wall or a checkered pattern in a mosaic are commonly supposed to constitute mere ornamentation, need not detain us.[4]

Once more, therefore, I resort to an ostensive definition. By the definition provided by circumstance, without further ado, I treat as symbolic all iconic representations of persons, events, or objects that we find in synagogues *in more than a single venue.* As we shall see, these tend to be grouped in time: synagogues in the fifth and sixth centuries ordinarily are decorated, those earlier are not; the repertoire of decorations of the fifth- and sixth-century synagogues contains no more than half a dozen items, only three of them broadly used. In the light of these facts, what persuades me that a "thing" that is represented is symbolic if the same thing occurs in many liturgical settings? My reasoning is that when a variety of artists and their patrons have chosen to represent on the floor or the wall of a synagogue the same thing, then that thing is deemed to

4. Nor do we have to follow Goodenough in maintaining that all markings were symbolic; my problem is not interpretation of symbols but only the discourse afforded by them.

bear meaning among Jews in many places, like words of a severely restricted vocabulary, chosen out of a compendious dictionary, deemed able to give a single and conventional message. The iteration of the thing bears the implication that the thing communicates and is not random—meaningless space filler or merely aesthetic ornamentation. I take for granted that the patrons and the artists of synagogues chose those objects in order to impart to that place a character or signification of a particular order, one that, moreover, could be readily discerned everywhere. Hence they had in mind a language that conveyed significance, but it was a language the vocabulary of which was conveyed in iconic form, the grammar of which in rules of arrangement, and the syntax in laws of positioning and order.[5]

So far as symbolic discourse in iconic form is a language, the evidence that a thing is a symbol then derives from the capacity of patrons and artists to use the same thing anywhere. That is evidence that, like a word, the thing is meant to signify, to make a statement, and, in context, combined with other such things, symbolic speech then is carried on. If, then, we find, for example, a *menorah* or a ram's horn in numerous settings, I posit that they have been selected to make a statement of some sort. I further take for granted that the objects are meant to transcend themselves in such a way that, whether or not they are denotative, they must be deemed connotative.[6] The repetition of some few items out of a much larger available repertoire strongly suggests that these objects, and in that context no others, spoke broadly and bore rich resonance. While a random selection can tell us answers to an aesthetic question, the restricted vocabulary before us suggests that we have in hand symbolic discourse and even permits us to specify the vocabulary that requires deciphering: a symbolic structure.[7]

That definition of the symbolic character of iconic art in synagogues therefore lays heavy stress upon the matter of recurrence, hence of

5. But, I repeat, I do not have to set forth more than the fact of a restricted iconic vocabulary; to make the point that symbolic discourse was carried forward in the two media under discussion, I do not have to set forth what I conceive to have been the messages or significations of that discourse. That is a separate problem, one, as I said, that I aim only at helping to set forth.
6. The argument of this book does not require me to attend to nonrepresentational art in synagogues. Erwin R. Goodenough, *Jewish Symbols in the Greco-Roman Period* (13 vols; New York: Pantheon Books, 1953–68) dealt with nonrepresentational art, holding that it was not mere decoration but intended to bear meaning. I do not enter into that question in these pages. My summary of Goodenough's contribution is in Appendix II.
7. The alternative proposition, that we deal with "mere decoration," has to be considered; what I offer here is only a starting point.

function and relationship, and ultimately of modes of combination into whole structures. If a given thing appears in many places and is portrayed with other things that appear in many places, then, in combination, it seems to me, these several things are intended to speak beyond themselves, to join together to make a statement that none of them makes individually, to transcend not only their own details but themselves altogether. When we come to the identification and definition of symbols in verbal media, we shall have to appeal to the same reasoning and consequent criteria. These are as follows: (1) the function and provenance, within a synagogue; (2) the combination or relationship with other representations of things; and (3) the selection of those few things among many that can have been represented. When these three conditions have been met by an iconic representation, that which is represented then is meant to serve as a symbol.[8]

SYMBOLS IN THE VERBAL MEDIUM

What about the representation of symbols in words?[9] Here we come to a much more difficult matter: to identify out of all the words of a given document the particular ones that serve as signs and therefore represent symbolic "things" in written form. The same components of the defini-

8. I do not concentrate on Goodenough's definitions of symbol and his methods of interpretation, because my problem is a different one from his. I seek to discern not universal meanings but the sense of symbolic discourse conveyed in a very specific setting, the particular language of symbolic speech of Judaism, the distinctive syntax and grammar (to return to my metaphors) that turns "things" or signs into intelligible and communicated content, whether attitudinal or emotional or intuitive or propositional and syllogistic. Goodenough's interests lay not in the particular but in the universal, leading him toward an account of the psychic unity of humankind. I am simply asking a different question. Not only so, but Goodenough never addressed the issue of how symbolic discourse could take place through symbols represented by words, rather than iconically, and, as will be clear, that issue forms the centerpiece of my inquiry. Indeed, the iconic symbols serve only by way of comparison and contrast.

9. I avoid the distinction between "literary" and "artistic" media for the representation of symbols, because in the evidence we shall consider, there is no symbol I can identify that can be represented only in a literary medium or only in an artistic medium. *Shofar* (ram's horn) or *menorah* (candelabrum) can be represented by a word or a drawing. When combined, whether in words or in iconic representations, they may mean the same thing, or verbal representation may evoke one set of connotations and iconic another. But so far as we deal solely with the representation of symbols, as distinct from their meanings, I do not think that the medium then forms a significant point of differentiation among the symbols we shall discuss. My case is only that symbolic discourse takes place in the two bodies of evidence, pertaining to the fifth and sixth centuries, that emerge from Judaism(s), the written and the iconic. But the equivalency, as to representation, of symbols in verbal and iconic form makes all the more striking the fact which we shall in due course discern, which is that art conveys one quite restricted vocabulary and literature an equally restricted vocabulary.

tion that has applied to symbols in iconic form must pertain. But the content of those components will shift. Can I identify the rather particular parts of the literary evidence that seem to me to speak through symbols rather than through sentences? How will I know when, in reading a document, a set of things portrayed through words, clearly, by an objective criterion, serves to speak not for itself alone but also (or only) beyond itself? The answer to that question derives, to begin with, from certain formal traits of the literary evidence. When I have set forth these traits, I shall be able to explain how, in documents of a given type, some words portray symbols rather than convey propositions: *so that symbolic discourse is under way.* We begin with familiar definitions of operative criteria.

First, symbols represented in words are those "things" (or signs) which transcend their particularity and signify, that is, deliver a message—verbal or intuitive—beyond themselves. These we must distinguish from the things that in context stand for themselves alone and that bear meanings restricted to their own characteristics, for example, the verbal explanations associated with them or the specific, explicit message conveyed along with them.

Second, symbols conveyed in words must represent a highly restricted vocabulary, so that some few words recur in symbolic, as distinct from restricted, senses. Only a few words ought to occur, time and again, in such a way as to warrant classification as symbolic, as distinct from propositional, discourse.

Third and most important, I must be able to specify why I think the verbal representation of a symbol functions along with other such verbal representations to make a statement that is of a symbolic, not a propositional or syllogistic, character. I have to offer a theory to explain, not why a word is symbolic in its context, but how sets of such symbols combine to convey meaning in a different medium of thought from the meaning conveyed through propositional constructions of words used in a sense restricted by their own traits or significance. Here again, therefore, I want to identify not the words but the syntax and grammar of symbolic discourse.

I shall demonstrate the simple fact that in certain documents within the canon of Judaism that took shape in late antiquity, some composites of compositions[10] utilize a particular form and join together things that

10. In this context, "composite" serves as synonym for "document," or "large component of a document." "Composition" refers to a completed and coherent unit of thought, corresponding in a general way to paragraph or even to entire chapter in our categories of literary division.

clearly are meant, in combination with other things, to transcend their particular meaning. The two elements of that somewhat opaque sentence forthwith require definition: (1) the particular forms and (2) the things that I maintain are meant in combination to bear meanings that, not in combination, they do not necessarily convey (connote or denote). When I have clarified the evidence that seems to me to testify to symbolic discourse, this exploration of the symbolic structure of Judaism, conveyed in both iconic and literary form, can commence.

1. There is a particular form that, in my view, means to conduct symbolic, as distinct from propositional and syllogistic, discourse. The form, amply instantiated in chapter 2, is based upon the repeated citation, in disciplined parsing, of a verse of Scripture and the successive imputation of various meanings, entirely cogent with one another, to each component of that verse. The form requires disciplined repetition of the parsed verse together with presentation of a repertoire of distinct meanings to be imputed to those components. The parsed verse then is explained in terms other than those specified by the verse when it is not parsed. When parsed, element by element, the verse is given a whole new set of meanings or reference points. And when this process is repeated, these new meanings prove multiple. If not repeated, the form is not present; not surprisingly, the form involved ordinarily bears a rhetorical signal, "another matter."

2. The key words that are utilized in that "another matter" composite form bear meaning only in combination, having in that context no denotative sense whatsoever outside the combination with other such verbal signs. Our task here is to recognize symbolic discourse when it occurs.[11]

How is the form just now described pertinent to our inquiry into the use of language for the representation of symbols, so that, within the cited form in particular, I can adduce evidence that words are utilized *solely* to portray symbols? Two considerations pertain, and both of them run parallel to the ones that apply to evidence of an iconic character concerning the symbolic structure of Judaism.

First is the matter of repetition, integral to the execution of the form just now introduced, just as the repeated use of iconic representations in the same circumstance (synagogue decoration) indicates that we have in

11. A later one is to find out how to decipher the principles of combination of those signs in verbal form and structure and so explain the way in which meaning is conveyed through those combinations. Then we shall have a key to the symbolic—as distinct from syllogistic and propositional—discourse of the canonical writings of Judaism.

those rerepeated presentations of the same few objects not mute decoration but transcendent symbols.

Second and concomitantly comes the consideration of a restricted vocabulary, which signals the utilization of a restricted, privileged code. How do these traits of symbolic discourse in iconic form pertain in the verbal medium? In our sequences of three or more representations of the same parsed verse, each with its own "other matter," we shall see that a restricted vocabulary of verbal representations of symbolic things recurs, with the same matter signified many times over.[12] When we gather all of the "things"—the signs—that serve in an entire collection of these kinds of compositions, we shall see that a strikingly limited repertoire of persons, events, or actions comprises all of the lists of these "other matters." That fact standing by itself will prove only that a restricted vocabulary characterizes the "another matter" compositions and composites.

But why are these words opaque signs, to be interpreted by appeal to a syntax and grammar that pertains to signs whether in verbal or iconic form, and why are they not to be classified as narrowly substantive and to be read by appeal to the conventional rules of the syntax and grammar of propositional discourse (within the terms of theology given in the Prologue, belief or faith *in* rather than belief or faith *that*)? The answer brings us to the consideration already introduced for the identification of symbols in iconic form: a symbol is a sign that transcends the details of its own representation. But can that same trait also characterize words, which surely denote, whether or not they also connote? Indeed so, in the present context at least. Let me give a theoretical instance and then state what I conceive to be the rule. These abstract definitions will be given ample instantiation in due course.

If I have a set of four components of the parsed verse, each component represented by J, K, L, and M, with words A, B, C, and D, linked to each, respectively, and then I have another set of the same four components of the parsed verse, with Q, R, S, and T, linked to each, two sets of words require attention. The first set comprises the four components of the parsed verse: J, K, L, M. Do these have freestanding meanings? Obvi-

12. Critical to Eli Ungar's study is the proposition that "another matter" is "the same matter again." That point is made, in one context, by William Scott Green, in a forthcoming article. Dr. Herbert Basser, Queen's University, kindly drew my attention to Y. L. Bohner, "A Historical and Methodological Exposition of Aggadic Sources," *Samuel K. Mirsky Memorial Volume: Studies in Law, Philosophy, and Literature,* (ed. G. Appel; New York: Sura Institute for Research, 1970) 155ff. Basser himself makes the same point in detail in his studies of Sifré to Deuteronomy, reviewed by Ungar in his article.

ously not, since the framer of the passage clearly intends to say that these four components of the parsed verse bear meaning only in combination with the repertoire of words (the A, B, C, D, or Q, R, S, T of the example), and that indeed is the point of his composition. Then the four components of the parsed verse themselves are transformed from denotative to (at best) connotative signs.

But, in my view, they also are not connotative; they in fact are opaque and derive whatever signification they are to have only in combination, only from the linkage with the A, B, C, and D. So the four components of the parsed verse, bearing propositional, even syllogistic meaning when standing together as a cogent statement, obeying the rules of syntax and grammar of the verse and chapter of Scripture in which they occur, in the form at hand have been taken apart ("deconstructed" being the current word). They no longer constitute denotative words or even connotative signs. They have been made opaque and gain significance only in accord with the rules of syntax and grammar of the form before us; and those rules govern symbolic discourse.

Then what about the A, B, C, and D/Q, R, S, and T words? Can we not say that these words bear well-established and conventional meanings, denotative meanings? Well, as a matter of fact, I shall show that that is not so. For to the framer of the "another matter" composition only a restricted vocabulary is available. He may refer, for example, to Abraham, Moses, David, Pharaoh, Sennacherib, and Nebuchadnezzar. But, as a matter of fact, he may not refer to, for example, Caleb, Samson, or Solomon, Cyrus or Abraham's allies. So far as Scripture defines the available repertoire, the framer of such passages, we shall see in detail, must choose from a restricted vocabulary. But do the words that the framer has in hand not bear denotative meaning, since surely David is always *that* man, the exodus at the sea *that* event, Sinai *that* moment?

Well, in point of fact, the mere appearance of a name by itself does not tell us where and how that name will serve, what meaning will be imputed to it, or how significance will be drawn from it. "Moses" or "David" may serve in any number of sentences, and these sentences may make a vast range of points, so "Moses" or "David" functions as a mere word, just as "dog" or "king" or "table" serves as a mere word, available for combination with other words into sentences and paragraphs— always in accord with the syntax and grammar of propositional discourse.

But what about symbolic discourse? In the context of the "another matter" composition, "Moses" or "David" or "Israel at the Sea" serves no propositional purpose at all—conveying no faith that, belief that—as a (mere) sign, but is available for combination with other signs into aggre-

gates meant to bear meaning, even to make points, in accord with the syntax and grammar solely of symbolic discourse. "David" or "Moses" in symbolic discourse bears no determinate meaning at all; when we see "Moses" or "the exodus" we do not know the subject of the signification that symbolic discourse will set forth, let alone the proposition (if any) that will be laid out. Only in combination does "David" or "Moses" or "*shofar*" or "*menorah*" gain any signification at all. And then the sense that is desired by the composer of the discourse will emerge not from the words that are used but from the combinations that are accomplished: combinations of the (otherwise senseless) parsed components of the verse at hand, along with the (otherwise senseless) symbolic signs that are used.

Let me set forth in abstract symbols the proposition in hand and then spell it out. I give the parsed elements of the verse of Scripture in boldface type, one set of symbols in verbal form in italics, and the other in plain type:

$$\mathbf{J} \ = \ A \ = \ Q$$
$$\mathbf{K} \ = \ B \ = \ R$$
$$\mathbf{L} \ = \ C \ = \ S$$
$$\mathbf{M} \ = \ D \ = \ T$$

There is no theoretical limit to the number of symbolic reiterations that can be effected within this logic of discourse; there is no control effected by the base verse, deprived as it is of determinate meaning by its deconstruction into its parsed components; there obviously is no control effected by the successive symbols in verbal form, which have no determinate meaning at all. The key to meaning is the combinations and recombinations—components of the parsed verse, symbols in verbal form. These can be repeated endlessly, since, quite obviously, the key to signification lies in the combination.

This point concerning the signification of the verbal "things" solely through combination, unlimited by determinate meaning of words (hence, "symbol" as some "thing" standing always for more than one thing) is so critical to the entire argument of the book that it requires iteration. In the case of the literary form before us, the sets of meanings, successively imputed to the words (the A, B, C, D/Q, R, S, T of my example) that are joined with the parsed components of a verse, rarely are restricted to the particular sense or significance signaled by the conventional meaning of those words. In the form under discussion, on rare occasion "David" may stand for "king David," but more often "David" is a mere sign, bearing significance only when joined with other signs. Only in combination with other "things" on the same list does the

sense of the passage as a whole—whether propositional, whether intuitive—emerge. A list may have, for example, Abraham, Moses, and David. What is Abraham or Moses or David to mean? On their own, the three names bear no answer to the question at all. Grouped together in context, the meaning emerges. So, standing on their own, the words Abraham, Moses, and David are opaque, deprived of all denotative meaning and as a matter of fact also lacking connotative sense. When they are joined together, however, sense emerges.

The criterion I offered at the outset for when a symbol is symbolic is met in three ways:

1. The thing (represented here by the word "David" or by the verbal expression of the event, "Israel at the Sea," for instance) signifies beyond its particularity.
2. In this context, the thing bears sense *only* in combination with other things.
3. The "thing" (sign) is one of some few things, among many candidates supplied, for example, by Scripture, that can have been used, to be repeated many times.

Whether the picture of a *menorah* on the wall of a synagogue, or the reference to Abraham, Moses, and David, or the exodus from Egypt, the destruction of the Temple, and the coming of the Messiah in strings of words joined with parsed verses of Scripture, the upshot is the same. We deal with symbols, representations of objects that bear meaning beyond the details, verbal evocations of things that bear meaning beyond their particularities.

So to conclude: in "another matter" composites, the figure of Moses, or the exodus from Egypt, or Sennacherib, Nebuchadnezzar, and Belshazzar, occur over and over again, in one combination or another. In these combinations the restricted vocabulary of symbolic discourse makes a virtually limitless number of points. In this regard, therefore, these things occur not as denotative words, where sense is limited to particular circumstance. Nor do they appear bearing determinate sense, for example, as solely connotative words, evoking a less determinate sense, for example, a particular emotion or an attitude that we can predict when a given word occurs. That explains why, as a matter of fact, the components of the "another matter" compositions and composites, when seen in the aggregate, require classification as not words bearing determinate meaning (however broadly constructed) as symbols in verbal, rather than iconic, representation. The reason for that claim requires emphasis: *whatever the words mean in particular has no bearing upon their utilization in symbolic discourse.*

We know that is the fact because—to conclude—with the words alone

in hand, we cannot predict the range of signification that they will be made to communicate: there is no clear limit to the possibilities of the sign "David" or "Israel at the Sea" when those "things" stand by themselves. We do not know what they may be permitted to signify and we also do not know what they may not be permitted to signify. In the combinations formed to comprise an "another matter" composition and composite, however, they conform to a syntax and grammar that imposes determinate meaning upon them: each joined to the other, sign after sign after sign, bears all together a very specific sense or significance. So it is not only that, viewed one by one, these words which serve in the "another matter" compositions bear meanings that transcend their own particularities. It is the simple fact that, standing alone, they have no determinate and conventional, predictable meanings but are opaque; they take on meaning only in combination. These "things" are signs and only signs and yield symbolic discourse and only that.

The compositor of a given "another matter" composition therefore accomplishes his goal through the combinations of things that he assembles to make his point: these things together signify this, not that. It follows that, whether in iconic form or in verbal form, we deal with signs: words that are used as symbols as much as icons that are used as symbols. Whence significance? In symbolic discourse it must derive from combinations of one kind or another. How do these "things"— iconic and verbal alike—then serve as symbols within the definition offered at the outset? First, as I have stressed, their sense (whether propositional, intuitive, or emotional) transcends their immediate limits; or they have no intrinsic sense at all. Second, they bear their meanings only in combination, and not on their own; the rules of grammar and syntax of propositional communication do not pertain at all. The words at hand—"the Sea," "Sinai," "David," "Abraham," "the Torah"—serve as written-down symbols not in bearing meaning that is transcended but *in bearing no meaning within themselves at all.* In the kind of rhetoric represented by "another matter" composites, very often, verbal representations of symbols are lucid *only as words serving a symbolic purpose.*

OPAQUE SYMBOLS AND THE SYMBOLIC
DISCOURSE OF RECOMBINANCY

I have laid heavy stress on the conception that, as much as an iconic representation, a verbal sign on its own bears no determinate meaning. I have now to make explicit the answer to the question of criteria: What traits will make me deem a word opaque except as a symbol, and then, therefore, in a symbolic structure or combination? To generalize on what

I have already said, I think a word is opaque when it can be used in so many different ways as to lose all specific and particular meaning. Such a word is only symbolic, never able to denote, never even limited as to the things that it can connote. Then it is only in its utilization, that is,—as with symbols in iconic form—in function and in context, that the word gains any discursive meaning at all.[13]

That is true not only of words that stand for concepts, commonly translated only in conventional terms, for example, love, mercy, justice, grace, as Max Kadushin demonstrated so decisively. He showed that, as a matter of fact, such words can be defined only contextually. But we now recognize that the same trait of utter opacity characterizes words that stand for persons, such as Abraham or Moses; for places, such as Sinai or Jerusalem; for things, such as the Torah; for events, such as the exodus or the destruction of the Temple (always: the first, never the second!); or for actions, such as those of moral or cultic weight alike. The reason I say so is that when we examine those words on their own, we have no clue whatsoever that will accurately permit us to define their meaning wherever they occur. That fact is shown by the simple experiment of collecting all the lists in which Abraham or the exodus or the destruction of the Temple takes a place. The point that Abraham or the destruction makes in one list—its evidentiary use—has simply nothing in common with the point that those same matters serve to make in some other list. A sign that can mean anything means nothing determinate, and words the denotative or even connotative sense of which we cannot establish in the contexts in which they occur bear significance only in combination and never on their own, so it seems to me. Then the key to deciphering symbolic discourse must lie in knowing the secret of the combinations: why this with that? why this not with that?

THE SYNTAX AND GRAMMAR OF SYMBOLIC DISCOURSE

The identification of how a word may serve as a symbol—connoting a meaning that transcends its own particularity, combining with other such verbal symbols to convey a meaning that emerges not through syllogistic speech—now requires demonstration. I am going to show at some length, and in rich detail, that some few things—again: persons, actions, conceptions, or events—in a restricted repertoire and in a clearly

13. I draw here on the results of Max Kadushin in a variety of his important books. My discussion of those works and what is important in them to my argument here is in J. Neusner, *From Literature to Theology in Formative Judaism: Three Preliminary Studies* (Brown Judaic Studies; Atlanta: Scholars Press, 1989) 13–23. I have given the main points of Kadushin's contribution to this work in Appendix I.

defined and conventional manner, serve as signs as they combine and recombine in written evidence of a particular kind. These signs in this evidence never occur by themselves but always in combination with other such "things." They very commonly refer to scriptural persons, events, actions, or attitudes, deriving from the Israelite Scriptures. They always combine with parsed verses of Scripture. (They never join together in discourse assigned to particular, named sages.[14]) It is in the combination of the opaque symbols in verbal form with the opaque clauses of a verse of Scripture that the signification of the whole takes place: that is what I mean by recombinancy.

So symbolic discourse undertaken in verbal form proves recombinant.[15] Only in context, in combinations with other such opaque signs, do symbols represented in verbal form begin to bear meaning, whether propositional or intuitive or emotional. The sole medium for conveying significance of any kind is to combine otherwise opaque symbols, whether conveyed in words or in iconic representation. The set of objects represented on the wall or the floor of a synagogue, or a list (for example, Abraham, Isaac, Jacob, Sinai) made up of words that in context do not transcend meaning but have no fixed mean—either constitutes symbolic discourse. Iconic symbols, of course, bear their signification only in combination. But the same is so for those words which serve only as signs, and it takes place when, in association with the parsed components of a given verse of Scripture, the opaque symbols combine to make sense, evoke an attitude, or even convey a message. As my example stated in abstract terms has shown, the recombinancy therefore is in two aspects: (1) the joining in a single list of several opaque symbols, on the one side, and (2) the joining of those opaque verbal signs with the parsed components of the cited verse of Scripture, on the other. The combinations are then two and distinct; the recombinancy forms the whole into a

14. That is the hypothesis of my student, Eli Ungar, in his Brown University senior honors thesis. It is published in J. Neusner ed., *Approaches to Ancient Judaism*, New Series (Atlanta: Scholars Press for South Florida Studies in the History of Judaism, 1990), vol. 2, 1–44. I am not entirely certain what that fact means, but it is an established trait of the "another matter" form that "another matter" never is used as a rhetorical signal in connection with sets of name-bearing rabbinical statements on a given theme or problem—or even verse of Scripture, properly parsed. It serves in the Midrash compilations to connect statements that commence with exegeses of parsed verses of Scripture. Ungar's discovery raises the question of where and how statements are assigned to named authorities, why that is done, and what attributions mean in a given context by comparison to their use in some other. Up until now, I have assumed that things were attributed because they were attributed, and I did not realize that the very resort to attributions itself constituted a convention and a significant trait. The cogency of composites of "another matter" is not critical to my argument but does serve it.

15. To borrow a metaphor that seems appropriate to what I think is happening here.

single statement, a discourse that is wholly carried on in the syntax and grammar of symbols, not in the syntax and grammar of words at all.

That is why I claim that "Abraham" or "the destruction of the Temple" constitutes not a concept but simply a sign in the form of a word. It is a word that is opaque until made lucid by utilization in the syntactic and grammatical ways by which symbolic discourse is carried on, and the meanings imputed to those words derive from the grammar and syntax of their utilization. Just as "king" or "child" or "murder" or "love" may serve in one sentence to convey one proposition or one sentiment and in another a quite different proposition or sentiment, so "Abraham" or "Sennacherib," "the pig" or "the lamb," may serve an evidently unlimited range of propositional purposes. Then how are we to interpret "Abraham" or "Sinai" or "the destruction of the Temple"? It can only be the way in which we interpret any other word: in the context defined by syntax and grammar. But in the present sort of evidence, where are we to uncover that context? It can only be in the setting of the "sentences" formed by sets of these symbols that are expressed in the form of words—opaque words, until, like all other words, they are used to make sentences. But the sentences then are comprised of sets of opaque symbols, and to make sense of the word symbols we have to learn how to decipher the sentences that form of those word symbols intelligible thought, whether propositional or intuitive or attitudinal. The issue, as with the visual symbols of the synagogue, then is the same: *how things combine, how we are to decipher the combinations.*

But the matter does not rest even there. In fact, a well-crafted "another matter" composition so functions as to join a vast range and variety of things (now: verbal symbols, in the sense just now spelled out) to make a single point. For as a matter of fact, in a set of three or five or eight "another matter" compositions formed into a single composite, we find in point of fact the same matter stated many times. So the medium of communication within the several compositions, which is combining and recombining symbols in verbal form, effects the formation of the entire set of compositions into a still larger, cogent statement, a statement made up of numerous statements, all of them effected through combining what are in fact words turned into symbols: recombinant symbolic speech. So much for locating symbols. Now to put the theory to work.

2

Symbols in Verbal Form

A CASE: OPAQUE SIGNS AND THEIR
COMBINATION INTO SYMBOLIC DISCOURSE

The rhetorical form that signals the utilization of words as symbols, bearing meaning only in combination with other, otherwise opaque symbols, ordinarily requires two or three statements, joined by the formula "another matter," to effect intelligible communication of a message. Now, in general, "another matter" signals "another way of saying the same thing"; or the formula bears the sense, "These two distinct things add up to one thing," with the further proviso that both are necessary to make one point that transcends each one.[1] That formula, in formal terms, serves as a signifier that the signs by themselves bear no meaning; the signs when joined together in one way, rather than in another, make this statement rather than that. Accordingly, the author of a composition gives way to the authorship of a composite. If individual authors made up the compositions, viewed as singletons, in which discrete elements of a parsed verse are joined with otherwise unconnected words ("theological things"[2]), their work is null. For the "another matter" composite makes its statement *only* by joining together a variety of

1. I have already cited Eli Ungar's study of this problem in Pesiqta deRab Kahana, as well as other pertinent bibliography; see p. 15, n. 14.
2. I find myself at a loss for a better word choice and must at this stage resort to the hopelessly inelegant, even self-indulgent, "'theological' things," to avoid having to repeat the formula that seems to me to fit the data, namely, "names, places, events, actions deemed to bear theological weight and to affect attitude and action." Still, better a simple Anglo-Saxon formulation than a fancy German or Greek or Latin one. And Hebrew, whether Mishnaic or modern, simply does not serve for analytical work except when thought conceived in some other language is translated back into that language, should anyone be interested. As an alternative and equivalent, I also use "signs," as "theological signs." This seems to me not ideal but at least serviceable.

treatments of a given verse of Scripture. A single combination of parsed elements of a verse and discrete and unconnected words may bear implications of a message; the repetition of different combinations—the same parsed elements of a verse, other discrete words—brings the message to the surface. Communication here takes place only in series.

Hence only when we have in hand the entire repertoire of "another matter" compositions do we gain access to the statement that the compositor wishes to make. In the first illustrative case, drawn from Song of Songs Rabbah, the fixed formula of the *"another matter"* compilation points toward what I call "theological things," that is, fixed formulas of theological thought. These comprise sets of otherwise opaque verbal symbols, which, when juxtaposed on a given list in a given order, do cohere and do work together to form a statement within symbolic discourse. In their aggregation the statement that the framer wishes to make emerges. But what sorts of words may function as these "theological things"?

As a matter of fact, these "things"—theological signs—encompass time, space, person and object, and action and attitude. I cannot think of a single person, event, or noteworthy locale in Scripture that in theory cannot serve, just as in theory Ben Sira and the author of Hebrews had available for their argument and proposition the entire Hebrew Scriptures. The very diversity of the signs, which may, in our categories, stand for persons, places, or things, proves their opacity; they do not on their own, by reason of their intrinsic traits of function in the form at hand, form taxa of their own, for example, lists only of objects, only of signifiers of time, only of signs of space, or of persons of one kind or another, or of actions of a given classification. The deliberate confusion of categories that the intrinsic characteristics of the things listed *ought* to dictate—the mixing of persons, places, and things for instance—underlines my claim that the things listed when viewed on their own are opaque. They gain sense only when joined together, that is, when combined and (as we shall see in the next chapter) recombined. David, Solomon, Messiah at the end of time; this age, the age to come; the exodus from Egypt, Sinai, the age to come—all may appear together within a single list. That means the persons: David, Solomon, Messiah; the significations of time: this age, the age to come; events: the exodus and "Sinai"—all are homogenized. Without regard to their own traits, then, they form a list because of traits extrinsic to the things listed; or because the things listed have no traits—except as their positioning on the list imputes to them traits.

Here is a concrete example of the symbolic discourse that, I maintain, the canonical writings of Judaism in its formative age present:

Song of Songs Rabbah to Song 1:5

V:I

1. A. "I am very dark, but comely, [O daughters of Jerusalem, like the tents of Kedar, like the curtains of Solomon]" (Song 1:5):
 B. "I am dark" in my deeds.
 C. "But comely" in the deeds of my forebears.
2. A. "I am very dark, but comely":
 B. Said the Community of Israel, "'I am dark' in my view, 'but comely' before my Creator."
 C. For it is written, "Are you not as the children of the Ethiopians to me, O children of Israel, says the Lord" (Amos 9:7):
 D. "as the children of the Ethiopians"—in your sight.
 E. But "to me, O children of Israel, says the Lord."
3. A. Another interpretation of the verse, "I am very dark": in Egypt.
 B. "but comely": in Egypt.
 C. "I am very dark" in Egypt: "But they rebelled against me and would not hearken to me" (Ezek. 20:8).
 D. "but comely" in Egypt: with the blood of the Passover offering and circumcision, "And when I passed by you and saw you wallowing in your blood, I said to you, In your blood live" (Ezek. 16:6)—in the blood of the Passover.
 E. "I said to you, In your blood live" (Ezek. 16:6)—in the blood of the circumcision.
4. A. Another interpretation of the verse, "I am very dark": at the sea, "They were rebellious at the sea, even the Red Sea" (Ps. 106:7).
 B. "but comely": at the sea, "This is my God and I will be comely for him" (Exod. 15:2).
5. A. "I am very dark": at Marah, "And the people murmured against Moses, saying, What shall we drink?" (Exod. 15:24).
 B. "but comely": at Marah, "And he cried to the Lord and the Lord showed him a tree, and he cast it into the waters and the waters were made sweet" (Exod. 15:25).
6. A. "I am very dark": at Rephidim, "And the name of the place was called Massah and Meribah" (Exod. 17:7).
 B. "but comely": at Rephidim, "And Moses built an altar and called it by the name 'the Lord is my banner'" (Exod. 17:15).
7. A. "I am very dark": at Horeb, "And they made a calf at Horeb" (Ps. 106:19).
 B. "but comely": at Horeb, "And they said, All that the Lord has spoken we will do and obey" (Exod. 24:7).
8. A. "I am very dark": in the wilderness, "How often did they rebel against him in the wilderness" (Ps. 78:40).
 B. "but comely": in the wilderness at the setting up of the tabernacle, "And on the day that the tabernacle was set up" (Num. 9:15).

9. A. "I am very dark": in the deed of the spies, "And they spread an evil report of the land" (Num. 13:32).

 B. "but comely": in the deed of Joshua and Caleb, "Save for Caleb, the son of Jephunneh the Kenizzite" (Num. 32:12).

10. A. "I am very dark": at Shittim, "And Israel abode at Shittim and the people began to commit harlotry with the daughters of Moab" (Num. 25:1).

 B. "but comely": at Shittim, "Then arose Phinehas and wrought judgment" (Ps. 106:30).

11. A. "I am very dark": through Achan, "But the children of Israel committed a trespass concerning the devoted thing" (Josh. 7:1).

 B. "but comely": through Joshua, "And Joshua said to Achan, My son, give I pray you glory" (Josh. 7:19).

12. A. "I am very dark": through the kings of Israel.

 B. "but comely": through the kings of Judah.

 C. If with my dark ones that I had, it was such that "I am comely," all the more so with my prophets.

V:II

5. A. [As to the verse, "I am very dark, but comely," R. Levi b. R. Haita gave three interpretations:

 B. "'I am very dark': all the days of the week.

 C. "'but comely': on the Sabbath.

 D. "'I am very dark': all the days of the year.

 E. "'but comely': on the Day of Atonement.

 F. "'I am very dark': among the Ten Tribes.

 G. "'but comely': in the tribe of Judah and Benjamin.

 H. "'I am very dark': in this world.

 I. "'but comely': in the world to come."

This is surely an easy example, for the message is communicated through contrasts, and if we had to specify the rule of intelligible discourse, it is: we convey our message by contrasting opposed cases. That is not the sole, or even the most paramount, mode of discourse, but it does establish the fact that communication is taking place through combining parsed elements of a verse of Scripture with lists of "theological things," just as I claimed in the preceding chapter.

The formal traits of this composite prove blatant. The base verse is parsed in three clauses, and the same parsing recurs throughout. Then in each sequence a different set of meanings is imputed: deeds, deeds of forebears; my view, my Creator's view; rebellion in Egypt, obedience in Egypt; rebellion at the Sea, obedience at the Sea; and so on. The items that are listed, time and again, by themselves bear no meaning that on its own is necessarily cogent with the other items on the same list. *But by*

effecting a pattern over and over again, the various items are made to deliver a single message: the contrast of rebellion and obedience. Do the several components bear that message? Horeb, Egypt, the Sea, the spies, the days of the week, and the Sabbath—none of these on its own bears the meaning that all together they convey. Is, then, some other message delivered by the listed items, Horeb, Egypt, the Sea? I see none. To the contrary, the words Horeb, Egypt, the Sea by themselves stand for nothing that the composite contains; the words in combination with other words—again, Horeb, Egypt, the Sea—likewise bear no clear sense. It is the joining of two sets of words, the components of the base verse, "I am dark" "but comely" together with the sequences, Horeb, Egypt, the Sea, that contains the message. The combinancy is Horeb, Egypt, the Sea; that produces no symbolic speech. The recombinancy is Horeb, Egypt, the Sea, in the pattern with "I am dark" "but comely"—and that produces a powerful and well-crafted message. Why do I classify the delivery of the message as symbolic discourse? Because at no point is the message made explicit, for example, propositionally, let alone syllogistically. The message is contained within the recombinant contrasts; it is fully exposed through the symbols that gain meaning in the recombinancy and contrast; and the message then is conveyed wholly through the manipulation of otherwise opaque words: hence, symbols in verbal form.

Let us now turn from the general theory of discourse to the details. The contrast of dark and comely yields a variety of applications; in all of them the same situation that is the one also is the other, and the rest follows in a wonderfully well crafted composition. What is the repertoire of items? Dark in deeds but comely in ancestry; dark in my view but comely before God; dark when rebellious, comely when obedient, a point made at no. 3 for Egypt; no. 4 for the Sea; no. 5 for Marah; no. 6 for Massah and Meribah; no. 7 for Horeb; no. 8 for the wilderness; no. 9 for the spies in the Land; no. 10 for Shittim; no. 11 for Achan/Joshua and the conquest of the Land; and no. 12 for Israel and Judah. But look what follows: the week as against the Sabbath, the weekdays as against the Day of Atonement, the Ten Tribes as against Judah and Benjamin, this world as against the world to come. Whatever classification these next items demand for themselves, it surely will not be that of events. Indeed, if by event we mean something that happened once, as in "once upon a time," then Sabbath as against weekday and Day of Atonement as against ordinary day form a different category; the Ten Tribes as against Judah and Benjamin constitute social entities, not divisions of time; and this age and the age to come form utterly antihistorical taxa altogether.

Events not only do not form a taxon, they also do not present a vast corpus of candidates for inclusion in some other taxon. The lists in the document at hand form selections from a most limited repertoire of candidates. If we were to catalogue all of the exegetical repertoire encompassed by *"another matter"* constructions in this document,[3] we should not have a very long list of candidates for inclusion in any list. And among the candidates, events are few indeed. They encompass Israel at the Sea and at Sinai, the destruction of the first Temple, the destruction of the second Temple, events as defined by the actions of some holy men such as Abraham, Isaac, and Jacob (treated not for what they did but for who they were), Daniel, Mishael, Hananiah, Azariah, and the like. It follows that the restricted repertoire of candidates for taxonomic study encompasses remarkably few events, remarkably few for a literary culture that is commonly described as quintessentially historical!

SYMBOLS IN PROPOSITIONAL DISCOURSE

So much for the positive demonstration of symbolic discourse. I have now to show that we can, indeed, distinguish this from that, classify nonsymbolic discourse as such by appeal to the absence of the traits that I have outlined in the exposition of my example. The counterpart to a null-hypothesis, in the next example I shall show how symbolic discourse is contravened and symbols are turned into words bearing determinate meaning. What we shall now see is that we can indeed tell the difference between symbolic discourse and other kinds of discourse undertaken in the same canon, indeed in the same compilation.

Here is an example of discourse that appeals to metaphors but is in no way bound to the rules of symbolic expression. We have poetry but no symbolism: "you are beautiful" joined in a repeated and compelling rhythm to a catalogue of those traits of Israel which make the nation beautiful, no. 1. Then Israel is compared to a dove, but the comparison is so laboriously spelled out that the advantages of symbolic discourse are lost. The symbol, "dove," does not speak for itself, for example, in combination with a list of other (otherwise opaque) symbols. It is deprived of its symbolic status by a fully articulated set of propositions that tell us what we are supposed to think and how we are supposed to respond to the symbol. So this symbol in propositional discourse shows

3. We do survey those of Song of Songs Rabbah; see chapter 7, below.

us, in the contrast to the foregoing, that in our documents we may find both propositional discourse and symbolic discourse and tells us how to discern the difference.

Song of Songs Rabbah XV:I

1. A. "Behold, you are beautiful, my love; behold, you are beautiful; [your eyes are doves]":
 B. "Behold, you are beautiful" in religious deeds,
 C. "Behold, you are beautiful" in acts of grace,
 D. "Behold, you are beautiful" in carrying out religious obligations of commission,
 E. "Behold, you are beautiful" in carrying out religious obligations of omission,
 F. "Behold, you are beautiful" in carrying out the religious duties of the home, in separating priestly ration and tithes,
 G. "Behold, you are beautiful" in carrying out the religious duties of the field, gleanings, forgotten sheaves, the corner of the field, poor person's tithe, and declaring the field ownerless,
 H. "Behold, you are beautiful" in observing the taboo against mixed species,
 I. "Behold, you are beautiful" in providing a linen cloak with woolen show-fringes,
 J. "Behold, you are beautiful" in [keeping the rules governing] planting,
 K. "Behold, you are beautiful" in keeping the taboo on uncircumcised produce,
 L. "Behold, you are beautiful" in keeping the laws on produce in the fourth year after the planting of an orchard,
 M. "Behold, you are beautiful" in circumcision,
 N. "Behold, you are beautiful" in trimming the wound,
 O. "Behold, you are beautiful" in reciting the Prayer,
 P. "Behold, you are beautiful" in reciting the *Shema*,
 Q. "Behold, you are beautiful" in putting a *mezuzah* on the doorpost of your house,
 R. "Behold, you are beautiful" in wearing phylacteries,
 S. "Behold, you are beautiful" in building the tabernacle for the Festival of Tabernacles,
 T. "Behold, you are beautiful" in taking the palm branch and *etrog* on the Festival of Tabernacles,
 U. "Behold, you are beautiful" in repentance,
 V. "Behold, you are beautiful" in good deeds,
 W. "Behold, you are beautiful" in this world,
 X. "Behold, you are beautiful" in the world to come.
3. A. "doves":

B. Just as a dove is innocent, so the Israelites are [Simon supplies: inno-
cent; just as the dove is beautiful in its movement, so Israel are] beauti-
ful in their movement, when they go up for the pilgrim festivals.

C. Just as a dove is distinguished, so the Israelites are distinguished: not
shaving, in circumcision, in show-fringes.

D. Just as the dove is modest, so the Israelites are modest.

E. Just as the dove puts forth its neck for slaughter, so the Israelites: "For
your sake are we killed all day long" (Ps. 44:23).

F. Just as the dove atones for sin, so the Israelites atone for other nations.

G. For all those seventy bullocks that they offer on the Festival of Taber-
nacles correspond to the nations of the world, so that the world should
not become desolate on their account: "In return for my love they are
my adversaries, but I am all prayer" (Ps. 109:4).

H. Just as the dove, once it recognizes its mate, never again changes him
for another, so the Israelites, once they recognized the Holy One,
blessed be he, never exchanged him for another.

I. Just as the dove, when it enters its nest, recognizes its nest and young,
fledglings and apertures, so the three rows of the disciples of the sages,
when they take their seats before them, knows each one his place.

J. Just as the dove, even though you take its fledglings from under it,
does not ever abandon its cote, so the Israelites, even though the
house of the sanctuary was destroyed, never nullified the three annual
pilgrim festivals.

K. Just as the dove renews its brood month by month, so the Israelites
every month renew Torah and good deeds.

L. Just as the dove [Simon:] goes far afield but returns to her cote, so do
the Israelites: "They shall come trembling as a bird out of Egypt"
(Hos. 11:11), this speaks of the generation of the wilderness; "and as a
dove out of the land of Assyria" (Hos. 11:11), this speaks of the Ten
Tribes.

M. And in both cases: "And I will make them dwell in their houses, says
the Lord" (Hos. 11:11).

The pattern of no. 1 derives from the hermeneutic that treats our
poem as a source of metaphors for Israel's religious reality. No. 2 follows
suit. No. 3 reverts to the metaphor of the dove for Israel. None of this
represents symbolic discourse of any kind; the message is fully articu-
lated in words, and the symbolic value of "dove" or of the catalogue of
Israel's merits is hardly realized. Accordingly, in the same compilation
symbolic discourse vastly differs from propositional discourse, and we
can tell the difference through a specific case.

How about an example in which both media of intelligible communi-
cation are represented? In the example that follows, we are readily able

to distinguish the several components of a composite in which symbolic discourse and propositional discourse take place. In the following composition, we see how a metaphor permits the manipulation of symbols, but the discourse—the mode of communication—is essentially propositional and not symbolic.

Song of Songs Rabbah XVIII:I

1. A. "I am a rose of Sharon, [a lily of the valleys]":
 B. Said the Community of Israel, "I am the one, and I am beloved.
 C. "I am the one whom the Holy One, blessed be he, loved more than the seventy nations."
2. A. "I am a rose of Sharon":
 B. "For I made for him a shade through Bezalel [the words for shade and Bezalel use the same consonants as the word for rose]: 'And Bezalel made the ark' (Exod. 38:1)."
3. A. "of Sharon":
 B. "For I said before him a song [which word uses the same consonants as the word for Sharon] through Moses:
 C. "'Then sang Moses and the children of Israel' (Exod. 15:1)."
4. A. Another explanation of the phrase, "I am a rose of Sharon":
 B. Said the Community of Israel, "I am the one, and I am beloved.
 C. "I am the one who was hidden in the shadow of Egypt, but in a brief moment the Holy One, blessed be he, brought me together to Raamses, and I [Simon:] blossomed forth in good deeds like a rose, and I said before him this song: 'You shall have a song as in the night when a feast is sanctified' (Isa. 30:29)."
5. A. Another explanation of the phrase, "I am a rose of Sharon":
 B. Said the Community of Israel, "I am the one, and I am beloved.
 C. "I am the one who was hidden in the shadow of the sea, but in a brief moment I [Simon:] blossomed forth in good deeds like a rose, and I pointed to him with the finger [Simon:] (opposite to me): 'This is my God and I will glorify him' (Exod. 15:2)."
6. A. Another explanation of the phrase, "I am a rose of Sharon":
 B. Said the Community of Israel, "I am the one, and I am beloved.
 C. "I am the one who was hidden in the shadow of Mount Sinai, but in a brief moment I [Simon:] blossomed forth in good deeds like a lily in hand and in heart, and I said before him, 'All that the Lord has said we will do and obey' (Exod. 24:7)."
7. A. Another explanation of the phrase, "I am a rose of Sharon":
 B. Said the Community of Israel, "I am the one, and I am beloved.
 C. "I am the one who was hidden and downtrodden in the shadow of the kingdoms. But tomorrow, when the Holy One, blessed be he, redeems me from the shadow of the kingdoms, I shall blossom forth like a lily

and say before him a new song: 'Sing to the Lord a new song, for he has done marvelous things, his right hand and his holy arm have wrought salvation for him' (Ps. 98:1)."

8. A. R. Berekhiah said, "This verse ["I am a rose of Sharon, a lily of the valleys"] was said by the wilderness.

B. "Said the wilderness, 'I am the wilderness, and I am beloved.

C. "'For all the good things that are in the world are hidden in me: "I will plant in the wilderness a cedar, an acacia tree" (Isa. 41:19).

D. "'The Holy One, blessed be he, has put them in me so that they may be guarded in me. And when the Holy One, blessed be he, seeks them from me, I shall return to him unimpaired the bailment that he has left with me.

E. "'And I shall blossom in good deeds and say a song before him: "The wilderness and parched land shall be glad" (Isa. 35:1).'"

9. A. In the name of rabbis they have said, "This verse ["I am a rose of Sharon, a lily of the valleys"] was said by the land [of Israel].

B. "Said the land, 'I am the land, and I am beloved.

C. "'For all the dead of the world are hidden in me: "Your dead shall live, my dead bodies shall arise" (Isa. 26:19).

D. "'When the Holy One, blessed be he, will ask them from me, I shall restore them to him.

E. "'And I shall blossom in good deeds and say a song before him: "From the uttermost parts of the earth we have heard songs" (Isa. 24:16).'"

This stunning and cogent exposition metaphorizes Israel in Egypt, at the Sea, at Sinai, and subjugated by the gentile kingdoms, and coherently explains how the redemption will come. The Song therefore has Israel singing to God. The voices change, but the basic motif of the metaphorization of Israel's life remains constant. The formal requirements are shown at no. 4 and are readily retrojected into nos. 1–3; the rest is entirely coherent. I find no special significance in the fact that we have five go-arounds. The development of the formal program and motif at nos. 8, 9 in no way diminishes from the power of the whole; it only adds to it. *But none of this is discourse through the manipulation of symbols.* The contrast between the present utilization of metaphors and the kind discussed earlier shows what I mean when I speak of symbolic discourse, as distinct from propositional discourse.

Now we shall deal with composites in which symbolic discourse takes place within the propositional kind, so that there are two messages, one that is made explicit and that involves syllogistic demonstration, another that is left implicit and that involves evocative images, set forth in the medium of symbolic discourse I have described. Let me give an example

of how, through both propositional discourse and symbolic discourse, a compositor may make his desired point.

Leviticus Rabbah XXVII:V

1. A. "God seeks what has been driven away" (Qoh. 3:15).

 B. R. Huna in the name of R. Joseph said, "It is always the case that 'God seeks what has been driven away' [favoring the victim].

 C. "You find when a righteous man pursues a righteous man, 'God seeks what has been driven away.'

 D. "When a wicked man pursues a wicked man, 'God seeks what has been driven away.'

 E. "All the more so when a wicked man pursues a righteous man, 'God seeks what has been driven away.'

 F. "[The same principle applies] even when you come around to a case in which a righteous man pursues a wicked man, 'God seeks what has been driven away.'"

2. A. R. Yosé b. R. Yudan in the name of R. Yosé b. R. Nehorai says, "It is always the case that the Holy One, blessed be he, demands an accounting for the blood of those who have been pursued from the hand of the pursuer.

 B. "Abel was pursued by Cain, and God sought [an accounting for] the pursued: 'And the Lord looked [favorably] upon Abel and his meal offering' [Gen. 4:4].

 C. "Noah was pursued by his generation, and God sought [an accounting for] the pursued: 'You and all your household shall come into the ark' [Gen. 7:1]. And it says, 'For this is like the days of Noah to me, as I swore [that the waters of Noah should no more go over the earth]' [Isa. 54:9].

 D. "Abraham was pursued by Nimrod, 'and God seeks what has been driven away': 'You are the Lord, the God who chose Abram and brought him out of Ur' [Neh. 9:7].

 E. "Isaac was pursued by Ishmael, 'and God seeks what has been driven away': 'For through Isaac will seed be called for you' [Gen. 21:12].

 F. "Jacob was pursued by Esau, 'and God seeks what has been driven away': 'For the Lord has chosen Jacob, Israel for his prized possession' [Ps. 135:4].

 G. "Moses was pursued by Pharaoh, 'and God seeks what has been driven away': 'Had not Moses His chosen stood in the breach before Him' [Ps. 106:23].

 H. "David was pursued by Saul, 'and God seeks what has been driven away': 'And he chose David, his servant' [Ps. 78:70].

 I. "Israel was pursued by the nations, 'and God seeks what has been driven away': 'And you has the Lord chosen to be a people to him' [Deut. 14:2].

J. "And the rule applies also to the matter of offerings. A bull is pursued
by a lion, a sheep is pursued by a wolf, a goat is pursued by a leopard.

K. "Therefore the Holy One, blessed be he, has said, 'Do not make
offerings before me from those animals that pursue, but from those
that are pursued: 'When a bull, a sheep, or a goat is born'" (Lev.
22:27).

The theological point is made very powerfully—and in two distinct
modes of discourse. It is that God favors the persecuted over the persecu-
tor, the pursued over the pursuer. This point is made in an abstract way
at no. 1, and then through a review of the sacred history of Israel at no. 2.
By listing the figures that are given, we see, the framer has made his
point; had he wished to speak solely through opaque symbols, he would
have omitted no. 1 and given us only no. 2. If, then, we knew the key to
decipher the opaque symbols, laid out in the way that they are, we
should have been able to discern the message wholly by our response to
the opaque symbols consisting of lists of names of persons, in a given
order and hence contrast: Abel/Cain, Noah/his generation, Abraham/
Nimrod.[4]

LISTENWISSENSCHAFT REVISITED

Putting this familiar fact together with that familiar fact in an unfamil-
iar combination constitutes what is new and important in the list; the
consequent conclusion one is supposed to draw, the proposition or rule
that emerges—these are rarely articulated and never important. True,
the list in Song of Songs Rabbah before us may comprise a rule, or it may
substantiate a proposition or validate a claim; but more often than not,
the effect of making the list is to show how various items share a single
taxic indicator, which is to say that the purpose of the list is to make the

4. In a variety of cases, particularly in Song of Songs Rabbah, we shall see that the
compositor has made the same point through both media of discourse, propositional
and symbolic, or has told a story and also assembled opaque verbal symbols in the right
combination, so that the point is made explicitly and then symbolically. These distinct
modes of discourse then stand side by side. But in a much larger selection of cases,
symbolic discourse is left without the reinforcement of an articulated message. For the
present argument, the main point is that we ourselves can readily distinguish, by appeal
to objective traits, between symbolic discourse and propositional discourse. However, we
should not suppose that setting side by side both propositional (even analytical)
discourse and symbolic discourse means that the authorship of a composite lacks faith
in the symbolic medium or in the reader's (or hearer's) capacity to grasp the message
delivered in that medium. That that is simply false is shown by the numerous cases in
which symbolic discourse is given no reinforcement in a propositional (re)statement of
the same position.

list. The making of connections among ordinarily not connected things is then one outcome of *Listenwissenschaft*. What I find engaging in *"another matter"* constructions is the very variety of things that, on one list or another, can be joined together—a list for its own sake. What we have is a kind of subtle restatement, through an infinite range of possibilities, of the combinations and recombinations of a few essentially simple facts (data). It is as though a magician tossed a set of sticks this way and that, interpreting the diverse combinations of a fixed set of objects. The propositions that emerge are not the main point; the combinations are.

That seems to me an important fact, for it tells me that the culture at hand has defined for itself a repertoire of persons and events and conceptions (e.g., Torah study), holy persons, holy deeds, holy institutions, presented candidates for inclusion in *"another matter"* constructions, and the repertoire, while restricted and not terribly long, made possible a scarcely limited variety of lists of things with like taxic indicators. That is to say, since the same items occur over and over again, but there is no pattern to how they recur. By a pattern I mean that items of the repertoire may appear in numerous *"another matter"* constructions or not; they may keep company with only a fixed number of other items, or they may not. Most things can appear in an "another matter" composition with most other things.

THEOLOGY THROUGH SYMBOLIC DISCOURSE

As a matter of simple fact, the vast majority of cases of symbolic discourse in the canonical writings deal with God's relationship with Israel and Israel's relationship with God.[5] Hence symbolic discourse serves the particular task of working out theological themes. It yields not so much propositions as attitudes, evokes sentiment and right feeling— love for God, for example, or the feeling of being loved by God. The theological tableau or diorama relies upon combinations of words that on their own have no meaning—the parsed verse, the "theological theme" and, as I have explained, it may be called recombinant, in that combinations are worked out again and again, all with the same purpose in view. Before us a medium of theology, in which the framer ("the theologian") selects from a restricted repertoire a few items for combination in one way, rather than some other, with this verse's parsed compo-

5. Our survey of the evidence in the shank of the book will leave no doubt about that fact.

nents, rather than those of some other. The theologian through recombinant representation of symbols intends sometimes to make a point (e.g., the contrast of obedient and disobedient Israel we saw just now), sometimes not. So I should call symbolic discourse in Judaism a medium for the working out of recombinant theology.

My insistence that this sector[6] of Judaic theological expression resorts to symbolic discourse requires me to return to the question, When is a symbol symbolic? In the case of history, can we define what taxic indicator dictates which happenings will be deemed events bearing symbolic messages beyond articulation—and which not? As a matter of fact, the events that are listed throughout the example just now presented are not data of nature or history but of *theology*: God's relationship with Israel, expressed in such facts as the three events, the first two in the past, the third in the future, namely, the three redemptions of Israel, the three patriarchs, and holy persons, actions, events, what have you. The symbols expressed in verbal form all pertain to theological facts, all of them provided by the written Torah or Scripture. The theological facts are manipulated in such a way as to conduct discourse, portrayed in such a way that the discourse is effected through symbolic media, so crafted as to set forth, through verbal symbols, a theological tableau. Then the symbols bear no message of a dynamic, syllogistic character, because they bear a message of a different order: theological truth set forth, not theological proposition subjected to argument and analysis. These are facts that are assembled and grouped; in our sample, drawn from Song of Songs Rabbah, the result is not propositional at all, or, if propositional, then essentially the repetition of familiar propositions through unfamiliar data.

To make this point concrete, here is a survey of sequences of components of such lists in Song of Songs Rabbah, that is, those combinations of "theological things" which by themselves bear no clear meaning whatsoever but in relationship to the elements of a parsed verse convey a quite explicit theological message, delivered entirely symbolically in the recombinant manner I have now explained:

6. I of course do not claim that all theology of Judaism within the canonical writings treated here resorts solely to symbolic discourse, and the examples already given show that propositional alongside symbolic media of expression work out the same conceptions. But I do argue that where we find a predominant appeal to symbolic discourse, we will not uncover a sustained analytical-theological inquiry at all, and, as a matter of fact, while we find propositions alongside symbols as media for the expression of theological views, we never find analytical-theological inquiries in that context.

Joseph, righteous men, Moses, and Solomon;

patriarchs as against princes, offerings as against merit, and Israel as against the nations; those who love the king, proselytes, martyrs, penitents;

first, Israel at Sinai; then Israel's loss of God's presence on account of the golden calf; then God's favoring Israel by treating Israel not in accord with the requirements of justice but with mercy;

Dathan and Abiram, the spies, Jeroboam, Solomon's marriage to Pharaoh's daughter, Ahab, Jezebel, Zedekiah;

Israel is feminine, the enemy (Egypt) masculine, but God the father saves Israel the daughter;

Moses and Aaron, the Sanhedrin, the teachers of Scripture and Mishnah, the rabbis;

the disciples; the relationship among disciples, public recitation of teachings of the Torah in the right order; lections of the Torah;

the spoil at the Sea = the exodus, the Torah, the tabernacle, the ark;

the patriarchs, Abraham, Isaac, Jacob, then Israel in Egypt, Israel's atonement and God's forgiveness;

the Temple where God and Israel are joined, the Temple is God's resting place, the Temple is the source of Israel's fecundity;

Israel in Egypt, at the Sea, at Sinai, and subjugated by the gentile kingdoms, and how the redemption will come;

Rebecca, those who came forth from Egypt, Israel at Sinai, acts of lovingkindness, the kingdoms who now rule Israel, the coming redemption;

fire above, fire below, meaning heavenly and altar fires; Torah in writing, Torah in memory; fire of Abraham, Moriam, bush, Elijah, Hananiah, Mishael, and Azariah;

the Ten Commandments, show-fringes and phylacteries, recitation of the *Shema* and the Prayer, the tabernacle and the cloud of the Presence of God, and the *mezuzah*;

the timing of redemption, the moral condition of those to be redeemed, and the past religious misdeeds of those to be redeemed;

Israel at the Sea, Sinai, the Ten Commandments; then the synagogues and schoolhouses; then the redeemer;

the exodus, the conquest of the Land, the redemption and restoration of Israel to Zion after the destruction of the first Temple, and the final and ultimate salvation;

the Egyptians, Esau and his generals, and, finally, the four kingdoms;

Moses' redemption, the first, to the second redemption in the time of the Babylonians and Daniel;

the litter of Solomon: the priestly blessing, the priestly watches, the Sanhedrin, and the Israelites coming out of Egypt;

Israel at the Sea and forgiveness for sins effected through their passing through the Sea; Israel at Sinai; the war with Midian; the crossing of the

Jordan and entry into the Land; the house of the sanctuary; the priestly watches; the offerings in the Temple; the Sanhedrin; the Day of Atonement;

God redeemed Israel without preparation; the nations of the world will be punished, after Israel is punished; the nations of the world will present Israel as gifts to the royal messiah, and here the base verse refers to Abraham, Isaac, Jacob, Sihon, Og, Canaanites;

the return to Zion in the time of Ezra, the exodus from Egypt in the time of Moses;

the patriarchs and with Israel in Egypt, at the Sea, and then before Sinai; Abraham, Jacob, Moses;

Isaac, Jacob, Esau, Jacob, Joseph, the brothers, Jonathan, David, Saul, man, wife, paramour;

Abraham in the fiery furnace and Shadrach Meshach and Abednego, the exile in Babylonia, now with reference to the return to Zion.

This list suffices to make the simple point under discussion. The "another matter" composites yield no fixed order of items or even commonly repeated list of items, though some do recur as sets, for example, first redemption (the Sea), second redemption (the return to Zion), third redemption (the end of time or the Messiah); Abraham, Isaac, Jacob; Moses, Aaron, Miriam; Moses, David, Messiah; and so on. But if we were to set side by side and then catalogue all of the exegetical repertoire encompassed by "another matter" constructions, we should have a very long list of candidates for inclusion in any list and nearly as long a list of groups of candidates that are included in some list.

LISTENWISSENSCHAFT AND THE SYMBOLIC DISCOURSE OF RECOMBINANT THEOLOGY

The upshot is simple. List making is accomplished within a restricted repertoire of items; the list making presents interesting combinations of an essentially small number of candidates for the exercise. But then, when making lists, one can do pretty much anything with the items that are combined; the taxic indicators are unlimited, but the data studied, severely limited. Take for example the case of history, meaning, events, or happenings. Forming part of the *davar aher* or "another matter" construction, history constitutes one among a variety of what I have been calling theological "things" but what we might call (mere) signs. These by themselves comprise names, places, events, and actions deemed to bear theological weight and to affect attitude and action. The play is worked out by a reprise of available materials, composed in some fresh and interesting combination. Events or happenings do not form random

possibilities but comprise highly selected lists; but combining and recombining items on those lists with the parsed elements of a verse, one can say pretty much anything.

The same is so of anything that Scripture affords.[7] When three or more such theological "things"—whether person, whether event, whether action, whether attitude—are combined, they form a theological structure, and, viewed all together, all of the theological "things" in a given document constitute the components of the entire theological structure that the document affords. The propositions portrayed visually, through metaphors of sight, or dramatically, through metaphors of action and relationship, or in attitude and emotion, through metaphors that convey or provoke feeling and sentiment, when translated into language prove familiar and commonplace. The work of the theologian in this context is not to say something new or even persuasive, for the former is unthinkable by definition and the latter unnecessary in context. It is, rather, to display theological "things" in a fresh and interesting way, to accomplish a fresh exegesis of the canon of theological "things."

The combinations and recombinations identify some events as facts sharing the paramount taxic indicators of a variety of other facts, comprising a theological structure within a larger theological system: a reworking of canonical materials. An event is therefore reduced to a "thing," losing all taxic autonomy, requiring no distinct indicator of an intrinsic order. It is simply something else to utilize in composing facts into knowledge; the event does not explain, it does not define, indeed, it does not even exist within its own framework at all. Judaism by "an event" means, in a very exact sense, nothing in particular. It is a component in a culture that combines and recombines facts into structures of its own design, an aspect of what I should call a culture that comes to full expression in recombinant theology.

RECOMBINANT SYMBOLS IN WORDS

We have been prepared for such a result as has been reached in our examination of an "another matter" construction by Jonathan Z. Smith, who has made us aware of the critical issue of the recombinancy of a fixed canon of "things" in his discussion of sacred persistence, that is, "the rethinking of each little detail in a text, the obsession with the significance and perfection of each little action." In the canonical litera-

7. That is not to suggest that Scripture is the only source of "theological things," but it is, as a matter of fact, the main source.

ture of Judaism, these minima are worked and reworked, rethought and recast in some other way or order or combination—but always held to be the same thing throughout. In this context I find important guidance in Smith's statement:

> An almost limitless horizon of possibilities that are at hand . . . is arbitrarily reduced . . . to a set of basic elements. . . . Then a most intense ingenuity is exercised to overcome the reduction . . . to introduce interest and variety. This ingenuity is usually accompanied by a complex set of rules.[8]

The possibilities out of which the authorship of our exemplary document has made its selections are limited not by the metaphorical potential of the Song of Songs (!) but by the contents of the Hebrew Scriptures as the textual community formed of the Judaic sages defined those contents within their Torah.

The importance of the restricted character of the symbolic vocabulary available for the recombinant discourse now becomes clear. If discourse can appeal to an unlimited vocabulary, we can scarcely claim to deal with a medium of disciplined thought, in which opaque signs of a limited repertoire may combine and recombine to convey through the syntax and grammar of symbolic communication a clearly accessible message. For every Abraham, Isaac, and Jacob that we find, there are Job, Enoch, Jeroboam, or Zephaniah, whom we do not find; for every Sea/Sinai/entry into the Land that we do find, there are other sequences, for example, the loss of the ark to the Philistines and its recovery, or Barak and Deborah, that we do not find. Ezra figures, Haggai does not; the Assyrians play a minor role, Nebuchadnezzar is on nearly every page. Granted, Sinai must enjoy a privileged position throughout. But why prefer Shadrach Meshach and Abednego, Hananiah, Mishael, and Azariah, over other trilogies of heroic figures? Our brief glance at Ben Sira's and Hebrews' lists shows that other authors made some of the same selections but also other selections as well.

So the selection is an act of choice, a statement of culture in miniature. But once restricted through this statement of choice, the same selected theological "things" then undergo combination and recombination with other theological things, the counterpart to Smith's "interest and variety." If we know the complex set of rules in play here, we also would understand the system that makes this document not merely an expression of piety but a statement of a theological structure: orderly, well composed and proportioned, internally coherent and cogent throughout.

8. Jonathan Z. Smith, "Sacred Persistence: Towards a Redescription of Canon," *Approaches to Ancient Judaism: Theory and Practice* (ed. William Scott Green; Brown Judaic Studies; Missoula, Mont.: Scholars Press, 1978) 11–28. Quotation is on p. 15.

The canonical, therefore anything but random, standing of events forms a brief chapter in the exegesis of a canon. That observation draws us back to Smith, who observes:

> The radical and arbitrary reduction represented by the notion of canon and the ingenuity represented by the rule-governed exegetical enterprise to apply the canon to every dimension of human life is that most characteristic, persistent, and obsessive religious activity. . . . The task of application as well as the judgment of the relative adequacy of particular applications to a community's life situation remains the indigenous theologian's task; but the study of the process, particularly the study of comparative systematics and exegesis, ought to be a major preoccupation of the historian of religions.[9]

Smith speaks of religion as an "enterprise of exegetical totalization," and he further identifies with the word "canon" precisely what we have identified as the substrate and structure of the list. If I had to define an event in this canonical context, I should have to call it merely another theological thing: something to be manipulated, combined in one way or in another, along with other theological things.

Have we access to other examples of cultures that define for themselves canonical lists of counterparts to what I have called "theological things"? Indeed, defining matters as I have, I may compare the event to a fixed object in a diviner's basket of the Ndembu, as Smith describes that divinitory situation:

> Among the Ndembu there are two features of the divinitory situation that are crucial to our concern: the diviner's basket and his process of interrogating his client. The chief mode of divination consists of shaking a basket in which some twenty-four fixed objects are deposited (a cock's claw, a piece of hoof, a bit of grooved wood, . . . withered fruit, etc.). These are shaken in order to winnow out "truth from falsehood" in such a way that few of the objects end up on top of the heap. These are "read" by the diviner both with respect to their individual meanings and their combinations with other objects and the configurations that result.[10]

In our case in Song of Songs Rabbah, Abraham, Isaac, Jacob, or the Sea and Sinai, or Hananiah, Mishael, and Azariah, are the counterpart to the cock's claw and the piece of hoof. The event, in Judaism, is the counterpart to a cock's claw in the Ndembu culture. Both will be fixed but will combine and recombine in a large number of different ways.

But then what of "the lessons of history," and how shall we identify the counterpart to historical explanation? I find the answer in the

9. Ibid., 18.
10. Ibid., 25.

Ndembu counterpart, the mode of reading "the process of interrogating the client." Again Smith:

> The client's situation is likewise taken into account in arriving at an interpretation. Thus . . . there is a semantic, syntactic, and pragmatic dimension to the "reading." Each object is publicly known and has a fixed range of meanings. . . . The total collection of twenty-four objects is held to be complete and capable of illuminating every situation. . . . What enables the canon to be applied to every situation or question is not the number of objects. . . . Rather it is that, prior to performing the divination, the diviner has rigorously questioned his client in order to determine his situation with precision. . . . It is the genius of the interpreter to match a public set of meanings with a commonly known set of facts . . . in order to produce a quite particular plausibility structure which speaks directly to his client's condition, which mediates between that which is public knowledge and the client's private perception of his unique situation.[11]

The task before us, the exegesis of exegesis, now requires a systematic account of the symbols that are expressed verbally. With such an account in hand, we shall have a dictionary of the language of symbolic discourse, and with cases of the lists of such opaque symbols before us, we shall further control a repertoire of sentences, which, properly parsed, ought to show us the syntax and grammar that imparts order and sense.

The theology of this Judaism—that is to say, our account of the world view that comes to expression within this literary culture and textual community—will take shape within the exegesis of the symbolic structure that we shall now describe. What must follow will be an account of evidence of a different order altogether, with the comparison of the two bodies of symbols, together with their syntax and grammar, permitting us to determine whether or not a single symbolic structure encompassed all of the evidence of symbolic discourse in the Judaism of antiquity.

11. Ibid., 25.

3

The Documentary Locus of Symbolic Discourse

SYMBOLIC DISCOURSE, PRESENT AND ABSENT: WHY HERE, NOT THERE?

Symbolic discourse, treating certain signs as opaque and elucidated only in the context of sequences and combinations of such signs, serves a distinctively theological purpose. The first exercise in testing that hypothesis draws our attention to the question, Is it correct to maintain that theological and not other topics come under discussion through the symbolic mode of discourse that I have outlined? If I can show that, when certain types of topics come up, other than symbolic discourse[1] characterizes the manner in which those topics are discussed, then I shall have taken a giant step toward my goal. That is to demonstrate two facts. The first is that theological discourse is undertaken through the manipulation of symbols in addition to (or: rather than) the specification of propositions and syllogisms. The second is that, when we can decipher the rules by which opaque symbols are combined and recombined in relationship with parsed elements of a verse of Scripture, we may speak of and describe (a) Judaism through its symbolic discourse and so, in time to come, identify the principal components of that Judaism's symbolic structure. And beyond these two propositions lies a further inquiry: to find out whether a single Judaism, adumbrated through a ubiquitous structure of opaque symbols, common to all types of evidence, is attested by the iconic and verbal symbols of Judaism in its formative age.[2]

1. For instance, narrative, or analytical, or propositional-syllogistic, to name three possibilities.
2. In chapter 9 we shall briefly consider that question within the framework of the results achieved in this book. But the question vastly transcends these limited results.

OPAQUE SYMBOLS IN NORMATIVE, LEGAL WRITINGS?

When considering the signs or "theological things" assembled in various combinations to make the point that rebellion is bad and obedience is good, we were struck by the treatment of the details of these signs. Specifically, we noticed that the intrinsic traits of the signs—Abraham, Israel at the Sea, the ten spies as against Joshua and Caleb, Sennacherib and Nebuchadnezzar—did not permit us to predict the proposition that manipulating those signs would produce. Abraham or the destruction of the Temple, Sinai or Haman—none of these things dictated the formation of taxa or constituted taxa on their own. All of them joined together, in one way or another, to find a place in some taxon other than the one that intrinsic traits will have demanded. So Abraham may join Moses and David in a taxon of one kind or another, but Abraham or Moses or David on its own does not define an organizing category. Persons, historical events, evil men—these do not define taxa.

Accordingly, we have observed that intrinsic traits of the persons, objects, events, or actions that were to be assembled in various combinations in no way dictated the character of the symbolic discourse that the recombinancy would yield. Any sign could produce any result, so it seemed, and all matters of meaning worked themselves out within the framework of the syntax and grammar of symbolic discourse. But there, it goes without saying, we gather, a very particular syntax and grammar does impose the rules for intelligible communication.

As a matter of fact, the difference between appeal to the intrinsic traits of things, in taxonomic structures for example, and conformity to rules of intelligible combination and recombination that do not attend to the traits of things at all, in the Mishnah and the documents that organize themselves around the Mishnah, the Tosefta and the two Talmuds, by contrast, the intrinsic traits of things govern discourse about those things. If we make a list of persons, objects, or actions, we may predict the range of discourse—the types of propositions, even the issues addressed in their connection—by examination of the intrinsic traits of those persons, objects, or actions. A given object or action or person of a certain status may join with another sort but will not combine with a third type; the range of discourse then finds its limitations in characteristics inherent in the things discussed. That fact emerges when we examine the principles of taxonomic organization and structure that characterize the Mishnah, for in them we see the simple fact that the traits of things dictate the taxonomic rules of combination and recombination. Words then are not opaque symbols, given distinctive character-

istics only in combination with one another but themselves not governing the making of combinations. They are, themselves, taxic indicators.

LISTENWISSENSCHAFTLICHE METHOD IN
THE MISHNAH AND IN SONG OF SONGS RABBAH

To demonstrate that fact we compare the principles of list making characteristic of the Mishnah and of Song of Songs Rabbah, the document that provided our initial example of the "another matter" construction.[3] The reason that the comparison is apt is simple. Both the "another matter" construction and the Mishnah's compositions and composites constitute lists. In the former case, nicely linked compositions as a complete composite communicate the point that an author or authorship has wished to make, for example, rebellion is bad, obedience good. In the latter case, lists of examples accumulate to make a point reiterated only through details and the comparison of the like and the unlike among those detailed cases. So in each kind of writing we have a variation of list making, or *Listenwissenschaft*.

Sequences of comments on the same verse, joined by "another matter," mean to establish compositions of taxically joined facts, that is to say, lists. Recognizing that obvious fact, we are drawn back to the Mishnah's method, which is that of list making as well. But learning accomplished through list making, that is, *Listenwissenschaft*, in the philosophical setting of the Mishnah vastly differs from the same method of learning worked out in the theological setting of Song of Songs Rabbah. The difference, as we shall soon see, is the propositional character of the former, in which lists make points, contrasted with the merely presentational character of the latter, in which lists portray different things that evoke the same attitude without proving how different things prove the same point. What is important for our inquiry should not be missed: the traits of things define the cogency of lists for the Mishnah but not for Song of Songs Rabbah (and, hence, for other documents like it, which combine and recombine opaque signs).

The Mishnah's method, that is, its logic of cogent discourse, establishes propositions that rest upon philosophical bases (e.g., through the proposal of a thesis) and the composition of a list of facts (e.g., through shared traits of a taxonomic order) that prove the thesis. The Mishnah

3. Later I shall show that that document is unique in its utilization of symbolic discourse; for the present it suffices to use it as a source of illuminating examples. But in chapter 4–6, we shall see that any other document can have provided us with acceptable cases for the present argument.

presents rules and treats stories (inclusive of history) as incidental and of merely taxonomic interest. Its logic is propositional, and its intellect does its work through a vast labor of classification, comparison, and contrast generating governing rules and generalizations. So, stated very simply, a document that consists in the main of lists, such as Song of Songs Rabbah, requires us to compare its method, the "another matter" composition, with the method of the Mishnah. The two documents have in common the method of list making, but they differ very profoundly on the respective uses of their lists.

List making, which places on display the data of the like and the unlike, implicitly (ordinarily, not explicitly) then conveys the rule. Once a series is established, the authorship assumes, the governing rule will be perceived. That explains why, in exposing the interior logic of its authorship's intellect, the Mishnah had to be a book of lists, with the implicit order, the nomothetic traits of a monothetic order, dictating the ordinarily unstated general and encompassing rule. The purpose of list making in the Mishnah is in order to make a single statement, endless times over, and to repeat in a mass of tangled detail precisely the same fundamental judgment. To form their lists, the framers of the Mishnah appeal solely to the traits of things. The logical basis of coherent speech and discourse in the Mishnah then derives from *Listenwissenschaft*. That mode of thought defines the way of proving propositions through classification, so establishing a set of shared traits that form a rule that compels us to reach a given conclusion. Probative facts derive from the classification of data, all of which point in one direction and not in another.

A catalogue of facts, for example, may be so composed that, through the regularities and indicative traits of the entries, the catalogue yields a proposition. A list of parallel items all together point to a simple conclusion; the conclusion may or may not be given at the end of the catalogue, but the catalogue—by definition—is pointed. All of the catalogued facts are taken to bear self-evident connections to one another, established by those pertinent shared traits implicit in the composition of the list, therefore also bearing meaning and pointing through the weight of evidence to an inescapable conclusion. The discrete facts then join together because of some trait common to them all. This is a mode of classification of facts to lead to an identification of what the facts have in common and, it goes without saying, an explanation of their meaning.

How in the Mishnah do lists work to communicate principles or propositions? The following abstract allows us to identify the *and* and the *equal* of Mishnaic discourse, showing us through the making of connections and the drawing of conclusions the propositional and essentially philosophical mind that animates the Mishnah. The importance of the

example lies in the contrast between the Mishnah list, with its interest in establishing philosophical propositions, and the counterpart list of the "another matter" composition in Song of Songs Rabbah, out of which it is very difficult to compose a proposition worthy of the name (then excluding ineffable banalities).

In the following passage, drawn from Mishnah tractate Sanhedrin Chapter Two, the authorship wishes to say that Israel has two heads, one of state and the other of cult, the king and the high priest, respectively, and that these two offices are nearly wholly congruent with each other, with a few differences based on the particular traits of each. Broadly speaking, therefore, our exercise is one of setting forth the genus and the species. The genus is head of holy Israel. The species are king and high priest. Here are the traits in common and those not shared, and the exercise is fully exposed for what it is, an inquiry into the rules that govern, the points of regularity and order, in this minor matter, of political structure. My outline, imposed in boldface type, makes the point important in this setting.

Mishnah Tractate Sanhedrin Chapter Two

1. **The rules of the high priest: subject to the law, marital rites, conduct in bereavement**

2:1. A. A high priest judges, and [others] judge him;
 B. gives testimony, and [others] give testimony about him;
 C. performs the rite of removing the shoe [Deut. 25:7–9], and [others] perform the rite of removing the shoe with his wife.
 D. [Others] enter levirate marriage with his wife, but he does not enter into levirate marriage,
 E. because he is prohibited to marry a widow.
 F. [If] he suffers a death [in his family], he does not follow the bier.
 G. "But when [the bearers of the bier] are not visible, he is visible; when they are visible, he is not.
 H. "And he goes with them to the city gate," the words of R. Meir.
 I. R. Judah says, "He never leaves the sanctuary,
 J. "since it says, *'Nor shall he go out of the sanctuary'* (Lev. 21:12)."
 K. And when he gives comfort to others
 L. the accepted practice is for all the people to pass one after another, and the appointed [prefect of the priests] stands between him and the people.
 M. And when he receives consolation from others,
 N. all the people say to him, "Let us be your atonement."
 O. And he says to them, "May you be blessed by heaven."
 P. And when they provide him with the funeral meal,
 Q. all the people sit on the ground, while he sits on a stool.

2. **The rules of the king: not subject to the law, marital rites, conduct in bereavement**

2:2. A. The king does not judge, and [others] do not judge him;

B. does not give testimony, and [others] do not give testimony about him;

C. does not perform the rite of removing the shoe, and others do not perform the rite of removing the shoe with his wife;

D. does not enter into levirate marriage, nor [do his brothers] enter levirate marriage with his wife.

E. R. Judah says, "If he wanted to perform the rite of removing the shoe or to enter into levirate marriage, his memory is a blessing."

F. They said to him, "They pay no attention to him [if he expressed the wish to do so]."

G. [Others] do not marry his widow.

H. R. Judah says, "A king may marry the widow of a king.

I. "For so we find in the case of David, that he married the widow of Saul,

J. "for it is said, 'And I gave you your master's house and your master's wives into your embrace' (2 Sam. 12:8)."

2:3. A. [If] [the king] suffers a death in his family, he does not leave the gate of his palace.

B. R. Judah says, "If he wants to go out after the bier, he goes out,

C. "for thus we find in the case of David, that he went out after the bier of Abner,

D. "since it is said, 'And King David followed the bier' (2 Sam. 3:31)."

E. They said to him, "This action was only to appease the people."

F. And when they provide him with the funeral meal, all the people sit on the ground, while he sits on a couch.

3. **Special rules pertinent to the king because of his calling**

2:4. A. [The king] calls out [the army to wage] a war fought by choice on the instructions of a court of seventy-one.

B. He [may exercise the right to] open a road for himself, and [others] may not stop him.

C. The royal road has no required measure.

D. All the people plunder and lay before him [what they have grabbed], and he takes the first portion.

E. *"He should not multiply wives to himself"* (Deut. 17:17)—only eighteen.

F. R. Judah says, "He may have as many as he wants, so long as they *do not entice him* [to abandon the Lord (Deut. 7:4)]."

G. R. Simeon says, "Even if there is only one who entices him [to abandon the Lord]—lo, this one should not marry her."

H. If so, why is it said, "He should not multiply wives to himself"?

I. Even though they should be like Abigail [1 Sam. 25:3].

J. *"He should not multiply horses to himself"* (Deut. 17:16)—only enough for his chariot.

K. *"Neither shall he greatly multiply to himself silver and gold"* (Deut. 17:16)—only enough to pay his army.

L. *"And he writes out a scroll of the Torah for himself"* (Deut. 17:17).

M. When he goes to war, he takes it out with him; when he comes back, he brings it back with him; when he is in session in court, it is with him; when he is reclining, it is before him,

N. as it is said, *"And it shall be with him, and he shall read in it all the days of his life"* (Deut. 17:19).

2:5. A. [Others may] not ride on his horse, sit on his throne, handle his scepter.

B. And [others may] not watch him while he is getting a haircut, or while he is nude, or in the bathhouse,

C. since it is said, *"You shall surely set him as king over you"* (Deut. 17:15)—that reverence for him will be upon you.

The subordination of Scripture to the classification scheme is self-evident. Scripture supplies facts. The traits of things—kings, high priests—dictate classification categories on their own, without Scripture's dictate. What is important for our inquiry is that the traits of things constitute the taxic indicators, and the lists are made up by appeal to intrinsic characteristics of the things that comprise the lists. The contrast, then, between this list—traits inherent in the king and traits inherent in the high priest, compared and contrasted to yield rules—and the lists of Song of Songs Rabbah is stunning. It suffices to repeat a few of the lists we surveyed in the preceding chapter:

> Dathan and Abiram, the spies, Jeroboam, Solomon's marriage to Pharaoh's daughter, Ahab, Jezebel, Zedekiah;
> Israel is feminine, the enemy (Egypt) masculine, but God the father saves Israel the daughter;
> Moses and Aaron, the Sanhedrin, the teachers of Scripture and Mishnah, the rabbis;
> the disciples; the relationship among disciples, public recitation of teachings of the Torah in the right order; lections of the Torah.

The (to us) random quality of the foregoing lists, the (by us) unpredictable character of the (consequent) propositions that a given sequence of items yields—these present a striking contrast with the Mishnah's lists. The former on their own generate no proposition that flows necessarily from the character of the items that are joined, a fact proven by our inability, looking at these combinations on their own, to guess at the conclusion we are supposed to draw. The latter—the Mishnah's parallel and contrasting lists—assuredly do dictate the conclusions we are supposed to draw, and, as is clear, the fact that the high priest does one thing

and the king another suffices to tell us the generalization that is at stake in aggregating the list.

Here in the Mishnah the list so works as to yield a conclusion that appeals to the traits of the items on the list but also transcends the components of the list itself, namely, the hierarchization of monarchy and priesthood. But lists of theological "things" not only do not appeal to the traits of the catalogued signs, they also do not yield a conclusion that transcends the components of the lists; rather, as we saw in the case given in chapter 2, those things simply restate the same thing, over and over again. I cannot point to a syllogistic composition in Song of Songs Rabbah to serve as a counterpart to this perfectly commonplace mode of making a point through establishing connections, comparisons and contrasts, that is, in the Mishnah, quite ubiquitous.

LIST MAKING AND THE TRAITS OF THINGS: THE DIFFERENCE BETWEEN THE MISHNAH'S AND SONG OF SONGS RABBAH'S *LISTENWISSENSCHAFT* AND THE OPACITY OF SIGNS

The philosophical cast of mind is amply revealed in this essay, which in concrete terms effects a taxonomy, a study of the genus, national leader, and its two species, (1) king and (2) high priest: how are they alike, how are they not alike, and what accounts for the differences. The argument that the framer wishes to construct must rest upon the foundation of the traits of things, which are intrinsic and taxonomically definitive. And, we recall, the position that the author of the passage in Song of Songs Rabbah that we read in no way appeals to the intrinsic traits of things but is worked out through the combination of things and then their recombination with parsed elements of the scriptural texts. Without the parsing, the composition is not possible; without the cited verses in the Mishnah passage before us, by contrast, the composition stands quite securely.

Why do the intrinsic traits of things dictate the course of *Listenwissenschaft* in the Mishnah? The premise is that national leaders are alike and follow the same rule, except where they differ and follow the opposite rule from one another. But that premise also is subject to the proof effected by the survey of the data consisting of concrete rules, those systemically inert facts which here come to life for the purposes of establishing a proposition. By itself, the fact that, for example, others may not ride on his horse bears the burden of no systemic proposition. In the context of an argument constructed for nomothetic, taxonomic pur-

poses, the same fact is active and weighty. The whole depends upon three premises:

1. the importance of comparison and contrast, with the supposition that
2. like follows the like rule and the unlike follows the opposite rule; and
3. when we classify, we also hierarchize, which yields the argument from hierarchical classification: if this, which is the lesser, follows rule X, then that, which is the greater, surely should follow rule X.

And that is the whole sum and substance of the logic of *Listenwissenschaft* as the Mishnah applies that logic in a practical way. And the dialectic of argument begins with the absolutely given fact that the traits of things define what we may say about those things: the comparison and contrast, the conception of like and unlike, the notion of hierarchization.

If I had to specify a single mode of thought that establishes connections between one fact and another, it is in the search for points in common and therefore also points of contrast. We seek connection between fact and fact, sentence and sentence in the subtle and balanced rhetoric of the Mishnah, by comparing and contrasting two things that are like and not alike. But then we draw conclusions from that fact. At the logical level, too, the Mishnah falls into the category of familiar philosophical thought. Once we seek regularities, we propose rules. What is like another thing falls under its rule, and what is not like the other falls under the opposite rule. Accordingly, as to the species of the genus, so far as they are alike, they share the same rule. So far as they are not alike, each follows a rule contrary to that governing the other. Thus the work of analysis is what produces connection, and therefore the drawing of conclusions derives from comparison and contrast: the *and,* the *equal.*

The proposition then that forms the conclusion concerns the essential likeness of the two offices, except where they are different, but the subterranean premise is that we can explain both likeness and difference by appeal to a principle of fundamental order and unity. That principle is represented by a single word: hierarchy. All things stand in hierarchical relationship to all other things. The social order here, the supernatural order beyond—both attest to that fundamental fact of ontology. To make these observations concrete, we turn to the case at hand. The important contrast comes at the outset. The high priest and the king fall into a single genus, but speciation, based on traits particular to the king, then distinguishes the one from the other. All of this exercise is conducted essentially independently of Scripture; the classifications derive from the system, are viewed as autonomous constructs; traits of things define

classifications and dictate what is like and what is unlike. And this brings us back to the list-making method of the case drawn from the document Song of Songs Rabbah.

When in Song of Songs Rabbah we have a sequence of items alleged to form taxon, that is, a set of things that share a common taxic indicator, of course what we have is a list.[4] The list presents diverse matters that all together share and therefore also set forth a single fact or rule or phenomenon. That is why we can list them, in all their distinctive character and specificity, on a common catalogue of "other things" that pertain all together to one thing. But the traits of the things that are listed are *not* then analyzed and conclusions are *not* then drawn from the result. The difference between the Mishnah's *Listenwissenschaft* and that of Song of Songs Rabbah is in the treatment of the things that are listed, and that difference derives from the purpose of the list. In the Mishnah, it is to draw conclusions from what is listed. In the writings typified here by Song of Songs Rabbah, the purpose of making the list is the list. The list in that document and those like it does not constitute a demonstration of a proposition formed out of established premises (traits of things yielding a generalization of a hierarchical character); it registers a single point many times, never proving it.

For while we can point to a conclusion for which the Mishnah's authorship uses its list, we can rarely point to a similar conclusion—*a proposition important to the components of the list but transcending them* —that forms the centerpiece of discourse of a list in Song of Songs Rabbah and its companions. Rather, what we find is a list made up of this and that, combined in one way rather than another, connected to this item rather than that. Absent a propositional goal closely tied to the items on the list in the way in which the proposition about the hierarchical superiority of the monarch transcends the items on the list we examined in the Mishnah, the display of an arrangement of the items

4. That the *petihta* form, one important source of "another matter" or *davar aher* constructions, constitutes a list is shown by Martin Jaffee, "The 'Midrashic' Proem: Towards the Description of Rabbinic Exegesis," *Approaches to Ancient Judaism* (ed. William Scott Green; Brown Judaic Studies; Atlanta: Scholars Press, 1983) 95–112. Jaffee describes the proem under study as "an amalgam of materials that the redactor intends to coexist as independent and mutually uninforming units." Again, the compositions "are linked together but never merged." That seems to me what happens in list making, in which discrete items are formed into a single list but not represented as the same as one another in all ways, rather only in the ways important for the compiling of that list in particular. Jaffee's judgment as to meaning seems to me unrealized in his paper: "Meaning is not derived by explanation and argument, but rather is suggested through skillful contextualization of disparate items of information." That seems to me a fancy way of describing a list.

forms the goal of the intellectual enterprise. What is set on display justifies the display: putting this familiar fact together with that familiar fact in an unfamiliar combination constitutes what is new and important in the list; the consequent conclusion one is supposed to draw, the proposition or rule that emerges—these are rarely articulated (my list of propositional composites shows the possibility) and never important.

True, the list in Song of Songs Rabbah may comprise a rule, or it may substantiate a proposition or validate a claim; but more often than not, the effect of making the list is to show how various items in combination—only in combination!—establish the same point. In that way alone do they share a single taxic indicator, which again is to say that the purpose of the list is to make the list. The making of connections among ordinarily not connected things is then one outcome of *Listenwissenschaft* in the documents of the order of Song of Songs Rabbah. Another, in my judgment less common one, is to make connections among things that should be connected and thus not to make connections among things that should not be connected; what we include out of the restricted repertoire testifies also to what we exclude. But that contrastive function of list making does not strike me as critical. What I find engaging in my catalogue of combinations given in chapter 2 is the very variety of things that, on one list or another, can be joined together—a list made (so to speak) "for its own sake." What we have is a kind of subtle restatement, through an infinite range of possibilities, of the combinations and recombinations of a few essentially simple facts (data). It is as though a magician tossed a set of sticks this way and that, interpreting the diverse combinations of a fixed set of objects. The propositions that emerge are not the main point; the combinations are.

SYMBOLIC DISCOURSE AND GENERIC EXEGESIS

It may be argued that the reason for the difference between the Mishnah's and Song of Song Rabbah's principles of *Listenwissenschaft* is not subject matter, as I argue, but (mere) form. The framers of the Mishnah—so it may be claimed—wish to establish normative and descriptive points of correct behavior. They deal with the laws of the everyday. Accordingly, they find it appropriate to work inductively by appeal to the traits of everyday objects, actions, persons, and the like. But exegesis of a received text, meant to yield not propositions of a sustained and cogent, philosophical order but rather episodic clarifications of this and that, will not find determinative the intrinsic traits of things. So the kind of discourse I call "symbolic" may in fact recapitulate the modes of

thought and rhetoric required for (mere) exegesis, and the principles of taxonomy, on the one side, and the kind of subject that is discussed, on the other, then have no bearing upon the explanation of matters.

To test that proposition, we turn to a single case, in which a passage of the Mishnah engages in the systematic exegesis of a verse of Scripture. What we want to know is whether we find traits of rhetoric and logic comparable to those which characterize the "another matter" composition of Song of Songs Rabbah that serves as our test case. We note that these are, first, the composite worked out of compositions made up of the parsed elements of a verse combined with a set of other, theological categories; second, disinterest in the traits of the things that are catalogued; third, repetition of the same point—attitude, proposition, sentiment, or emotion—in a construction that achieves effect through reiteration rather than argument. While exegesis of verses of Scripture in the Mishnah proves rare, we do have a few chapters that form counterparts to the treatment of Scripture routine in such Midrash compilations as Song of Songs Rabbah, and to one of these we now turn.

Mishnah Tractate Sotah Chapter Eight

8:1. A. The anointed for battle, when he speaks to the people, in the Holy Language did he speak,

 B. as it is said, "And it shall come to pass when you draw near to the battle, that the priest shall approach (this is the priest anointed for battle) and shall speak to the people (in the Holy Language) and shall say to them, Hear, O Israel, you draw near to battle this day" (Deut. 20:2–3).

 C. "against your enemies" (Deut. 20:3)—and not against your brothers,

 D. not Judah against Simeon, nor Simeon against Benjamin.

 E. For if you fall into their [Israelites'] hand, they will have mercy for you, as it is said, "And the men which have been called by name rose up and took the captives and with the spoil clothed all that were naked among them and arrayed them and put shoes on their feet and gave them food to eat and something to drink and carried all the feeble of them upon asses and brought them to Jericho, the city of palm trees, unto their brethren. Then they returned to Samaria" (2 Chron. 28:15).

 G. "Against your enemies do you go forth."

 H. For if you fall into their hand, they will not have mercy upon you.

 I. "Let not your heart be faint, fear not, nor tremble, neither be afraid" (Deut. 20:3).

 J. "Let not your heart be faint"—on account of the neighing of the horses and the flashing of the swords.

 K. "Fear not"—at the clashing of shields and the rushing of the tramping shoes.

L. "Nor tremble"—at the sound of the trumpets.

M. "Neither be afraid"—at the sound of the shouting.

N. "For the Lord your God is with you" (Deut. 20:4)—

O. they come with the power of mortal man, but you come with the power of the Omnipresent.

P. The Philistines came with the power of Goliath. What was his end? In the end he fell by the sword, and they fell with him.

Q. The Ammonites came with the power of Shobach [2 Sam. 10:16]. What was his end? In the end he fell by the sword, and they fell with him.

R. But you are not thus: "For the Lord your God is he who goes with you to fight for you"—

S. —this is the camp of the ark.

The composition before us in no way may be classified as recombinant or even combinant. The interest is in relating clauses of the base verses to rules that the framer wishes to set forth or attitudes that he wishes to impart. The form involves, not a repeated parsing of the same verse in the same way, with sequences of meanings imputed to the elements of the verse, but a simple progression through the base verse, with the meanings imputed to the clauses dictated by the sense of the clauses at hand:

"against your enemies" (Deut. 20:3)—and not against your brothers,
"Fear not"—at the clashing of shields and the rushing of the tramping shoes.
"Nor tremble"—at the sound of the trumpets.
"Neither be afraid"—at the sound of the shouting.
"For the Lord your God is with you" (Deut. 20:4)—they come with the power of mortal man, but you come with the power of the Omnipresent.

At each point the sense of the clause of the verse limits the contents of the amplificatory phrase. "Enemies" is the opposite of "brothers"; "fear not"—on what account? "do not tremble" because of what? "Neither be afraid"—of what? Obviously, amplification proves antonymic: "for the Lord is with you," but they come only with mortal power. It is hardly necessary, at this point in the argument, to do more than adduce in evidence a single example of the "another matter" construction to show how different these lists are:

7. A. "I am very dark": at Horeb, "And they made a calf at Horeb" (Ps. 106:19).

B. "but comely": at Horeb, "And they said, All that the Lord has spoken we will do and obey" (Exod. 24:7).

"Dark" does not yield an antonymic meaning, nor does "comely"; the verse is not amplified in its own terms. Rather, it is set forth in combination with elements of other verses, and only in the combination of these elements does a point emerge. Recombinancy is not a trait of the genus exegesis; generic exegesis (if we may for the moment entertain the possibility of a genus "exegesis") in no way imposes the requirement that meaning emerge from the combination of otherwise opaque signs. The opposite is the case in the Mishnah's exegesis, so the case at hand indicates.

RECOMBINANCY AND THEOLOGY

What are listed in the combinant and recombinant lists examined in chapter 2 are not data of nature, such as we find in the Mishnah, but facts, supplied by the Torah, of theology: God's relationship with Israel, expressed in such facts as the three redemptions, the three patriarchs, and holy persons, actions, events, what have you. These are facts which are assembled and grouped, just as in the Mishnah traits of persons, places, things, and actions are assembled and grouped. In the Mishnah the result is propositions, rules; in Song of Songs Rabbah the result is not propositional at all, or, if propositional, then essentially the repetition of familiar propositions through unfamiliar data. That seems to me an important fact, for it tells me that a repertoire of persons and events and conceptions (e.g., Torah study), holy persons, holy deeds, holy institutions, presented candidates for inclusion in "another matter" compositions, and the repertoire, while restricted and not terribly long, made possible a scarcely limited variety of lists of things with like taxic indicators.

That is to say, the same items occur over and over again, but there is no pattern to how they recur. By a pattern I mean that items of the repertoire may appear in numerous "another matter" compositions or not; they may keep company with only a fixed number of other items, or they may not. A fixed unit is formed by Abraham, Isaac, and Jacob. But a fixed unit is not formed by Jacob, Moses, and Hananiah, Mishael, and Azariah. We have a fixed unit in the three redemptions but not in the holy way of life sequences, the destruction of the Temple sequences, and the patriarch sequences. Where we have fixed companions, such as the patriarchs or the three redemptions, these rarely form the generative structure of the "another matter" composition in which they occur, and ordinarily they do not. But when we ask, then, Is there a counterpart definition of items drawn from the fixed repertoire that ordinarily occur together? the answer is, Not at all. Most things can appear in a *davar*

aher composition with most other things. No clear pattern has as yet struck me very forcefully. What that means is that the list making is accomplished within a restricted repertoire of items that can serve on lists; the list making then presents interesting combinations of an essentially small number of candidates for the exercise. But then, when making lists, one can do pretty much anything with the items that are combined; the taxic indicators are unlimited, but the data studied are severely limited. And that fact brings us to the question of the substrate of documents that represent through recombinant compositions, deemed intelligible and instructive, of otherwise opaque symbols a theological structure.

The structures we shall examine do not form a theological system, made up of well-joined propositions and harmonious positions, nor do I discern in the several lists propositions that I can specify and that are demonstrated syllogistically through comparison and contrast. The point of list making of opaque signs given meaning through combination and recombination with elements of verses of Scripture is just the opposite. It is to show that many different things really do belong on the same list.

DISCOURSE IN LAW AND DISCOURSE IN THEOLOGY: SYSTEM *VS.* STRUCTURE

That observation returns us to our starting point. The recombinant symbols yield not a proposition like the one that the Mishnah's list syllogistically demonstrates. The list utilized for recombinant theology yields only itself but, to be sure, also invites exegesis. It is, specifically, the exegesis of the items on the list, which, in fact, constitute a canon of selected items. So the list in theological discourse of a symbolic character is the opposite of the syllogistic and propositional list of the Mishnah; it is a canon of items, canonical because selected. Then the connections among these items dictate what requires exegesis. What theology expressed through symbolic discourse adds up to, then, is not argument for proposition, hence comparison and contrast and rule making of a philosophical order, but rather structure comprising (for example) well-defined attitudes.

Accordingly, while the listed items can have yielded propositions, what is important is not the proposition but the interesting array and arrangement of the components of the "another matter" compositions themselves. The "another matter" composition serves without consequential propositional result, even though it very commonly yields some sort of commonplace affirmation. But the details, where the framers

have put their best work, serve to repeat in many ways that one point, commonly, the right attitude; in the Mishnah's counterpart, the details serve to demonstrate a proposition. The difference then seems to be that the Mishnah's list contributes toward a system, while (in the case at hand) Song of Songs Rabbah's list portrays a structure. The theological purpose therefore is to arrange and rearrange a few simple propositions, represented by a limited vocabulary of symbols. In such a structure we organize set-piece tableaux rather than putting forth and demonstrating propositions. Philosophy's syllogistic argument in behalf of well-tested propositions contrasts with theology's evocation through well-arrayed symbols of correct attitudes.

The reason for the difference in the methods of the two list-making documents is blatant. In the Mishnah, philosophy sets forth a system, dynamic and dialectical in character, while in Song of Songs Rabbah, the theology sets forth a structure, static and unchanging in its display of fixed truth about God and God's relationship with Israel. Were we to catalogue the propositions of Song of Songs Rabbah stated in the language of philosophical discourse, they would repeatedly set forth the same point: *God loves Israel, Israel loves God, and the Torah is the medium of that reciprocal love.* However diverse the language and however original the arrangement of the theological "things" that convey that message, the message is uniform throughout, and the articulation is essentially through the repetition in marginally different theological "things" of the same thing: *davar aher* really does stand for "another matter" that is in fact the same matter. So the same method of learning is used for different purposes, the one philosophical, systematizing the evidence of nature, the other theological, recapitulating the evidence of supernature revealed by God in the Torah.

4

Rabbinic Lists of "Theological Things"

THE DOCUMENTARY EVIDENCE.
[1] THE HALAKHIC MIDRASH COMPILATIONS

SYMBOLIC DISCOURSE IN JUDAISM: THE DOCUMENTARY REPERTOIRE OF "ANOTHER MATTER" COMPOSITIONS ON THEOLOGICAL TOPICS

I have now claimed that symbolic discourse takes place in the canonical writings of Judaism and that I know how to identify compositions and composites in which words bear indeterminate meaning. I further allege to know what kind of rhetorical patterns will yield symbolic, rather than propositional, discourse. And, finally, I have set forth the proposition that symbolic discourse serves a quite distinctive purpose, that of conveying theological truth and no other. These three propositions all together constitute my account of symbolic discourse in the formative stages of the Judaism represented by the canon of the dual Torah, oral and written, from the Mishnah, ca. A.D. 200, through the Talmud of Babylonia, ca. A.D. 600. So, having linked symbolic discourse to a particular literary form and a distinctive type of topic, claiming that in that form, and concerning that topic, alone do we find words used as opaque symbols that gain meaning only in combination with other such words and in recombination with parsed (hence on their own meaningless) phrases of Scripture, I face the task of proof.

My evidence consists of a complete survey of the Midrash compilations that were made from the closure of the Mishnah through the completion of the Talmud of Babylonia as well as one ancillary compilation. What we shall see is that, as a matter of fact, the form I have identified as necessary for symbolic discourse does occur, mostly episodically. When

we find that form, we also uncover precisely the type of discourse under discussion in this book. Further, all instances we survey deal with theological, and only theological, themes. And, finally, the one document that really does devote a sizable and even coherent portion of the whole to symbolic discourse is the only document that devotes itself entirely to the theme, the relationship of God to Israel and of Israel to God through the Torah.

"ANOTHER MATTER" COMPOSITIONS IN SIFRA

There is none—not one!—and that conforms to the logic just now outlined. For Sifra is wholly devoted to the exposition of halakhic and not aggadic[1] subjects, and, according to my reasoning and theory of matters, we should find "another matter" constructions in other than legal, normative compositions and composites. The form under discussion, after all, serves a particular type of materials, those which are not broadly exegetical but very narrowly theological.[2]

Sifra, an extended exploration of certain problems in connection with the book of Leviticus in relationship with the Mishnah, ought not to contain a rich repertoire of "another matter" constructions in the form now defined, since the bulk of that document pertains to issues of philosophical taxonomy worked out in normative-legal and not theological categories.[3] The document consistently presents a different rhetorical joining pattern or form, one that serves a different purpose altogether. In place of "another matter," it joins coherent and parallel compositions by the language, "along these same lines," which gives "another instance of a phenomenon just now set forth." That shift by itself in joining language is trivial. But the key indicators of a rhetorical character, for example, the parsing of the same verse time and again in the same way but with supposedly different results, are absent. A single example suffices to make that point. In the following, we have two proofs of the same proposition, joined by "along these same lines." That this

1. To invoke the native categories of the literature under consideration.
2. That is not to suggest that all theological discourse will take the form of the "another matter" construction, my claim being only that that form is deemed particularly suited to symbolic discourse on theological themes.
3. See J. Neusner, *Uniting the Dual Torah: Sifra and the Problem of the Mishnah* (Cambridge: Cambridge University Press, 1990). We need not enter into the issues of that work, which are not relevant here. In the previous chapter's discussion of whether or not the intrinsic traits of objects define taxic indicators, or whether category formation derives from some other source—in this case, Scripture—I have already alluded to some of the broader issues of that work.

form has nothing in common with the one that seems to me to serve a distinctively theological purpose is self-evident.

Sifra II:II

1. A. "[The Lord called to Moses and spoke to him] from the tent of meeting, [saying, 'Speak to the Israelite people and say to them']" (Lev. 1:1):
 B. [The stress on Moses' receiving the message] indicates that the voice came to an end [at the bound of the tent of meeting] and did not resonate outside the tent. [Only Moses heard it.]
 C. Might one suppose that this was because it was a subdued voice?
 D. Scripture says, "And he heard the voice" (Num. 7:89).
 E. For Scripture refers to "the voice" to indicate that it is only that voice to which Scripture makes explicit reference.
 F. And what indeed is that voice to which Scripture makes explicit reference?
 G. It is the one to which the following verses of Scripture refer:
 H. "The voice of the Lord is power, the voice of the Lord is majesty; the voice of the Lord breaks cedars; the Lord shatters the cedars of Lebanon. [He makes Lebanon skip like a calf, Sirion like a young wild ox.] The voice of the Lord kindles flames of fire; the voice of the Lord convulses the wilderness; the Lord convulses the wilderness of Kadesh; the voice of the Lord causes hinds to calve and strips forests bare" (Ps. 29:4-7).
 I. If that is the case, why does it say, "from the tent of meeting"?
 J. [The stress on Moses' receiving the message] indicates that the voice came to an end [at the bound of the tent of meeting] and did not resonate outside the tent. [Only Moses heard it.]
2. A. Along these same lines: "The sound of the cherubs' wings could be heard as far as the outer court, like the voice of God Almighty when he speaks" (Ezek. 10:5):
 B. Might one suppose that this was because it was a subdued voice?
 C. Scripture says, ". . . like the voice of God Almighty when he speaks at Sinai."
 D. If so, why is it said, ". . . as far as the outer court"?
 E. Once the sound got to the outer court, it no longer resonated.

No. 1.I-J is simply tacked on to revert to the opening; there is no sense to "if that is the case. . . ." No. 2 goes over the same proposition, that the sound of God's voice could be kept within the bounds of the holy space. This kind of composite has nothing in common with the one that is at issue here. The handful of "another matter" composites in no way follow the formal requirements defined in chapter 3. Here is an example of what we do find, and not commonly at that:

Sifra CLXXVIII:I

15. A. "on the front of the mercy seat":
 B. And this serves as the generative analogy. Wherever Scripture refers to "before the mercy seat," it means in the eastern side.
16. A. Another matter concerning "on the front of the mercy seat":
 B. he did not intentionally sprinkle upward or downward, but he did it like one who cracks a whip [M. Yoma 5:4M–N].
17. A. "before the mercy seat he shall sprinkle the blood with his finger seven times":
 B. Not seven drops.
 C. "Seven times":
 D. he is to count seven times, lo, "one and seven. . . ."

We see that "another matter" simply links two distinct readings of the same clause, without any internal matching of one element to the next. That these two forms have nothing in common with the one I claim serves distinctively theological purposes is now obvious. And, as a matter of fact, I find in the entire document *not a single composite* made up of "another matter"s as defined here. When the language, "along these same lines," or "another matter" occurs, it serves only to join two distinct compositions, not to link matched and balanced sets that go over the same elements of the same verse in the same way. So much for the indicative evidence deriving from rhetorical patterns.

What about the topical program? When the compilers of the document do work on theological topics, it is not through symbolic discourse but by means of setting forth propositions to be demonstrated through argument, on the one side, and appeal to the sense of a verse of Scripture, on the other. The following passage wishes to set forth the proposition, already familiar, that obedience to God is praiseworthy, rebellion not. What is important is not the theological proposition but the way in which it is set forth:

Sifra CCLXIV:I

1. A. "But if you will not hearken to me [and will not do all these commandments, if you spurn my statutes and if your soul abhors my ordinances, so that you will not do all my commandments but break my covenant, I will do this to you . . .]":
 B. "But if you will not hearken to me" means, if you will not listen to the exposition of sages.
 C. Might one suppose that reference is made to Scripture [rather than to sages' teachings]?
 D. When Scripture says, "and will not do all these commandments," lo, reference clearly is made to what is written in the Torah.

E. Then how shall I interpret, "But if you will not hearken to me"?

F. It means, if you will not listen to the exposition of sages.

2. A. "But if you will not hearken":

B. What is the point of Scripture here?

C. This refers to one who knows God's lordship and intentionally rebels against it.

D. And so Scripture says, "Like Nimrod, a mighty hunter [before the Lord]" (Gen. 10:9).

E. Now what is the point of saying "before the Lord"?

F. [It really means, rebellion, for the letters of the name for Nimrod can spell out "rebel," so that] this refers to one who knows God's lordship and intentionally rebels against it.

3. A. And so Scripture says, "The men of Sodom were evil and sinful against the Lord greatly" (Gen. 13:13).

B. Now why does Scripture say, "against the Lord"?

C. It is because they knew God's lordship and intentionally rebelled against it.

4. A. "But if you will not hearken to me [and will not do all these commandments]":

B. What is the point of Scripture in saying, "will not do"?

C. You have someone who does not learn but who carries out [the teachings of the Torah].

D. In that connection, Scripture says, "But if you will not hearken to me and will not do."

E. Lo, whoever does not learn [the Torah] also does not carry it out.

F. And you have someone who does not learn [the Torah] and also does not carry it out, but he does not despise others [who do so].

G. In that connection, Scripture says, "if you spurn my statutes."

H. Lo, whoever does not learn the Torah and does not carry it out in the end will despise others who do so.

I. And you furthermore have someone who does not learn [the Torah], and also does not carry it out, and he does despise others [who do so], but he does not hate the sages.

M. In that connection, Scripture says, "and if your soul abhors my ordinances"—

N. lo, whoever does not learn [the Torah], also does not carry it out, and does despise others [who do so], in the end will hate the sages.

O. And you furthermore have someone who does not learn [the Torah], does not carry it out, despises others [who do so], and hates the sages, but who lets others carry out [the Torah].

P. Scripture says, "so that you will not do [all my commandments but break my covenant]"—

Q. lo, whoever does not learn [the Torah], does not carry it out, despises others [who do so], and hates the sages, in the end will not let others carry out [the Torah].

R. Or you may have someone who does not learn [the Torah], does not carry it out, despises others [who do so], hates the sages, does not let others carry out [the Torah], but he confesses that the religious duties were spoken from Sinai.

S. Scripture says, "all my commandments"—

T. lo, whoever does not learn [the Torah], does not carry it out, despises others [who do so], hates the sages, does not let others carry out [the Torah], in the end will deny that the religious duties were spoken from Sinai.

U. Or you may have someone who exhibits all these traits but does not deny the very Principle [of God's existence and rule].

V. Scripture says, "but break my covenant"—

W. lo, whoever exhibits all these traits in the end will deny the very Principle [of God's existence and rule].

No. 1 goes over the familiar polemic in favor of obedience to sages. Rebellion against sages, no. 2, is implicit. No. 4 reverts to this theme and does so with enormous force, identifying respect for sages with the verses that speak of spurning God's statutes and abhoring God's ordinances! We find no trace of symbolic discourse through cataloguing lists of contrasting figures, on the one side, nor is there an element of systematic reading of components of the verse in terms of combinations of opaque symbolic references, on the other. It is the simple fact, therefore, that our "another matter" composite has no counterpart in Sifra, and the authorship of Sifra addresses issues of a theological character through other media altogether than that of symbolic discourse. These negative results will be replicated time and again, underlining the affirmative propositions with which we commenced.

"ANOTHER MATTER" COMPOSITIONS
IN SIFRÉ TO NUMBERS 1–115

In its strict form, we do not find the "another matter" composition in this document. What we do find is merely the rhetorical usage, joining two distinct ideas; the characteristic features—a parsing of one verse and imputation of meanings to the elements in successive, related constructions—are absent in the following:

Sifré to Numbers XI:II

1. A. ". . . and unbind the hair of the woman's head":

 B. "The priest turns to her back and undoes her hair, so as to carry out in her regard the religious duty of unbinding her hair," the words of R. Ishmael.

2. A. Another matter: The verse teaches concerning Israelite women that they keep their heads covered.
 B. And while there is no clear proof for that proposition, there certainly is ample evidence in its favor:
 C. "And Tamar put dirt on her head" (2 Sam. 13:19).

This item and similar ones obviously have nothing in common with our form, which is not realized merely by the formal device of adding "another matter." Nor do successive proofs of the same proposition such as we find, for example, "The one who sins is punished first," followed by various cases that prove the same thing, joined by "along these same lines" (XVIII:I; LXIX:IV; LXXXIV:IV; LXXXVII:II; XCV:II; XCIX: III; CV:V; etc.).

That is not to suggest the entire absence of the form I have identified as unique in the conduct of symbolic discourse. Quite to the contrary, where we do find theology as the subject, we may find a theological tableaux in the discourse of recombinant opaque symbols. The following seems to me to execute our form:

Sifré to Numbers XL:I

3. A. R. Nathan says, "'The Lord bless you' with property, 'and keep you' in good health."
 B. R. Isaac says, "'And keep you' from the evil impulse."
 C. And so Scripture says, "For the Lord will be your confidence and will keep your foot from being caught" (Prov. 3:26).
4. A. Another interpretation of ". . . and keep you":
 B. So that others will not rule over you.
 C. And so Scripture says, "The sun shall not smite you by day, nor the moon by night." "Behold, he who keeps Israel will neither slumber nor sleep. The Lord is your keeper; the Lord is your shade on your right hand." "The Lord will keep you from all evil; he will keep your life. The Lord will keep your going out and your coming in from this time forth and forevermore" (Ps. 121).

The form before us requires a citation of the base verse, a few words that set forth a proposition, then a proof text from some other passage of Scripture. It proceeds to the following propositions, as nos. 5–10: he will keep you from demons, he will keep the covenant, he will keep the foreordained end, he will keep your soul at the hour of death, he will keep your foot from Gehenna, he will guard you in the world to come. I find this a well-executed verse of the besought form, because, at each point, a verse on the one side is combined with a sequence of events that, all together, deliver a message that is not otherwise articulated. The message, it seems to me, accumulates and makes a single point: God will

keep you at each and every step in your life, from birth through death to the world to come. I see no important way in which the composite differs from the one I offered as my example:

4. A. Another interpretation of the verse, "I am very dark": at the sea, "They were rebellious at the sea, even the Red Sea" (Ps. 106:7).
 B. "but comely": at the sea, "This is my God and I will be comely for him" (Exod. 15:2).

The composite that follows in context repeats the same form for the same purpose, now exploring the various senses of God's showing grace:

XLI:II

1. A. ". . . and be gracious to you":
 B. He will be gracious to you in responding to your requests.
 C. And so it says, "I shall be gracious to him to whom I shall be gracious, and I shall show mercy to him to whom I shall show mercy" (Exod. 33:19).

XLI:II

2. A. ". . . and be gracious to you":
 B. He will make you gracious in the view of other people.
 C. And so it says, "And the Lord was with Joseph, and he showed him mercy and made him gracious in the view of the ruler of the prison" (Gen. 39:21).
 D. And it says, "And Esther had grace in the view of all who saw her" (Esther 2:15).
 E. And it says, "And God made Daniel gracious and merciful and compassionate" (Dan. 12:9).
 F. And it says, "And find grace and enlightenment in the eyes of God and man" (Prov. 3:4).

XLI:II

3. A. ". . . and be gracious to you":
 B. Showing grace by giving you knowledge, understanding, enlightenment, virtue, and wisdom.

XLI:II

4. A. ". . . and be gracious to you":
 B. Showing grace by giving you mastery of the study of the Torah.
 C. And so it says, "She will place on your head a fair garland, she will bestow on you a beautiful crown" (Prov. 4:9).
 D. And it further says, "For they are a fair garland for your head and pendants for your neck" (Prov. 1:9).

XLI:II

5. A. "... and be gracious to you":
 B. He will show grace to you by favoring you with the gift of grace [unmerited favor].
 C. And so it says, "Behold, as the eyes of servants look to the hand of their master, as the eyes of a maid to the hand of her mistress, so our eyes look to the Lord our God, till he have mercy upon us" (Ps. 123:2).
 D. "Have mercy upon us, O Lord, have mercy upon us, for we have had more than enough of contempt" (Ps. 123:3).
 E. And it says, "O Lord, be gracious to us, we wait for you, be our arm every morning, our salvation in the time of trouble" (Isa. 33:2).

Even though we lack the desired "another matter," the composite proceeds in a familiar form, now covering grace in these senses: responding to prayers, being liked by others, having knowledge, understanding, mastering Torah study, and so on. The basic proposition that unites the set hardly requires articulation.

We note that, in both cases, a variety of items are utilized in discrete formulations cumulatively to make a single point. But the one thing I do not see in the second case is that use of opaque symbols which struck me so forcefully in my *locus classicus* for the form at hand, the example drawn from Song of Songs Rabbah. We may readily catalogue the discrete turnings in life as a set of opaque words, which, by themselves, do not permit us to speculate on the proposition they will be asked to set forth; that proposition only emerges when the words—signs—combine with the base verse and when the sets recombine to form the composite that bears the single message. Still, it seems clear, Sifré to Numbers does contain at least one instance, and possibly two, in which our form signals resort to symbolic discourse. And, we note, the discourse is undertaken specifically in a theological context, precisely as I suggested it should.

"ANOTHER MATTER" COMPOSITIONS IN SIFRÉ TO DEUTERONOMY

Sequences of proofs, on the basis of various facts, of particular propositions, for example, sequences of "along these same lines" and the like, require no catalogue. The effort is to compose a syllogism aimed at proving a particular proposition concerning word usages; there are fine proofs. But they serve the purpose opposite to that of symbolic discourse, here to endow words with determinate meaning, based on the determinate meaning of other words. In intention and in form the combinant

and recombinant medium of composition and formation of a composite differs in every possible way from that form. A brief snippet of one example suffices:

Sifré to Deuteronomy I:I

1. A. ". . . and thus you shall eat your fill. Take care not to be lured away to serve other gods and bow to them. [For the Lord's anger will flare up against you, and he will shut up the skies so that there be no rain and the ground will not yield its produce; and you will soon perish from the good land that the Lord is assigning to you]" (Deut. 11:13-17):

 B. He said to them, "Take care lest you rebel against the Omnipresent. For a person rebels against the Omnipresent only in prosperity."

 C. For so it is said, "Lest when you have eaten and are satisfied and have built large houses and lived in them, and when your herds and your flocks multiply, and your silver and your gold" (Deut. 8:12-13).

 D. What then? "Then your heart be lifted up and you forget the Lord your God" (Deut. 8:14).

 E. Along these same lines: "For when I shall have brought them into the land which I swore to their fathers, flowing with milk and honey" (Deut. 31:20).

 F. What then? "And turned to other gods and served them" (Deut. 31:20).

 G. Along these same lines: "And the people sat down to eat and to drink" (Exod. 32:6).

 H. What then? "They have made a molten calf" (Exod. 32:8).

2. A. Along these same lines in connection with the men of the generation of the flood, they rebelled against the Omnipresent only in prosperity.

 B. What is said in their regard? "Their houses are safe, without fear . . . their bull genders, they send forth their little ones like a flock . . . they spend their days in prosperity" (Job 21:9-13).

 C. This is what made them act as they did: "Depart from us, we do not desire knowledge of your ways. What is the almighty that we should serve him" (Job 21:14-15).

 D. They said, "Not even for a drop of rain do we need him, for 'There goes up a mist from the earth'" (Gen. 2:6).

 E. Said to them the Omnipresent, "In the very act of goodness which I have done for you, you take pride before me? Through that same act I shall exact a penalty from you."

 F. "And the rain was upon the earth forty days and forty nights" (Gen. 7:12).

The passage runs on, but the example is sufficient to show what it means to identify no symbolic discourse at all. What we have is a syllogism that is sustained by a variety of probative cases. In no way do we identify in

the passage the indicators of the recombinant symbolic structure.⁴ By
contrast, in this document we do have a few entirely perfect executions

4. Here is another example of the use of "another matter" as joining language, and
even the parsing of the verse, without recourse to symbolic discourse. But what follows
must be classified as a marginal case, since one may wish to argue that the discourse is
not all that different from the recombinant lists of opaque words that I have identified as
my model.

Sifré to Deuteronomy CCCVII

CCCVII:I

1. A. ["The Rock—his deeds are perfect. Yes, all his ways are just; a faithful God,
never false, true and upright is he. Children unworthy of him—that crooked
perverse generation—their baseness has played him false. Do you thus
require the Lord, O dull and witless people? Is not he the father who
created you, fashioned you and made you endure!" (Deut. 32:4–6).]
 B. "The rock": [The letters for the word "rock" may be read to mean artist,
design, and form or create, thus yielding this sense:] the artist, for he
designed the world first, and formed man in it [and all of these deeds are
perfect].
 C. For it is said, "The Lord God formed man" (Gen. 2:7).
2. A. ". . . his deeds are perfect":
 B. What he does is entirely perfect with all those who are in the world, and
none may complain against his deeds, even the most minor nitpicking.
 C. Nor may anyone look askance and say, "Would that I had three eyes,"
"would that I had three hands," "would that I had three legs," "would that I
walked on my head," "would that my face were turned around toward my
back"—"how nice it would be for me!"
 D. Scripture states, ". . . his deeds are perfect."
3. A. ". . . his deeds are perfect":
 B. [Since the word translated "perfect" can also be read as "just," we interpret
as follows:] He sits as judge for every single person and gives to each what is
coming to him.
4. A. ". . . a faithful God":
 B. For he believed in the world and created it.
5. A. ". . . never false":
 B. For people were not created to be wicked but to be righteous, and so
Scripture says, "Behold, this only have I found, that God made man
upright, but they have sought out many inventions" (Qoh. 7:29).
6. A. ". . . true and upright is he":
 B. He conducts himself in uprightness with everyone in the world.

CCCVII:II

1. A. Another comment concerning the verse, "The Rock—[his deeds are perfect.
Yes, all his ways are just; a faithful God, never false, true and upright is
he:]."
 B. ["Rock" means] "the mighty."
2. A. ". . . his deeds are perfect":
 B. What he does is entirely perfect with all those who are in the world, and
none may complain against his deeds, even the most minor nitpicking.
 C. Nor may anyone look askance and say, "Why did the generation of the flood
drown in water?" "Why did the generation of the tower of Babylon get

dispersed to the ends of the world?" "Why did the people of Sodom drown in fire and brimstone?" "Why did Aaron take the priesthood?" "Why did David take the monarchy?" "Why did Korah and his conspiracy get swallowed up by the earth?"

D. Scripture says, ". . . his deeds are perfect."

E. [Since the word translated "perfect" can also be read as "just," we interpret as follows:] He sits as judge for every single person and gives to each what is coming to him.

3. A. ". . . a faithful God":

B. He is like a bailee [Hammer: who keeps his trust].

4. A. ". . . never false":

B. He collects what is coming to him only at the end, for the trait of the Holy One, blessed be he, is different from the trait of mortal man.

C. A mortal leaves a deposit with his fellow, a pouch of two hundred *zuz* and he owes the bailee a hundred; when he comes to get what is his, the bailee says to him, "I'll take the *maneh* [the hundred *zuz*] which you owe me, and you keep the rest."

D. So too in the case of a worker who worked for a householder and who is owed a *denar*. When he comes to collect his wage, the other says to him, "I'll take the *denar* you owe me, and here's the rest of what is coming to you."

E. But the One who spoke and brought the world into being is not like that.

F. Rather: ". . . a faithful God":

G. He is like a bailee [Hammer: who keeps his trust].

H. He collects what is coming to him only at the end.

5. A. ". . . true and upright is he":

B. In line with this verse: "For the Lord is righteous, he loves righteousness" (Ps. 11:7).

CCCVII:III

1. A. Another comment concerning the verse, "The Rock—[his deeds are perfect. Yes, all his ways are just; a faithful God, never false, true and upright is he:]."

B. ["Rock" means] "the mighty."

2. A. ". . . his deeds are perfect":

B. What he does is entirely perfect with all those who are in the world.

C. The recompense of the righteous and the punishment of the wicked [are entirely correct, for] the former have gotten nothing of what is coming to them in this world, and the latter have never gotten what is coming to them in this world either.

D. And how on the basis of Scripture do we know that the righteous have never gotten what is coming to them in this world?

E. As it is said, "Oh, how abundant is your goodness, which you have laid up for them who fear you" (Ps. 31:20).

F. And how on the basis of Scripture do we know that the wicked have never gotten what is coming to them in this world?

G. As it is said, "Is not this laid up in store with me, sealed up in my treasuries" (Deut. 32:34).

H. When does each get what is coming to him?

I. ". . . all his deeds are perfect."

E. [Since the word translated "perfect" can also be read as "just," we interpret

as follows:] Tomorrow, when he takes his seat in the throne of justice, he sits as judge for every single person and gives to each what is coming to him.

3. A. "... a faithful God":

B. Just in the world to come as he pays back a completely righteous person a reward for the religious duty that he did in this world,

C. so in this world he pays the completely wicked person a reward for every minor religious duty that he did in this world.

D. And in the world to come just as he exacts punishment from a completely righteous person for the transgression that he did in this world,

E. so in this world he exacts from the completely righteous person a penalty for every minor transgression that he did in this world.

4. A. "... never false":

B. When someone dies, all the person's deeds come and are spelled out before him, saying to him, "Thus and so did you do on such and such a day, and thus and so did you do on such and such a day.

C. "Do you confess these things?"

D. And he says, "Yes."

E. They say to him, "Sign here,"

F. as it is said, "The hand of every man shall seal it, so that all men may know his deeds" (Job 37:7).

5. A. "... true and upright is he":

B. Then he justifies the decision saying, "I have been fairly judged,"

C. as Scripture says, "That you may justify the judgment when you speak" (Ps. 51:6).

CCCVII:V

1. A. Another comment concerning the verse, "The Rock—[his deeds are perfect. Yes, all his ways are just; a faithful God, never false, true and upright is he:]."

B. When Moses came down from Mount Sinai, the Israelites gathered around him and said to him, "Our lord, Moses, tell us what is the measure of justice above."

C. He said to them, "I shall not tell you [only] that he justifies the innocent and convicts the guilty, but he does not even confuse [the one with the other]:

D. "'a faithful God, never false.'"

The elements of the base verse are "the rock," "his deeds," "faithful God," "never false," "true and upright." These are joined with the following propositions or meanings: artist/creation, creation is perfect, he believed in the world and created it, people were created to be righteous, and he is righteous. I find in the first set (CCCVII:I.1–6) no opaque symbols of any kind but a sequence of well-joined propositions, all of them making the same point. The next set, CCCVII:II, introduces the same basic thesis, underlining the perfection and righteousness of God. The third sequence, CCCVII:III, sets forth the proposition that what he does is entirely perfect with all those who are in the world, and people get what is coming to them. The fourth set, CCCVII:IV.1, not given, breaks the form and introduces martyrdom. It is intruded, though for very good reason. The fifth set, CCCVII:V.1, is formally equally inappropriate. So all we have are three exercises, none of them combining the elements of the verse with another set of elements, the opaque symbols to which I have made reference.

of the pertinent form, all of them, predictably now, in the context of theological discourse.

Sifré to Deuteronomy does yield a fine example of the utilization of opaque symbols through various combinations and recombinations to set forth a theological tableaux:

Sifré to Deuteronomy CCCXIII

CCCXIII:I

1. A. ["He found him in a desert region, in an empty howling waste. He engirded him, watched over him, guarded him as the pupil of his eye. Like an eagle who rouses his nestlings, gliding down to his young, so did he spread his wings and take him, bear him along on his pinions; the Lord alone did guide him, no alien god at his side" (Deut. 32:10–12).]
 B. "He found him in a desert region":
 C. This refers to Abraham.
 D. The matter may be compared to the case of a king who went with his legions into the wilderness. His legions deserted him in a difficult situation, a place in which were marauding bands and thugs, and went their way.
 E. He appointed for himself a single hero, who said to him, "My lord, king, do not be disheartened, and do not take fright for any reason. By your life! I am not going to leave you before you walk into your own palace and sleep in your own bed."
 F. That is in line with the statement of Scripture, "He said to him, 'I am the Lord, who took you out of Ur Casdim'" (Gen. 15:7).
2. A. ". . . He engirded him":
 B. In line with this verse: "The Lord said to Abram, 'Go from your land'" (Gen. 12:1).
3. A. ". . . watched over him":
 B. Before Abraham came into the world, it was as if the Holy One, blessed be he, was king only over heaven alone, as it is said, "The Lord, God of heaven, who has taken me . . ." (Gen. 24:7).
 C. But when Abraham our father came into the world, he made him king over heaven and also over earth, as it is said, "I impose an oath upon you, by the Lord, God of heaven and God of earth" (Gen. 24:2).
4. A. ". . . guarded him as the pupil of his eye":
 B. Even if the Holy One, blessed be he, had asked from our father Abraham the pupil of his eye, he would have given it to him, and not

This case therefore does not serve, but it also is not to be dismissed, because of its repeated parsing of the base verse. Another example of the same thing is at CCCV:I–V, where I find nothing more than a patterned parsing of the same verse but no recombinancy to speak of.

only the pupil of his eye, but even his soul, which was the most precious to him of all things.

C. For it is said, "Take your son, your only son, Isaac" (Gen. 22:2).

D. Now was it not perfectly self-evident to him that it was his son, his only son.

E. But this refers to the soul, which is called "only," as it is said, "Deliver my soul from the sword, my only one from the power of the dog" (Ps. 22:21).

CCCXIII:II

1. A. Another teaching concerning, "He found him in a desert region":
 B. This refers to Israel, as it is said, "I found Israel like grapes in a desert" (Hos. 9:10).
2. A. ". . . in an empty howling waste":
 B. It was in a difficult situation, a place in which were marauding bands and thugs.
3. A. "He engirded him":
 B. Before Mount Sinai, as it is said, "And you shall set a boundary for the people round about" (Exod. 19:12).
4. A. ". . . watched over him":
 B. Through the Ten Commandments.
 C. This teaches that when the act of speech went forth from the mouth of the Holy One, blessed be he, the Israelites saw it and understood it and knew how much amplification was contained therein, how much law was contained therein, how many possibilities for lenient rules, for strict rulings, how many analogies were contained therein.
5. A. ". . . guarded him as the pupil of his eye":
 B. They would fall back twelve mils and go forward twelve mils at the sound of each and every act of speech,
 C. yet they did not take fright on account of the thunder and lightning.

CCCXIII:III

1. A. Another teaching concerning, "He found him in a desert region":
 B. Everything was available and provided for them in the wilderness.
 C. The well surged up for them, manna came down for them, quail was provided for them, clouds of glory surrounded them.
2. A. ". . . in an empty howling waste":
 B. It was in a difficult situation, a place in which were marauding bands and thugs.
3. A. "He engirded him":
 B. That was with pendants, three in the north, three in the south, three in the east, and three in the west.
4. A. ". . . watched over him":
 B. It was with reference to the two gifts [of food and drink, specifically:]

C. For when any one of the nations put a hand out to take up a handful of the manna, it would not go up in his hand at all.

D. And when any one of the nations put a hand out to take up water from the well, it would not go up in his hand at all.

5. A. ". . . guarded him as the pupil of his eye":

B. That is in line with this verse: "Rise up, O Lord, and let your enemies be scattered, and make those who hate you flee" (Num. 10:35).

CCCXIII:IV

1. A. Another teaching concerning, "He found him in a desert region":

B. This refers to the age to come.

C. So Scripture says, "Therefore behold, I will seduce her and bring her into the wilderness and speak tenderly to her" (Hos. 2:16).

2. A. ". . . in an empty howling waste":

B. This refers to the four kingdoms, as it is said, "Who led you through the great and dreadful wilderness" (Deut. 8:15).

3. A. "He engirded him":

B. With elders.

4. A. ". . . watched over him":

B. With prophets.

5. A. ". . . guarded him as the pupil of his eye":

B. He guarded them from demons, that they not injure them, in line with this verse: "Surely one who touches you touches the apple of his eye" (Zech. 2:12).

We have these readings of the base verse: Abraham; Israel; the age to come. Israel serves twice, first, in the wilderness, then at Sinai, through the Ten Commandments; then the wilderness, the well, food and drink, protection from the nations; finally, Israel in history, the four kingdoms, demons, and the like. The theological tableaux joins Abraham to Israel, Israel in the wilderness before Sinai to Israel in history among the nations, then the whole to Israel in the world to come. The opaque symbols that are utilized when set forth in the order—but, obviously, no other order—and combination we have yield the portrait of God's love and protection for Israel in the model of his love and protection for Abraham. But if we took the words Israel/Abraham/wilderness/Sinai, separating them from the parsed elements of the base verse—deconstructing the combination of words and their recombination with the clauses of the base verse—we in no way can have produced the meaning and the sense that prove so transparent in the recombinant symbolic tableaux before us. That proves we deal with symbolic discourse, as defined, and it further demonstrates that the traits I have identified as indicative in fact tell us the difference between symbolic discourse and

other kinds of discourse. A complete accounting of all such passages, in which in this chapter and the coming three we are engaged, will then demonstrate the final proposition, which is that where we find symbolic discourse, the topic is uniquely theological and, within theology, concerns only one massive subject: the relationship of God to Israel and of Israel to God.

There is one more example of the besought phenomenon, and an equally good one, in which the base verse is repeatedly parsed within a single model and combined with a fixed set of otherwise opaque symbols, the whole creating a tableaux of stunning effect:

Sifré to Deuteronomy CCCXVII

CCCXVII:I

1. A. ["He set him atop the highlands, to feast on the yield of the earth; he fed him honey from the crag, and oil from the flinty rock, curd of kine and milk of flocks; with the best of lambs and rams and he-goats, with the very finest wheat—and foaming grape-blood was your drink" (Deut. 32:13–14).]
 B. ". . . curd of kine and milk of flocks":
 C. This was in the time of Solomon:
 D. "Ten fat oxen, twenty oxen out of the pastures, and a hundred sheep" (1 Kings 5:3).
2. A. ". . . with the best of lambs and rams and he-goats":
 B. This was in the time of the Ten Tribes:
 C. "And eat the lambs out of the flock, and the calves out of the midst of the stall" (Amos 6:4).
3. A. ". . . with the very finest wheat—and foaming grape-blood was your drink":
 B. This was in the time of Solomon:
 C. "And Solomon's provision for one day was thirty measures of fine flour" (1 Kings 5:2).
4. A. ". . . and foaming grape-blood was your drink":
 B. This was in the time of the Ten Tribes:
 C. "That drink wine in bowls" (Amos 6:6).

CCCXVII:II

1. A. Another teaching concerning the verse, "He set him atop the highlands":
 B. This refers to the house of the sanctuary, which was higher than the entire world:
 C. "And you will get up and go up to the place . . ." (Deut. 17:8).
 D. "And many peoples will go and say, 'Go, let us go up to the mountain of the Lord'" (Isa. 2:3).

2. A. ". . . to feast on the yield of the earth":
 B. This refers to the baskets of firstfruits.
3. A. ". . . he fed him honey from the crag, and oil from the flinty rock":
 B. These are the libations of oil.
4. A. ". . . curd of kine and milk of flocks; with the best of lambs and rams and he-goats":
 B. This refers to the sin offering, the burnt offering, peace offerings, thank offerings, guilt offerings, and Lesser Holy Things.
5. A. ". . . with the very finest wheat":
 B. This refers to the meal offerings.
6. A. ". . . and foaming grape-blood was your drink":
 B. This refers to the libations of wine.

CCCXVII:III

1. A. Another teaching concerning the verse, "He set him atop the highlands":
 B. This refers to the Torah, as it is said, "The Lord acquired me at the beginning of his way" (Prov. 8:22).
2. A. ". . . to feast on the yield of the earth":
 B. This refers to Scripture.
3. A. ". . . he fed him honey from the crag":
 B. This refers to the Mishnah.
4. A. ". . . and oil from the flinty rock":
 B. This refers to the Talmud.
5. A. ". . . curd of kine and milk of flocks; with the best of lambs and rams and he-goats":
 B. This refers to argument a fortiori, analogies, laws, and responses to queries.
6. A. ". . . with the very finest wheat":
 B. This refers to those laws which form the essentials of the Torah.
7. A. ". . . and foaming grape-blood was your drink":
 B. This refers to lore, which entices the heart of a person as does wine.

CCCXVII:IV

1. A. Another teaching concerning the verse, "He set him atop the highlands":
 B. This refers to the age [of Rome's rule]:
 C. "The boar out of the woods ravages it" (Ps. 80:4).
2. A. ". . . to feast on the yield of the earth":
 B. This refers to the four kingdoms.
3. A. ". . . he fed him honey from the crag, and oil from the flinty rock":
 B. This refers to the oppressors, who seized the Land of Israel, and it is as hard to get a penny from them as from a rock.
 C. Tomorrow, however, Israel will inherit their property, which will be as pleasant to them as honey and oil.

CCCXVII:V

1. A. ". . . curd of kine [and milk of flocks; with the best of lambs and rams and he-goats]":
 B. This refers to their [Hammer:] consuls and their generals.
2. A. ". . . and milk of flocks":
 B. This refers to their [Hammer:] colonels.
3. A. ". . . with the best of lambs [and rams and he-goats]":
 B. This refers to their centurions.
4. A. "the very finest . . .":
 B. [Hammer:] this refers to the privileged soldiers, who extract [food] from between their teeth.
5. A. ". . . goats . . .":
 B. This refers to their senators.
6. A. ". . . with the very finest wheat":
 B. This refers to their aristocratic women.
7. A. ". . . and foaming grape-blood was your drink":
 B. Tomorrow, however, Israel will inherit their property, which will be as pleasant to them as honey and oil.[5]

The first verbal symbols are Solomon and the time of the Ten Tribes; the house of the sanctuary, the firstfruits, oil libations, meat offerings and meal offerings and wine offerings; the Torah, Scripture, the Mishnah, the Talmud, talmudic arguments; the rule of the four kingdoms, oppressors, then Israel's inheritance; the gentiles' officers, senators, women, and Israel's inheritance. So what we have is a tableaux that sets forth Israel's prosperity in the time of Solomon and the Temple, the interim in which the Torah governs, the age in which the four kingdoms rule, leading to Israel's final inheritance of the whole. I need not repeat my remarks concerning the prior example. It remains to observe, however, that, in the Tannaite Midrash compilations, the form and the discourse it conveys occur only very seldom. This same pattern of merely episodic utilization of the form and the discourse will be shown to pertain to all other Midrash compilations, except for Song of Songs Rabbah.

FORM HISTORY

The results leave no doubt that for the framers of the so-called Tannaite Midrashim, the medium of symbolic discourse served, so far as it did, only for theological topics. No composition on a normative-legal subject or discussion of a verse of Scripture deemed to yield a law utilized the form. "Another matter" by itself, to be sure, served a variety of tasks. As

5. I get nothing out of CCXVII:VI, which violates the form.

to the particular task of signaling the presence of symbolic discourse of theological topics through the representation of a tableaux of ideas to set forth an implicit proposition, it is clear, authors and authorships can have expressed their ideas in this way. But it is equally self-evident that, while available, the form scarcely served. But the powerful utilization of the form in the few cases we do have shows that it could have been used. When the mode of discourse takes a prominent role in a document, it is not because of the invention of a suitable form for the representation of that discourse or the discovery of a proper topic in which that discourse served uniquely well. It is because authors and compilers identified an available form as uniquely suitable to their purposes.

5

Rabbinic Lists of "Theological Things"

THE DOCUMENTARY EVIDENCE. [2] THE EARLIER AGGADIC MIDRASH COMPILATIONS

THE TRAITS OF THE EARLIER AGGADIC MIDRASH COMPILATIONS

A Midrash compilation that assembles comments on verses of scriptural narrative, as distinct from Scripture law, is called an aggadic Midrash compilation. For the formative age, there are seven such compilations. Three are generally assigned to the late fourth and fifth centuries: Genesis Rabbah, Leviticus Rabbah, and the closely related document Pesiqta deRab Kahana; and four are ordinarily situated in the sixth or seventh centuries: Lamentations Rabbati, Ruth Rabbah, Esther Rabbah I (covering the first two chapters of the book of Esther), and Song of Songs Rabbah. The first-named, Genesis Rabbah, follows most of the book of Genesis verse by verse, organizing its presentations in exegetical form. Over all, the others prove thematic and propositional, making little or no pretense at providing a verse-by-verse commentary to the scriptural books that form their base. Leviticus Rabbah and Pesiqta deRab Kahana provide large-scale compositions concerning successive propositions. Each large-scale composite (*pisqa* or *parashah*) makes a single point in various ways.

While the halakhic Midrash compilations, Genesis Rabbah, and Leviticus Rabbah, all organize their materials around scriptural books, Pesiqta deRab Kahana marks a turning. In other ways similar to Leviticus Rabbah in propositional character, its *pesiqtaot* focus upon liturgical occasions, for example, holy days. The later aggadic Midrash compilations,

carrying forward this same principle of cogency, address scriptural books selected for liturgical reasons, that is, works that are read in the synagogue on particular occasions, such as Purim, the Ninth of Ab, and Pentecost. The other four compilations in general work out a single theme in a variety of ways, saying the same thing over and over throughout. But these same compilations also present long stretches of discrete exegeses of verses, which yield no propositions that I can discern at all. The survey of the seven documents and The Fathers According to Rabbi Nathan, introduced below, demonstrates the three fundamental points, two concerning rhetoric and one topic,[1] that I have already stressed as probative of the proposition of this book.[2]

Briefly to review: first, the "another matter" composite rigidly follows a precise form, in which a base verse (e.g., for Genesis Rabbah a verse of the book of Genesis, and so throughout) is brought into juxtaposition with an intersecting verse, meaning a verse of Scripture from some other book. This other, intersecting verse is then repeatedly parsed, always in the same way, then joined with a set of what I have called "theological things," or symbols in verbal form. Second, the stated form joins together an indeterminate number of recurrent formulations of the same parsed verse with diverse symbols in verbal form, all such formulations making precisely the same point. Third, we can always state that point's message, showing that in most instances, "another matter" is the same

1. At this point I omit reference to the logical description of the form, that is, the logic of intelligible discourse that the form requires. It suffices for the moment to stipulate that the logic that joins the whole, in a narrowly formal sense, is dual: for the discrete compositions, fixed-associative, in that the elements of the parsed verse hold together whatever is attached to them; for the composites, fixed-associative, in that repeating the same verse imparts coherence to the entire composite. But, of course, my claim that "another matter" signals the same matter again contains within itself the further claim that propositional, not merely fixed-associative, logic renders cogent and intelligible not only the compositions but also the composites.

2. But there is no need to repeat large-scale examples of these same matters. Once I have defined where "another matter" does not signal the presence of symbolic discourse and why I maintain that that is the case, in my survey of the later compilations I do not repeatedly present long illustrations of the same negative phenomenon. The appearance of "another matter" by itself is not pertinent to our inquiry; it is the parsing of the intersecting verse, with the recurrent joining language, "another matter," that proves indicative throughout. Repeated reference to "another matter" by itself has no bearing upon our problem, since there is no appeal to the use of words in an opaque and symbolic, as distinct from determinate and denotative, sense. A good example of the use of "another matter" merely as joining language, not as part of a rhetorical form aimed at a very particular sense and meaning, is at Gen. R. XXXVIII:VI.1-3. I do not need to give the pertinent passage, since it is already clear when we do not take into account the occurrence, by itself, of the rhetorical particle, "another matter."

matter another time. And the proposition invariably bears upon theological or moral matters.[3] That the combinations of opaque symbols in verbal form do yield intelligible propositions shows that symbolic discourse does take place with demonstrable, cognitive results: messages sent and received.

To accomplish the goal of surveying the repertoire of "theological things" within the stated form (and no other form!), for each document I give a single example of the compilation's "another matter" composite, which suffices to demonstrate the rigor characterizing the formulation of thought in the "another matter" form in that Midrash compilation. Readers will simply have to stipulate that the same form that is represented characterizes all of the instances to which I make reference. I then catalogue the remaining instances of the appearance of the form utilized for symbolic discourse. For each instance of "another matter" composites beyond the first, I take up three matters. First, I state what I conceive to be the proposition that, in many ways, is presented by the compositions and composite as a whole. Second, I catalogue the symbols that bear the message, when joined together and ordered as they are. Third, it will follow—in general merely implicitly, since I need not repeat what is obvious—that the stated form serves only one kind of subject matter, namely, the theological. In the later aggadic Midrash compilations, we shall not find a single instance in which the "another matter" composition concerns itself with other than a theological topic and proposition. That catalogue will then form the basis for our inquiry into the symbolic discourse of the Judaism represented by the documents before us.

"ANOTHER MATTER" COMPOSITIONS IN GENESIS RABBAH

The compilation presents only a few suitable examples,[4] of which one is as follows:

3. But it goes without saying that a wide range of forms may serve for theological topics and propositions. My point is that this form in particular, as defined here, is utilized solely to represent theological positions or principles.

4. The first "another matter" composite, Gen. R. I:I.1–2, while somewhat brief, exhibits the traits catalogued just now. A base verse is joined together with an intersecting verse, and the intersecting verse is parsed. The parsed elements then are examined, yielding in the aggregate a single point. But the elaborate treatment of the parsed elements, repeated an indeterminate number of times, and the joining together of a list of "theological things" to those parsed elements, do not characterize that composite.

Genesis Rabbah XCVIII

XCVIII:I

1. A. "Then Jacob called his sons [and said, 'Gather yourselves together, that I may tell you what shall befall you in days to come. Assemble and hear, O sons of Jacob, and hearken to Israel, your father. Reuben, you are my first born, my might and the firstfruits of my strength, preeminent in pride and preeminent in power. Unstable as water, you shall not have preeminence, because you went up to your father's bed, then you defiled it, you went up to my couch!']" (Gen. 49:1–4):

 B. "I will cry to God Most High, [unto God who completes it for me]" (Ps. 57:3):

 C. "I will cry to God Most High": on the New Year.

 D. ". . . unto God who completes it for me": on the Day of Atonement.

 E. To find out which [goat] is for the Lord and which one is for an evil decree.

2. A. Another matter: "I will cry to God Most High, [unto God who completes it for me]" (Ps. 57:3):

 B "I will cry to God Most High": refers to our father, Jacob.

 C. ". . . unto God who completes it for me": for the Holy One, blessed be he, concurred with him to give each of the sons a blessing in accord with his character.

 D. "Then Jacob called his sons [and said, 'Gather yourselves together, that I may tell you what shall befall you in days to come']."

XCVIII:II

1. A. "The lot is cast into the lap, but the decision is wholly from the Lord" (Prov. 16:33):

 B. "The lot is cast into the lap": this refers to the Day of Atonement.

 C. ". . . but the decision is wholly from the Lord": to find out which [goat] is for the Lord and which one is for an evil decree.

2. A. Another matter: "The lot is cast into the lap": this refers to the lot of the tribal fathers.

 B. ". . .but the decision is wholly from the Lord": for the Holy One, blessed be he, concurred with him to give each of the sons a blessing in accord with his character.

 C. "Then Jacob called his sons [and said, 'Gather yourselves together, that I may tell you what shall befall you in days to come.'"

Here is a fine example of symbolic discourse through opaque verbal symbols, which, in the right order and combination, yield the proposition that the author wished to set forth. The intersecting verse invites the

comparison of the judgment of the Days of Awe to the blessing of Jacob, and that presents a dimension of meaning that the narrative would not otherwise reveal. Just as God decides which goat serves what purpose, so God concurs in Jacob's judgment of which son/tribe deserves what sort of blessing. So Jacob stands in the stead of God in this stunning comparison of Jacob's blessing to the day of judgment. The link between Jacob's biography and the holy life of Israel is fresh. The proposition is effected through these opaque symbols: New Year, Day of Atonement, Jacob, Jacob's sons (the tribal progenitors). By themselves those entries yield no proposition such as the one that, all together, in combination and in right order, they present.

Overall, our document yields very few such composites. In general, the various *parashiyyot* commence with a base verse and an intersecting verse,[5] but the latter then is not subjected to parsing and sustained, systematic interpretation, along the lines of the "another matter" compositions and composites that form the subject of this inquiry.

5. Let me give a single, brief example of the form characteristic of the document overall, in which the intersecting verse is brought to bear upon the base verse without a sustained exposition of the former:

XIX:I

1. A. "Now the serpent was more subtle [than any other wild creature that the Lord God had made]" (Gen. 3:1):
 B. "For in much wisdom is much anger, and he who increases knowledge increases sorrow" (Qoh. 1:18).
 C. If a person increases knowledge for himself, he increases anger against himself, and he adds to learning for himself, he adds to anguish for himself.
 D. Said Solomon, "Because I increased knowledge for myself, I increased anger against myself, and because I added learning for myself, I added anguish for myself.
 E. "Did you ever hear someone say, 'This ass went out and caught "the sun"' [Freedman: ague] or 'caught a fever'?
 F. "Where are sufferings located? They are located among men."

The intersecting verse, B, in no way is parsed and interpreted but merely imparts to the base verse, A, a dimension and meaning deemed otherwise to be lacking. This form has nothing in common with the one that interests us here. The reason is that no opaque verbal formulation occurs; all the words bear determinate sense, and none seems to require interpretation other than in its own limited terms. That is to say, to make sense of the components of the intersecting verse, we do not appeal to sets of symbols in verbal formulation, and the verbal components we do have in hand all bear meaning without requiring our recourse to the broader context established, e.g., through repetition.

When we survey the document overall,[6] we find only a single additional case:[7]

LX:I.1–2: Ps. 50:10 is applied to Gen. 24:12, Abraham, with the sequence: Abraham, Mesopotamia, the Holy One, blessed be he; then Eliezer, the servant of Abraham, Rebecca, and the Holy One, blessed be he, in both instances giving him light. Both compositions end with praise of "trust in the name of the Lord" (Isa. 50:10), showing that both Abraham and Eliezer did so. Here is then a fine example of the form utilized in the way we wish: parsed, combined with a set of instances or examples (here: persons and deeds), yielding, in recombinant form, the same proposition, which is that God gives light and the faithful person trusts in God. The verbal symbols that are used—Abraham/Eliezer, Mesopotamia/Rebecca—by themselves cannot yield the proposition that is represented, but the tableaux overall does just that.

The upshot is that Genesis Rabbah yields no sizable corpus of "another matter" compositions, and the ones it does present may illustrate, but scarcely justify, the claim that, through symbolic discourse, theological positions are portrayed.[8]

6. The "another matter" composites that do not conform to the formal requirements at hand, lacking a parsed intersecting verse but merely joining freestanding compositions, will not be considered. My claim is not that all uses of "another matter" signal theological discourse through symbolic recombinancy, only that all uses of "another matter" that conform to the rhetorical pattern specified at the outset do. So the other utilizations of the formula "another matter" have no bearing upon my argument.

7. It is certainly possible that others may identify further examples, which I may have missed, but overall I doubt that the document contains a sizable repertoire of instances of the besought form.

8. There are, however, three cases, which, while they do not conform to our paradigm, in some respects may appear to. The cases do involve an intersecting verse that is treated in successive instances, but the utilization of the verse does not conform to our model at all:

Genesis Rabbah XCV:I

1. A. "He sent Judah before him to Joseph, to appear before him in Goshen, and they came into the land of Goshen" (Gen. 46:28):
 B. "The wolf and the lamb shall feed together" (Isa. 65:25).
 C. Come and see how every wound that the Holy One, blessed be he, inflicts in this world he heals in the age to come. [At issue is the following intersecting verse: "Then the eyes of the blind shall be opened, then shall the lame man leap as a hart, and the tongue of the dumb shall sing" (Isa. 35:5).]
 D. The blind are healed: "Then the eyes of the blind shall be opened."
 E. The lame are healed: ". . . then shall the lame man leap as a hart."
 F. The dumb are healed: ". . . and the tongue of the dumb shall sing."

G. All are healed, but just as a person goes out, so he comes back to life.

H. If he goes out blind, he comes back blind, if he goes out deaf, he comes back deaf, if he goes out dumb, he comes back dumb, if he goes out lame, he comes back lame.

I. Just as he is garbed when he goes out, so he is garbed when he comes back: "It is changed as clay under the seal, and they stand as in a garment" (Job 38:14).

J. From whom do you learn that lesson? It is from Samuel the Ramathite. When Saul brought him up, what did he say to the woman? "'What form is he of?' And she said, 'An old man comes up, and he is covered with a robe'" (1 Sam. 28:14).

K. For that is what he had been wearing: "Moreover his mother made him a little robe" (1 Sam. 2:19).

L. And why is it the case that just as a person goes out, so he comes back to life?

M. It is so that the wicked of the world will not claim that, after they have died, the Holy One, blessed be he, will heal them and afterward bring them back to life. It then would appear that these are not the ones who died, but others.

N. Accordingly, the Holy One, blessed be he, says, "If so, let them rise up out of the dust just as they went, and afterward I shall heal them."

O. Why so? "That you may know that . . . before me there was no God formed, neither shall any be after me" (Isa. 43:10).

P. And afterward even the wild beasts are healed, as it is said, "The wolf and the lamb shall feed together." All are healed.

Q. But the one who brought [the ultimate] injury [of death] on all will not be healed: "And dust shall be the serpent's food" (Isa. 45:28).

R. Why? Because he brought all of life down to the dust.

2. A. Another interpretation of the verse: "The wolf and the lamb shall feed together, the lion like the ox shall eat straw" (Isa. 65:25):

B. "The wolf": this refers to Benjamin: "Benjamin is a wolf that tears at prey" (Gen. 49:27).

C. ". . . and the lamb": this speaks of the tribal fathers: "Israel is a scattered sheep" (Jer. 50:17).

D. ". . . shall feed together": When is this the case? When Benjamin went down with them.

What makes this construction striking is its focus on the eschatological meaning of the story at hand, which now gains yet a deeper dimension. If we start with no. 2, as the form requires us to do, we find that the intersecting verse, Isa. 65:25, is made to refer to the tribal progenitors. Then the story at hand, involving the reunion and reconciliation of the tribes, finds its reference point in the end of days. The message of no. 2 draws us back to no. 1, and here the vision of the eschatological moment comes to full expression. All will be healed—the blind, deaf, dumb—but all return as they had been. That point of emphasis in no. 1 imparts its sense on no. 2. In the coming age, Israel will be restored to life as it had been before, but then God will heal Israel. The art of the composition requires that the whole be read as a single statement, a single judgment upon Israel in the world to come: pretty much like Israel now, only to be healed. Then the theme, the reconciliation and unification of Israel, finds its moment of realization in the age to come, a rather wry comment on the present state of affairs. The opaque symbols of no. 1 are not readily identified; those of no. 2 are Benjamin (B), the tribal fathers (C). The rest of no. 2 pursues its own interests. We have therefore a composition like those involving Noah and Sarah listed below, not, strictly speaking, the type we

"ANOTHER MATTER" COMPOSITIONS IN LEVITICUS RABBAH

Leviticus Rabbah differs from Genesis Rabbah in its basic plan and program. The framers present not sustained treatments of successive verses of the book of Leviticus but, rather, thematic essays, nicely composed and then suspended from a single verse of Leviticus. So we now move from the familiar verse-by-verse mode of compiling Midrash exegeses of Scripture, such as characterized, structurally and in content, Sifra, the two Sifrés, and Genesis Rabbah, to a propositional mode of formulation and presentation of what are not, strictly speaking, exegeses at all. Each *parashah* begins with a composition in which, following the citation of a base verse, an intersecting verse is systematically expounded.

A perfect example of the form that executes the theological symbolic discourse through opaque symbols is as follows:

Leviticus Rabbah XXVIII:IV

1. A. "His harvest the hungry eat, and he takes it even without a buckler; and the thirsty pant after their wealth" (Job 5:5).
 B. "His harvest" refers to the four kingdoms (of Gen. 14:1).
 C. "The hungry eat" refers to our father, Abraham.
 D. "And he takes it even without a buckler"—without a sword, without a shield, but with prayer and supplications.
 E. This is in line with the following verse of Scripture: "He led forth his trained servants [empty-handed, understanding the Hebrew word RK as empty], those born of his house, three hundred and eighteen" (Gen. 14:14).

seek. But the passage is so suggestive and rich that it demands attention in its own terms. Others of the same sort are as follows:

XXXIV:II.1–2 "The Lord tries the righteous" means the righteous, not the wicked, and it also refers to Noah. This is part of a sequence of citations that refer to Noah, e.g., things that Noah did or was told to do. The intersecting verses, beyond the first, are not parsed; a variety of intersecting verses are invoked in sequence, with only the first of them treated as required by our form, and the passages do not conform to the required pattern.

LVIII:I.1–2 "Sarah lived a hundred and twenty-seven years" (Gen. 23:1) is interposed with Ps. 37:18: "The Lord knows the days of those who are without blemish." The point is made that "just as they are without blemish, so their years are without blemish," and then, at no. 2, that same verse, with the same meaning, is referred to Sarah. This is hardly the sort of composite that we seek.

Another instance of the same utilization of "another matter" as given here is at LXIII:II.1, 3; LXXXIX:I.1, 2; LXXXIX:II.1–2; LXXXIX:III.1, 2. These have no particular bearing upon our problem.

F. Said R. Simeon b. Laqish, "It was Eliezer alone [whom Abraham took with him]. And how do we know? [The numerical value of the letters that make up the Hebrew name] Eliezer adds up to three hundred and eighteen.]

G. "And the thirsty pant after their wealth"—who trampled on the wealth of the four kingdoms? It was Abraham and all those who were allied with him.

2. A. Another interpretation: "His harvest" refers to Pharaoh.

B. "The hungry eat" refers to Moses.

C. "And he takes it even without a buckler"—without a sword, without a shield, but with prayer and supplications.

D. "And the Lord said to Moses, 'Why do you cry out to me?'" (Exod. 14:15).

E. "And the thirsty pant after their wealth"—who trampled the wealth of Pharaoh? It was Moses and all those who were allied with him.

3. A. Another interpretation: "His harvest" refers to Sihon and Og.

B. "The hungry eat" refers to Moses.

C. "And he takes it even without a buckler"—without a sword, without a shield, but with a [mere] word.

D. "And the Lord said to Moses, 'Be not afraid of him, because I have given him into your hand'" (Num. 21:34).

E. "And the thirsty pant after their wealth"—who trampled on the wealth of Sihon and Og? It was Moses and all those who were allied with him.

4. A. Another interpretation: "His harvest" refers to the Canaanites.

B. "The hungry eat" refers to Joshua.

C. "And he takes it even without a buckler"—without a sword, without a shield, but with hailstones.

D. That is in line with the following verse of Scripture: "And as they fled before Israel, while they were going down the ascent of Beth-horon, the Lord threw down great stones from heaven upon them [as far as Azekah, and they died; there were more who died because of the hailstones than the men of Israel killed with the sword]" (Josh. 10:11).

E. "And the thirsty pant after their wealth"—who trampled upon the wealth of the Canaanites? It was Joshua and all those who were allied with him.

5. A. Another interpretation: "His harvest" refers to Sisera.

B. "The hungry eat" refers to Deborah and Barak.

C. "And he takes it even without a buckler"—without a sword, without a shield, but [solely] by means of good deeds.

D. That is in line with the following verse of Scripture: "Was shield or spear to be seen among forty thousand in Israel?" (Judg. 5:8).

E. "And the thirsty pant after their wealth"—who trampled on the wealth of Sisera? It was Deborah and Barak and all those who were allied with them.

6. A. Another interpretation: "His harvest" refers to Sennacherib.
 B. "The hungry eat" refers to Hezekiah.
 C. "And he takes it even without a buckler"—without a sword, without a shield, but [solely] through prayer.
 D. "And Hezekiah the king and Isaiah ben Amoz, the prophet, prayed concerning this matter" (2 Chron. 32:20).
 E. "And the thirsty pant after their wealth"—who trampled on the wealth of Sennacherib? It was Hezekiah and all those who were allied with him.

7. A. Another interpretation: "His harvest" refers to Haman.
 B. "The hungry eat" refers to Mordecai.
 C. "And he takes it even without a buckler"—without a sword, without a shield, but solely with sack and ashes, as it is said, "Many lay in sackcloth and ashes" (Esther 4:3).
 D. "And the thirsty pant after their wealth"—who trampled upon the wealth of Haman? It was Mordecai and Esther and all those who were allied with them.

8. A. Said the Holy One, blessed be he, to Israel, "My children, I have fed you the harvest of the kingdoms. Take care that others not come and eat your harvest."
 B. Therefore Moses admonished the Israelites, saying to them, "When you come into the land which I give you and reap its harvest, you shall bring the sheaf of the firstfruits of your harvest to the priest" (Lev. 23:10).

There can be no finer example of the form and its utilization. The proposition is that Israel triumphs through faith and good works. It is worked out not through syllogistic discourse but through the composition of a list of names and cases; the right names, in the right order, yield that point and no other: symbolic discourse at its most compelling, because not only does the proposition emerge with great clarity, it also is demonstrated with great power—all through the opaque symbols, the (mere) names, properly selected and arranged.

Some *parashiyyot* of our document commence with a clearly articulated statement, through recombinancy, of a theological proposition; the statement is worked out through hanging onto the parsed elements of an intersecting verse a variety of opaque symbols, sometimes spelled out and fully articulated as in the case before us, sometimes left in narrowly symbolic form as simple allusions to persons, events, actions, or right attitudes.[9] Others utilize the base-verse/intersecting-verse construction

9. But note XIX:IV.1–4: Qoh. 10:10 speaks of the Israelites before Sinai; the Israelites in the time of Jeremiah; sloth in covering one's head; a woman who does not cover herself in a modest way. The verse stresses that sloth leads to penalties, and the cases make the same point. I do not see how we have a set of opaque symbols arranged

for different purposes from the one that concerns us here.[10] But every *parashah* at that point turns to a variety of other formal patterns to conduct quite different discourse from the symbolic kind.[11] A survey of the thirty-seven *parashiyyot* of Leviticus Rabbah yields the following combinations of intersecting verses with base verses, and of "theological things," to yield the stated propositions:[12]

I:IV.1, 4, 5 Abraham, David, Moses. These are faithful leaders, whom God chose to save Israel. God communicates in two media to the three great heroes.

III:I.1–6 The theological things include these: the Sabbath day vs. six days of work; the world to come and this world, bad people punished then for what they do now; the tribes of Reuben and Gad wanted the Holy Land than Transjordan. A second glance permits us to compose the following list: (1) Torah study; (2) redemption in Egypt; (3) Sabbath day/six days of labor; (4) this world/world to come; (5) Holy Land/other lands; and (6) cereal offering/incense. These indeed are "theological things," or symbols in verbal form; they are opaque, in that the combinations (3, 4, 5, 6) do not permit us to predict the proposition we are to establish.

IV:I.1–4 Qoh. 3:16 pertains to the Sanhedrin and the murder of Zechariah and Uriah in the Temple; the golden calf and the wickedness of Israel in making it; the generation of the flood; Sodomites; the

in a way to make a point, such as in the other cases. The form is utilized in the desired manner but without the desired result.

10. A good instance is at Parashah XVII, which systematically provides an exegesis for the clauses of Ps. 73:1–3. Another is at Parashah XVIII, which systematically spells out the sense of Qoh. 12:1–7. So our utilization of the form is not the only or even the most important one.

11. I have explained how the document moves from one form to another to conduct a variety of types of discourse—symbolic, in the form before us; exegetical, in the form involving citations and gloss; and also propositional in discursive form—in J. Neusner, *Judaism and Scripture: The Evidence of Leviticus Rabbah* (Chicago: University of Chicago Press, 1986) 20–58. The phenomenology of discourse, taken for granted here, is explained in the work by J. Neusner and William Scott Green, *Writing with Scripture* (Minneapolis: Fortress Press, 1989). The results presented there are not repeated here; it suffices merely to allude to them, as I move forward along the lines suggested in prior work.

12. As a matter of fact, every *parashah* in Leviticus Rabbah begins with an intersecting-verse/base-verse construction. The first two or three or even four major units of discourse will commonly appeal to a variety of intersecting verses, each of them parsed and repeatedly joined with opaque verbal symbols to make an important point. But not all the opening units of the *parashiyyot* address theological matters or utilize opaque verbal symbols or present instances of recombinancy and so conform to the besought pattern. Hence I catalogue only the pertinent items. My interest is in compiling a list of all of the "theological things" that serve to establish intelligible propositions other than through propositional-syllogistic media, that is, in the recombinant symbolic discourse that I maintain serves for presenting theological principles and attitudes in some of the canonical documents.

incident at Shittim. These are the opaque symbols. In all instances, then, "in the place of justice, wickedness was there" serves to show that the attribute of justice was carried out against all those who received supernatural punishment. The basic intent throughout nos. 1–4 is to read Qoh. 3:16 as a colloquy between the complainant, Israel, and the Holy Spirit. The former then asks why the paradox of "wickedness in the place of justice," meaning, then, either bad things happening in the holy place or, mostly, justice overdone, that is, excessive punishment. The latter explains that it is right that there should be wickedness where there is righteousness. Accordingly, at each point the opening element of the intersecting verse speaks for itself, while the second element is assigned to the Holy Spirit. At no. 2 the complaint is that the Sodomites suffered punishment in this world and in the next, and the Holy Spirit justifies the double jeopardy once again. No. 3 goes over exactly the same ground. The point of no. 4 is that the leaders died, so why did 24,000 Israelites have to perish also? The Holy Spirit then answers. God had turned a curse into a blessing, and yet all the people had gone and sinned just afterward.

V:I.1–7; V:II.1–3; V:III.1–13 Job 34:29–30 speaks to the generation of the flood; the Sodomites; the Ten Tribes. All three cases show that God first gives tranquillity but then punishes those who interpret their prosperity in an arrogant way and so rebel and sin. When God hides his face in consequence of which people suffer, it is for just cause. No one can complain. God is long-suffering but in the end exacts penalties. These cover deliberate sin, and that is the point of the generation of the flood, Sodom, and the Ten Tribes.

VII:I.1–2 Prov. 10:12 speaks of the hatred pent up between Israel and their father in heaven because of their idolatry in Egypt; the hatred that Aaron brought between Israel and their father in heaven by making the golden calf. The proposition is that love can overcome even a long-term grudge, God's grudge against Israel for idolatry, God's grudge against Aaron.

IX:I.1–3; IX:II, III Ps. 50:23 refers to one who brings a sin offering as a sacrifice; also to Achan, who sacrifices his impulse to do evil as a thanksgiving offering; to scribes, Mishnah teachers, those who teach children in true faith; to shopkeepers who sell only fully tithed produce; those who kindle light for the public. This does not seem to me to be a well-executed example of the form.

X:I, II, III Ps. 45:7 refers to Abraham, who pleaded for mercy for the people; Isaiah, who did the same; and Aaron, who did the same. The devotion to the people vindicates the priest and gains forgiveness for the priest's sins.

XI:I–IV Prov. 9:1ff. speaks of the creation of the world; the eschatological rebuilding of the Temple, the Torah, and the tent of meeting.

There is no explicit proposition, but the theme is Israel's salvation through the cult and the Torah.

XVI:V.1–6: Qoh. 5:5 refers to those who renege on their charity pledge; those who misinterpret the Torah; those who gossip; those who vow; Miriam. These various actions show how one sins through speech.

XVIII:II.1–6 Hab. 1:7 speaks of the first man; Esau; Sennacherib; Hiram, king of Tyre; Nebuchadnezzar; Israel. Great men, and the nation, are punished for their sins in such a way that the punishment derives from them themselves. Eve, who emerged from Adam, caused his punishment. In the case of Esau, Obadiah as the source of the punishment is spelled out, 2.E, a valuable gloss. So we move along a rather strange line of people who sinned through their arrogance: Adam, Esau, Sennacherib, Hiram, Nebuchadnezzar, then: Israel! But the part of Israel under discussion is the part punished through the affliction, through natural, internal causes, of leprosy or flux. Merely listing the items at hand would not have yielded that point.

XX:II.1–6 Ps. 75:4 yields the point that one should not make merry in my world. The righteous do not do so, but the wicked do: the first man did not; Abraham did not; the Israelites did not; Elisheba daughter of Amminadab did not. What strikes the exegete is the contrast between the rejoicing of Aaron and his family at their consecration to the priesthood and the mourning that overtakes them on the day of their celebration. This then leads to the observation that the boastful or the ones who rejoice soon come to mourning. This point is made concerning Adam, no. 2, a section bearing heavy interpolations. I assume the reference is to the marriage canopy. Then we have the case of Abraham, whose rejoicing was turned to mourning at Sarah's death, and, finally, the wife of Aaron and mother of Nadab and Abihu.

XXI:I–IV Ps. 27:1 speaks of Israel at the Red Sea; the Philistines with Goliath; the Amalekites; the New Year and Day of Atonement. The crises in Israel's life, at the Red Sea, with Pharaoh, with the Philistines, with the Amalekites, and then, in a stunning shift, with Satan are invoked. So the past history of Israel is reappropriated as a metaphor for the human condition of the Israelite, facing a supernatural enemy but saved by God's favor. The Day of Atonement then is not merely the event of the cult described in Leviticus 16 but a day of national salvation from enemies in this world and above. Psalm 27 is read during the entire month of Elul, leading up to the Days of Awe.

XXII:I–IV Qoh. 5:8, referring to the superfluities of the land, and a king makes himself servant to the field, pertains to material possessions, then the Torah; the rabbis; creation, Zion, religious duties; the

prophets; other divine messengers. The proposition is that nothing is superfluous and everything has its mission.

XXIII:I–V Song 2:2 speaks of Rebecca, who did not follow the pattern of her surroundings, so too Israel in Egypt, Israel before Sinai, Israel carrying out acts of loving-kindness; current generations. Though surrounded by thorns, the rose, Israel, remains loyal to God and will be saved as a rose is plucked, by fire. XXIII:VI compares Israel to occasions for rejoicing; the righteous; this world and the world to come, Sabbath and festivals, and so on and so forth. It is a vast set of metaphors, all of them making the same point. Israel is superior to the gentiles and will be saved. XXIII:VII proceeds to deal with Israel in Canaan, compared to Israel in Egypt. This composition does not adhere to the desired form quite so neatly as the others do. It is more elaborate and makes its simple point in more diverse ways.

XXVII:V.1–2 Qoh. 3:15, God seeks what has been driven away, proves that God favors the victim: the righteous man pursued by a wicked man; Abel by Cain; Noah by his generation; Abraham by Nimrod; Isaac by Ishmael; Jacob by Esau; Moses by Pharaoh; David by Saul; Israel by the nations; and the offerings. This is a classic instance of how a sequence of verbal symbols can be arranged to make a single point, as given earlier, in chapter 2.

XXVIII:IV.1–8 Job 5:5, "His harvest the hungry eat . . . ," refers to the four kingdoms with Abraham, who triumphed without a sword or a shield but with prayer and supplication; Pharaoh and Moses; Sihon and Og and Moses; Canaanites and Joshua; Sisera and Deborah and Barak; Sennacherib and Hezekiah; Haman and Mordecai. Seven instances serve to make the point that Israel overcomes its enemies through faith and good deeds. As I said at the beginning of this chapter, I could not give a more perfect example of the execution of the desired form than this one.

[XXXII:II.1–5 This composition, concerning Qoh. 10:20, conforms to the desired form but does not spell out sequences of opaque symbols to make a point. It does not typify the kind of discourse analyzed here, but it should be noted.]

XXXII:V.1–3 Song 4:12 refers to virgins, Israelites in Egypt, Sarah in Egypt, Joseph in Egypt, all of whom avoided sexual licentiousness and were therefore saved. Listing the second through fourth as a single composite would have made the point without any articulated proposition.

The document presents a striking contrast to all that have come before, since it presents a significant selection of examples. But, in the context of the whole, we cannot maintain that symbolic discourse constitutes a principal or even a paramount medium of expression in Leviticus Rab-

bah. It does, however, take a sufficiently large part to prove (1) that the form and mode of discourse utilizing that form were entirely available to authors and compositors prior to the formation of Song of Songs Rabbah and (2) that the form and mode of discourse served theological and moral, but no other, topics.[13]

"ANOTHER MATTER" COMPOSITIONS IN PESIQTA DERAB KAHANA

In Pesiqta deRab Kahana a syllogism is generated through the impact of an intersecting, or contrastive verse, upon the reading of the base verse and its theme, and that is the consistent pattern through all twenty-three *pisqaot* that are unique to Pesiqta deRab Kahana.[14] We shall now see that, when that form occurs, it conveys precisely the symbolic discourse concerning theological subjects that, I maintain, constitutes a principal Judaic medium for theological thought and expression.[15] But the same form—systematic exposition of an intersecting verse—is used for other than symbolic discourse, rather, as a medium for entirely propositional representation of ideas. The matching of parsed elements of an intersecting verse with lists of words—persons, events, actions—that, in context and in sequence, convey thought is uncommon, and the use of the same form—the parsed intersecting verse—joins a variety of articulated propositions. So with reference to the "another matter" composition, symbolic discourse is not primary in the document at hand.

As before, I present one example and then a catalogue of the other instances, with stress on, first, the implicit proposition that is conveyed and, second, on the opaque symbols in verbal form that express that proposition.

13. Once more I underline that of the three elements of classical literary analysis—rhetoric, logic, and topic—I treat only rhetoric and topic. I really do not understand the logic of symbolic discourse as carried on in these documents.

14. Pesiqta deRab Kahana shares with Leviticus Rabbah five of its twenty-eight *pisqaot*, nos. 8, 9, 23, 26, and 27. In my *Pesiqta deRab Kahana: An Analytical Translation* (Brown Judaic Studies; Atlanta: Scholars Press, 1987), pt. 1, 169ff., I have shown that *parashiyyot* shared by both Leviticus Rabbah and Pesiqta deRab Kahana are original to the former and borrowed by the latter, since the *parashiyyot* distinctive to the latter follow demonstrably different forms.

15. The other two forms of the document are exegetical, in which we find exegesis of the elements of the base verse in line with the implicit syllogism announced at the outset in the intersecting-verse/base-verse composition, and then a syllogistic list, in which the base verse contributes a fact to prove a proposition independent of all verses on the list. But the main repertoire comprises the propositional form worked out through intersecting-verse/base-verse and the exegetical form.

Pesiqta deRab Kahana VI:II

1. A. *A righteous man eats his fill, [but the wicked go hungry]* (Prov. 13:25):
 B. This refers to Eliezer, our father Abraham's servant, as it is said, *Please let me have a little water to drink from your pitcher* (Gen. 24:17)—one sip.
 C. . . . *but the wicked go hungry:*
 D. This refers to the wicked Esau, who said to our father, Jacob, *Let me swallow some of that red pottage, for I am famished* (Gen. 28:30).
3. A. Another interpretation of the verse, *A righteous man eats his fill:*
 B. This refers to Ruth the Moabite, in regard to whom it is written, *She ate, was satisfied, and left food over* (Ruth 2:14).
 C. Said R. Isaac, "You have two possibilities: either a blessing comes to rest through a righteous man, or a blessing comes to rest through the womb of a righteous woman.
 D. "On the basis of the verse of Scripture, *She ate, was satisfied, and left food over,* one must conclude that a blessing comes to rest through the womb of a righteous woman."
 E. . . . *but the wicked go hungry:*
 F. This refers to the nations of the world.
5. A. Another interpretation of the verse, *A righteous man eats his fill, [but the wicked go hungry]* (Prov. 13:25):
 B. This refers to Hezekiah, king of Judah.
 C. They say concerning Hezekiah, king of Judah, that [a mere] two bunches of vegetables and a *litra* of meat did they set before him every day.
 D. And the Israelites ridiculed him, saying, "Is this a king? *And they rejoiced over Rezin and Remaliah's son* (Isa. 8:6). But Rezin, son of Remaliah, is really worthy of dominion."
 E. That is in line with this verse of Scripture: *Because this people has refused the waters of Shiloah that run slowly and rejoice with Rezin and Remaliah's son* (Isa. 8:6).
 F. What is the sense of *slowly?*
 G. Bar Qappara said, "We have made the circuit of the whole of Scripture and have not found a place that bears the name spelled by the letters translated *slowly.*
 H. "But this refers to Hezekiah, king of Judah, who would purify the Israelites through a purification bath containing the correct volume of water, forty *seahs,* the number signified by the letters that spell the word for slowly."
 I. Said the Holy One, blessed be he, "You praise eating? *Behold the Lord brings up the waters of the River, mighty and many, even the king of Assyria and all his glory, and he shall come up over all his channels and go over all his bands and devour you as would a glutton* (Isa. 8:7)."
6. A. . . . *but the wicked go hungry:* this refers to Mesha.

B. *Mesha, king of Moab, was* a noked (2 Kings 3:4). What is the sense of *noked?* It is a shepherd.

C. *"He handed over to the king of Israel a hundred thousand fatted lambs and a hundred thousand wool-bearing rams* (2 Kings 3:4)."

D. What is the meaning of wool-bearing rams?

E. R. Abba bar Kahana said, "Unshorn."

7. A. Another interpretation of the verse, *A righteous man eats his fill, [but the wicked go hungry]* (Prov. 13:25):

B. This refers to the kings of Israel and the kings of the House of David.

C. *... but the wicked go hungry* are the kings of the East:

D. R. Yudan and R. Hunah:

E. R. Yudan said, "A hundred sheep would be served to each one every day."

F. R. Hunah said, "A thousand sheep were served to each one every day."

8. A. Another interpretation of the verse, *A righteous man eats his fill* (Prov. 13:25):

B. this refers to the Holy One, blessed be he.

C. Thus said the Holy One, blessed be he, "My children, among all the offerings that you offer before me, I derive pleasure from you only because of the scent: *the food for the food offering of soothing odor, to me at the appointed time."*

God does not need the food of the offerings; at most he enjoys the scent. The same point is made as before at Pesiqta deRab Kahana VI:I.11: what God gets out of the offering is not nourishment but merely the pleasure of the scent of the offerings. God does not eat; but he does smell. The exegesis of Prov. 13:25, however, proceeds along its own line, contrasting Eliezer and Esau, Ruth and the nations of the world, Hezekiah and Mesha, Israel's kings and the kings of the East, and then God—with no contrast at all. I cannot claim that, given the list without the proposition, I could have identified the proposition that the opaque symbols, set forth in the order and contrasts before us, were meant to convey. We now survey the relevant compositions in our document, placing in square brackets candidates that for given reasons I reject as inappropriate:

I:IV.1–4 "Whoever has gone up to heaven" refers to God, prayer, Elijah, Moses. The climax comes with Moses' setting up the tabernacle, for the entire world was set up with it. I do not think that the list of names by itself can have yielded that proposition. But joining together the base verse, Num. 7:1, the intersecting verse, Prov. 30:4, and the list of names at least suggests the theme, if not the proposition, that the symbolic discourse is meant to treat.

IV:IV.1–11 "Who is wise enough" (Qoh 8:1) pertains to the Holy One, blessed be he, who explained the meaning of the Torah to Israel; the prophets; the first man; Israel; a disciple of sages, and Moses. The wisdom in all cases is shown by the power to explain a difficult matter. But the one who was wise also sinned, his face changed, and God changed his plans for that person. Sin causes "the strength of his face to be changed." The base verse is not cited; it concerns the red heifer and burning it up to make ashes for purification water. My guess is that the water, called "water of the sin offering," brings to mind sin, and the rest follows. But this is another case in which, by itself, the list of opaque word symbols generates no proposition that I can discern; knowing both the base verse and the intersecting verse, along with the parsing and the opaque symbols, by contrast, yields the possibility of guessing at the desired proposition.

V:III.1–8 "Hope deferred makes the heart sick" (Prov. 13:12) refers to one who betrothes a woman but marries her only after a delay; David, who was anointed but had to wait two years before he could rule; the Israelites before they were redeemed. The base verse yields the fact that when Moses made his announcement that in Nisan Israel would be redeemed, that marked the end of hope deferred and desire fulfilled.

VI:II is given above.

[X:I.1–4 In the context of tithing, "The miser is in a hurry to grow rich" (Prov. 28:22) refers to Ephron, a borrower who was too much of a miser to rent two oxen at the same time but would borrow one and rent one; one who lent money to Israelites at usurious terms; those who do not tithe properly. The proposition is that the miserly person pays a penalty. Though the form is unflawed, it is difficult to claim that we deal here with symbolic discourse. I give the case only for the sake of completeness. Other instances of the same kind of presentation are at X:III; XI:I; XI:VI; XII:III; XVI:III, V; etc. This shows that we may have a fine execution of the form—the intersecting verse, repeatedly parsed in the same way—without resort to symbolic discourse through recombinant "theological things."]

XVIII:I.1–10 "O sons of a man, how long shall my honor suffer shame" (Ps. 4:2–3), in the context of Isa. 54:11–14, "O afflicted one, storm-tossed, and not comforted . . . ," refers to Doeg and Ahitophel, who are sons of Abraham, Isaac, and Jacob, to whom David speaks in 1 Sam. 20:27; 22:7, so the first case is Doeg, Ahitophel, vs. David; the second is the nations of the world, the house of the sanctuary. The message is that just as David answered Doeg and Ahitophel, so the sanctuary will answer the nations of the world. David is set against

his detractors, then the Temple and Jerusalem against theirs. The messiah theme is linked to the message at hand, with David's temporary removal from the throne compared to the temporary defeat of Jerusalem and temporary destruction of the Temple. Here is a case in which symbolic discourse makes its point with extraordinary economy and therefore great power. Listing Ahitophel and Doeg/David, nations of the world/Jerusalem-Temple alongside Ps. 4:2 and Isa. 54:11 accomplishes the task of communicating the message at hand—perfect symbolic discourse, yielding a proposition that is not articulated because it does not have to be.

XX:I.1–8 Ps. 113:9 refers to Sarah, Rebecca, Rachel, Leah, the wife of Manoah, Hannah, and Zion, in context of Isa. 54:1–8.[16]

XXIV:XI.1–8 Here we do not have our required form, but it may be readily supplied, since we are given a list of cases that sustain the point, "I accepted the repentance of worse than you, so should I not accept your repentance?" The cases involve Cain, Ahab, the men of Anathoth, the men of Nineveh, Manasseh, and Jeonaiah. The base verse is Isa. 55:8–9 and the intersecting verse is Hos. 14:1–3. On the basis of the list and those verses, a well-composed structure, conveying its message through the list of those named, is easily reconstructed. But in our document, that is not how the message is conveyed, the symbolic medium being set aside in favor of fully articulated and somewhat prolix propositional discourse.

16. The execution is so perfect that an abstract of the whole is worth examining:

XX:I

1. A. . . . *who makes the woman in a childless house a happy mother of children* (Ps. 113:9):
 B. There are seven childless women [in Scripture]: Sarah, Rebecca, Rachel, Leah, the wife of Manoah, Hannah, and Zion.
2. A. Another interpretation of the verse . . . *who makes the woman in a childless house a happy mother of children* (Ps. 113:9):
 B. This refers to our mother, Sarah: *And Sarah was barren* (Gen. 11:30).
 C. *As a joyful mother of children* (Ps. 113:9): *Sarah has given children suck* (Gen. 21:7).
3. A. Another interpretation of the verse . . . *who makes the woman in a childless house a happy mother of children* (Ps. 113:9):
 B. This refers to our Rebecca: *And Isaac entreated to the Lord on account of his wife, because she was barren* (Gen. 25:21).
 C. *As a joyful mother of children* (Ps. 113:9): *And the Lord was entreated by him and his wife Rebecca conceived* (Gen. 25:21).

The catalogue generated by the base verse accomplishes the goal of comparing Zion to the barren women who ultimately bore important children. The pertinence of the intersecting verse to the base verse cannot be called into question, and the result is a powerful statement of the context of the base verse and therefore of its meaning.

FORM HISTORY

Our results for these three documents considerably outweigh those produced by the so-called Tannaite Midrash compilations but in the aggregate prove paltry. Genesis Rabbah does not present a substantial corpus of "another matter" compositions or composites. When it begins with an intersecting verse, its exposition of that verse does not require the systematic reading of the intersecting verse in the light of a list of "theological things," opaque symbols that bear meaning as they combine and recombine with the parsed elements of the intersecting verse. Rather, the intersecting verse is expounded on its own, element by element. What we find, therefore, is a persistent interest in reading the base verse in the light of the intersecting verse, but not in the exposition of the latter. The definitive trait of the base-verse/intersecting-verse form when used in Genesis Rabbah is the interest in a sequence of intersecting verses, not in the sustained exposition of a single intersecting verse.

When we come to Leviticus Rabbah and Pesiqta deRab Kahana, by contrast, we find a fair representation of the form that effects symbolic discourse of theological matters. But our survey yields only a modest number of cases. Not only so, but the "another matter" composition serves a broad variety of purposes, only one of them pertinent to our inquiry. It is the simple fact that instances of the use of the form under study for theological discourse in a symbolic medium are few and proportionately unimportant in the documents at hand. In general, the intersecting verse is treated only once; where, moreover, we find "another matter," it is not to link matched compositions of the same parsed verb, joined with diverse symbols in verbal form, whether names of persons, references to events, or allusions to actions. So at neither point—the treatment of the intersecting verse, the utilization of "another matter"—do we find that symbolic discourse which I claim to be an important medium for thought and expression on theological matters.

That means that by the end of the fifth century, at which point the three documents considered in this chapter had reached closure, while the form under study had been assigned its distinctive and specific purpose, the mode of discourse hardly proved a principal one for any circle of authors or compositors in the extant documents. For the purposes of the present inquiry we must regard the earlier aggadic Midrash compilations as transitional. That is to say, while the form under discussion served the purpose that I have identified, that was only one, and not

the most important, way in which the specified form was used. Symbolic discourse on theological subjects indeed is represented in the documents surveyed here, but it was not a principal medium of discourse at all, and so far as theological subjects are raised and pursued, it is not through symbolic discourse at all.[17]

17. For the purposes of this book it is not necessary to set forth what I consider to be the principal media for theological discourse in the earlier aggadic Midrash compilations. That is a problem to be worked out in its own terms. It suffices to say that form analysis of theological discourse is entirely feasible and will yield very interesting results. But my concern here is only to show how discourse carried on through symbols rather than through propositions is carried on in the literary medium, then to compare that symbolic discourse with its counterpart in the iconic medium. Other studies will produce results that, in due course, will have to be brought into relationship with the results of this one.

6

Rabbinic Lists of "Theological Things"

THE DOCUMENTARY EVIDENCE. [3] THE LATER AGGADIC MIDRASH COMPILATIONS

THE LATER AGGADIC MIDRASH COMPILATIONS

The later aggadic Midrash compilations combine two quite distinct programs. First, they work out a variety of ways of expressing a single proposition. In presenting each document, I shall state what I believe that proposition to be. It is repeated over and over again but never changes. Second, they present brief expositions of the sense of discrete phrases or verses; these exegeses rarely cohere with others, fore and aft, and very commonly play no role in advancing the overall thesis of the compilation. So we deal with two quite distinct types of material. In the aggregate, as a guess, approximately half of a given compilation proves propositional and the other half exegetical. We find no substantial representation of symbolic discourse in three of the four compilations of the sixth and seventh centuries.

"ANOTHER MATTER" COMPOSITIONS IN RUTH RABBAH

Ruth Rabbah is made up of four *petihtaot*, or proems, and eighty-five *parashiyyot*. The latter sequentially address nearly all of the verses of the book of Ruth. Ruth Rabbah has only one message, which concerns the outsider who becomes the principal, the Messiah out of Moab, and the document registers that this miracle is accomplished through mastery of the Torah. I find these points: (1) Israel's fate depends upon its proper conduct toward its leaders. (2) The leaders must not be arrogant. (3) The

admission of the outsider depends upon the rules of the Torah. These differentiate among outsiders. Those who know the rules are able to apply them accurately and mercifully. (4) The proselyte is accepted because the Torah makes it possible to do so, and the condition of acceptance is complete and total submission to the Torah. Boaz taught Ruth the rules of the Torah, and she obeyed them carefully. (5) Those proselytes who are accepted are respected by God and are completely equal to all other Israelites. Those who marry them are masters of the Torah, and their descendants are masters of the Torah, typified by David. Boaz in his day and David in his day were the same in this regard. (6) What the proselyte therefore accomplishes is to take shelter under the wings of God's presence, and the proselyte who does so stands in the royal line of David, Solomon, and the Messiah. Over and over again, the point is made that Ruth the Moabitess, perceived by the ignorant as an outsider, enjoyed complete equality with all other Israelites, because she had accepted the yoke of the Torah, married a great sage, and produced the Messiah-sage, David.

The first example of the "another matter" composition that undertakes theological discourse through utilization of opaque symbols in verbal form is somewhat imperfect but serves. I eliminate parts that obscure the form.

Ruth Rabbah Petihta Two

II:I

1. A. "And it came to pass in the days when the judges ruled":
 B. "Slothfulness casts into a deep sleep, and an idle person will suffer hunger. [He who keeps the commandment keeps his life; he who despises the word will die]" (Prov. 19:15–16):
 C. ["Slothfulness casts into a deep sleep"] because the Israelites were slothful about burying Joshua:
 D. "And they buried him in the border of his inheritance . . . on the north of the mountain of Gaash" (Josh. 24:30)
 K. "The Holy One, blessed be he, wanted to cause an earthquake to come upon the inhabitants of the world: 'Then the earth did shake [a word that uses the same consonants as the word for Mount Gaash] and quake'" (Ps. 18:8).
2. A. "and an idle person will suffer hunger":
 B. It is because they were deceiving the Holy One, blessed be he.
 C. Some of them were worshiping idols.
 D. Therefore he starved them of the Holy Spirit [as in the continuation of the intersecting verse, "He who keeps the commandment keeps his life; he who despises the word will die"]:

E. "And the word of the Lord was precious in those days."

3. A. Another interpretation of the verse, "Slothfulness casts into a deep sleep, and an idle person will suffer hunger. [He who keeps the commandment keeps his life; he who despises the word will die]" (Prov. 19:15-16):

B. ["Slothfulness casts into a deep sleep"] because the Israelites were slothful about repenting in the time of Elijah.

C. "casts into a deep sleep":—prophecy increased.

D. But the verse says, "causes to fall" [meaning, prophecy decreased], and you say that it increased?

E. It is in line with the saying, "the market for fruit has fallen" [because a lot of fruit has come to the market for sale, the price of fruit has gone down].

6. A. "and an idle person will suffer hunger":

B. It is because they were deceiving the Holy One, blessed be he.

C. Some of them were worshiping idols, and some of them were worshiping the Holy One, blessed be he.

D. That is in line with what Elijah said to them, "How long will you halt between two opinions?" (1 Kings 18:21).

7. A. ". . . will suffer hunger":

B. a famine in the days of Elijah: "As the Lord of hosts lives, before whom I stand" (1 Kings 18:15).

8. A. Another interpretation of the verse, "Slothfulness casts into a deep sleep, [and an idle person will suffer hunger]":

B. ["Slothfulness casts into a deep sleep"] because the Israelites were slothful about repentance in the time of the Judges,

C. they were "cast into a deep sleep."

9. A. "and an idle person will suffer hunger":

B. Because they were deceiving the Holy One, blessed be he: some of them were worshiping idols, and some of them were worshiping the Holy One, blessed be he,

C. the Holy One, blessed be he, brought a famine in the days of their judges:

D. [Supply: "And it came to pass in the days when the judges ruled, there was a famine in the land."]

The intersecting verse bears three interpretations: slothfulness in the time of Joshua, because of excess commitment to one's own affairs (no. 1+2), slothfulness in the time of Elijah, now about repentance (no. 3+6-7, with interpolated materials of nos. 4, 5), and, finally, slothfulness about repentance in the time of the Judges, nos. 8-9. Not in combination with the clauses of the parsed verse, the names Joshua, Elijah, and Judges, in that or any other order, in no way will have permitted us to

predict the message that is delivered, which is that Israel's sloth and slumber causes a famine of God's word: "he starved them of the Holy Spirit," "there was a famine in the days of Elijah," "there was a famine in the days of the Judges." But the combination of the names, then recombined with the elements of the parsed verse, accomplishes the signification of the message. Further examples of the desired form and its utilization are as follows:

> III:I.1–4 Prov. 21:8 speaks of Esau/Israel and the Holy One, blessed be he, the nations of the world/Israel and the Holy One, blessed be he, Israel/the Holy One. In all three cases there are rebellion and estrangement from God. Israel gets its reward in the world to come because, through suffering in this world, Israel repents; famine is part of God's larger program for Israel.
>
> [XL:I.1–6 We have six interpretations of the base verse, "And at mealtime Boaz said to her, 'Come here and eat some bread, and dip your morsel in the wine.' So she sat beside the reapers, and he passed to her parched grain; and she ate until she was satisfied, and she had some left over." The verse is systematically referred to the throne via David, Solomon, Hezekiah, Manasseh, the Messiah, and Boaz. A list of these six names would, of course, produce a proposition pertinent to the throne and the Messiah, but the substance of the proposition would not be self-evident. I furthermore find no key via an intersecting verse to the symbolic discourse that is undertaken. The whole therefore is merely another propositional exegesis of a cited verse of Scripture.]
>
> XIX:I.2–5 Ps. 119:62 refers to Pharaoh/Abraham and Sarah; the Egyptians/the Israelites; the Ammonites and the Moabites/Boaz and Ruth. These combinations yield the point that, in line with the intersecting verse, God brings harsh judgments upon the wicked and righteous judgments upon the righteous.

"ANOTHER MATTER" COMPOSITIONS IN ESTHER RABBAH I

The message of Esther Rabbah I is that the nations are swine, their rulers fools, and Israel is subjugated to them, though it should not be, only because of its own sins. But just as God saved Israel in the past, so the salvation that Israel can attain will recapitulate the former ones. But the message is somewhat more complicated than merely a negative judgment against the nations. If I have to identify one recurrent motif that captures that theology, it is the critical role of Esther and Mordecai, particularly Mordecai, who, as sage, emerges in the position of messiah.

For Esther and Mordecai, woman and the sage-Messiah, function in this document in much the same way that Ruth and David, woman and sage-Messiah, work in Ruth Rabbah. The first utilization of the besought form for the defined purpose is as follows:

Esther Rabbah I. Petihta 2

II:i

1. A. Samuel commenced by citing the following verse of Scripture: "'Yet for all that, when they are in the land of their enemies, I will not spurn them, neither will I abhor them so as to destroy them utterly and break my covenant with them, for I am the Lord their God; but I will for their sake remember the covenant with their forefathers, whom I brought forth out of the land of Egypt in the sight of the nations, that I might be their God: I am the Lord'" (Lev. 26:44–45):
 B. "'I will not spurn them': in Babylonia.
 C. "'neither will I abhor them': in Media.
 D. "'so as to destroy them utterly': under Greek rule.
 E. "'and break my covenant with them': under the wicked kingdom.
 F. "'for I am the Lord their God': in the age to come.
 G. Taught R. Hiyya, "'I will not spurn them': in the time of Vespasian.
 H. "'neither will I abhor them': in the time of Trajan.
 I. "'so as to destroy them utterly': in the time of Haman.
 J. "'and break my covenant with them': in the time of the Romans.
 K. "'for I am the Lord their God': in the time of Gog and Magog."

This is not an ideal example, but it does mean to communicate through a list of otherwise inchoate names of kingdoms, then persons, when joined with the elements of the verse of Scripture. The list consists of Babylonia, Media, Greek rule, the wicked kingdom; then Vespasian, Trajan, Haman, the Romans, Gog and Magog. The point that emerges from the sequences of names is an obvious one: in the end God will rule through the Messiah and restore Israel's fortunes. To show how this same sequence of opaque symbols, given together in this order, works perfectly well with another intersecting verse, we note the following:

Esther Rabbah I. Petihta 3

III:i

5. A. Along these same lines: "Open to me, my sister, my love, my dove, my undefiled" (Song 5:2):
 B. "Open to me, my sister": this is Babylonia.
 C. "my love": this is Media.
 D. "my dove": this is Greece.
 E. "my undefiled": this is Edom.

F. "Dove" speaks of the age of Greece, because in the time of the rule of the Greeks the Temple was standing, and the Israelites would offer pigeons and doves on the altar.

6. A. R. Phineas and R. Levi in the name of R. Hama b. Hanina interpret the following verse of Scripture: "'In my distress I called upon the Lord, and cried to my God. Out of his temple he heard my voice, [and my cry came before him into his ears]' (Ps. 18:7).

B. "'In my distress I called upon the Lord': in Babylonia.

C. "'and cried to my God': in Media.

D. "'Out of his temple he heard my voice': in Greece."

7. A. Said R. Huna in his own name, "'Open to me, my sister, my love, my dove, my undefiled':

B. "'My dove': this is the kingdom of Greece, because in the time of the rule of the Greeks the Temple was standing, and the Israelites would offer pigeons and doves on the altar.

C. "Therefore: 'Out of his temple he heard my voice.'

D. "'and my cry came before him into his ears': this speaks of Edom."

These are fine examples of how lists of "theological things" convey messages not propositionally but through the correct array, in the right order, of opaque symbols in verbal form. For no one can miss the message that is delivered in these discrete statements. We have no further examples of the same mode of discourse in this document, but for the sake of completeness I include in square brackets two rejected candidates:

[IX:I.1-2 Isa. 14:22, "I will cut off . . . name and remnant" refers to Nebuchadnezzar, Evil-merodach, Belshazzar, and Vashti; script, language, son and grandson. I do not see this as a correct execution of the form at hand for the stipulated purpose.]

[XVIII:II.1-6; III:1-3; IV:1-4; XXXVI:I.1-3 in no way conform to the pattern of specifying a variety of opaque symbols.]

"ANOTHER MATTER" COMPOSITIONS
IN LAMENTATIONS RABBAH

Lamentations Rabbah focuses upon a single message, a covenantal theology, in which Israel and God mutually and reciprocally have agreed to bind themselves to a common Torah; the rules of the relationship are such that an infraction triggers its penalty willy-nilly; but obedience to the Torah likewise brings its reward, in the context envisaged by our compilers, the reward of redemption. Israel suffers because of sin, God will respond to Israel's atonement, on the one side, and loyalty to the covenant in the Torah, on the other. And when Israel has attained

the merit that accrues through the Torah, God will redeem Israel. That is the simple, rock-hard and repeated message of the document. Here is an example of the utilization of the "another matter" composite in the manner important for our study. The verse is "For a sound of wailing is heard from Zion, How we are ruined! We are utterly shamed, because we have left the land, because they have cast down our dwellings" (Jer. 9:19–21):

Lamentations Rabbah Petihta Eight

VIII.I

2. A. "How we are ruined":
 B. How did this happen to us? Through despoilers.
3. A. "We are utterly shamed, because we have left the land":
 B. This refers to the Land of Israel, concerning which it is written, "A land for which the Lord your God cares" (Deut. 11:120).
4. A. "because they have cast down our dwellings":
 B. this refers to synagogues and study houses.
5. A. Another reading of the phrase, "We are utterly shamed, because we have left the land":
 B. This refers to words of Torah,
 C. in line with this verse: "The measure thereof is longer than the earth" (Job 11:9).
6. A. "because they have cast down our dwellings":
 B. this refers to synagogues and study houses.
7. A. Another reading of the phrase, "We are utterly shamed, because we have left the land":
 B. This refers to the house of the sanctuary,
 C. in line with this verse: "And from the bottom of the ground to the lower settle" (Ezek. 43:14).
8. A. "because they have cast down our dwellings":
 B. this refers to the destruction of the first Temple and the destruction of the second Temple.

No. 2 begins with the Land of Israel, then synagogues and study houses; we proceed to words of Torah, no. 5, with synagogues and study houses once more; then the house of the sanctuary. If I had to specify the point, it would be that the Land and words of Torah and the sanctuary all form a seamless realm of reality. If we listed all three without the verse at hand—Land, Torah, sanctuary—that proposition is surely not the only possibility. But putting the three together with Jer. 9:19ff. allows the point to emerge. Further instances of the desired form utilized in the manner at issue are these:

[XXXVI:III works out a sustained reading of Ps. 57:7–11, but the formal requirements are scarcely met.]

[XL.I.1 The exposition of Lam. 1:6 yields a sequence of readings of the phrase "all her majesty," encompassing the Holy One, blessed be he, the Sanhedrin, the disciples of sages, the priestly watches, the children. Then a conclusion is drawn: the Holy One, blessed be he, loves children. The Ten Tribes went into exile, but the Presence of God did not go into exile. Judah and Benjamin went into exile, but the Presence of God did not go into exile. The Sanhedrin went into exile, but the Presence of God did not go into exile. The priestly watches went into exile, but the Presence of God did not go into exile. But when the children went into exile, then the Presence of God went into exile: "her children have gone away, captives before the foe." If we did not have the exposition, we could never have gotten the point merely from the list with which the pericope commences. This therefore does not seem to me a very effective piece of symbolic discourse.]

[CI.1 "How the gold has grown dim, how the pure gold is changed" refers to the disciples of sages who had to go out to make a living, Josiah, the men of Jerusalem, who were like a golden ornament. I do not see how this list yields any point.]

CXXX:I.1 Slaves rule over us; there is none to deliver us from their hand refers to the Egyptians and Moses, then the four kingdoms and the Holy One, blessed be he. This is not a great example, but it shows that the form could serve. But what proposition the matched lists, by themselves, can have yielded none can say.

CXLIII:I.2 "Renew our days as of old" refers to the first Adam, Moses, the time of Solomon, the time of Noah, the time of Abel; all three possibilities link the coming redemption to a time of perfection, Eden, or the age prior to idolatry, or the time of Moses and Solomon, the builders of the cult and the Temple, respectively.

"ANOTHER MATTER" COMPOSITIONS IN THE FATHERS ACCORDING TO RABBI NATHAN

The Fathers According to Rabbi Nathan, serving to amplify and supplement Mishnah Tractate Avot, is not definitively assigned a provenance. But its materials in the aggregate fall into the framework of those of the Talmud of Babylonia, and we survey the document, which is not a Midrash compilation in any way, in the present context. While this document treats theological subjects and also repeatedly cites a given verse of Scripture in compositions joined into a composite by "another interpretation," it does not contain a single example of symbolic discourse.

Let me give a single example of how the form that uniquely serves for symbolic discourse also is utilized for what is simply propositional and argumentative discourse. I cut out all but the essential sentences.

The Fathers According to Rabbi Nathan Chapter Twenty

XX:II

1. A. He would say, *"Do not look on me, that I am dark, that the sun has tanned me, my mother's sons were angry against me, they made me keeper of the vineyards, but my own vineyard have I not kept* (Song 1:6).

 B. *"Do not look on me, that I am dark, that the sun has tanned me, my mother's sons were angry against me*—this refers to the councils of Judea, who broke off the yoke of the Holy One, blessed be he, from upon themselves and accepted upon themselves the dominion of a mortal king."

XX:III

1. A. Another interpretation of the statement, *my mother's sons were angry against me*: this refers to Moses, who killed the Egyptian.

 B. For it is said, *And it came to pass in those days, when Moses had grown up, that he went out to his brethren and looked on their burdens. And he looked this way and that, and when he saw that there was no man, he killed the Egyptian and hid him in the sand* (Exod. 2:11).

XX:IV

1. A. Another interpretation of the statement, *my mother's sons were angry against me*: this refers to Moses, who fled to Midian.

 B. For it is said, *Now when Pharaoh heard this thing, he sought to slay Moses. But Moses fled from Pharaoh and settled in the land of Midian, and he sat down by a well. The priest of Midian had seven daughters . . . and the shepherds came and drove them away, but Moses stood up and helped them and watered their flock* (Exod. 2:15–17).

 C. Moses came and went into session as a court in judgment over them. He said to them, "It is the way of the world that men draw the water and women water the flocks, but here the women draw the water and the men water the flocks. [Goldin:] Justice is perverted in this place!"

XX:V

1. A. Another interpretation of the statement, *my mother's sons were angry against me*: this refers to the Israelites, who made the golden calf.

 B. For to begin with they said, *Whatever the Lord says we shall do and obey* (Exod. 24:5).

 C. But they went and said, *These are your gods Israel* (Exod. 32:4).

XX:VI

1. A. Another interpretation of the statement, *my mother's sons were angry against me*: this refers to the spies, who produced a bad report concerning the land and caused the Israelites to die:

 B. *In this wilderness your carcasses will fall* (Num. 14:29).

XX:VI

2. A. *They made me keeper of the vineyards.*

 B. Said the Holy One, blessed be he, "What is it that made me do good for the nations of the world? It was Israel.

 C. "For so long as the nations of the world enjoy prosperity, Israel is afflicted, driven out, driven from place to place."

XX:VII

1. A. Another explanation of the verse, *they made me keeper of the vineyards, but my own vineyard have I not kept*:

 B. This refers to the Israelites, who went into exile to Babylonia.

 C. The prophets that were among them arose and said to them, "Designate a portion of your crop for priestly rations and for tithes."

 D. They said to them, "The exile from our land itself is solely on account of our not designating portions of the crops as priestly rations and tithes, and now do you tell us to designate a portion of the crop as priestly rations and as tithes?"

 E. That is the point of the statement: *they made me keeper of the vineyards, but my own vineyard have I not kept.*

Here is a fine example of something other than symbolic discourse. I see the whole as miscellaneous and incoherent. We have the form, but not the mode of discourse: a verse that is systematically interpreted by appeal to a repertoire of candidates: the councils of Judea, Moses, again Moses, Israel in making the golden calf, the spies who produced a bad report concerning the Land. I see no recurrent pattern, no resort to a list of names to establish a point or communicate a message. The basic formal disjuncture lies in the treatment of the verse, which is not parsed and so broken up into nonsense units. The verse left whole, it is simply enriched with diverse cases, each of which makes a point pretty much on its own.[1]

FORM HISTORY

The form for the "another matter" composition contributes nothing weighty to Ruth Rabbah. Apart from the illustrative example, I find

1. Note also The Fathers According to Rabbi Nathan XXVII:I and II.

nothing pertinent in Esther Rabbah I; the form occurs, but not for the anticipated purpose. The examples in Lamentations Rabbah are few and not very compelling. Up to this point, therefore, the representation of what I have classified as symbolic discourse has turned out to be episodic and paltry. Were our evidence to conclude with these documents, we should have to judge that the canonical documents simply do not utilize symbolic discourse carried in verbal form—though they might have. But we shall now see that one document's authors and compilers found that particular medium of communication particularly useful in conveying their thought about a principal theological issue, the one of the relationship of Israel and God. Taking a work deemed to speak in metaphors of that relationship, these authors and compilers turned metaphors into symbols, symbols into media for intelligible communication of a wholly-other kind from the propositional and analytical sort that ordinarily served.

7

Symbolic Discourse in Song of Songs Rabbah

SONG OF SONGS RABBAH

If, in its way, the Talmud of Babylonia joins the Mishnah to Scripture in its formation of the structure of the dual Torah as one,[1] Song of Songs Rabbah joins metaphor to theology, symbol to structure, in setting forth that same whole. Standing in the same period, at the end of the canonical process, in the sixth century, its authorship accomplished in its way that same *summa* which the authorship of the Bavli set forth. But they worked with far more delicate, and also more dangerous, materials, and their achievement excels. For it is one of not intellect but sentiment, not proposition but attitude and emotion. When we appreciate and respond to their writing, we are changed in heart and soul and spirit, in depths and dimensions in which, when we find ourselves compelled by the Bavli, we are untouched. For the Bavli rules over the mind and tells us what to think and do, while Song of Songs Rabbah, made wholly our own, tells us how to think and feel, forming of sensibility a faith, belief in, in its way paramount over the faith, belief that, that is the Bavli's construction. And conviction, belief in, comes prior to proposition, belief that, in the formation of the heart at one with God.

What is important in the inquiry into symbolic discourse scarcely demands specification. It is the simple fact that Song of Songs Rabbah forms the largest single repository of cases of symbolic discourse in all of the rabbinic canon of late antiquity. In sheer volume it sets forth as many examples as all the other surveyed documents put together. We know

1. I refer to J. Neusner, *Judaism: The Classical Statement, The Evidence of the Bavli* (Chicago: University of Chicago Press, 1986) and idem, *The Bavli and Its Sources* (Brown Judaic Studies; Atlanta: Scholars Press, 1987).

full well that the rhetorical form required for symbolic discourse, the view of the character of language and the indeterminacy of words— these requirements for that discourse were entirely available even in the earliest of the Midrash compilations. But while present, they were scarcely used. My large selection of cases from Song of Songs Rabbah demonstrates that its compilers assigned vastly greater value assigned to symbolic discourse than had their earlier counterparts. Not only so, but, as we shall now see, the potentialities of communication through words in symbolic form were realized in more different ways and for more different purposes than in all of the earlier writings put together. At the end I shall explain why, in my view, that is the fact. Let us begin with the facts.

AN EXEMPLARY CASE

We begin with an ordinary example, one lacking traits of special interest, to show an entirely ordinary instance of the utilization of symbolic discourse to convey signification, if not a propositional message, then an attitude, or to evoke an emotion or impart a proper sentiment.

Song of Songs Rabbah CVIII:II

1. A. "for love is strong as death":
 B. As strong as death is the love with which the Holy One, blessed be he, loves Israel: "I have loved you, says the Lord" (Mal. 1:2).
 C. "jealousy is cruel as the grave":
 D. That is when they make him jealous with their idolatry: "They roused him to jealousy with strange gods" (Deut. 32:16).
2. A. Another explanation of "for love is strong as death":
 B. As strong as death is the love with which Isaac loved Esau: "Now Isaac loved Esau" (Gen. 25:28).
 C. "jealousy is cruel as the grave":
 D. the jealousy that Esau held against Jacob: "And Esau hated Jacob" (Gen. 27:41).
3. A. Another explanation of "for love is strong as death":
 B. As strong as death is the love with which Jacob loved Joseph: "Now Israel loved Joseph more than all his children" (Gen. 37:3).
 C. "jealousy is cruel as the grave":
 D. the jealousy that his brothers held against him: "And his brothers envied him" (Gen. 37:11).
4. A. Another explanation of "for love is strong as death":
 B. As strong as death is the love with which Jonathan loved David: "And Jonathan loved him as his own soul" (1 Sam. 18:1).
 C. "jealousy is cruel as the grave":
 D. the jealousy of Saul against David: "And Saul eyed David" (1 Sam. 18:9).

5. A. Another explanation of "for love is strong as death":
 B. As strong as death is the love with which a man loves his wife: "Enjoy life with the wife whom you love" (Qoh. 9:9).
 C. "jealousy is cruel as the grave":
 D. the jealousy that she causes in him and leads him to say to her, "Do not speak with such-and-so."
 E. If she goes and speaks with that man, forthwith: "The spirit of jealousy comes upon him and he is jealous on account of his wife" (Num. 5:14).
6. A. Another explanation of "for love is strong as death":
 B. As strong as death is the love with which the generation that suffered the repression loved the Holy One, blessed be he: "No, but for your sake we are killed all day long" (Ps. 44:23).
 C. "jealousy is cruel as the grave":
 D. the jealousy that the Holy One, blessed be he, will hold for Zion, that is a great zealousness: "Thus says the Lord, I am jealous for Zion with a great jealousy" (Zech. 1:14).
7. A. "Its flashes are flashes of fire, a most vehement flame":
 B. R. Berekiah said, "Like the fire that is on high,
 C. "that fire does not consume water, nor water, fire."

The exposition, nos. 1–6, shows us a satisfying way in which to put together and amplify a base verse. Through symbolic discourse we are able to encompass a variety of topics, yet both formally and conceptually make a coherent statement. We contrast love and jealousy, favoring the one and denigrating the other. No. 1 does not prepare us for that contrast, since here God's love for Israel contrasts with the emotions that Israel provokes in God; yet the contrast is established, so the rest will follow. No. 2, Isaac, Jacob, Esau; no. 3, Jacob, Joseph, the brothers; no. 4, Jonathan, David, Saul; and no. 5, man, wife, paramour then work in sets of three, and no. 6 reverts to no. 1's pattern. Aesthetically this must be deemed a perfect design, without a single false move. No. 7 is routine. Now that we see how a list of names, otherwise opaque, combined with one another and then recombined with the parsed verse, yields its message through aesthetic rather than syllogistic communication, we review a sizable repertoire of cases in the document in which this mode of discourse is principal.

IMPORTANT EXAMPLES OF TRAITS OF SYMBOLIC DISCOURSE

Because of the primary position of Song of Songs Rabbah in the exposition of symbolic discourse in Judaism, I shall now give a much richer display of examples than in the past. For a mere catalogue does not do justice to the document's power to speak through symbols, as

much as through words—and rather than through words. Each example, however, is meant to stand for another aspect of the rules of symbolic discourse, or the potentialities thereof, in this document.

Let me begin, as before, with examples of what I mean by symbolic discourse in the document at hand.[2]

Song of Songs Rabbah I:I

1. A. "The song of songs which is Solomon's":
 B. This is in line with that which Scripture said through Solomon: "Do you see a man who is diligent in his business? He will stand before kings, he will not stand before mean men" (Prov. 22:29).
 C. "Do you see a man who is diligent in his business":
 D. This refers to Joseph: "But one day, when he went into the house to do his work [and none of the men of the house was there in the house, she caught him by his garment, saying, 'Lie with me.' But he left his garment in her hand and fled and got out of the house]" (Gen. 39:10–13).

3. A. "He will stand before kings":
 B. this refers to Pharaoh: "Then Pharaoh sent and called Joseph and they brought him hastily from the dungeon" (Gen. 41:14).

4. A. "he will not stand before mean men":
 B. this refers to Potiphar, whose eyes the Holy One, blessed be he, darkened [the word for "darkened" and "mean men" share the same consonants], and whom he castrated.

5. A. Another interpretation of the verse, "Do you see a man who is diligent in his business" (Prov. 22:29):
 B. this refers to our lord, Moses, in the making of the work of the tabernacle.
 C. Therefore: "He will stand before kings."
 D. this refers to Pharaoh: "Rise up early in the morning and stand before Pharaoh" (Exod. 8:16).
 E. "he will not stand before mean men":
 F. this refers to Jethro.
 G. Said R. Nehemiah, "[In identifying the king with Pharaoh,] you have made the holy profane.
 H. "Rather, 'He will stand before kings': this refers to the King of kings of kings, the Holy One, blessed be he: 'And he was there with the Lord forty days' (Exod. 34:28).
 I. "'he will not stand before mean men': this refers to Pharaoh: 'And there was thick darkness' (Exod. 10:22)."

6. A. Another interpretation of the verse, "Do you see a man who is diligent in his business" (Prov. 22:29):

2. Other examples from this same compilation have been given in chapters 2 and 3.

B. this refers to those righteous persons who are occupied with the work of the Holy One, blessed be he.

C. Therefore: "He will stand before kings."

D. this refers to those who stand firm in the Torah: "By me kings rule" (Prov. 8:15).

E. "he will not stand before mean men":

F. this refers to the wicked: "And their works are in the dark" (Isa. 29:15); "Let their way be dark and slippery" (Ps. 35:6).

9. A. Another interpretation of the verse, "Do you see a man who is diligent in his business" (Prov. 22:29):

B. this refers to Solomon son of David.

C. "He will stand before kings."

D. for he was diligent in building the house of the sanctuary: "So he spent seven years in building it" (1 Kings 6:38).

16. A. [Resuming the discussion of 8.D:] "He will stand before kings."

B. before the kings of the Torah he will stand.

C. "he will not stand before mean men":

D. this refers to a conspiracy of wicked men.

While this somewhat overburdened composition hardly adheres to the required form, its basic outlines are not difficult to discern.[3] We have an

3. I have omitted extraneous material to ease the burden on the reader. But this account of the whole alerts the reader to what has been eliminated. The invocation of the figure of Joseph ought to carry in its wake the contrast between the impure lust of Potiphar's wife and the pure heart of Joseph, and, by extension, Solomon in the Song. But I do not see that motif present. The form is scarcely established—clause by clause exegesis in the light of the principal's life—before it is broken with the insertion of 1.E–G, lifted whole from Gen. R. LXXXVII:VII, where it belongs. No. 2 is then parachuted down as part of the Joseph sequence; but it does not occur in the parallel. No. 3 then resumes the broken form, and no. 4 completes it. So the first statement of the formal program is not difficult to follow. The confluence of the consonants for "mean" and "dark" accounts for the sequence of applications of the third clause to the theme of darkness. The second exercise, with Moses, is laid out with little blemish in no. 5. No. 6 goes on to the righteous, and here too the sages' passage is worked out with no interpolations. No. 7, by contrast, provides an excuse to insert no. 8. Without no. 7, no. 8 of course would prove incomprehensible in this context (though entirely clear standing on its own). Finally, at no. 9, we come to Solomon. Perhaps the coming theme of the magical works performed through stones, those used in the Temple, with Daniel, and so on, persuaded the person who inserted nos. 7–8 of the relevance of those passages; but even if they prove thematically in place, the sequence is disruptive and hardly respects the formal program that clearly has guided the framer. No. 10 introduces the contrast of the two verses, our proof text at no. 9 plus a contradictory one. This yields a suitable harmonization, which sustains the supplements at nos. 11, 12, and 13. Nos. 11 and 12 are simply freestanding sentences. No. 13, with nos. 14 and 15, in its wake, by contrast is a full-scale composition, again about miracles done with stones. Hanina's passage would have found a more comfortable home here (if anywhere). Only at no. 16 are we permitted to resume our progress through the established form. No. 17 is tacked on because of the reference of 16.D to a conspiracy of wicked men; the issue, then, is whether Solomon belongs with them, in line with

intersecting verse, Prov. 22:29, aimed at reaching the goal of naming
Solomon, who is author of the Song of Songs, and showing him in the
context of Joseph, the righteous, and Moses. The reason throughout is
the same: each one of them "stood before kings, not before mean men."
The names then are Joseph, Pharaoh, Potiphar; Moses, Pharaoh, Jethro;
righteous persons occupied with the work of the Holy One, Torah, the
wicked; Solomon, the Temple, the kings of the Torah. With these names
but without the intersecting verse, we should have some difficulty,
because the third set violates the program of the first two, Jethro and
Potiphar standing for nobility. The fourth set is equally problematic,
now because the Temple is out of place. By themselves, therefore the
third and fourth entries are somewhat asymmetrical. But with the inter-
secting verse, the message is a clear one, though it is not made explicit.
But it is still a diverse message, involving as it does Solomon, who will
not be subjected to a conspiracy of mean men; kings, who will pay
homage to masters of the Torah; Joseph and Moses. To allege that the
complex contains a single message or speaks in a uniform way therefore
would contradict the symbols and their manipulation. Even at this point,
however, we note the considerable difference between this case and the
examples provided by the documents surveyed in the foregoing chap-
ters, which proved simple and one-dimensional by contrast to the rather
variegated composition before us.[4]

The second example introduces us to how to read the same verse
through both symbolical discourse and propositional discourse. We shall
see that, side by side, both kinds of discourse are set forth, each serving to
convey its own message in the medium thought appropriate. (In a later
example we shall see symbolic discourse fully exposed right within
propositional discourse, a still more complicated medium of significa-
tion.) The treatment of Song 1:2, "O that you would kiss me with the
kisses of your mouth! [For your love is better than wine]," which follows,
runs through a variety of propositions, all but the last of them expressed
in words rather than in a repertoire of otherwise uninterpreted verbal
symbols. Then comes a sequence of other than propositional formula-
tions. Thus II:I.1 asks, "In what connection was this statement made?"

17.A–B. 17.E forms a bridge to the sustained discussion of Ps. 45:17. But since the
exposition of that verse makes no reference to the foregoing, we should regard the
rather run-on sequence before us as winding down at no. 17, and, despite the rhetorical
joining language of "therefore," I treat the discussion of Ps. 45:17 as autonomous. It
assuredly has no formal ties to the intersecting verse on which we have been working.

4. We note that the remainder of Song of Songs Rabbah chapter 1 goes on to other
treatments of the base verse but does not then present further symbolic discourses
parallel to this one.

and holds that it was stated at the Sea, or at Sinai, or at the tent of meeting, or in connection with the eternal house (the Temple of Jerusalem). Solomon's name is interpreted, no. 2. The ministering angels are credited with the Song, no. 3. What follows, therefore, clearly shows the difference between propositional discourse and symbolic discourse and allows us to identify the distinctive rhetorical traits of each:

Song of Songs Rabbah II:I

1. A. "O that you would kiss me with the kisses of your mouth! [For your love is better than wine]":
 B. In what connection was this statement made?
 C. R. Hinena b. R. Pappa said, "It was stated at the sea: '[I compare you, my love,] to a mare of Pharaoh's chariots' (Song 1:9)."
 D. R. Yuda b. R. Simon said, "It was stated at Sinai: 'The song of songs' (Song 1:1)—the song that was sung by the singers: 'The singers go before, the minstrels follow after' (Ps. 68:26)."
4. A. R. Yohanan said, "It was said at Sinai: 'O that you would kiss me with the kisses of your mouth!' (Song 1:2)."
5. A. R. Meir says, "It was said in connection with the tent of meeting."
 B. And he brings evidence from the following verse: "Awake, O north wind, and come, O south wind! Blow upon my garden, let its fragrance be wafted abroad. Let my beloved come to his garden, and eat its choicest fruits" (Song 4:16).
 C. "Awake, O north wind": this refers to the burnt offerings, which were slaughtered at the north side of the altar.
 D. "and come, O south wind": this refers to the peace offerings, which were slaughtered at the south side of the altar.
 E. "Blow upon my garden": this refers to the tent of meeting.
 F. "let its fragrance be wafted abroad": this refers to the incense offering.
 G. "Let my beloved come to his garden": this refers to the Presence of God.
 H. "and eat its choicest fruits": this refers to the offerings.
6. A. Rabbis say, "It was said in connection with the house of the ages [the Temple itself]."
 B. And they bring evidence from the same verse: "Awake, O north wind, and come, O south wind! Blow upon my garden, let its fragrance be wafted abroad. Let my beloved come to his garden, and eat its choicest fruits" (Song 4:16).
 C. "Awake, O north wind": this refers to the burnt offerings, which were slaughtered at the north side of the altar.
 D. "and come, O south wind": this refers to the peace offerings, which were slaughtered at the south side of the altar.
 E. "Blow upon my garden": this refers to the house of the ages.
 F. "let its fragrance be wafted abroad": this refers to the incense offering.

G. "Let my beloved come to his garden": this refers to the Presence of God.

H. "and eat its choicest fruits": this refers to the offerings.

I. The rabbis furthermore maintain that all the other verses also refer to the house of the ages.

J. Said R. Aha, "The verse that refers to the Temple is the following: 'King Solomon made himself a palanquin, from the wood of Lebanon. He made its posts of silver, its back of gold, its seat of purple; it was lovingly wrought within by the daughters of Jerusalem' (Song 3:9–10)."

K. Rabbis treat these as the intersecting verses for the verse, 'And it came to pass on the day that Moses had made an end of setting up the tabernacle' (Num. 7:1).

Now we turn to treatment of the same verse through symbolic, as distinct from the foregoing propositional, discourse. The shift in rhetoric is immediate. The difference in the mode for conveying meaning emerges only as sequences of opaque symbols are combined with sequences of (equally opaque) clauses of the parsed verse.

II:IX

1. A. Another explanation of the verse, "For your love is better":
 B. This refers to the patriarchs.
 C. "than wine":
 D. this refers to the princes.
2. A. Another explanation of the verse, "For your love is better":
 B. This refers to the offerings.
 C. "than wine":
 D. this refers to the libations.
4. A. Another explanation of the verse, "For your love is better":
 B. This refers to Israel.
 C. "than wine":
 D. this refers to the gentiles.
 E. [For the numerical value of the letters that make up the word for wine] is seventy,
 F. teaching you that the Israelites are more precious before the Holy One, blessed be he, than all of the nations.

The composition, with its modest interpolation at no. 3, forms a powerful triplet,[5] in which the more valuable is compared with the less

5. Well-crafted symbolic discourse for the clear representation of the proposed signification should set forth sequences of three or more, there being no series in fewer than three cases. Song of Songs Rabbah's examples, we shall see, provide a rich repertoire of sets—three or more—of recombinant symbols. A glance at the preceding documents' examples shows that that is not so characteristic of the prior compilations. But that is only an impression.

valuable, first patriarchs as against princes, then offerings as against merit, and finally Israel as against the nations. That the whole is inseparable and unitary is shown by the climax, no. 4, aiming at the final point, 4.F. What if we listed patriarchs/princes; offerings/libations; Israel/nations? Without further ado, we should readily make the simple point: Israel is more valued than the nations. 4.F is superfluous! We note that, when symbolic discourse is executed in this blatant manner, we scarcely need an intersecting verse to clarify the message; then the use of visual or iconic symbols instead of verbal ones can and ought to have delivered precisely the same message.

Now that the difference in our document between the use of words for symbolic discourse as distinct from propositional discourse is clear, we proceed to survey further cases of symbolic communication. The next example shows us the combination of symbolic discourse and propositional discourse serving the same purpose. It is as though the author or compiler did not place sufficient confidence in the audience's capacity to grasp the message in symbolic form, so he went and repeated it as a proposition. The first six components deliver the message in opaque symbols, the seventh, as a proposition. The seventh composition ignores the preceding ones.

Song of Songs Rabbah VI:III

1. A. "My mother's sons were angry with me":
 B. R. Meir and R. Yosé:
 C. R. Meir says, "'My mother's sons': the sons of my nation [which word uses the same consonants], that is, Dathan and Abiram.
 D. "'were angry with me': attacked me, filled with wrath the judge who [ruled] against me.
 E. "'they made me keeper of the vineyards': while he brought justice among the daughters of Jethro, could he not bring justice between me and my brothers in Egypt?
 F. "thus: 'but my own vineyard I have not kept.'"
2. A. Another interpretation:
 B. "My mother's sons": the sons of my nation [which word uses the same consonants], that is, Jeroboam b. Nebat.
 C. "were angry with me": attacked me, filled with wrath the judge who [ruled] against me.
 D. "they made me keeper of the vineyards": the task of guarding the two golden calves of Jeroboam [1 Kings 12:28].
 E. "but my own vineyard I have not kept": "I did not keep the watch of the priests and Levites.
 F. Thus: "but my own vineyard I have not kept."
4. A. Another explanation: "My mother's sons were angry with me": the

sons of my nation [which word uses the same consonants]. This refers
to Ahab.

B. "were angry with me": attacked me, filled with wrath the judge who
[ruled] against me.

C. "they made me keeper of the vineyards": "They made me provide
dainties for and feed Zedekiah b. Canaanah and his allies."

D. But I had one true prophet there, Micaiah, and he ordered them to
"feed him with little bread and little water" (1 Kings 22:27), thus: "but
my own vineyard I have not kept."

5. A. Another explanation: "My mother's sons": the sons of my nation
[which word uses the same consonants]. This refers to Jezebel.

B. "were angry with me": attacked me, filled with wrath the judge who
[ruled] against me.

C. "they made me keeper of the vineyards": She was providing dainties
for and feeding the prophets of Baal and Asherah.

D. But to Elijah, of blessed memory, who was the true prophet, she sent
word, "If I do not make your life as the life of one of them by
tomorrow" (1 Kings 19:2). Thus: "but my own vineyard I have not
kept."

6. A. Another explanation: "My mother's sons": that is, Zedekiah the king.

B. "were angry with me": attacked me, filled with wrath the judge who
[ruled] against me.

C. "they made me keeper of the vineyards": This is because he gave
dainties to Pashhur b. Malkiah and his colleagues.

D. One true prophet I had, namely, Jeremiah, about whom it is written,
"And they gave him daily a loaf of bread out of the bakers' street" (Jer.
37:21).

E. What is the meaning of "the bakers' street"?

F. Said R. Isaac, "This is coarse bread, sold outside the [Simon:] confec-
tioner's shop, and it is blacker than coarse barley bread."

G. Thus: "but my own vineyard I have not kept."

The clause-by-clause exposition identifies as the speaker a variety of
figures. Meir and Yosé concur that it is Moses, but then they differ on the
case to which he refers. From no. 2 onward, the speaker is not so clear,
since we speak of incidents rather than persons. Then the speaker should
be Israel itself, and that is the upshot at the end. Then at no. 2 we have
Israel referring to the golden calves of Jeroboam. The important line is at
the end: "My own vineyard I have not kept," now meaning Jerusalem.
(This precipitates the insertion of no. 3, balancing the decline of Jerusa-
lem with the rise of Rome, a common motif.) From Jeroboam we go on
to other figures in first Temple times: Ahab, Jezebel, Zedekiah. The
Community of Israel is the speaker. What lesson is to be drawn? Without

the conclusion, given presently, we have the comparison of Solomon with Ahab, Jezebel, and Zedekiah. That yields the point that Solomon's rule of Jerusalem produced negative consequences.

No. 7 now makes the matter explicit—and in doing so, simply ignores the prior, symbolic delivery of the same message.

7. A. R. Hiyya in the name of R. Yohanan: "Said the Community of Israel before the Holy One, blessed be he, 'Because I did not observe the law about giving a single dough offering in the proper manner in the Land of Israel, lo, I keep the law concerning setting aside two dough offerings in Syria [Simon, p. 61 n. 3: one for the priest and one to be burnt, out of doubt].

 B. "I was hoping that I might receive the reward for setting aside two, but I receive the reward for only one of them."

 C. R. Abbah in the name of R. Yohanan: "Said the Community of Israel before the Holy One, blessed be he, 'Because I did not observe the law of keeping a single day holy as the festival in the proper manner in the Land of Israel, lo, I keep the law concerning keeping two successive days holy as the festival applicable to the exiles, outside the land.

 D. "I was hoping that I might receive the reward for setting aside two, but I receive the reward for only one of them."

 E. R. Yohanan cited concerning them the following verse: "Wherefore I gave them also statutes that were not good" (Ezek. 20:25).

Of course no. 7 is autonomous, but including it, the compilers have made explicit the point that they wish to register. This composition as a whole is powerful and unrelenting, cogent and quite particular.

Up to now I have argued, in behalf of recombinancy, that we require the verse—the recombinant aspect—to conduct our discourse in verbal symbols. Nearly all of the cases yielded in the other documents sustained that view. But we shall now see that simply combining a set of names, actions, or events, embodied in a word or two, with one another may convey our message. Here the repetition of "another matter" (*davar aher*) proves a valuable signal of what is in play. The following case shows us how a sequence of symbols in verbal form manages quite well to accomplish the framer's goal, which in this case is not so much to make a point as to impart an attitude:

Song of Songs Rabbah X:I

1. A. "Your cheeks are comely with ornaments":

 B. just as the cheeks are created only for speech, so Moses and Aaron were created only for speech.

 C. "your neck with strings [of jewels]":

D. [since the words for jewels and the word for strings use the same consonants, the sense is,] with the two Torahs, the Torah that is in writing and the Torah that is in memory.

2. A. Another interpretation of "[your neck] with strings [of jewels]":

B. with many Torahs: "This is the Torah of the burnt offering" (Lev. 6:2); "this is the Torah of the sin offering" (Lev. 7:1); "this is the Torah of the peace offering" (Lev. 7:11); "this is the Torah when a man shall die in a tent" (Num. 19:14).

3. A. Another explanation of "with strings":

B. with two ornaments [a word using the same consonants],

C. with two brothers, speaking of Moses and of Aaron,

D. who treat each other with a gracious demeanor.

E. This one took pleasure in the achievements of that one, and that one took pleasure in the achievements of this one.

X:ii

1. A. "your neck with strings of jewels":

B. This refers to the seventy members of the Sanhedrin who were strung out after them [Moses and Aaron] like a string of pearls.

2. A. Another explanation of the phrase, "your neck with strings of jewels":

B. This refers to those who teach Scripture and repeat Mishnah, instructing children in good faith.

C. "your neck with strings of jewels" refers to children.

3. A. Another explanation of the verse, "Your cheeks are comely with ornaments":

B. This refers to the rabbis.

C. "your neck with strings of jewels":

D. This refers to the disciples, who [Simon:] strain their necks to hear the teachings of the Torah from their mouth,

E. like someone who has never heard teachings of the Torah in his entire life.

4. A. Another explanation of the verse, "Your cheeks are comely with ornaments":

B. when they pronounce the law with one another, for instance, R. Abba b. R. Qomi and his colleagues.

C. "your neck with strings of jewels":

D. When they make connections among teachings of the Torah, then go on and make connections between teachings of the Torah and teachings of the prophets, teachings of the Prophets and teachings of the Writings, and fire flashes around them, then the words rejoice as when they were given from Mount Sinai.

The exposition of the base verse moves from Moses and Aaron to Torah teaching and the giving of the Torah. The verse is hardly necessary to the creation of the effect, but it works well to supply a metaphor to

this new theme. The strength of the hermeneutic is not its complexity but its simplicity and serviceability to all the intertwined themes that our authorship wishes to set forth in the present context. And the utility of the mode of discourse in holding together a variety of symbols, even when not composed into some sort of message that can be translated into a proposition, is clear. The purpose here in resorting to symbolic discourse conducted through lists of names is not so much to deliver a message as to convey an attitude.

Since I claim that Song of Songs Rabbah puts on display a symbolic structure, utilizing the specified mode of discourse to do so, let me give an example of how such a structure, nicely proportioned and well crafted, is portrayed. What is required in the representation of such a structure is to place into a single statement a variety of symbols, to hold them together in a manner that preserves their symbolic (nondiscursive, assuredly nonpropositional) character: to let the symbol speak symbolically. That means, of course, to establish a mood or convey an attitude rather than prove a point or make a case. The formally sustained and well-crafted exposition that follows is interesting because it shows us how a repertoire of closely related symbols finds metaphorization in the base verse.

Song of Songs Rabbah XI:I

1. A. "We will make you ornaments of gold":
 B. this refers to the spoil at the Sea.
 C. "studded with silver":
 D. this refers to the spoil of Egypt.
2. A. Just as there is a difference between silver and gold, so there is greater value assigned to the money gotten at the Sea than the spoil of Egypt.
 B. For it is said, "And you came with ornaments upon ornaments" (Ezek. 16:7):
 C. "ornaments" refers to the spoil of Egypt.
 D. "upon ornaments" refers to the spoil at the Sea.
3. A. Another interpretation of "We will make you ornaments of gold":
 B. this refers to the Torah, which [Simon:] Onqelos, the nephew of Hadrian, learned.
 C. "studded with silver":
 D. R. Abba b. R. Kahana said, "These are the letters."
 E. R. Aha said, "These are the words."
4. A. Another interpretation of "We will make you ornaments of gold":
 B. this is the writing.
 C. "studded with silver":
 D. this is the ruled lines.
5. A. Another interpretation of "We will make you ornaments of gold":

B. this refers to the tabernacle: "And you shall overlay the boards with gold" (Exod. 26:29).
C. "studded with silver":
D. "The hooks of the pillars and their fillets shall be silver" (Exod. 27:10).
6. A. R. Berekhiah interpreted the verse to speak of the ark:
B. "'We will make you ornaments of gold':
C. "this refers to the ark, as it is said, 'And you shall overlay it with pure gold' (Exod. 25:11)."
D. "'studded with silver':
E. "this refers to the two pillars that stand before it, which were made of silver, like [Simon:] columns of a balcony."
8. A. Judah, the son of Rabbi, says, "'Your cheeks are comely with ornaments':
B. "this refers to the Torah.
C. "'your neck with strings of jewels': this refers to the prophets.
D. "'We will make you ornaments of gold':
E. "this refers to the Writings.
F. "'studded with silver':
G. "this refers to the Song of Songs,
H. "[Simon:] something complete and finished off."

Here we see the fully exposed hermeneutical method of the document—not the exegetes that are cited but the authorship that has assembled the materials and, I think, done so for its own purposes. The important point is not the detail but the utilization of a complete and fully formed symbolic system in the exposition of the base verse(s), that is, of the Song as a whole—and the appeal to the Song as a whole as a framework in which to hold together and treat as one the symbols. What, then, are these symbols? In the present instance I catalogue the following: (1) the spoil at the Sea = the exodus (nos. 1, 2); (2) the Torah (nos. 3, 4); (3) the tabernacle (no. 5); (4) the ark (nos. 6, 7). Then comes what is surprising and out of context, no. 8's Song of Songs itself.

But of course that is the centerpiece, the climax, and the key to the whole. As if we could have missed the powerful message of the prior entries, which have walked us through the book of Exodus and its principal components—exodus, Sinai, tabernacle—the Song of Songs as a whole fully and completely contains the story of the exodus, Sinai, and the tabernacle, which is to say that the parts contribute to a whole that transcends them; the parts point to God's love for Israel, the whole expresses that love, vastly exceeding those parts. In the expression of the attitude of love, metaphors, resorting for expression to symbols, serve better than articulated propositions. That is what I mean by the utiliza-

tion of symbols to put forth a structure—one that can be visual as much as verbal!—and to evoke an attitude or provoke a mood through the contemplation of that structure.

Ideally, such a symbolic structure should avoid propositional discourse altogether (though, as is clear, not many do), and here is the case of a set of lists put forth with no clear proposition in mind at all. What I gain from the following is an attitude and an emotion—burning love, satiation—rather than a proposition and a syllogistic argument.

Song of Songs Rabbah XXII:I

1. A. "Sustain me with raisins, [refresh me with apples; for I am sick with love:]"
 B. [With reference to letters of the word for raisins, we interpret the opening clause:] with two fires, the fire above, the fire below [the heavenly fire, the altar fire].
2. A. Another explanation: "Sustain me with raisins":
 B. with two fires, the Torah in Writing, the Torah in Memory.
3. A. Another explanation: "Sustain me with raisins":
 B. with many fires, the fire of Abraham, the fire of Moriah, the fire of the bush, the fire of Elijah, and the fire of Hananiah, Mishael, and Azariah.
4. A. Another explanation: "Sustain me with raisins":
 B. This refers to the well-founded laws.
5. A. "refresh me with apples":
 B. this refers to the lore, the fragrance and taste of which are like apples.
6. A. "for I am sick with love":
 B. Said the Congregation of Israel before the Holy One, blessed be he, "Lord of the world, all of the illnesses that you bring upon me are so as to make me more beloved to you."
7. A. Another interpretation of the phrase, "for I am sick with love":
 B. Said the Congregation of Israel before the Holy One, blessed be he, "Lord of the world, all of the illnesses that you bring upon me are because I love you."
8. A. Another interpretation of the phrase, "for I am sick with love":
 B. "Even though I am sick, I am beloved unto him."

The raisins—dried in the sun—stand for fire, heavenly and earthly; Torah, in writing and oral; Abraham, Moriah, the bush, Elijah, Hananiah, Mishael, and Azariah—the fire of testing and faith. They include the rest because it seems to me coherent with the foregoing, even though nos. 6, 7 clearly mean to establish propositions.

The theme, then, is the love of God for Israel, of Israel for God, and the symbolic structure that is set forth (whether in symbols in verbal form, or in symbols in visual form—or, not preserved in any way of

course, in music or in dance or in drama, procession or scent or clothing
and ornament) portrays love, without having to describe love in words.
Love, then, is to be felt, a sentiment and an emotion, and proposition
falls away as a useful instrument of signification. What follows is a
standard recombinant list: metaphors of divine love, on the one side, and
symbols of Israel's response through keeping the commandments, on
the other:

Song of Songs Rabbah XXIII:I

1. A. "O that his left hand were under my head":
 B. this refers to the first tablets.
 C. "and that his right hand embraced me":
 D. this refers to the second tablets.
2. A. Another interpretation of the verse, "O that his left hand were under
 my head":
 B. this refers to the show-fringes.
 C. "and that his right hand embraced me":
 D. this refers to the phylacteries.
3. A. Another interpretation of the verse, "O that his left hand were under
 my head":
 B. this refers to the recitation of the *Shema*.
 C. "and that his right hand embraced me":
 D. this refers to the Prayer.
4. A. Another interpretation of the verse, "O that his left hand were under
 my head":
 B. this refers to the tabernacle.
 C. "and that his right hand embraced me":
 D. this refers to the cloud of the Presence of God in the world to come:
 "The sun shall no longer be your light by day nor for brightness will
 the moon give light to you" (Isa. 60:19). Then what gives light to you?
 "The Lord shall be your everlasting light" (Isa. 60:20).
5. A. Another interpretation of the verse, "O that his left hand were under
 my head":
 B. this refers to the *mezuzah*.

The layout seems to me rather typical, in that the disciplined and well-
composed materials come first, repeating their point through a standard
sequence of topics available for metaphorization, then appending other,
more miscellaneous items. Why we invoke, as our candidates for the
metaphor at hand, the Ten Commandments, show-fringes and phylac-
teries, recitation of the *Shema* and the Prayer, the tabernacle and the
cloud of the Presence of God, and the *mezuzah* seems to me clear from
the very catalogue. These reach their climax in the analogy between the
home and the tabernacle, the embrace of God and the Presence of God.
So the whole is meant to list those things which draw the Israelite near to

God and make the Israelite cleave to God, as the base verse says; hence the right hand and the left hand stand for the most intimate components of the life of the individual and the home with God.

One of the rich subtleties of Song of Songs Rabbah now comes to the fore. It is not only the union of symbolic discourse and propositional discourse side by side but their integration within the same composition and composite. Symbolic discourse may take place even within what appears to be propositional communication. In the following somewhat complex composite, we ring the changes on Israel in Egypt, at the Sea, Sinai, and in the age to come. There is no proposition; rather, communication of a pattern and tableaux. No. 2 sets forth the pattern, and nos. 3, 4, 5 (+6–7) somewhat superfluously prove the lot. Then at the next principal entry, we move from Israel's encounters with God "in history" to God's encounters with Israel in the synagogue and the schoolhouse. In context, the conclusion is triumphant. The third principal component proceeds from the here and now to the messianic time.

Song of Songs Rabbah XXVI:I

2. A. "My beloved is like a gazelle":

 B. Just as a gazelle leaps from mountain to mountain, hill to hill, tree to tree, thicket to thicket, fence to fence,

 C. so the Holy One, blessed be he, lept from Egypt to the sea, from the sea to Sinai, from Sinai to the age to come.

 D. In Egypt they saw him: "For I will go through the land of Egypt" (Exod. 12:12).

 E. At the sea they saw him: "And Israel saw the great hand" (Exod. 14:31); "This is my God and I will glorify him" (Exod. 15:2).

 F. At Sinai they saw him: "The Lord spoke with you face to face in the mountain" (Deut. 5:4); "The Lord comes from Sinai" (Deut. 33:2).

3. A. "or a young stag":

 B. R. Yosé b. R. Hanina said, "Meaning, like young deer."

4. A. "Behold, there he stands behind our wall":

 B. behind our wall at Sinai: "For on the third day the Lord will come down" (Exod. 19:11).

5. A. "gazing in at the windows":

 B. "And the Lord came down upon Mount Sinai, at the top of the mountain" (Exod. 19:11).

6. A. "looking through the lattice":

 B. "And God spoke all these words" (Exod. 20:1).

7. A. "My beloved speaks and says to me, ['Arise, my love, my fair one, and come away'] (Song 2:10)":

 B. What did he say to me?

 C. "I am the Lord your God" (Exod. 20:2).

XXVI:II

2. A. "My beloved is like a gazelle":
 B. Just as a gazelle leaps from mountain to mountain, hill to hill, tree to tree, thicket to thicket, fence to fence,
 C. so the Holy One, blessed be he, leaps from synagogue to synagogue, schoolhouse to schoolhouse.
 D. All this why? So as to bestow blessing upon Israel.
 E. And on account of what merit?
 F. It is for the merit accruing to Abraham: "And the Lord appeared to him by the terebinths of Mamre and he was sitting" (Gen. 18:1).
7. A. "Behold, there he stands behind our wall":
 B. behind the walls of the synagogues and schoolhouses.
8. A. "gazing in at the windows":
 B. from between the shoulders of the priests.
9. A. "looking through the lattice":
 B. from between the fingers of the priests.
10. A. "My beloved speaks and says to me":
 B. What did he say to me?
 C. "The Lord bless you and keep you" (Num. 6:24).

We go over the same matter as before, moving on from the redemption at Sinai to the union of synagogue, schoolhouse, and Temple, with the priestly blessing at the climax.

XXVI:III

2. A. "or a young stag":
 B. Just as a stag appears and then disappears, appears and then disappears,
 C. so the first redeemer [Moses] came but then disappeared and then reappeared.
5. A. "Behold, there he stands behind our wall":
 B. behind the Western Wall of the house of the sanctuary.
 C. Why so?
 D. Because the Holy One, blessed be he, took an oath to him that it would never be destroyed.
 E. And the Priests' Gate and the Huldah gate will never be destroyed before the Holy One, blessed be he, will restore them.
6. A. "gazing in at the windows":
 B. through the merit of the matriarchs.
7. A. "My beloved speaks and says to me":
 B. What did he say to me?
 C. "This month shall be for you the beginning of the months" (Exod. 12:2).

The discourse proceeds at two levels, the propositional (much of which I have simply excised) and the symbolic. The former is diffuse

and makes a variety of points. The latter is tight and cogent and makes no points. Rather, it sets up three ages in the form of verbal diaromas: Egypt, the Sea, Sinai; synagogues and schoolhouses; and the age to come and the merit that will save Israel. This is symbolic discourse of the most sophisticated order, *because it survives its verbal garb.*

The same trilogy of conditions—Egypt, the present, the messianic future—is expressed in the following. The case is important because it shows us the dimensions in sustained discourse that take the measure of the symbolic mode of communication. What we see is a sustained presentation, a variety of symbols held together in such a way that the very size of the representation constitutes part of the message. If I had in a few words to say what single message the medium of symbolic discourse was meant to deliver, it would be this: everything holds together, everything fits together, many things form into a single statement.[6]

Song of Songs Rabbah XXX:II

1. A. Another comment on the verses, "My beloved speaks and says to me, ['Arise, my love, my fair one, and come away, for lo, the winter is past, the rain is over and gone. The flowers appear on the earth, the time of singing has come, and the voice of the turtledove is heard in our land. The fig tree puts forth its figs, and the vines are in blossom; they give forth fragrance. Arise, my love, my fair one, and come away']" (Song 2:10-13):
 B. "My beloved speaks and says to me":
 C. R. Azariah said, "Are not 'speaking' and 'saying' the same thing?
 D. "But 'he spoke to me' through Moses, and 'said to me' through Aaron."
2. A. What did he say to me? "Arise, my love, my fair one, and come away, for lo, the winter is past":
 B. This refers to the forty years that the Israelites spent in the wilderness.
3. A. "the rain is over and gone":
 B. This refers to the thirty-eight years that the Israelites were as though excommunicated in the wilderness.
 C. For the Lord did not speak with Moses until that entire generation had perished: "And the days in which we came from Kadesh-barnea . . . moreover the hand of the Lord was against them . . . so it came to pass that when all the men of war were consumed . . . the Lord spoke to me saying" (Deut. 2:14-17).

6. I hardly need remind readers that my argument in reading the Mishnah philosophically points to the same recurrent proposition, the hierarchical unity of all being. But the message here is not abstract but very concrete. In the Mishnah, by contrast, concrete cases point toward the abstract proposition I have identified as philosophical, an Aristotelian method used to form a proposition within the framework of Neo-platonism.

4. A. "The flowers appear on the earth":
 B. the conquerors appear on the earth,
 C. that is, the princes: "Each prince on his day" (Num. 7:11).
5. A. "the time of singing has come":
 B. the time of the foreskin to be removed.
 C. the time for the Canaanites to be cut off.
 D. the time for the Land of Israel to be split up: "Unto these the land shall be divided" (Num. 26:53).
6. A. "and the voice of the turtledove is heard in our land":
 B. Said R. Yohanan, "'The voice of the good pioneer is heard in our land' [the words for turtledove and pioneer or explorer using the same consonants].
 C. "This refers to Joshua when he said, 'Pass in the midst of the camp.'"
7. A. "The fig tree puts forth its figs":
 B. this refers to the baskets of firstfruits.
8. A. "and the vines are in blossom; they give forth fragrance":
 B. this refers to drink offerings.

The form is now established and will be followed quite carefully. We proceed to the protracted exposition I promised at the outset: the union of diverse symbols within a single structure. The first set of applications deals with the exodus and the conquest of the Land.

XXX:III

1. A. Another reading of the verse, "My beloved speaks and says to me":
 B. He "spoke to me"—through Daniel,
 C. and "said to me"—through Ezra.
 D. And what did he say to me?
2. A. "Arise, my love, my fair one, and come away, for lo, the winter is past":
 B. this refers to the seventy years that the Israelites spent in exile.
3. A. "the rain is over and gone":
 B. this is the fifty-two years between the time that the first Temple was destroyed and the kingdom of the Chaldaeans was uprooted.
 C. But were they not seventy years?
 D. Said R. Levi, "Subtract from them the eighteen years that an echo was circulated and saying to Nebuchadnezzar, 'Bad servant! Go up and destroy the house of your Master, for the children of your Master have not obeyed him.'"
4. A. "The flowers appear on the earth":
 B. For example, Mordecai and his colleagues, Ezra and his colleagues.
5. A. "the time of singing has come":
 B. the time of the foreskin to be removed.
 C. the time for the wicked to be broken: "The Lord has broken off the staff of the wicked" (Isa. 14:5),

D. the time for the Babylonians to be destroyed,

E. the time for the Temple to be rebuilt: "And saviors shall come up on Mount Zion" (Obad. 1:21); "The glory of this latter house shall be greater than that of the former" (Hag. 2:9).

6. A. "and the voice of the turtledove is heard in our land":

B. Said R. Yohanan, "'The voice of the good pioneer is heard in our land' [the words for turtledove and pioneer or explorer using the same consonants].

C. "This refers to Cyrus: 'Thus says Cyrus, king of Persia . . . all the kingdoms of the earth . . . whoever there is among you of all his people . . . let him go up . . . and build the house of the Lord' (Ezra 1:2–3)."

7. A. "The fig tree puts forth its figs":

B. this refers to the baskets of firstfruits.

8. A. "and the vines are in blossom; they give forth fragrance":

B. this refers to drink offerings.

The second reading carries us to the second redemption, with the restoration of Israel to Zion. The decision to create the entire composition comes prior to the inquiry into what materials may serve, since the repetitions fill obvious gaps.

XXX:IV

1. A. Another explanation of the verse, "My beloved speaks and says to me":

B. He "spoke"—through Elijah,

C. and "said to me"—through the Messiah.

D. What did he say to me?

2. A. "Arise, my love, my fair one, and come away, for lo, the winter is past":

B. Said R. Azariah, "'for lo, the winter is past': this refers to the kingdom of the Cutheans [Samaritans], which deceives [the words for winter and deceive use some of the same consonants] the world and misleads it through its lies: 'If your brother, son of your mother, . . . entices you' (Deut. 13:7)."

3. A. "the rain is over and gone":

B. this refers to the subjugation.

4. A. "The flowers appear on the earth":

B. the conquerors appear on the earth.

C. Who are they?

D. R. Berekhiah in the name of R. Isaac: "It is written, 'And the Lord showed me four craftsmen' (Zech. 2:3),

E. "and who are they? Elijah, the royal Messiah, the Melchizedek, and the military Messiah."

5. A. "the time of singing has come":

B. the time for the Israelites to be redeemed has come,

C. the time of the foreskin to be removed.

D. the time for the kingdom of the Cutheans to perish,

E. the time for the kingdom of heaven to be revealed: "and the Lord shall be king over all the earth" (Zech. 14:9).

6. A. "and the voice of the turtledove is heard in our land":

B. What is this? It is the voice of the royal Messiah,

C. proclaiming, "How beautiful upon the mountains are the feet of the messenger of good tidings" (Isa. 52:7).

7. A. "The fig tree puts forth its figs":

B. Said R. Hiyya b. R. Abba, "Close to the days of the Messiah a great pestilence will come to the world, and the wicked will perish."

8. A. "and the vines are in blossom; they give forth fragrance":

B. this speaks of those who will remain, concerning whom it is said, "And it shall come to pass that he who is left in Zion and he who remains in Jerusalem" (Isa. 4:3).

The trilogy now comes to its climax with the third and final redemption, the exodus and conquest, the return to Zion, and the ultimate salvation then forming the entire corpus for which the language of the Song serves as metaphor. What we see is precisely what the immediately preceding set presented: a division of Israel's ages into three parts and characterization of each of the parts, past, present, future, first redemption, holy life now, second and final redemption. As I promised, we have been given a survey of a vast corpus of discrete symbols; in their combination and recombination with the base verse they have been set forth as a whole structure. The structure then places on display a cogent picture of Israel's life in time and eternity. I am now prepared to claim that symbolic discourse exhibits capacities for communication of a certain kind of theological truth that propositional and analytical discourse simply cannot sustain. For I defy anyone to show me a counterpart passage in all of the canon of Judaism in late antiquity in which so much is said with so little.

So much for symbolic discourse concerning Israel. What about God? The same mode of discourse that serves so well, to say so much, in so economical a manner, speaks about God with equal power. We now work our way through the natural and the supernatural abodes of God, from the tabernacle, to the ark and the Temple, and on upward. Here again the symbolic discourse takes place beneath the surface of the exegesis of the verses at hand, and it is easy to lose sight of the repertoire of words that mean to establish an account of the supernatural order of Israel's encounter with God. I omit the extraneous material so as to highlight only the sequence of representations, in words, of symbolic realities:

Song of Songs Rabbah XLII:I

1. A. "King Solomon made himself a palanquin, [from the wood of Lebanon]":
 B. R. Azariah in the name of R. Judah b. R. Simon interpreted the verse to speak of the tabernacle:
 C. "'palanquin' refers to the tabernacle.
3. A. "King Solomon made himself a palanquin":
 B. he is the king whose name is peace.
 C. "from the wood of Lebanon":
 D. "And you shall make the boards for the tabernacle of acacia wood, standing up" (Exod. 26:15).

XLIV:I

1. A. "He made its posts of silver":
 B. this speaks of the pillars: "The hooks of the pillars and their fillets shall be of silver" (Exod. 27:10).
 C. "its back of gold:
 D. "And you shall overlay the boards with gold" (Exod. 26:29).
 E. "its seat of purple":
 F. "And you shall make a veil of blue and purple" (Exod. 26:31).
4. A. When did the Presence of God come to rest on the world?
 B. On the day on which the tabernacle was raised up: "And it came to pass on the day that Moses had made an end" (Num. 7:1).

XLIII:II

1. A. [Supply: "King Solomon made himself a palanquin, from the wood of Lebanon. He made its posts of silver, its back of gold, its seat of purple; it was lovingly wrought within by the daughters of Jerusalem":]
 B. R. Yudan b. R. Ilai interpreted the verses to speak of the ark:
 C. "'a palanquin': this is the ark."
4. A. [Reverting to 1.C:] "'King Solomon made himself': the king to whom peace belongs.
 B. "'from the wood of Lebanon': 'And Bezalel made the ark of acacia wood' (Exod. 37:1).
 C. "'He made its posts of silver': these are the two pillars that stand within the ark, which were made of silver.
 D. "'its back of gold': 'and he overlaid it with pure gold' (Exod. 37:2)."
5. A. "its seat of purple":
 B. R. Tanhuma says, "This is the veil that adjoined it."
 C. R. Bibi said, "This refers to the ark cover, for the gold of the ark cover was like purple."
6. A. "it was lovingly wrought within by the daughters of Jerusalem":
 B. R. Yudan said, "This refers to the merit accruing to the Torah and those who study it."

C. R. Azariah said in the name of R. Yudah in the name of R. Simon, "This refers to the Presence of God."

7. A. Said R. Abba b. Kahana, "'And there I will meet with you' (Exod. 25:22):
 B. "This serves to teach you that even what is on the other side of the ark cover the space was not empty of the Presence of God."

XLIII:III

1. A. [Supply: "King Solomon made himself a palanquin, from the wood of Lebanon. He made its posts of silver, its back of gold, its seat of purple; it was lovingly wrought within by the daughters of Jerusalem":]
 B. Another interpretation of "a palanquin":
 C. this refers to the house of the sanctuary.
 D. "King Solomon made himself":
 E. this refers in fact to Solomon.
 F. "from the wood of Lebanon":
 G. "And we will cut wood out of Lebanon" (2 Chron. 2:15).
 H. "He made its posts of silver":
 I. "And he set up the pillars of the porch of the Temple" (1 Kings. 7:21).
 J. "its back of gold":
 K. So we have learned on Tannaite authority: The entire house was overlaid with gold, except the backs of the doors.
 L. Said R. Isaac, "That teaching on Tannaite authority applies to the second building, but as to the first building, even the back parts of the doors were covered with gold."

3. A. "its seat of purple":
 B. "And he made the veil of blue and purple and crimson and fine linen" (2 Chron. 3:14).

4. A. "it was lovingly wrought within by the daughters of Jerusalem":
 B. R. Yudan said, "This refers to the merit attained through the Torah and the merit attained through the righteous who occupy themselves with it."
 C. R. Azariah in the name of R. Judah in the name of R. Simon said, "This refers to the Presence of God."

XLIII:IV

1. A. [Supply: "King Solomon made himself a palanquin, from the wood of Lebanon. He made its posts of silver, its back of gold, its seat of purple; it was lovingly wrought within by the daughters of Jerusalem":]
 B. Another interpretation of "a palanquin":
 C. this refers to the world.
 D. "King Solomon made himself":
 E. the king to whom peace belongs.

F. "from the wood of Lebanon":

G. for [the world] was built out of the house of the Most Holy Place down below.

3. A. "He made its posts of silver":

B. this refers to the chain of genealogies.

C. "its back of gold":

D. this speaks of the produce of the earth and of the true, which are exchanged for gold.

E. "its seat of purple":

F. "Who rides upon heaven as your help" (Deut. 33:26).

N. "it was lovingly wrought within by the daughters of Jerusalem":

O. R. Yudan said, "This refers to the merit attained through the Torah and the merit attained through the righteous who occupy themselves with it."

P. R. Azariah in the name of R. Judah in the name of R. Simon said, "This refers to the Presence of God."

XLIII:V

1. A. [Supply: "King Solomon made himself a palanquin, from the wood of Lebanon. He made its posts of silver, its back of gold, its seat of purple; it was lovingly wrought within by the daughters of Jerusalem":]

B. Another interpretation of "a palanquin":

C. this refers to the throne of glory.

D. "King Solomon made himself":

E. the king to whom peace belongs.

F. "from the wood of Lebanon":

G. this is the House of the Most Holy Place above, which is directly opposite the House of the Most Holy Place down below,

H. as in the following usage: "The place . . . for you to dwell in" (Exod. 15:17),

I. that is, directly opposite your dwelling place [above].

J. "He made its posts of silver":

K. "The pillars of heaven tremble" (Job 26:11).

L. "its back of gold":

M. this refers to teachings of the Torah: "More to be desired are they than gold, yes, than much fine gold" (Ps. 19:11).

N. "its seat of purple":

O. "To him who rides upon the heaven of heavens, which are of old" (Ps. 68:34).

P. "it was lovingly wrought within by the daughters of Jerusalem":

Q. R. Berekhiah and R. Bun in the name of R. Abbahu: "There are four proud [creatures]:

R. "The pride of birds is the eagle.

S. "The pride of domesticated beasts is the ox.

T. "The pride of wild beasts is the lion.

U. "The pride of them all is man.

V. "And all of them did the Holy One, blessed be he, take and engrave on the throne of glory: 'The Lord has established his throne in the heavens and his kingdom rules over all' (Ps. 103:19).

W. "Because 'The Lord has established his throne in the heavens,' therefore: 'his kingdom rules over all.'"

From the ark we move on to the sanctuary, with predictable results; primary is the object chosen as metaphor, secondary is the expansion of the verses that are used to amplify the connection. That the framers have nothing new to say, once they have selected their basic object for metaphorization, is shown at the end, which is repeated verbatim. That shows that the motivation derives not from the base verse but from the basic plan. The move from the Temple to the natural world is not surprising, since the Temple and its cult are understood to correspond to the world beyond the walls, which focus within; there the produce of nature is offered to the supernatural. So the symbolism moves on a steady course. The next move is from this world upward to God. The conclusion is truly triumphant, as we now succeed in holding together within the single metaphor earth with heaven. The palanquin has stood for each of the principal components of the world of sanctification, in nature, cult, and supernature. All is made explicit. The love, then, is cosmopolitan: King Solomon's palanquin is all of reality, which loves, and is loved by, God.

So far I have shown successful utilizations of symbolic discourse, as though there were no limitations. But the opacity of the symbols that are used imposes its limitations, since combinations of opaque symbols without recombination with the elements of a parsed verse, and without successive restatements of those combinations and recombinations, yield no sense, or nonsense. The fundamental rules of symbolic discourse then are (1) sufficient repetition to establish a series and (2) sufficient cogency among the recombinations to set forth intelligible sense.[7] An instance of the limitations of symbolic discourse is as follows. To show how symbolic discourse may yield either ambiguity or no clear meaning at all, I give no. 1 only at the end. Here without that opening narrative the real point of the combination of names and verse is not entirely blatant. So the compositor has had to join two media of discourse, the symbolic and the narrative, to make his point. But then he does so with enormous effect:

7. As noted earlier, some combinations even without recombination with the parsed verse also bear clearly intelligible sense, but this seems to me exceptional.

Song of Songs Rabbah LXXXVIII:I

2. A. Another explanation of the verse, "Before I was aware, my fancy set me in a chariot beside my prince":

 B. Scripture speaks of the righteous Joseph.

 C. Yesterday: "His feet they hurt with fetters, his person was laid in iron" (Ps. 105:18).

 D. Today: "And Joseph was the governor over the land" (Gen. 42:6).

 E. So in his own regard he recited the verse, "Before I was aware, my fancy set me in a chariot beside my prince."

3. A. Another explanation of the verse, "Before I was aware, my fancy set me in a chariot beside my prince":

 B. Scripture speaks of David.

 C. Yesterday he was escaping from Saul.

 D. Today: "David was king" (2 Sam. 8:15).

 E. So in his own regard he recited the verse, "Before I was aware, my fancy set me in a chariot beside my prince."

4. A. Another explanation of the verse, "Before I was aware, my fancy set me in a chariot beside my prince":

 B. Scripture speaks of Mordecai.

 C. Yesterday: "He put on sackcloth with ashes" (Esther 4:1).

 D. Today: "And Mordecai went forth from the presence of the king in royal apparel of blue and white" (Esther 8:15).

 E. So in his own regard he recited the verse, "Before I was aware, my fancy set me in a chariot beside my prince."

5. A. Another explanation of the verse, "Before I was aware, my fancy set me in a chariot beside my prince":

 B. Scripture speaks of the Community of Israel.

 C. The Community of Israel says to the nations of the world, "'Do not rejoice against me, O my enemy; though I have fallen, I shall arise' (Micah 7:8).

 D. "When I dwelled in darkness, the Holy One, blessed be he, brought me forth to light: 'Though I sit in darkness, the Lord is a light to me' (Micah 7:8)."

 E. So in her own regard she recited the verse, "Before I was aware, my fancy set me in a chariot beside my prince."

Joseph, David, and Mordecai—all went from difficult circumstances to the heights, and then the Community of Israel, for whom they stand, no. 5. Listing the names with the cited verse evidently is not deemed sufficient to make the point. For the compositor began with no. 1. Now we can see how symbolic discourse and propositional discourse (here: in narrative form) are joined.

1. A. "Before I was aware, my fancy set me in a chariot beside my prince":

 B. It was taught on Tannaite authority by R. Hiyya, "The matter may be

compared to the case of a princess who went out gathering stray sheaves.

C. "The king turned out to be passing and recognized that she was his daughter.

D. "He sent out his friend to take her and seat her with him in the carriage.

E. "Now her girl friends were surprised at her and said, 'Yesterday you were gathering stray sheaves, and today you are seated in a carriage with the king.'

F. "She said to them, 'Just as you are surprised at me, so I am surprised at myself, and I recited in my own regard the following verse of Scripture, "Before I was aware, my fancy set me in a chariot beside my prince."'

G. "Thus too when the Israelites were enslaved in Egypt in mortar and bricks, they were rejected and despised in the view of the Egyptians.

H. "But when they were freed and redeemed and made prefects over everyone in the world, the nations of the world expressed surprise, saying, 'Yesterday you were working in mortar and bricks, and today you have been freed and redeemed and made prefects over everyone in the world!'

I. "And the Israelites replied to them, 'Just as you are surprised at us, so we are surprised at ourselves,' and they recited in their own regard, 'Before I was aware, my fancy set me in a chariot beside my prince.'"

The basic attitude is that what will happen to Israel in time to come will surprise not only the nations but also Israel herself. That is the point of no. 1. Seeing the whole together, we realize how the compiler has utilized both symbolic discourse and narrative discourse to good effect.

My final example shows how a protracted discourse is worked out. It is important as an instance of the reason the authors and compositors of Judaism's reading of Song of Songs chose symbolic discourse: the remarkable power to say much through little. People intending to speak about God and their relationship with God, and God's relationship with them, rich in a tradition of writing with Scripture but poor in a literary tradition of poetry,[8] did well to recast language. They emptied words of determinate meaning, yielding a shell of associations and connotations alone. They then explored, for the topic at hand, the potentialities of the manipulation of such words, transformed into opaque symbols, and

8. There is not a single compilation of poetry in all of the canon of Judaism in its formative age. Indeed, I am not entirely certain what the authors of that age will have regarded as poetry. I have, of course, traced the mnemonics of the Mishnah, which resemble poetry in certain formal aspects. But if the poetry of Isaiah or Job sets the standard, then there is simply no counterpart in the whole of rabbinic literature in late antiquity.

discovered a medium of communicating their message that was quite unique. In words but not poetry, appealing to images but not iconic, drawing upon symbols that, in the aggregate, were not visual and could not be visualized,[9] they succeeded in conveying what was on their minds and in their hearts on what mattered most of all: God and Israel, God in us, we in God. And this they did economically, whether in few symbols or in many, because symbols stand for much, and, rightly manipulated, say more than words can ever make explicit.

CX:I

1. A. "We have a little sister":
 B. this refers to Israel.
 C. R. Azariah in the name of R. Judah b. R. Simon: "All the angelic princes who watch over the nations of the world in the coming age are going to come and make the case against Israel before the Holy One, blessed be he, saying, 'Lord of the world, these have worshiped idols, and those have worshiped idols. These have fornicated and those have fornicated. These have shed blood and those have shed blood. How come these go down to Gehenna, while those do not go [to hell]?'
 D. "The Holy One, blessed be he, will say to them, 'We have a little sister.' Just as in the case of a child, whatever he does, people do not stop him—why? because he's a child, so in the case of however the Israelites soil themselves all the days of the year through their transgressions, when the Day of Atonement comes, it effects atonement in their behalf: 'For on this day shall atonement be made for you' (Lev. 16:30)."

2. A. R. Berekhiah interpreted the verse to speak of our father, Abraham:
 B. "'We have a little sister': this refers to Abraham, as it is said, 'Abraham was one and he inherited the land' (Ezek. 33:24).
 C. "[The sense is,] he stitched together all those who pass through the world before the Holy One, blessed be he [since the word for one and stitched together share the same consonants]."
 D. Bar Qappara said, "He was like a man who stitches a tear."
 E. [Continuing C:] "While he was still a child, he engaged in religious duties and good deeds.
 F. "'and she has no breasts': he had not yet reached the age at which he

9. That is, easily represented in iconic form, with a few lines for instance. Try to symbolize the exodus from Egypt or the return to Zion, Sennacherib or Nebuchadnezzar, Joseph or Benjamin or Mordecai, in the economic way in which you can represent the *etrog* and *lulab*, *menorah* and altar, in a very few, easily drawn lines, and you will see the difference between a symbol that is not visual and cannot be visualized (in the sense now given) and one that is visual and is readily drawn. The next chapter spells out the visual symbols used by others in synagogues in more or less the same time—the fifth and sixth centuries—as Song of Songs Rabbah.

was subject to the obligation of carrying out religious duties and good deeds.

G. "'What shall we do for our sister, on the day when she is spoken for?' On the day on which the wicked Nimrod made a decree and told him to go down into the fiery furnace."

No. 1 prepares the way for no. 2. By itself it makes no sense to declare Israel exempt from punishment because it is immature. No. 2 then is continued in what follows. The entire treatment of Song of Songs 8:8 is continuous with 8:9, as we shall now see. Beyond Abraham, we shall have Sodom and Israel, Hananiah, Mishael, and Azariah, the exiles who returned from Babylon, and so on.

CXI:I

1. A. [Continuing CX:i.2:] "If she is a wall, we will build upon her a battlement of silver":
 B. "If she is a wall": this refers to Abraham.
 C. Said the Holy One, blessed be he, "If he insists on his views like a firm wall,
 D. "'we will build upon her a battlement of silver': we shall save him and build him in the world.
 E. "'but if she is a door': if he is poor [a word that uses consonants that appear also in the word for door], impoverished of religious duties and [Simon:] sways to and fro in his conduct like a door,
 F. "'we will enclose her with boards of cedar': just as a drawing [a word that uses the same consonants as the word for enclose] lasts for only a brief hour, so I will stand over him for only a brief time. [Simon, p. 312 n. 2: In his own lifetime only, but his merit will not be so great that I should stand by his children for his sake.]"
 G. Said Abraham before the Holy One, blessed be he, "'I was a wall': and I shall be insistent upon my habit of doing good deeds like a firm wall.
 H. "'and my breasts were like towers': for I am destined to raise up parties and fellowships of righteous men in my model in your world."
 I. "then I was in his eyes as one who brings peace":
 J. Said to him the Holy One, blessed be he, "Just as you descended into the fiery furnace, so I shall bring you out in peace: 'I am the Lord who brought you out of the furnace of the Chaldaeans' (Gen. 15:7)."

The first reading of the verse, which began in the preceding chapter, is fully worked out, with enormous care as to matching details, and the metaphor of the little sister has God praise Abraham. We proceed to a quite separate reading of the same metaphor. I see no interpolated material, only a sustained and well-crafted exposition of one thing in terms of something else, beautifully articulated.

Song of Songs Rabbah CXI:II

1. A. R. Yohanan interpreted the verses to speak of Sodom and of Israel:
 B. "'We have a little sister': this refers to Sodom: 'And your elder sister is Samaria . . . and your younger sister . . . is Sodom' (Ezek. 16:46).
 C. "'and she has no breasts': for she has not sucked of the milk of religious duties and good deeds [by contrast to Abraham].
 D. "'What shall we do for our sister, on the day when she is spoken for': on the day on which the heavenly court made the decree that she is to be burned in fire: 'Then the Lord caused to rain upon Sodom and upon Gomorrah brimstone and fire' (Gen. 19:24).
 E. "'If she is a wall, we will build upon her a battlement of silver': this refers to Israel.
 F. "Said the Holy One, blessed be he, 'If they stand firm in their good deeds like a wall, we will build upon them and deliver them.'
 G. "'but if she is a door': if they [Simon:] sway to and fro in their conduct like a door,
 H. "'we will enclose her with boards of cedar': [God continues] 'just as a drawing lasts for only a brief hour, so I will stand over him for only a brief time.'
 I. "'I was a wall': said the Israelites before the Holy One, blessed be he, 'Lord of the world, we are a wall, and we shall stand by the religious duties and good deeds [that we practice] as firm as a wall.'
 J. "'and my breasts were like towers': 'for we are destined to raise up parties and fellowships of righteous men in my model in your world.'
 K. "'then I was in his eyes as one who brings peace': why so? For all the nations of the world taunt Israel, saying to them, 'If so, why has he sent you into exile from his land, and why has he destroyed his sanctuary?'
 L. "And the Israelites reply to them, 'We are like a princess who went to celebrate in her father's house the [Simon:] first wedding anniversary after her marriage. [That is why we are in exile in Babylonia.]'"
2. A. Another interpretation of "If she is a wall":
 B. this refers to Hananiah, Mishael, and Azariah.
 C. Said the Holy One, blessed be he, "If they stand firm in their good deeds like a wall, we will build upon them and deliver them.'
 D. "'but if she is a door': if they sway to and fro in their conduct like a door,
 E. "'we will enclose her with boards of cedar': [God continues] just as a drawing lasts for only a brief hour, so I will stand over them for only a brief time."
 F. "I was a wall": said they before the Holy One, blessed be he, "[Lord of the world,] we are a wall, and we shall stand by the religious duties and good deeds [that we practice] as firm as a wall.
 G. "'and my breasts were like towers': for we are destined to raise up parties and fellowships of righteous men in my model in your world."

H. "then I was in his eyes as one who brings peace":

I. Said to them the Holy One, blessed be he, "Just as you have gone down into the fiery furnace in peace, so I shall bring you out of there in peace: 'Then Shadrach, Meshach, and Abednego came forth' (Dan. 3:26)."

We see now how carefully matched the treatments of the base verses are. The possibility of understanding 1.L, in particular, derives solely from the initial reading in terms of Abraham. And that seems to me the point of the exercise, thus far: to link Israel's exile to Babylonia to Abraham's initial origin. Not only so, but the link between Abraham in the fiery furnace and Shadrach, Meshach, and Abednego is explicit. That proves beyond a doubt the unity of the "another interpretation" and shows that the whole was planned as a single composition to express one fundamental and encompassing point. The third and final exposition, which completes the set, confirms that view.

CXI:III

1. A. Rabbis interpret the verses to speak of those who came up from the exile:

B. "'We have a little sister': this refers to those who came up from the exile.

C. "'little': because they were few in numbers.

D. "'and she has no breasts': this refers to the five matters in which the second house [Temple] was less than the first one:

E. "[1] fire from above, [2] anointing oil, [3] the ark, [4] the Holy Spirit, and [5] access to the Urim and Thumim: 'And I will take pleasure in it and I will be glorified says the Lord' (Hag. 1:8), with the word for 'I will be glorified' written without the letter H, which stands for five.

F. "'What shall we do for our sister, on the day when she is spoken for': on the day on which Cyrus issues the decree, 'Whoever has crossed the Euphrates has crossed, but whoever has not crossed will not cross.'

G. "'If she is a wall': if the Israelites had gone up like a wall from Babylonia, the house of the sanctuary that they built at that time would not have been destroyed a second time [a sufficiently large population having been able to defend it]."

2. A. R. Zeira went out to the market to buy things and said to the storekeeper, "Weigh carefully."

B. He said to him, "Why don't you get out of here, Babylonian, whose fathers destroyed the Temple!"

C. Then R. Zeira said, "Are my fathers not the same as that man's fathers?"

D. He went into the meetinghouse and heard R. Shila's voice in session,

expounding, "'If she is a wall': if the Israelites had gone up like a wall from Babylonia, the house of the sanctuary that they built at that time would not have been destroyed a second time."

E. He said, "Well did that ignoramus teach me."

3. A. [Reverting to 1.G:] "'but if she is a door, we will enclose her with boards of cedar': just as in the case of a drawing, if it is removed, still its traces are to be discerned,

B. "so even though the house of the sanctuary has been destroyed, the Israelites have not annulled their pilgrim festivals three times a year."

C. "I was a wall":

D. Said R. Aibu, "Said the Holy One, blessed be he, 'I am going to make an advocate for Israel among the nations of the world.'

E. "And what is it? It is the echo: 'Except the Lord of hosts had left to us a very small remnant' (Isa. 1:9)."

4. A. It has been taught on Tannaite authority:

B. Once the final prophets, Haggai, Zechariah, and Malachi had died, the Holy Spirit ceased from Israel.

C. Even so, they would make use of the echo.

5. A. There was the case of sages voting in the upper room of the house of Gedia in Jericho. An echo came forth and said to them, "There is among you one man who is worthy of receiving the Holy Spirit, but his generation is not suitable for such to happen."

B. They set their eyes upon Hillel the Elder.

C. When he died, they said in his regard, "Woe for the modest one, woe for the pious one, the disciple of Ezra."

6. A. There was another case, in which the Israelite sages took a vote, in the vineyard in Yavneh.

B. Now were they really *in* a vineyard! Rather, [they were like a vineyard, for] this was the Sanhedrin, that sat in rows and rows, lines and lines, like a well-ordered vineyard.

C. An echo came forth and said to them, "There is among you one man who is worthy of receiving the Holy Spirit, but his generation is not suitable for such to happen."

D. They set their eyes upon Samuel the Younger.

E. When he died, they said in his regard, "Woe for the modest one, woe for the pious one, the disciple of Hillel the Elder."

7. A. Also: he said three things when he was dying: "Simeon and Ishmael are for the sword, the rest of his colleagues are destined to be killed, the rest of the people to be plundered, and great sufferings are going to come upon the world."

B. This he said in Aramaic.

8. A. Also: for Judah b. Baba they ordained that when he died, they should say of him, "Woe for the modest one, woe for the pious one, the disciple of Samuel,"

B. but the time was inappropriate, for people do not conduct public funeral services of mourning for those put to death by the government.

9. A. There was the case in which Yohanan, the high priest, heard an echo come forth from the Most Holy Place, saying, "The young men who went out to war have won at Antioch."

B. They wrote down that day and that hour, and that is how matters were: on that very day they had won their victory.

10. A. There was the case in which Simeon the Righteous heard an echo come forth from the Most Holy Place, saying, "The action has been annulled that the enemy has planned to destroy the Temple, and Caius Caligula has been killed and his decrees annulled."

B. This he heard in Aramaic.

11. A. [Explaining the difference between the echo and the Holy Spirit or prophecy,] R. Hunia in the name of R. Reuben: "When the king is in town, people appeal to him and he acts.

B. "If the king is not in town, his icon is there.

C. "But the icon does not act in the way that the king can act."

12. A. R. Yohanan and R. Samuel b. R. Nahman:

B. R. Yohanan said, "'But the Lord will give you there a trembling heart' (Deut. 18:65):

C. "When they went up from exile, trembling, having been given to them, went up with them."

D. R. Samuel b. R. Nahman said, "There [in Babylonia] was trembling, but when they went up, they were healed."

13. A. When R. Simeon b. Laqish saw them [Babylonians] swarming in the marketplace [in the Land of Israel], he would say to them, "Scatter yourselves."

B. He would say to them, "When you went up, you did not come up as a wall [of people 1.G], now have you come to form a wall [of people]?"

14. A. When R. Yohanan would see them, he would rebuke them, saying, "If a prophet can rebuke them, 'My God will cast them away, because they did not listen to him' (Hos. 9:17),

B. "can I not rebuke them?"

15. A. Said R. Abba b. R. Kahana, "If you have seen the benches in the Land of Israel filled with Babylonians, look forward for the coming of the Messiah.

B. "How come? 'He has spread a net for my feet' (Lam. 1:13). [The word for net has consonants shared with the word for Persians, so, Simon, p. 317 n. 1, 'The presence of Babylonians (Persians) is a net to draw the Messiah.']"

16. A. R. Simeon b. Yohai taught on Tannaite authority, "If you have seen a Persian horse tied up to gravestones in the Land of Israel, look forward to the footsteps of the Messiah.

B. "How come? 'And this shall be peace: when the Assyrian shall come

into our land, and when he shall tread in our palaces, then shall we raise against him seven shepherds and eight princes among men' (Micah 5:4)."

17. A. [Supply: "And this shall be peace: when the Assyrian shall come into our land, and when he shall tread in our palaces, then shall we raise against him seven shepherds":]

B. Who are the seven shepherds?

C. David in the middle, to the right, Adam, Seth, and Methuselah; to the left, Abraham, Jacob, and Moses.

D. Where is Isaac? He goes and takes a seat at the gate of Gehenna to deliver his descendants from the punishment of Gehenna.

E. "and eight princes among men":

F. Who are the eight princes?

G. Jesse, Saul, Samuel, Amos, Zephaniah, Hezekiah, Elijah, and the Messiah.

The final exposition reverts to the exile in Babylonia, now with reference to the return to Zion, so nos. 1, 3, with a minor interpolation at no. 2. The main point of the whole then cannot be missed. The history of Israel from Abraham to the exile and back to the Land, encompassing also Israel in the Land after the destruction of the second Temple, is brought into relationship, and, at the end, the resolution of the tension lies in Israel's access to continuing divine revelation through the echo. How this fits with the allegation that in the second Temple there was no Holy Spirit is quite clear, and, in context, an effective statement: the Holy Spirit, Urim and Thummim, and other means of access to heaven have now been succeeded by the echo. That, and one other consideration, account also for tacking on the heavenly-echo materials that follow.

The other consideration is that Hillel came from Babylonia—so the materials available to our compilers believed—and, as is made explicit here, he was disciple of Ezra, in that he came from Babylonia to the Land of Israel and brought with him the Torah, just as Ezra had. So the inclusion is not an accident and not a mere secondary expansion for essentially agglutinative reasons; it is deliberate and further enriches the compilers' program and plan for this enormous and successful, cogent statement of theirs. What this proves is that symbolic, narrative, and analytical and propositional discourse served a single purpose, whatever the compositors of a set of compositions thought that purpose might be. And it is clear that the compositors, and even authors of compositions, had a clear sense that one kind of discourse served best for one sort of topic or theme or problem, another for a different one. So I have at the end to answer the question: Why this, not that?

METAPHOR AND SYMBOL

Song of Songs Rabbah, the most sublime of the writings of "our sages of blessed memory," forms the theological counterpart to the Mishnah and to the Bavli. Like those two foundation documents, respectively, it set forth a complete and cogent statement of an entire system, simple and pure in its proposition and complex, subtle, and artful in its articulation. But unlike them, it did so through a portrait—a vision conveyed in words. Why the difference? Working our way from what was said to why what was said was stated in one way rather than in another, we find an answer. It is that, for talking of God and conveying thought on God's relationship to Israel and Israel's relationship to God, symbolic, rather than narrative or propositional, discourse was found singularly appropriate. The scriptural data dictated the preference. When sages wanted to know about how God loved Israel and Israel God, they opened the Song of Songs. There they were given an account of that relationship through the medium of metaphors, in poetry.

But sages were not poets, as I said earlier, and did not think in metaphor and produce poetry. They thought in propositions and produced, in the Mishnah, a philosophical system for the social order; in the Talmud of the Land of Israel, a religious system for the social order; and in the Talmud of Babylonia, even a theological statement of that same religious system.[10] So metaphorical thinking, yielding poetry, lay beyond their power of expression. To accomplish their goal, they resorted to discourse of the same genus as poetry, but of a different species: symbolic discourse. Specifically, as we have seen, they dismantled the poetry of Song of Songs and used the parts to compose a discourse of another kind, treating the metaphors as opaque, joining them to equally opaque symbols, the whole in verbal form. Out of that enterprise emerged the

10. I refer to the findings of these books of mine: *The Making of the Mind of Judaism* (Brown Judaic Studies; Atlanta: Scholars Press, 1987); *The Economics of the Mishnah* (Chicago: University of Chicago Press, 1990); *The Formation of the Jewish Intellect: Making Connections and Drawing Conclusions in the Traditional System of Judaism* (Brown Judaic Studies; Atlanta: Scholars Press, 1988); *Rabbinic Political Theory: Religion and Politics in the Mishnah* (Chicago: University of Chicago Press, forthcoming); *The Philosophical Mishnah*, Vol. 1: *The Initial Probe;* vol. 2: *The Tractates' Agenda: From Abodah Zarah through Moed*; vol. 3: *The Tractates' Agenda: From Nazir to Zebahim*; vol. 4: *The Repertoire* (all: Brown Judaic Studies; Atlanta: Scholars Press, 1989); *The Mishnah as Philosophy* (Columbia, S.C.: University of South Carolina Press, 1991); and *The Transformation of Judaism: From Philosophy to Religion* (Champaign, Ill.: University of Illinois Press, 1991). My next major project will justify the reference to the Talmud of Babylonia: *The Transformation of Judaism: From Religion to Theology*. The planned work will deal with the movement of category formation from the Yerushalmi to the Bavli.

sustained theological structure we have now reviewed in vast detail: a structure, not a system, but a structure entirely able to sustain a system.

Reading the Song of Songs as a metaphor for Israel's love for God and God's love for Israel, sages interpreted the metaphor, stating, in considerable measure in symbolic discourse, their response to it. So in a systematic and orderly way through the manipulation of symbols they set forth the entire theological structure, the "Judaism," to which the whole canon of the dual Torah of late antiquity points. Song of Songs Rabbah joins metaphor to theology, symbol to structure.[11] We should therefore not find surprising the simple fact that much of the message of Song of Songs Rabbah is expressed in symbolic discourse, not in propositional and syllogistic discourse. The Song itself being a metaphor, its interpretation takes a form that is appropriate. The symbolic structure of the canon reaches its richest expression in the document before us. But symbolic discourse in Judaism in the time of the compilation and the closure of Song of Songs Rabbah took place not only in opaque symbols in verbal form but also in symbols in iconic form. We now turn to survey the kinds of visual symbols that were used and where they occur.[12]

11. I distinguish theological structure, a static tableaux, from theological system, a dialectical, analytical, and of necessity propositional argument. Symbolic discourse yields a structure of theology; propositional discourse, including analytical discourse, yields a system. A structure stands intact and inert, placing truth on display. A system begins, makes points, leads onward, and ends with conclusions. As a matter of fact, Song of Songs Rabbah contains not only symbolic but also propositional discourse, and it not only places theological truth on display through the combination and recombination of "theological things," it also advances theological argument in behalf of theological propositions. Only the former kind of discourse is set forth in this chapter.

12. What is at stake in this survey and its results will emerge in chapter 9.

8

Symbolic Discourse in Iconic Form

THE ARCHAEOLOGICAL EVIDENCE.
WITH TABLES BY ANDREW G. VAUGHN,
AS REVISED BY JAMES F. STRANGE

THE ART OF THE SYNAGOGUES AND
SYMBOLIC DISCOURSE IN JUDAISM

Most synagogues built from the third to the seventh century, both in the land of Israel and abroad, had decorated floors or walls. Some symbols out of the religious life of Judaism or of Greco-Roman piety occur nearly everywhere. Other symbols, available, for example, from the repertoire of items mentioned in Scripture, or from the Greco-Roman world, never make an appearance at all. A *shofar,* a *lulab* and *ethrog,* a *menorah,* all of them Jewish in origin, but also such pagan symbols as a Zodiac, with symbols difficult to find in Judaic written sources—all of these form part of the absolutely fixed symbolic vocabulary of the synagogues of late antiquity. By contrast, symbols of other elements of the calendar year, at least as important as those that we do find, turn out never to make an appearance. And, obviously, a vast number of pagan symbols proved useless to Judaic synagogue artists. It follows that the artists of the synagogues spoke through a certain set of symbols and ignored other available ones. That simple fact makes it highly likely that the symbols they did use meant something to them, represented a set of choices, delivered a message important to the people who worshiped in those synagogues.

Because the second commandment forbids the making of graven images of God, however, people have long taken for granted that Judaism should not produce an artistic tradition. Or, if it does, it should be

essentially abstract and non-representational, much like the rich decorative tradition of Islam. But from the beginning of the twentieth century, archaeologists began to uncover in the Middle East, North Africa, the Balkans, and the Italian peninsula, synagogues of late antiquity richly decorated in representational art. For a long time historians of Judaism did not find it possible to accommodate the newly discovered evidence of an on-going artistic tradition. They did not explain that art, they explained it away. One favorite explanation was that "the people" produced the art, but "the rabbis," that is, the religious authorities, did not approve it or at best merely tolerated it. That explanation rested on two premises. First, because talmudic literature—the writings of the ancient rabbis over the first seven centuries of the common era—made no provision for representational art, therefore representational art was subterranean and "unofficial." Second, rabbis are supposed to have ruled everywhere, so the presence of iconic art had to indicate that rabbinic authority was either absent or ignored.

Aware of the existence of sources which did not quite fit into the picture that emerged from talmudic literature as it was understood in those years or which did not serve the partly apologetic purposes of their studies, scholars such as George Foot Moore in his *Judaism: The Age of the Tannaim*[1] posited the existence of "normative Judaism," which is to be described by reference to talmudic literature and distinguished from "heretical" or "sectarian" or simply "non-normative" Judaism of "fringe sects." Normative Judaism, exposited so systematically and with such certainty in Moore's *Judaism*, found no place in its structure for art, with its overtones of mysticism (except "normal mysticism"), let alone magic, salvific or eschatological themes except within a rigidly reasonable and mainly ethical framework; nor did Judaism as these scholars understood it make use of the religious symbolism or ideas of the Hellenistic world, in which it existed essentially apart and at variance.

Today the testimony of archaeology, especially of the art of the synagogues of antiquity, finds a full and ample hearing. In understanding the way in which art contributes to the study of the history of a religion, we find in Judaism in late antiquity a fine example of the problems of interpretation and how they are accommodated and solved. In this chapter I undertake what I believe to be a fresh approach to the problem of interpretation:[2] dealing with the evidence in a gross and summary way,

1. Cambridge, 1927: Harvard University Press.
2. In Appendix Two I introduce the approach to the interpretation of synagogue art and its symbolism that is worked out by Erwin R. Goodenough.

asking what, among the many objects that are represented in many dozens of sites, on the surface should represent symbolic utilization of iconic representations. Specifically, I offer an account of the objects that I think we can show were used symbolically. Then we shall compare the symbolic vocabulary represented by those objects with the symbolic vocabulary yielded by the literary evidence.

TESTING THE HYPOTHESIS
YIELDED BY LITERARY EVIDENCE

We recall that in writings addressing the relationship of God and Israel, and of Israel and God, symbolic discourse went forward within, and alongside, propositional-analytical and narrative discourse. Symbolic discourse proved distinctively important in Song of Songs Rabbah, generally assigned a date in the sixth century. So a mode of discourse formerly unimportant among the writers of documents later deemed canonical now served in a quite specific context. It was for the expression of religious feeling, the communication, in words, of religious sentiments. Synagogue decoration in the fourth, fifth, and sixth centuries, we shall now see, likewise utilized symbols for the communication of religious sentiments. A restricted vocabulary of symbols served. A single mode of discourse came to prominence in the same age and for the same purpose, so it will appear. We have now to ask, Do we have other evidence about means of communication for sentiments or attitudes of the same order? And, if we do, does that evidence also point toward the resort, among Judaic believers, to symbolic discourse for the expression of those sentiments?

The answer to both questions is affirmative. Synagogues, ordinarily left without symbolic decoration prior to the period under discussion— the fourth, fifth, and sixth centuries—at this time were commonly given symbolic decoration. And, we shall see, a strikingly limited repertoire of symbols predominated. I earlier stipulated that to be symbolic a sign must prove, if not ubiquitous, then commonplace, that is, appear in more than a single venue. Second, to be symbolic signs must represent a highly restricted vocabulary, so that some few recur very broadly and many possible ones (out of the same corpus) not at all. Signs meant to serve as symbols are therefore distinguished, in iconic form, by three traits: (1) the function and provenance, within a synagogue; (2) the combination or relationship with other representations of things; and (3) the selection of those few things among many that can have been repre-

sented.[3] We shall now see that these conditions are met by synagogue iconic representation in the fourth, fifth, and the sixth centuries, so it would appear that symbolic discourse as a medium for the expression of religious feeling served not only the authors of compositions and compilers of composites but also the patrons and artists responsible for the decoration of synagogues. A brief survey of the data, summarily reviewed, validates that claim.

SYNAGOGUE ICONOGRAPHY: THE DISTRIBUTION OVER TIME

The convergence of modes of discourse in literary and iconic evidence is what I propose to show in this section. Specifically, the tables that follow, prepared by Andrew G. Vaughn, as revised by James F. Strange, yield a simple result.[4] (1) If synagogues were decorated at all before the fifth and sixth centuries (and many were), they exhibited diverse iconic representations, and, so far as we can see, no severely limited repertoire of iconic items governed. By contrast, (2) most synagogues were decorated in the fifth and sixth centuries, and among them, (3) most utilized a severely restricted symbolic vocabulary. By the criteria just now set forth, therefore, the marks of symbolic discourse then are exhibited by the iconic evidence of Judaism in the fifth and sixth centuries.[5]

Let us start with the distribution of iconography. The following summary shows that from the second century onward it became routine to decorate synagogues in one way or another.

3. An entirely separate study of the symbolism of the synagogue poetry, produced in these same years, will prove important in the extension of the theory that is here proposed. But I am not able to undertake that study, and I am unable to identify studies that provide the information to permit description, for the present purpose, of the data of the *piyyut* writings.

4. In addition to Vaughn's research, I consulted Eric R. Meyers and James F. Strange, *Archaeology, the Rabbis, and Early Christianity* (Nashville: Abingdon Press, 1981); and Moshe Dothan, "Research on Ancient Synagogues in the Land of Israel," *Recent Archaeology in the Land of Israel*, Hershel Shanks and Benjamin Mazar; (Washington and Jerusalem: Biblical Archaeology Society and Israel Exploration Society, 1981) 89–96. Dothan refers to 120 synagogues discovered in the Land of Israel, with 70 investigated. The provenance in time is pretty much as represented here. His interest is in synagogue layout and design. He marks off the fourth century as a transitional period. It seems to me the shift in decoration signaled in Vaughn's tables accords with that well-established view. Further bibliography is in Chiat, cited below. My former colleague, Professor Calvin Goldscheider, Department of Sociology and Program in Judaic Studies, Brown University, kindly reviewed my tables and gave me the benefit of his criticism.

5. At this point I do not differentiate between the Land of Israel and the Greco-Roman diaspora.

Century	Decorated Synagogues		Undecorated Synagogues	
I	1	25%	3	75%
II	4	66%	2	33%
III	24	75%	8	25%
IV	20	69%	9	31%
V	18	90%	2	10%
VI	8	73%	3	27%
[Undated	15	35%	28	65%]

The category of undated synagogues, if distributed among the centuries in proper proportions, would not significantly change the picture. The fifth century, then, was the heyday of synagogue decoration, in that nearly all synagogues dated to that period yield iconic evidence. But was that evidence of the sort to indicate that people found symbolic discourse compelling? After a review of Vaughn's tables, as revised by James F. Strange,[6] we proceed to the next exercise.

First Century
Gamla — Rosette
Gamla — Meanders, swastikas
Herodium — None
Magdala — None
Masada — None
Second Century
Emmaus — None
Gaza — Oil jug
Nabratein — None
Third Century
Akhmadiyye — Menoroth, two seven-branched
Eagle
Bird

6. Source throughout: Marilyn Chiat, *Handbook of Synagogue Architecture* (Chico, 1980: Scholars Press for Brown Judaic Studies). Other sources (consulted by James F. Strange): Marilyn Chiat, *Handbook of Synagogue Architecture* (Chico, 1980: Scholars Press for Brown Judaic Studies). Supplemented by Michael Avi-Yonah, editor, *Encyclopedia of Archaeological Excavations in the Holy Land* (Jerusalem: The Israel Exploration Society and Massada Press, 1975); Virgilio C. Corbo, Cafarnao I: *Gli edifici della Citta* (Jerusalem: Franciscan Printing Press, 1975); Moshe Dothan, *Hammath Tiberias*. Series: Ancient Synagogue Studies. Jerusalem: Israel Exploration Society, University of Haifa, and the Department of Antiquities and Museums, 1983); Lee I. Levine, editor, *Ancient Synagogues Revealed* (Jerusalem: The Israel Exploration Society, 1981); Hershel Shanks, *Judaism in Stone: The Archaeology of Ancient Synagogues* (New York: Harper & Row and Washington: Biblical Archaeology Society, 1979); Eleazar Lipa Sukenik, *The Ancient Synagogue of Beth Alpha* (Hildesheim, New York: Georg Olms Verlag, 1975 = reprint of Jerusalem: At the University Press, 1932).

Akhmadiyye, *cont.*	Vine, grape
	Grape cluster
	Menorah, nine-branched
	Shofar
	Flowers
	Ethrog
	Amphora
Alma	Leaves, ornamental
	Rosette, six-petalled
Apheka	Menorah, five-branched
	Menorah
	Shofar
	Menorah, nine-branched
	Ethrog
	Menorah, seven-branched
Arbela	Vine scroll?
Batra	Vine scroll
	Shell
	Amphorae, two small
Bet Akkar	None
Butmiyyeh	Crosses, rectilinear
	Ethrogs
	Clover, four leaf
	Menorah, ten-branched
	Menorah, ten-branched
	Wheel, spoked
Dabiyye	Menorot, two seven-branched
Dalton	None
Ed-Dankalle	Wreath tied with a Hercules knot
	Menorah
	Menorot, two seven-branched
	Wreath tied with a Hercules knot
	Cross
	Wheel
Ed-Dikke	Wreath
	Vine rinceau
	Genii, two (victories?)
	Rosette
En-Gedi	Swastika
Er-Ramah	Genii, two winged
	Wreath
Gaza	Shofar
	Menorah
	Menorah, seven-branched
	Lulab

Gaza, *cont.*	Ethrog
	Leaves, laurel
Gush Halav	Eagle holding a garland
Hammath-Tiberias	Vine trellis
	Flowers
Horvat Amudim	Lions
	Wreath
Horvat Ofrat	None
Horvat Summaqa	Eagle
Huha	Eagle
Kefar Bar'am	Torus, twisted ropelike
	Genii, two
	Hercules knot
	Crown of olive leaves
	Leaf pattern, bay
	Wreath
	Genii, two winged
	Rosette
	Vine scrolls
	Lion's head, 3-dimensional
Khirbet Shema	Menorah, seven-Branched
	Eagle in a garland
	Rosettes
Khirbet Tieba	Plants
	Birds (eagles?)
	Birds (eagles?)
Kokhav Ha-Yarden	Rosettes
	Shofar
	Vines
	Grape leaves
	Lulab
	Plants
	Menorah, seven-branched
	Geometric patterns
	Incense shovel
	Torah Shrines, two
Nabratein	Torah Shrine
	Lions, two
	Rosettes
	Shell
	Menorah, seven-branched
Nazareth	None
Peqi'in	Shell
	Shofar
	Grapevine

Peqi'in, *cont.* Ethrog
 Torah Shrine
 Menorah, seven-branched
 Lulab
 Incense Shovel
Qazyon None
Rafid Cross
 Birds (doves?)
Safed Eagle
Summaqa Menorah, seven-branched
Tiberias Birds, two
 Menorot
 Menorah
 Menorah, seven-branched
 Shell
 Vines, grape
Yahudiyye Menorah, five-branched
Fourth Century
Ascalon Lulab
 Menorah, seven-branched
 Shofar
 Menorah, seven-branched
 Ethrog
 Shofars
 Ethrogs
Beth Guvrin Menorah, seven-branched
 Amphora, gadrooned
Daburra Man
 Eagles holding snakes, two
 Animal: fish
 Meander (swastikas)
 Eagle
Dabyrah Wreath tied with a Hercules knot
 Shell
 Birds, two
 Man and Child
 Eagles
 Animals: snakes
 Eagle
 Animal: fish
 Wheel
 Amphora
 Wreath tied with a Hercules knot
 Figures, two winged (Genii?)
David's Tomb None

En Gedi	Birds, peacocks, four pairs
	Grape clusters
	Birds, two pairs
	Menorah, seven-branched
En-Natosh	Lions
	Menorah, seven-branched
Eshtemoa	Amphora
	Menorah
	Shells, two
	Grapevine
	Wreath tied with a Hercules knot
	Star, six-pointed
	Menorah
	Wheel, spoked
	Shell, small
	Wreath tied with a Hercules knot
Hammath Gadera	Lulabs, two
	Wreath tied with a Hercules knot
	Tree, cyprus
	Menorah, seven-branched
	Lions, two
	Wreath tied with a Hercules knot
	Floral motif
Hammath-Tiberias	Zodiac
	Curtain, ark
	Ethrogs, two
	Cross in place of the menorah
	Flowers, four-petaled
	Torah Shrine
	Lulabs, two
	Incense shovels, two
	Menorah, seven-branched
	Menorot, two seven-branched
	Shofars, two
	Shofar
	Four Seasons
	Helios driving his quadriga
	Lions, two
	Vine scroll
	Floral scroll
	Shell
	Amphora
Horvat Al-Ishaqiya	None
Horvat Kishor	Grape cluster
	Menorah, seven-branched

Japhia	Animals: dolphins
	Animal: head of a horned
	Rosettes
	Eagle
	Tree
	Menorah, seven-branched
	Zodiac
	Acanthus leaves
	Animal: oxen
	Wreath tied in a knot
	Medusa Head
	Animal: tiger
	Eagles, two
	Lion's head
Kafr Kanna	None
Khirbet Susiya	Birds
	Torah Shrine
	Lulab
	Ethrog
	Swastikas
	Animals: two stags
	Rosette
	Palm tree surrounded by eagle
	Palm tree surrounded by eagles
	Floral motifs
	Menorot, two seven-branched
	Tree surrounded by lions
	Daniel in the Lion's Den
	Zodiac?
	Grape clusters
	Shell
Meiron	None
	Eagle
Nabratein	Grapevine
	Leaves, Bay or laurel
	Animal: hare
	Lion's head
	Menorah, seven-branched
	Lion, bas-relief
	Hercules knot
Naveh	Shofars
	Lulabs
	Menorah, seven-branched
	Menorah, seven-branched
Qisrin	Menorah, three-branched

Qisrin, *cont.*	Menorah, five-branched
	Amphorae
	Bird: peacock (?)
	Menorah, eleven-branched
	Pomegranates
	Wreath
Rabbat Moabno	None
Rehov	Geometric Patterns
	Lion head
Safsaf	Bucranium
	Hercules knot
	Vine, grape
	Wreath
Salbit	Flowers, four-petaled
	Menorot, seven-branched, two
Sasa	Leaf motif
	Trees, two
	Animal: unidentified
Shiloh	Wreath
	Amphora
	Altar, horned
Tafasno	Ornamentation found
Fifth Century	
Azothus Mesogaeus/Hippenus	Wreath
	Shofar
	Lulab
	Wreath tied in a knot
	Menorah, seven-branched
	Lulab
	Menorah
	Shofar
Beth Alpha	Animal: snake (?)
	Incense shovels
Beth She'an	Grape cluster
	Star motif
	Torah Shrine
	Fruits, various
	Menorot, seven-branched
	Menorah
	Shofars
Caesarea	Menorot, two
	Solomon's knots
Capernaum	Star, six-pointed
	Star, five-pointed
	Acanthus leaves
	Hercules knot

Capernaum, *cont.*	Eagle
	Wreaths, two with ribbon
	Flowers, 5-petaled with swags
	Shell
	Garlands, five
	Acanthus Wreath
	Eagles, two
	Torah Shrine, pedimented
	Genii, three pairs
	Grapevines and clusters
	Carriage, wheeled (Torah Shrine)
	Shell
	Meanders (swastikas)
	Olive branch
	Wreath
	Pomegranate
	Flowers, eight-petaled
	Hercules knot
	Menorah, seven-branched
	Lions, two 3-dimensional
	Lions, two bas-relief
	Torah Shrine, wheeled
	Shofar
	Grape cluster
	Capricorn
	Vine trellis
	Menorah, five-branched
	Palm, date
	Eagles
	Grapevine
	Griffins
	Incense shovel
Chorazin	Man and a Woman
	Lions
	Lions, two, 3-dimensional
	Menorah
	Medusa head
	Lioness
	Vine scroll
	Man holding a staff
	Grape cluster
	Grape cluster
	Centaur
	Chair of Moses
	Lion attacking a Centaur
	Eagle

Chorazin, *cont.*	Menorah
	Acanthus Wreath
En Nashut	Eagle
	Lion
	Hercules knot with snake heads
	Wreath tied with Hercules knot
	Amphoras
	Menorah, nine-branched
	Menorah, seven-branched
	Rosette in circle
	Lioness
	Rosette
	Bird pecking grapes
	Wreath with Hercules knot
Gerasa	Plants
	Shofar
	Flowers
	Box, small
	Menorah
	Noah after the flood
	Ethrog
	Animals
	Lulab
	Birds
Horvat Marus	Grape clusters
	Pomegranate with leaves around
	Vine tendrils and leaves
	Leaves around pomegranate
	Animal: fish?
	Leaves
	Amphora
Horvat Qoshet	Menorah
	Acanthus scrolls
Huldah	Wreath
	Lulab
	Shofar
	Ethrog
	Menorah, seven-branched
	Incense shovel
Husifah	Head, female, human
	Shofars, two
	Lulabs, two
	Birds: two peacocks
	Incense shovels, two
	Menorot, two seven-branched
	Zodiac

Husifah, *cont.*	Ethrogs, two
	Wreath
	Vine trellis
	Four Seasons
Khirbet Marus	Zodiac?
	David with Goliath's armor
Khirbet Nator	None
Ma'oz Hayyim	Lions, two
	Birds, two (?)
	Wreath
	Menorah, seven-branched
	Meanders (swastikas)
Na'aneh	Menorah, seven-branched
	Acanthus leaf
	Leaves, heart-shaped
	Trefoil, small
	Lions, two
	Animal: hare
	Menorot, two seven-branched
	Four Seasons
	Helios driving his quadriga
	Torah Shrine
	Menorah, seven-branched
	Lamps, four hanging
	Daniel
	Animal: jackal
	Bird in a cage
	Birds
	Fruits and vegetables
	Plants
	Animals
Nabratein	Torah Shrine
Sepphoris	None found
Umm el-Kanatir	Eagle
	Grape clusters
	Lion forequarters
	Eagle
	Vine scroll
Sixth Century	
Beer Sheba	None
Beth Alpha	Birds: hen with chicks
	Vines, intertwined
	Bird: pheasant
	Birds, two
	Pomegranate tree
	Animal: fish

Beth Alpha, *cont.*

Grape cluster with leaves
Binding of Isaac
Bird
Animal:hare
Bird in a fruit tree
Lions, two
Torah Shrine
Ethrogs, two
Zodiac
Four Seasons
Shofars, two
Lamp, hanging
Vessel with fruit
Helios driving his quadriga
Shell
Incense shovels, two
Grape cluster
Goblets, three
Animal: fox eating grapes
Man holding bird
Basket of fruit
Lulabs, two
Baskets of fruit
Animal: ox
Lion
Animal: cat?
Menorot, two seven-branched

Beth She'an

Birds: two pheasants
Shofar
Birds
Grape clusters
Animals: two goats
Animals: dog chasing a deer
Baskets
Birds: partridges
Ethrog
Grape tendrils
Bird: peacock
Animal: elephant
Lions, two
Fruits
Animal: fox chasing a hen
Menorah, seven-branched
Leaves
Animal: hare
Lamp, hanging

Beth She'an, *cont.*	Animals: two bulls
	Pomegranate tree
	Incense shovels
	Grape leaves
	Animal: bear
	Bird: dove
	Amphora with vine
Gaza	King David
	Animal: giraffe
	Vine trellis
	Lioness with nursing cub
	Pomegranates
	Birds: partridges
	Birds: two peacocks
	Animal: goat
	Birds: flamingoes
	Lyre
	Menorah, seven-branched
	Animals: foxes
	Rosettes
	Animal: leopard
	Animal: tigress
	Bird in a cage
	Grapes
	Animal: donkey
	Animal: antelope
	Animal: ram
	Animal: bear
	Crown
	Animal: zebra
Givat Horvat Jebata	None
Horvat Habra	None
Horvat Rimmon	Menorah, seven-branched
Jamnia	None
Jericho	Shell
	Vines, Maltese Grape
	Lulab
	Crosses, floral shapes forming
	Shofar
	Pomegranates
	Torah Shrine
	Zodiac
	Menorah, seven-branched
Kefar Bilu	None
Khirbot Shura	Wreath
	Rosette

Ma'on	Bowl with fruit
	Grapes, basket of
	Flowers, interlacing
	Grape cluster
	Eagle
	Vase of wine
	Bird: pheasant
	Vine trellis
	Bird: goose
	Fruit, bowl of
	Bird: crane
	Birds: two doves
	Shofar
	Ethrogs, two
	Bird: guinea
	Menorah, seven-branched
	Pomegranates, basket of
	Animal: two oxen
	Lions, two
	Birds: two partridges
	Animals: two elephants
	Bird in a cage
	Animal: ibex
	Birds: two peacocks
	Animals: hares, two
	Birds: two pairs of doves
	Animal: dog
	Bird: flamingo
	Animal: leopard
	Amphora
	Basket of grapes
	Lulab
	Basket of fruit
	Palms, date, two
	Basket of pomegranates
	Bird of prey
	Bird: hen with egg in basket
	Animal: stag
	Animal: buffalo
	Animal: sheep
Ramat Aviv	Plant motifs
Rehov	Wreath
	Menorah, seven-branched
Tel Menorah	Menorah, seven-branched
	Shofar
	Bird

SYNAGOGUE ICONOGRAPHY: THE FIXED
VOCABULARY AND ITS PROVENANCE OVER TIME

This survey of Vaughn's catalogue of iconic representations (as re-
vised by James F. Strange) draws our attention to these items: *lulab* and
etrog (nearly always together, so not to be differentiated as two distinct
symbols), *shofar*, and *menorah* (variously represented, with five or seven
or nine branches).[7] If any iconic representations are to be deemed sym-
bolic merely by reason of frequent appearance in a wide variety of set-
tings, they are those.

We shall forthwith turn to an account of the provenance of these items
over time. "Other" stands for all other symbols except those named. I
have made a rough calculation, then, of all of the types of symbolic icons
in the chart. Then "total" refers to figures in parenthesis, specifically, to
the total number of different symbols that are portrayed in synagogues
assigned to each of the centuries. My interest is in asking about the entire
repertoire of symbols that, in one place or another, people utilized. What
I show is that among all of the available symbols that occur anywhere,
three are vastly overrepresented. These figures and proportions are at
best approximate. The figures given here cover the charts, but other
readings of the same charts may produce a higher or a lower number of
total symbols than I have given. The figures in parentheses are approxi-
mate, because the actual identification of some of the items that are
counted is in doubt, and whether or not "bird" and "eagle" and "phea-
sant" count as one symbol or as three is not obvious to me.

Century	*Etrog* and *Lulab*	*Shofar*	*Menorah*	Other	(Total)
I	—	—	—	1	(1)
II	2	3	9	7	(6)
III	4	3	15	60	(20)
IV	4	4	19	70	(20)
V	8	8	21	86	(30)
VI	3	3	5	44	(25)

These numbers by themselves can only suggest the shape of the evi-
dence. However, they do permit a fairly reliable picture of the propor-
tions of use of various symbols. Specifically, we shall now see, the *etrog*,

7. For the present purpose, it suffices to treat all representations of a *menorah* as the
same, even though it is not necessarily the same symbol when it is given different
numbers or arrangements of branches. Along these same lines I treat the *lulab* and *etrog*
as a single symbol. The argument I am constructing does not require much refinement
of symbolic distinctions.

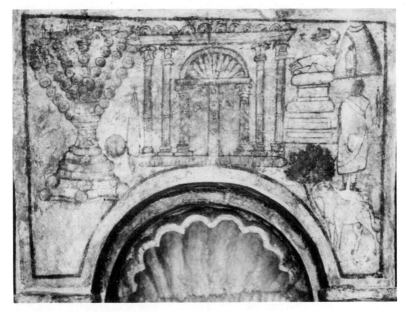

Detail of the fresco above the Torah Shrine from
the Dura-Europos synagogue.

lulab, shofar, and *menorah* form a stable and recurrent set of symbols and
occur together, and no other symbols compare either in broad represen-
tation or in stable association.

The basis for that judgment is simple. The proportions of *etrog* and
lulab, shofar, and *menorah,* among all counted items, by century, show
the following results:

Century	Etrog/Shofar, Menorah	Other	Total	Percentage
I	0	1	1	0%
II	14	7	21	66%
III	22	69	91	32%
IV	28	70	98	29%
V	37	86	123	24%
VI	11	33	44	25%

Omitting reference to the first and second centuries, we find that the
three symbols that are grouped together would appear to form, on the
average, between one-fourth and one-third of all iconic representations.
Since, as a rough guess, we may count upward of 100 different items
represented on the sites that are examined, the three items occur a
disproportionate number of times. The appearance of these particular

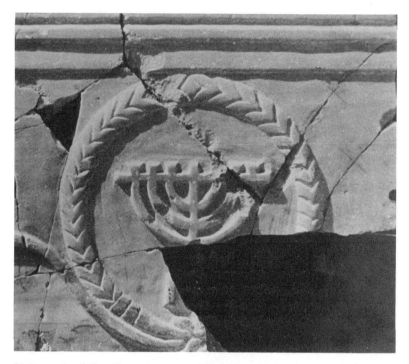

Photograph of the Chancel screen with the *menorah* from the ancient synagogue at Rehob in the Beit She'an region.

items is therefore highly unlikely to have occurred by chance alone. No such result favoring one item is likely to have appeared randomly, and the probabilities of three items forming a traveling unit are still more remote.

These results therefore seem to me to point toward these propositions:

1. The *etrog* and *lulab* and *shofar* travel together, and the *menorah* goes with them. Among the sites in which the *etrog, lulab,* and *shofar* occur, the *menorah* is always portrayed. Where there is an *etrog* and a *lulab,* there is ordinarily a *shofar* as well (18 sites for the *etrog* and *lulab,* 18 sites for the *shofar,* with only two discrepancies).

2. While, by my rough guess, any "other" symbol may occur at two or at most three sites by chance or randomly, the grouping of *etrog* and *lulab, shofar,* and *menorah* is very unlikely to have occurred by chance alone. If the *etrog, lulab,* and *shofar* occur, it will always be with a *menorah.*

It follows that, by the same criteria imposed on the literary evidence,

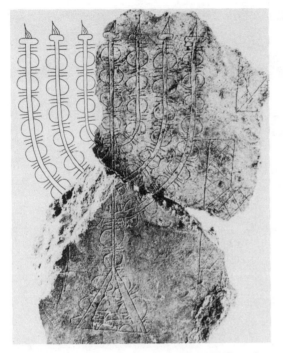

Photograph of the menorah of the Second Temple
period found in the Jewish Quarter of Jerusalem.

we may conclude that (1) symbolic discourse did go forward through
utilization of combinations of symbols in iconic form; (2) single combi-
nation of iconic symbols did circulate very broadly; and (3) that set of
symbols in iconic form does represent a clear-cut selection among a
much larger repertoire of available symbols. Whether or not those 97
other objects that are represented in synagogue art (a rough count at
best!) were symbolic and not decorative I do not claim to know. But the
etrog and *lulab*, *shofar*, and *menorah* do form a repertoire of icons that
clearly served to carry on symbolic discourse.

The tables by Vaughn, as revised by James F. Strange,[8] on which
these statements rest, now follow. As before my estimates of the numbers
of various phenomena may be awry, since quite how one counts every
item is not invariably clear. That is why I have aimed at only gross and
general observations about the numbers of provenance of various
symbols.

8. Source throughout: Marilyn Chiat, *Handbook of Synagogue Architecture* (Chico,
1980: Scholars Press for Brown Judaic Studies).

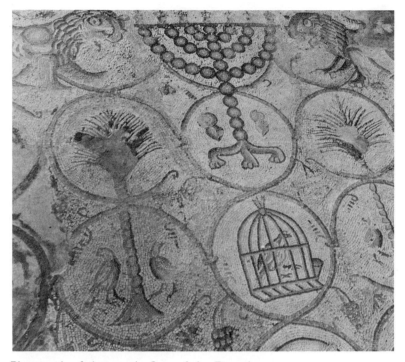

Photograph of the mosaic floor of the Byzantine
synagogue near Kibbutz Mirim.

SYNAGOGUE ART AND ORNAMENTATION:
STATISTICAL SUMMARY

Motif	Century	Sites	Instances	Instances per site
Acanthus leaves	4th	1	1	1.00
	5th	4	5	1.25
Total:		5	6	1.20
Altar, horned	4th	1	1	1.00
Amphora	3rd	2	3	1.50
	4th	6	6	1.00
	5th	2	2	1.00
	6th	2	2	1.00
Total:		12	13	1.08
Animals	4th	6	13	2.17
	5th	4	7	1.75
	6th	4	36	9.00
Total:		14	56	4.00

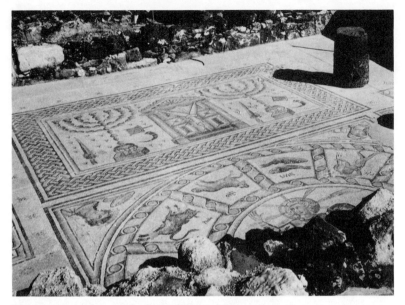

Photograph of the mosaic floor of the synagogue at
Hamej Tiberias.

Motif	Century	Sites	Instances	Instances per site
Basket of fruit	6th	3	6	2.00
Binding of Isaac	6th	1	1	1.00
Birds	3rd	4	7	1.75
	4th	4	17	4.25
	5th	5	9	1.80
	6th	5	38	7.60
Total:		18	71	3.94
Bowl with fruit	6th	1	1	1.00
Box	5th	1	1	1.00
Bucranium	4th	1	1	1.00
Capricorn	5th	1	1	1.00
Carriage, wheeled (Torah Shrine)	5th	1	1	1.00

Motif	Century	Sites	Instances	Instances per site
Centaur	5th	1	1	1.00
Chair of Moses	5th	1	1	1.00
Cross	3rd	3	3	1.00
	4th	1	1	1.00
	5th	0	0	none
	6th	1	1	1.00
Total:		5	5	1.00
Crown	3rd	1	1	1.00
	4th	0	0	none
	5th	0	0	none
	6th	1	1	1.00
Total:		2	2	1.00
Curtain, ark	4th	1	1	1.00
Daniel	4th	1	1	1.00
	5th	1	1	1.00
Total:		2	2	1.00
Eagle	3rd	7	7	1.00
	4th	5	11	2.20
	5th	5	10	2.00
	6th	1	1	1.00
Total:		18	29	1.61
Ethrog	3rd	5	6	1.20
	4th	3	6	2.00
	5th	3	4	1.33
	6th	3	5	1.67
Total:		14	21	1.50
Flowers	3rd	2	2	1.00
	4th	4	5	1.25
	5th	2	3	1.25
	6th	1	1	1.00
Total:		9	11	1.22
Four Seasons	4th	1	1	1.00
	5th	2	2	1.00
	6th	1	1	1.00
Total:		4	4	1.00

Motif	Century	Sites	Instances	Instances per site
Fruits	4th	2	2	1.00
	5th	2	2	1.00
Total:		4	4	1.00
Garlands	5th	1	1	1.00
Genii, pair	3rd	3	4	1.33
	4th	1	1	1.00
	5th	1	3	3.00
Total:		5	8	1.60
Geometric patterns	3rd	1	1	1.00
	4th	1	1	1.00
Total:		2	2	1.00
Goblets	6th	1	1	1.00
Grapevine, cluster leaves	3rd	3	3	1.00
	4th	5	5	1.00
	5th	5	0	0.00
	6th	4	8	2.00
Total:		17	24	1.41
Griffins	5th	1	1	1.00
Helios driving	4th	1	1	1.00
his quadriga	5th	1	1	1.00
	6th	1	1	1.00
Total:		3	3	1.00
Hercules knot	3rd	2	2	1.00
	4th	5	5	1.00
	5th	2	4	2.00
Total:		9	11	1.22
Incense shovel	3rd	2	2	1.00
	4th	1	2	2.00
	5th	4	5	1.25
	6th	2	3	1.50
Total:		9	12	1.33
David	5th	1	1	1.00
	6th	1	1	1.00
Total:		2	2	1.00

Motif	Century	Sites	Instances	Instances per site
Lamps, hanging	5th	1	4	4.00
	6th	2	2	1.00
Total:		3	6	2.00
Leaves	3rd	3	3	1.00
	4th	2	2	1.00
	5th	2	3	1.50
	6th	1	1	1.00
Total:		8	9	1.13
Lions	3rd	3	4	1.33
	4th	6	9	1.50
	5th	6	15	2.50
	6th	4	8	2.00
Total:		19	36	1.89
Lulab	3rd	3	3	1.00
	4th	5	8	1.60
	5th	4	6	1.50
	6th	3	4	1.33
Total:		15	21	1.40
Lyre	6th	1	1	1.00
Man	4th	2	2	1.00
	5th	1	2	2.00
	6th	1	1	1.00
Total:		4	5	1.25
Meanders, swastikas	1st	1	1	1.00
	2nd	0	0	0.00
	3rd	0	0	0.00
	4th	1	1	1.00
	5th	2	2	1.00
Total:		4	4	1.00
Medusa Head	4th	1	1	1.00
	5th	1	1	1.00
Total:		2	2	1.00
Menorah	3rd	13	26	2.00
	4th	14	23	1.64
	5th	14	23	1.64
	6th	8	9	1.13

Motif	Century	Sites	Instances	Instances per site
Total:		49	81	1.65
Noah after the flood	5th	1	1	1.00
None Found	1st	3	3	1.00
	2nd	3	3	1.00
	3rd	5	5	1.00
	4th	5	5	1.00
	5th	1	1	1.00
	6th	6	6	1.00
Total:		23	23	1.00
Oil jug	2nd	1	1	1.00
Olive branch	5th	1	1	1.00
Palm, date	4th	1	1	1.00
	5th	1	1	1.00
	6th	1	2	2.00
Total:		3	4	1.33
Plant motifs	3rd	3	3	1.00
	4th	0	0	0.00
	5th	2	2	1.00
	6th	1	1	1.00
Total:		6	6	1.00
Pomegranate	4th	1	1	1.00
	5th	2	2	1.00
	6th	5	5	1.00
Total:		8	8	1.00
Rosette	1st	1	1	1.00
	2nd	0	0	0.00
	3rd	6	6	1.00
	4th	2	2	1.00
	5th	1	2	2.00
	6th	2	2	1.00
Total:		12	13	1.08
Shell	3rd	4	4	1.00
	4th	4	6	1.50
	5th	1	2	2.00
	6th	2	2	1.00
Total:		11	14	1.27

Motif	Century	Sites	Instances	Instances per site
Shofar	3rd	5	5	1.00
	4th	3	6	2.00
	5th	6	8	1.33
	6th	5	6	1.20
Total:		19	25	1.32
Solomon's knots	5th	1	1	1.00
Star	4th	1	1	1.00
	5th	2	3	1.50
Total:		3	4	1.33
Swastika	3rd	1	1	1.00
	4th	1	1	1.00
Total:		2	2	1.00
Torah Shrine	3rd	3	4	1.33
	4th	2	2	1.00
	5th	4	5	1.25
	6th	2	2	1.00
Total:		11	13	1.18
Torus, twisted ropelike	3rd	1	1	1.00
Tree	4th	4	5	1.25
Trefoil, small	5th	1	1	1.00
Vessel with fruit	6th	1	1	1.00
Vase of wine	6th	1	1	1.00
Vine	3rd	8	8	1.00
	4th	2	2	1.00
	5th	5	5	1.00
	6th	4	4	1.00
Total:		19	19	1.00
Wheel	3rd	2	2	1.00
	4th	2	2	1.00
Total:		4	4	1.00
Wreath	3rd	5	5	1.00
	4th	7	7	1.00
	5th	6	9	1.50

Motif	Century	Sites	Instances	Instances per site
	6th	2	2	1.00
Total:		20	23	1.15
Zodiac	4th	3	3	1.00
	5th	2	2	1.00
	6th	2	2	1.00
Total:		7	7	1.00

Synagogue Art and Ornamentation.

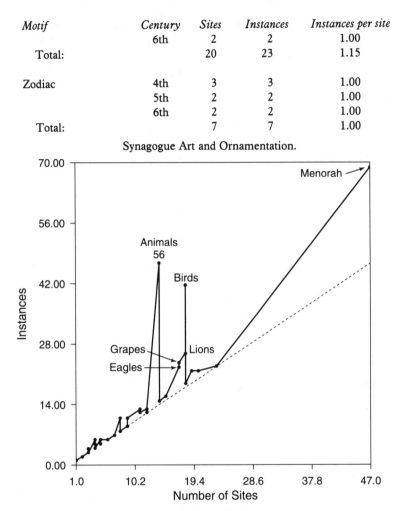

THE SYMBOLIC VOCABULARY OF THE SYNAGOGUE
AND SYMBOLIC DISCOURSE WITHIN THE SYNAGOGUE

To review, I classify an icon as a symbol by appeal to these indicators: (1) the function and provenance, within a synagogue; (2) the combination or relationship with other representations of things; (3) the selection of those few things among many that can have been represented. While we find a variety of iconic representations in synagogues, among them, only the *etrog* and *lulab*, *shofar*, and *menorah* are greatly overrepresented; of these, the *menorah* is principal. When synagogues were decorated, chances were that these items would be used. Do we find variation by

centuries in utilization of the symbols I have identified as paramount? The following chart indicates the answer:

Century	Number of Decorated Sites	Decorated Sites with Menorah Etc.	
II	4	3	(75%)
III	24	11	(45%)
IV	20	13	(65%)
V	18	15	(83%)
VI	8	5	(62%)

In the fourth, fifth, and sixth centuries, but particularly in the fifth, when people built synagogues, whatever else they used for decoration, they most commonly portrayed the *etrog* and *lulab, shofar,* and *menorah.* These therefore comprise iconic presentations of symbols and may be compared to other presentations of symbols yielded by the Judaic evidence of roughly the same period.

The data, however raw, prove that the *shofar, lulab, etrog,* and *menorah* occur (1) very routinely in synagogues; they occur (2) together. They clearly have been selected out of a very large repertoire of candidates— 100 or more. By the criteria offered here, in function and provenance, these four items are synagogue symbols. They combine with one another. They occur with disproportionate frequency, in most synagogues of the fourth, fifth, and sixth centuries. None of the other items that occur in the synagogues assigned to the period at hand exhibit these traits, at all or in equivalent proportion. If therefore we wish to claim that symbolic discourse was carried on in synagogue iconography as much as in canonical writing, it was through the four items identified here. We have now to ask whether the symbols in iconic form and those in verbal form form a single symbolic structure.

INTEGRATING SYMBOLIC DISCOURSE
IN ICONIC AND VERBAL FORMS:
WHAT IS AT STAKE FOR THE STUDY OF JUDAISM?

Now that we have seen evidence of symbolic discourse, within synagogues, in iconic form, we proceed to ask about integrating discourse in two distinct forms, verbal and iconic. Before proceeding, let me place this problem into the context of scholarship today. I mean now to reopen a quest that has not attracted broad interest for a while, which is, how to hold together in a single interpretative framework the iconic evidence concerning Judaism, deriving from synagogues and burial grounds of Jews, with the literary evidence concerning Judaism, deriving in particular from the master-disciple circles called rabbis and generally

accepted from late antiquity to the present day as canonical. These two bodies of evidence until now in general have been kept distinct from one another when the description of Judaism in late antiquity has been proposed.

Scientific studies on "Talmudic Judaism," which began about a century ago, led eventually to the grand syntheses of Moore, Schechter, and in their path, Ginzberg, Kadushin, and Finkelstein—syntheses which rested on the presupposition that talmudic literature might by itself yield a whole and accurate view of Judaism in the early centuries of the Common Era. Iconic evidence was simply ignored. Aware of the existence of sources which did not quite fit into the picture that emerged from talmudic literature as it was understood in those years or which did not serve the partly apologetic purposes of their studies, Moore and others posited the existence of "normative Judaism," which is to be described by reference to talmudic literature and distinguished from "heretical" or "sectarian" or simply "non-normative" Judaism of "fringe sects." Normative Judaism, expounded so systematically and with such certainty in Moore's Judaism, found no place in its structure for mysticism (except "normal mysticism"), magic, salvific or eschatological themes except within a rigidly reasonable and mainly ethical framework; nor did Judaism as these scholars understood it make use of the religious symbolism or ideas of the Hellenistic world, in which it existed essentially apart and at variance.

Today no sophisticated student of Judaism in late antiquity works within the framework of such a synthesis, for this old way is no longer open. The path to a conception of a single "normative Judaism" was closed by a number of scholars and by the infusion of new attitudes, the former working in isolation from one another, and the latter barely articulated and yet informing the thought of recent scholars.[9] That

9. This is not the place to spell out all of the attitudes which characterize the historical researches of the recent scholars, though, for a beginning, one should study the late Rene Bloch's "Note Methodologique pour l'tude de la littrature rabbinique," *Recherches de Sciences Religieuses* 43, 1955, pp. 194–225. Helpful if not original, G. Vermes paraphrases and summarizes Bloch's methodological proposals in *Scripture and Tradition in Judaism* (Leiden, 1961, and compare Brevard S. Childs, "Interpretation in Faith," *Interpretation, A Journal of Bible and Theology*, 1964, 18:432–49. The issue is not merely a broadening of the focus of interpretation, however. A graver problem is whether we know as much as we think we know. The former generation of historians working with talmudic literature, for example, treated that literature as if descriptions of events were written by a stenographer for the use of a newspaper reporter; as if, in other words, talmudic sources provide an adequate, critical description of events. The great issue was to establish an accurate text. If they had such a text, the former historians thought that all their problems were solved, and that they knew fairly well exactly what had happened, what had been said, what had been done, even though the interpretation of events might still have posed problems. When one realizes the fact that critical

talmudic literature evolved in creative symbiosis in the Hellenistic-Roman world was proved in a most masterful manner by Saul Lieberman who, following the early researches of S. Krauss and others, demonstrated how deeply embedded in late Hellenism were the methods and vocabulary of the Rabbis. But Lieberman went much further. He drew attention to the divisions within Jewry, thus implicitly admitting the existence of more than a single Judaism. In an essay, "Pleasures and Fears,"[10] Lieberman stated:

The wisdom of the East [in this context, astrology] could not be entirely ignored. A learned and cultured man of those times could not reject the science of Astrology, a science recognized and acknowledged by all the civilized ancient world. To deny at that time the efficacy of Astrology would mean to deny a well established fact, to discredit a "science" accepted by both Hellenes and Barbarians . . . Lieberman goes on to trace the attitude of the Rabbis toward Astrology, and to show how they mediated between it and Judaism, concluding: "The power of Astrology is not denied, but it is confined to the Gentiles only, having no influence on Israel." What is important here is Lieberman's willingness to take seriously the challenges of Hellenistic science, magic, and religion, not merely in the faith of "assimilated" Jews nor in the practices of the "ignorant masses" but in the bastions of the faith and their guardians. Here we find no effort to explain away embarrassing and irritating

history is a modern conception, and that no one in late antiquity, least of all Jewish chroniclers, wrote without a very clear-cut didactic purpose, and that in any case the talmudic accounts we have of events pertaining to the Jews and Judaism are by no means word-for-word transcriptions of what, if anything, observers saw and heard, then matters become much more complicated. An example of the literalism, not to say historiographical fundamentalism, of the greatest of talmudic historians may be seen in G. Alon's discussions of Yohanan ben Zakkai's escape to Yavneh, cited and criticized in my *Life of Rabban Yohanan ben Zakkai* (Leiden, 1962: E. J. Brill), pp. 104–128, 147–171. Alon offers an exegesis of what Yohanan said and did not say in his encounter with Vespasian which, to my way of thinking, ignores the nature of the sources available for such exegesis. There are numerous lessons still to be learned by students of this period from New Testament scholarship, the very first of them being the need to take a hard-headed ("higher-critical") view of what in fact we know, and how we know it. Other areas of learning, to be sure, are characterized by a critical perspective absent in the study of the rabbinic sources. See, for two fine examples, Y. Liver's *Toledot Bet David* (Jerusalem, 1959) and Y. Heinemann's *HaTefila biTekufat HaTannaim veHaAmoraim* (Jerusalem, 1964). But much new research ignores the most fundamental critical problems and therefore is disappointing, if not completely useless. See my *Reading and Believing: Ancient Judaism and Contemporary Gullibility.* Atlanta, 1986: Scholars Press for Brown Judaic Studies. There I give a variety of examples. My forthcoming *Studying Classical Judaism: A Primer.* Louisville, 1990: Westminster/John Knox Press, provides a more systematic picture of what we know, and how we know it, in connection with history, literature, religion, and theology.

10. *Greek in Jewish Palestine* (N.Y., 1942), pp. 115–143. Passage cited is on pp. 98–9.

contradictions to the prevailing view of a rationalistic and antiseptic this-worldly faith but rather a realistic effort to take all evidence seriously. Nor did Lieberman in that early time, before 1950, stand alone. Gershom Scholem's researches[11] on Jewish mysticism in late antiquity demonstrated how both talmudic and extra-talmudic literature point toward the existence of Hellenistic themes, motifs, and symbols deep within the circles of "pious" Jews. Since the rabbinic literature scarcely accounts for the vitality of such themes within the life of Jewry, the existence of more than a single authoritative Judaism once more became a plausible hypothesis in the description, analysis, and interpretation of that religion. Furthermore, as we shall see in Appendix Two, Erwin R. Goodenough,[12] studying archaeological remains and Hellenistic litera-ture, came to very much the same conclusions on the nature of Judaism, at least among the circles in which the artifacts bearing pagan symbols, or symbols bearing Jewish values different from those associated with their original pagan setting, were used. Goodenough was the first explic-itly to posit the existence of more than one Judaism.

Morton Smith pointed out the striking convergence of the scholarly results of several distinct inquiries, results based upon disparate sources and produced by scholars who, though aware of one another's work, specialized in a single body of evidence. Smith drew the proper conclu-sion:

. . . it is amazing how the evidence from quite diverse bodies of materials, studied independently by scholars of quite different back-grounds and temperaments, yields uniform conclusions which agree with the plain sense of these discredited passages. Scholem's study of the materials in the hekhalot tradition, for instance, has just led us to conclu-sions amazingly close to those reached by Goodenough from his study of the archaeological remains: to wit, the Hellenistic period saw the devel-opment of a Judaism profoundly shaped by Greco-Oriental thought, in which mystical and magical . . . elements were very important. From this common background such elements were derived independently by the magical papyri, Gnosticism, Christianity, and Hellenistic and Rabbinic Judaism. . . .[13] The integration of these bodies of evidence into a coher-ent picture of, if not one Judaism, then multiple Judaisms, has yet to take

11. *Major Trends in Jewish Mysticism*, also *Jewish Gnosticism, Merkabah Mysticism, and Talmudic Tradition* (N.Y., 1960), and *On the Kabbalah and its Symbolism* (N.Y., 1955).
12. *Jewish Symbols in the Greco-Roman Period* (N.Y., 1953 et seq.), vols. I-XII, extensively discussed presently.
13. "Observations on Hekhalot Rabbati," pp. 153-4, in *Biblical and Other Studies*, ed. Alexander Altmann (Cambridge, 1963), pp. 142-160.

place. But it is clear that the history of Judaism in late antiquity will tell the story of convergence and divergence.[14] Smith further states:

Of all these four bodies of evidence—the works of the Biblical tradition, the Jewish literature of pagan style, the testimonia concerning Jews, and the archaeological material—no one is complete by itself. Each must be constantly supplemented by reference to all the others. And each carries with it a reminder that the preserved material . . . represents only a small part of what once existed. . . . Yet even this preserved material . . . testifies consistently to the hellenization of ancient Judaism.[15] But at stake is not so much "the hellenization," viewed as a single thing, of "Judaism," likewise seen as one thing. Rather it is the recognition of a variety of Judaisms (and, I take for granted, a variety of phenomena that will stand in various contexts for "hellenization"). And that recognition of the diversity of Judaisms brings us to the issues of chapter 9: the convergence upon a single mode of discourse, the symbolic, but, as I shall now argue, the divergence of what is said within that mode of discourse.

14. Naturally, efforts have continued to retain the old one-dimensional and rationalistic synthesis, to explain new evidence in terms of old hypotheses. One cannot hope to convince the proponents of the old view that we must reconsider matters in a fundamental way. But such efforts to explain away the evidence will produce less and less insight. Among them is the strikingly unconvincing view of E. E. Urbach, who states:

These finds from Beth She'arim [of scenes from pagan mythology in the sarcophagi of the rabbis] put an end to all the theories based on making a clear distinction between the private world of the Sages, as reflected in the talmudic and mishnaic laws about idolatry, and the other world that existed outside theirs . . . Urbach prefers to "explain" the evidence in a way calculated to rule out any genuine confrontation with Hellenism. Jewish artisans, he says, were employed in making statues and images for pagans. They sometimes sold their products to Jews without making any change in their design of conventional patterns for idol-worshipping Gentile customers. Urbach never says why Jews bought them, or why rabbis let Jews do so. In any event, even the pagans, Urbach says, used idols and images for decorative purposes only. He does not tell us just what that means or how he knows. If these paintings and adornments were introduced into private houses for aesthetic reasons, it is not surprising that they should have found their way into synagogues and cemeteries, so Urbach. But I must ask, why is it not surprising? It seems that, for all his ostentatious erudition, Urbach has not paid serious attention to how surprising such phenomena would have been in an earlier period (before 70), as the archaeological evidence reveals, and in the period after they were very rigidly excluded (in the 5th and 6th centuries C. E. [A.D.]). If Jewish craftsmen did not, as Urbach says, consider it a sin to make use of pagan motifs in their work, still how liberal must the rabbis of Beth She'arim have been to accept such artifacts into their burial caves! I cannot regard his explanation, in any case, as wholly congruent to the phenomena to be explained, as relevant to all situations in which they are found and to all issues posed by their form and explanation.

15. "Image of God," *Bulletin of the John Rylands Library,* 1958, 40:473–512, quotation: pp. 486-7.

9

The Two Vocabularies of Symbolic Discourse

Before proceeding, let me review the reasons for our procedures in both chapters 4 through 7 and also chapter 8. These will justify the comparison between the vocabulary of symbolic discourse in iconic form and that of the same mode of discourse carried on in verbal form.

As to chapters 4 through 7, in some of the canonical writings we find lists of different things joined with the words "another matter." These different things cohere in two ways. First, all of them address the same verse of Scripture. Second, each of these other matters in its way proves to make the same statement as all the others. Appeal is made to what we shall see is a standard and fixed repertoire of things—events, named persons, objects or actions or attitudes. As these things combine and recombine, a thing appearing here next to one thing, there next to another, they appear to serve, as words serve, to make statements. Strung out in one selection of the larger vocabulary of symbols, they then say this, and in another set of choices made out of the same larger repertoire, they say that. How do people know which things to choose for which statement? Why combine this with that? These are the questions I bring to the examination of the numerous sets of "another matter" composites, scattered throughout the canonical literature.

Now to chapter 8: the second concerns the restricted repertoire of persons, events, and objects that are portrayed in synagogue art, mosaics, frescoes, carvings, and the like. Were we to compose a list of things that might have been chosen, it would prove many times longer than the list of things that in fact were selected and represented by the synagogue

artists. Do these too make a statement, and if they do, how are we to discern what it is?

ONE SYMBOLIC LANGUAGE OR TWO?

In asking the literary and artistic evidence to tell us about shared convictions of a common Judaism attested for late antiquity in both written and iconic representation, how are we to proceed? It is, first, by identifying the sort of evidence that serves. We limit our analysis to this public and official evidence: in literature, what anonymous, therefore genuine, authorities accepted as the implicit message of canonical and normative writings, on the one hand; in art, what synagogue communities accepted as the tacit message of the symbols in the presence of which they addressed God, on the other. Excluded then are expressions deriving from individuals, for example, letters or private writings, ossuaries and sarcophagi, which can have spoken for everyone but assuredly spoke for only one person.

Second, within public evidence, what do we identify as potential evidence for a shared vocabulary, common to evidence in both media, written and iconic, and shared among all sponsors—artists and patrons, authors, authorships, and authorities of canonical collections alike? The answer must be, the evidence provided by symbolic discourse, which is the only kind of discourse that can be shared between iconic and literary expressions. By definition, iconic evidence does not utilize the verbal medium, and, it goes without saying, our documents are not illustrated and never were. But the two bodies of publicly accepted and therefore authoritative evidence on the symbolic structure of Judaism deliver their messages in the same way. So constant reference to a set of what we must classify as not facts but symbols will turn up evidence for a shared vocabulary.

Once we have seen the restricted iconic vocabulary of the synagogue, too, we wish to bring it into juxtaposition, for purposes of comparison and contrast, with that of the canonical books. What we want to know is first, whether the same symbols occur in both media of expression, literary and artistic. Second, we ask whether the same messages are set forth in the two media, or whether the one medium bears one message and the other a different message. If, as I claim, symbolic discourse in the fifth and sixth centuries took place in Judaic expression in both synagogues and among sages, the one in iconic form and the other in

written form, we naturally wonder whether the symbols were the same and whether the discourse was uniform. To frame the question in simple terms: Were the same people saying the same things in different media, verbal and iconic, or were different people saying different things in different media? At the present, elementary stage in our reading of the symbolic discourse, we cannot expect to reach a final answer to that question. But the outlines of an answer even now will emerge when we compare the symbolic language of synagogue iconography with the symbolic language framed in verbal terms in the rabbinic Midrash compilations.

Effecting that comparison of course requires us to frame in the same medium the two sets of symbols. But which medium—the visual (in our imagination at least) or the verbal? If it is to be the verbal, then we have to put into words the symbolic discourse portrayed for us on the walls and the floors of synagogues. That is to say, we have to set forth in a manner parallel to symbolic discourse in words the symbols of the *etrog* and *lulab*, *shofar*, and *menorah*. And we have to do so in accord with the rhetoric forms that sustain symbolic discourse in verbal media. But by definition that cannot be done. First, symbolic discourse in verbal form requires us to identify and parse a verse of Scripture. But which verse for the items at hand? Second, we should require a clear notion of the meanings of the iconic symbols. But among the possible meanings, for example, for the *shofar*—the New Year and Day of Atonement, Abraham binding Isaac on the altar, the coming of the Messiah, Moriah and the Temple—which are we to choose? And, third, since the symbolic discourse in iconic form obviously joins the *etrog* and *lulab*, *shofar*, and *menorah*, translating the three (or four) into words demands a theory about what those symbols mean when they are joined in order, arrangement, and context. What do the symbols mean together that they do not mean when apart? The key, as I said at the outset, is why certain combinations yield meaning, others, gibberish (Moses and Sennacherib on the same list, for example). Since we do not have that key for symbolic discourse in iconic form, we had best consider the alternative.

Since we cannot meet any one of those three conditions, we take the other road, which is open. That is, we must proceed to translate into visual images (in our imagination) the symbols in verbal form that we have. Here, by definition, we have access to the context defined by a parsed verse of Scripture. We have a fairly explicit statement of the meanings imputed to the symbols, that is, the use in communication that is made of them. And, finally, the combinations of symbols for symbolic

discourse are defined for us by our documents—again by definition. So we can turn to written evidence and ask whether, in verbal form, symbolic discourse seems to converge with the counterpart discourse in the iconic medium.

CONNECTIONS, ICONIC AND VERBAL

To repeat: the key to a symbolic code must explain what connects with one thing but not with another, and how correct connections bear meaning and incorrect ones gibberish. Now to carry forward that notion we ask whether a single key will serve to decipher the code of symbolic discourse that governs symbols in both verbal and iconic form. The answer to that lies on the surface, in the connections that people made between and among symbols. If we find the same connections in both verbal and literary symbolic discourse, we may not know what message (if any) is supposed to be communicated, but we have solid grounds for thinking that a single code governs discourse in both media. On the other hand, if we find no combinations of the same symbols in both media of symbolic discourse, then we have no reason to suppose that a single key will explain what connects one thing with some other or why one thing connects with this other but not with that other. So the first test of whether or not we have a single discourse in two media or two distinct discourses, symbolic in both cases, but differentiated by media, is whether or not we find the same combination of symbols in both writing and iconography. We take as our test case symbols that we now know are very commonly connected, the *etrog* and *lulab*, *shofar*, and *menorah*. Our question is simple: When in writing people refer to the *lulab* or to the *shofar*, do they forthwith think also of the *menorah* and *shofar*, along with the *lulab*, or the *lulab* and *menorah*, along with the *shofar*? Or do they think of other things—or of nothing? As a matter of fact, they think of other things but not, in the case of the *lulab*, of the *menorah* and *shofar*; and not, in the case of the *shofar*, of the *lulab* and *menorah*. So the combinations that people make in writing are not of the same symbols as the combinations that people make iconically. In combination with these things that in iconic form clearly connect with one thing and not some other, they think of other things.[1]

1. I state categorically that in no case of symbolic discourse in verbal form that I have examined do we find the combinations of the *etrog* and *lulab*, *shofar*, and *menorah*. I have taken the more difficult problem, therefore, of moving beyond the specific evidence of discourse of a symbolic character and treating propositional discourse as well.

To satisfy ourselves that the distinctive combination of symbols—the *etrog* and *lulab, shofar*, and *menorah*—does not occur in the literary form of discourse (whether symbolic or otherwise) I present a brief account of how the Midrash compilations treat two of the three items, the first and the second. Here we shall see that the persistent manipulation of the three symbols as a group finds no counterpart in writing. The connections are different.

We begin with the *lulab* and ask whether representation of that symbol provokes discourse pertinent, also, to the symbols of the *shofar* and of the *menorah*, or even only of the *menorah*. The answer is negative. Other matters, but not those matters, are invoked. Leviticus Rabbah Parashah Thirty treats the Festival of Tabernacles (*Sukkot*), the sole point in the liturgical calendar at which the *etrog* and *lulab* pertain. The base verse that is treated is Lev. 23:39–40: "You shall take on the first day the fruit of goodly trees, branches of palm trees and boughs of leafy trees and willows of the brook," and that statement is taken to refer, specifically, to the *lulab*. When sages read that verse, they are provoked to introduce the consideration of Torah study; the opening and closing units of the pertinent unit tell us what is important:

Leviticus Rabbah XXX:I

1. A. "[On the fifteenth day of the seventh month, when you have gathered in the produce of the land, you shall keep the feast of the Lord seven days . . .] And you shall take on the first day [the fruit of goodly trees, branches of palm trees and boughs of leafy trees and willows of the brook, and you shall rejoice before the Lord your God for seven days]" (Lev. 23:39–40).
 B. R. Abba bar Kahana commenced [discourse by citing the following verse]: "Take my instruction instead of silver, [and knowledge rather than choice gold]" (Prov. 8:10).
 C. Said R. Abba bar Kahana, "Take the instruction of the Torah instead of silver.
 D. "'Why do you weigh out money? Because there is no bread' (Isa. 55:2).
 E. "'Why do you weigh out money to the sons of Esau [Rome]? [It is because] "there is no bread," because you did not sate yourselves with the bread of the Torah.
 F. "'And [why] do you labor? Because there is no satisfaction' [Isa. 55:2].
 G. "'Why do you labor while the nations of the world enjoy plenty? 'Because there is no satisfaction,' that is, because you have not sated yourselves with the wine of the Torah.
 H. "For it is written, 'Come, eat of my bread, and drink of the wine I have mixed'" (Prov. 9:5).

6. A. Said R. Abba bar Kahana, "On the basis of the reward paid for one act of 'taking,' you may assess the reward for [taking] the palm branch [on the Festival of Tabernacles].

 B. "There was an act of taking in Egypt: 'You will take a bunch of hyssop' [Exod. 12:22].

 C. "And how much was it worth? Four *manehs*.

 D. "Yet that act of taking is what made Israel inherit the spoil at the sea, the spoil of Sihon and Og, and the spoil of the thirty-one kings.

 E. "Now the palm branch, which costs a person such a high price, and which involves so many religious duties—how much the more so [will a great reward be forthcoming on its account]!"

 F. Therefore Moses admonished Israel, saying to them, "And you shall take on the first day . . . " (Lev. 23:40).

Whatever the sense of *lulab* to synagogue artists and their patrons, the combination with the *etrog*, *menorah*, and *shofar* was critical; nothing in these words invokes any of those other symbols. What would have led us to suppose some sort of interchange between iconic and verbal symbols? If we had an association, in iconic combinations, of the Torah-Shrine and the *etrog* and *lulab*, we might have grounds on which to frame the hypothesis that some sort of association—comparison or contrast, for instance—between the symbols of the Festival of Tabernacles and Torah study was contemplated. Here there is no basis for treating the iconic symbols as convergent with the manipulation of those same symbols in propositional discourse. It suffices to say that nowhere in Leviticus Rabbah Parashah Thirty do we find reason to introduce the other iconic symbols.

What about the *shofar*? If we speak of that object, do we routinely introduce the *etrog*, *lulab*, *menorah*? The answer is negative. We introduce other things, but not those things. Pesiqta deRab Kahana *pisqa* 23 addresses the New Year as described at Lev. 23:24: "In the seventh month on the first day of the month you shall observe a day of solemn rest, a memorial proclaimed with blast of trumpets." The combination of judgment and the end of days is evoked in the following. I give two distinct statements of the same point to show that it is in context an important motif.

Pesiqta deRab Kahana XXIII:II

2. A. *For I will make a full end of all the nations* (Jer. 30:11): As to the nations of the world, because they make a full end (when they harvest even the corner of) their field, concerning them Scripture states: *I will make a full end of all the nations among whom I scattered you*.

B. But as to Israel, because they do not make a full end (when they harvest, for they leave the corner of) their field, therefore: *But of you I will not make a full end* (Jer. 30:11).

C. *I will chasten you in just measure, and I will by no means leave you unpunished* (Jer. 30:11). I shall chasten you through suffering in this world, so as to leave you unpunished in the world to come.

D. When?

E. *In the seventh month, [on the first day of the month]* (Lev. 23:24).

Pesiqta deRab Kahana XXIII:V

1. A. R. Jeremiah commenced [discourse by citing the following verse]: "*The wise man's path of life leads upward, that he may avoid Sheol beneath* (Prov. 15:24).

B. "*The path of life:* The path of life refers only to the words of the Torah, for it is written, as it is written, *It is a tree of life* (Prov. 3:18).

C. "Another matter: *The path of life:* The path of life refers only to suffering, as it is written, *The way of life is through rebuke and correction* (Prov. 6:23).

D. "[*The wise man's path*] . . . *leads upward* refers to one who looks deeply into the Torah's religious duties, [learning how to carry them out properly].

E. "What then is written just prior to this same matter (of the New Year)?

F. "*When you harvest your crop of your land, you will not make a full end of the corner of your field* (Lev. 23:22).

G. "The nations of the world, because they make a full end when they harvest even the corner of their field, [and the rest of the matter is as is given above: *I will make a full end of all the nations among whom I have driven you* (Jer. 30:11). But Israel, because they do not make a full end when they harvest, for they leave the corner of their field, therefore, *But of you I will not make a full end* (Jer. 30:11). *I will chasten you in just measure, and I will by no means leave you unpunished* (Jer. 30:11)." When? *In the seventh month, on the first day of the month, [you shall observe a day of solemn rest, a memorial proclaimed with blast of trumpets* (Lev. 23:24)].

What is now linked is Israel's leaving the corner of the field for the poor (Lev. 23:22); the connection between that verse and the base verse here is what is expounded. Then there is no evocation of the *menorah* or the *lulab* and *etrog*—to state the obvious. We can explain what is combined, and we also can see clearly that the combination is deliberate. That means what joined elsewhere but not here bears another message but not this one. An elaborate investigation of the role of *lulab* and *etrog*, *shofar*, and *menorah* in the literary evidence of the Midrash compilations hardly

is required to demonstrate what we now know: we find no evidence of interest in the combination of those items in literary evidence.

ONE VERSION OF A SYMBOLIC STRUCTURE OF JUDAISM: SYMBOLS IN VERBAL FORM

Now that we have identified the iconic representations that form, if not a system, at least a structure—items that occur together in a given manner—let me set forth one example of what I conceive to be a fine statement of the symbolic structure of Judaism as symbols in verbal form set forth such a structure. This will serve as an example of the kinds of symbols we find in general in symbolic discourse in verbal form.[2] Our further experiments will then draw on the symbolic repertoire that a single passage—counterpart to a single synagogue—has supplied. The character of the passage will explain why I have chosen it as representative:

Genesis Rabbah LXX:VIII

2. A. "As he looked, he saw a well in the field":
 B. R. Hama bar Hanina interpreted the verse in six ways [that is, he divides the verse into six clauses and systematically reads each of the clauses in the light of the others and in line with an overriding theme:
 C. "'As he looked, he saw a well in the field': this refers to the well [of water in the wilderness, Num. 21:17].
 D. "'. . . and lo, three flocks of sheep lying beside it': specifically, Moses, Aaron, and Miriam.
 E. "'. . . for out of that well the flocks were watered': for from there each one drew water for his standard, tribe, and family."
 F. "And the stone upon the well's mouth was great":
 G. Said R. Hanina, "It was only the size of a little sieve."
 H. [Reverting to Hama's statement:] "'. . . and put the stone back in its place upon the mouth of the well': for the coming journeys." [Thus the first interpretation applies the passage at hand to the life of Israel in the wilderness.]
3. A. "'As he looked, he saw a well in the field': refers to Zion.
 B. "'. . . and lo, three flocks of sheep lying beside it': refers to the three festivals.
 C. "'. . . for out of that well the flocks were watered': from there they drank of the Holy Spirit.

2. A reference to the materials gathered in chapters 4 through 7 will suffice to show that what follows is reasonably proposed as representative.

D. "'. . . The stone on the well's mouth was large': this refers to the rejoicing of the house of the water drawing."

E. Said R. Hoshaiah, "Why is it called 'the house of the water drawing'? Because from there they drink of the Holy Spirit."

F. [Resuming Hama b. Hanina's discourse:] "'. . . and when all the flocks were gathered there': coming from 'the entrance of Hamath to the brook of Egypt' (1 Kings. 8:66).

G. "'. . . the shepherds would roll the stone from the mouth of the well and water the sheep': for from there they would drink of the Holy Spirit.

H. "'. . . and put the stone back in its place upon the mouth of the well': leaving it in place until the coming festival." [Thus the second interpretation reads the verse in the light of the Temple celebration of the Festival of Tabernacles.]

4. A. "'. . . As he looked, he saw a well in the field': this refers to Zion.

 B. "'. . . and lo, three flocks of sheep lying beside it': this refers to the three courts, concerning which we have learned in the Mishnah: **There were three courts there, one at the gateway of the Temple mount, one at the gateway of the courtyard, and one in the chamber of the hewn stones [M. San. 11:2].**

 C. "'. . . for out of that well the flocks were watered': for from there they would hear the ruling.

 D. "'The stone on the well's mouth was large': this refers to the high court that was in the chamber of the hewn stones.

 E. "'. . . and when all the flocks were gathered there': this refers to the courts in session in the Land of Israel.

 F. "'. . . the shepherds would roll the stone from the mouth of the well and water the sheep': for from there they would hear the ruling.

 G. "'. . . and put the stone back in its place upon the mouth of the well': for they would give and take until they had produced the ruling in all the required clarity." [The third interpretation reads the verse in the light of the Israelite institution of justice and administration.]

5. A. "'As he looked, he saw a well in the field': this refers to Zion.

 B. "'. . . and lo, three flocks of sheep lying beside it': this refers to the first three kingdoms [Babylonia, Media, Greece].

 C. "'. . . for out of that well the flocks were watered': for they enriched the treasures that were laid upon up in the chambers of the Temple.

 D. "'. . . The stone on the well's mouth was large': this refers to the merit attained by the patriarchs.

 E. "'. . . and when all the flocks were gathered there': this refers to the wicked kingdom, which collects troops through levies over all the nations of the world.

 F. "'. . . the shepherds would roll the stone from the mouth of the well and water the sheep': for they enriched the treasures that were laid upon up in the chambers of the Temple.

G. "'. . . and put the stone back in its place upon the mouth of the well': in the age to come the merit attained by the patriarchs will stand [in defense of Israel]." [So the fourth interpretation interweaves the themes of the Temple cult and the domination of the four monarchies.]

6. A. "'As he looked, he saw a well in the field': this refers to the Sanhedrin.

 B. "'. . . and lo, three flocks of sheep lying beside it': this alludes to the three rows of disciples of sages that would go into session in their presence.

 C. "for out of that well the flocks were watered": for from there they would listen to the ruling of the law.

 D. "'. . . The stone on the well's mouth was large': this refers to the most distinguished member of the court, who determines the law decision.

 E. "'. . . and when all the flocks were gathered there': this refers to disciples of the sages in the Land of Israel.

 F. "'. . . the shepherds would roll the stone from the mouth of the well and water the sheep': for from there they would listen to the ruling of the law.

 G. "'. . . and put the stone back in its place upon the mouth of the well': for they would give and take until they had produced the ruling in all the required clarity." [The fifth interpretation again reads the verse in the light of the Israelite institution of legal education and justice.]

7. A. "'As he looked, he saw a well in the field': this refers to the synagogue.

 B. "'. . . and lo, three flocks of sheep lying beside it': this refers to the three who are called to the reading of the Torah on weekdays.

 C. "'. . . for out of that well the flocks were watered': for from there they hear the reading of the Torah.

 D. "'. . . The stone on the well's mouth was large': this refers to the impulse to do evil.

 E. "'. . . and when all the flocks were gathered there': this refers to the congregation.

 F. "'. . . the shepherds would roll the stone from the mouth of the well and water the sheep': for from there they hear the reading of the Torah.

 G. "'. . . and put the stone back in its place upon the mouth of the well': for once they go forth [from the hearing of the reading of the Torah] the impulse to do evil reverts to its place." [The sixth and last interpretation turns to the twin themes of the reading of the Torah in the synagogue and the evil impulse, temporarily driven off through the hearing of the Torah.]

Genesis Rabbah LXX:IX

1. A. R. Yohanan interpreted the statement in terms of Sinai:

 B. "'As he looked, he saw a well in the field': this refers to Sinai.

C. "'. . . and lo, three flocks of sheep lying beside it': these stand for the priests, Levites, and Israelites.

D. "'. . . for out of that well the flocks were watered': for from there they heard the Ten Commandments.

E. "'. . . The stone on the well's mouth was large': this refers to the Presence of God."

F. ". . . and when all the flocks were gathered there."

G. R. Simeon b. Judah of Kefar Akum in the name of R. Simeon: "All of the flocks of Israel had to be present, for if any one of them had been lacking, they would not have been worthy of receiving the Torah."

H. [Returning to Yohanan's exposition:] "'. . . the shepherds would roll the stone from the mouth of the well and water the sheep': for from there they heard the Ten Commandments.

I. "'. . . and put the stone back in its place upon the mouth of the well': 'You yourselves have seen that I have talked with you from heaven' (Exod. 20:19)."

The six themes read in response to the verse cover (1) Israel in the wilderness, (2) the Temple cult on festivals with special reference to Tabernacles, (3) the judiciary and government, (4) the history of Israel under the four kingdoms, (5) the life of sages, and (6) the ordinary folk and the synagogue. The whole is an astonishing repertoire of fundamental themes of the life of the nation, Israel: at its origins in the wilderness, in its cult, in its institutions based on the cult, in the history of the nations, and, finally, in the twin social estates of sages and ordinary folk, matched by the institutions of the master-disciple circle and the synagogue. The vision of Jacob at the well thus encompassed the whole of the social reality of Jacob's people, Israel. Yohanan's exposition adds what was left out, namely, reference to the revelation of the Torah at Sinai. The reason I have offered the present passage as a fine instance of symbolic discourse is now clear. If we wished a catalogue of the kinds of topics addressed in passages of symbolic, as distinct from propositional, discourse, the present catalogue proves compendious and complete. Our next experiment is now possible.

SYMBOLIC DISCOURSE IN ICONIC FORM AND IN VERBAL FORM: CONVERGENCE OR DIVERGENCE?

A simple set of indicators will now permit us to compare the character of symbolic discourse in verbal form with that in iconic form. The question is now a simple one. Let us represent the Judaism—way of life, world view, theory of who or what is "Israel"?—set forth by symbolic discourse in iconic form effected by the *lulab* and *etrog*, *shofar*, and *menorah*. Let us further represent the Judaism set forth by symbolic

discourse in verbal form, treating as exemplary a discourse that will appeal to visual images appropriate to the themes of Israel in the wilderness, the Temple cult, the judiciary and government, Israel under the four kingdoms and at the end of time, the life of sages, and ordinary folk and the synagogue. How do these statements relate?

The shared program will cover the standard topics that any symbolic structure of representing a religion should treat: holy day, holy space, holy word, holy man (or: person), and holy time or the division of time.

	Iconic Symbols	Verbal Symbols
Holy day	New Year/Tabernacles/Hanukkah	Tabernacles/Pentecost/Passover
Holy space	Temple	Temple/Zion
Holy man/person	no evidence	the sage and disciple
Holy time	Messiah (*shofar*)	four kingdoms/Israel's rule
Holy event	not clear	exodus from Egypt

The important point of convergence is unmistakable: holy space for both symbolic structures is defined as the Temple and Mount Zion. That is hardly surprising; no Judaic structure beyond A.D. 70 ignored the Temple, and all Judaisms both before and after A.D. 70 found it necessary to deal in some way with, to situate themselves in relationship to, that paramount subject. So the convergence proves systemically inert, indeed trivial.

Whether or not we classify the treatment of holy time as convergent or divergent is not equally obvious to me. Both structures point toward the end of time; but they speak of it differently. So far as the *shofar* means to refer to the coming of the Messiah, the gathering of the exiles, and the restoration of the Temple, as in the synagogue liturgy it does, then the iconic representation of the messianic topic and the verbal representation of the same topic diverge. For the latter, we see in our case and in much of the evidence surveyed earlier, frames the messianic topic in terms of Israel's relationship with the nations, and the principal interest is in Israel's rule over the world as the fifth and final monarchy. That theme is repeated in symbolic discourse in verbal form, and, if the *shofar* stands in synagogue iconography for what the synagogue liturgy says, then the message, if not an utterly different one, is not identical with that delivered by symbols in verbal form. So here matters are ambiguous.

The unambiguous points of divergence are equally striking. The most important comes first. Symbolic discourse in verbal form privileges the three festivals equally and utterly ignores Hanukkah. So far as the *menorah* stands for Hanukkah—and in the literary evidence, the association is firm—we may suppose that, just as the *lulab* and *etrog* mean to evoke

Tabernacles and the *shofar* the New Year and Day of Atonement, so the *menorah* speaks of Hanukkah. Then we find a clear and striking divergence. That the *menorah* serves also as an astral symbol is well established, and if that is the fact, then another point of divergence is registered. In symbolic discourse in verbal form I find not one allusion to an astral ascent accessible to an Israelite, for example, through worship or Torah study. A survey of the cited passages yields not a trace of the theme of the astral ascent.

The second point of divergence seems similarly unambiguous. Critical to the symbolic vocabulary of the rabbinic Midrash compilations is study of the Torah, on the one side, and the figure of the sage and disciple, on the other. I do not find in the extant literary sources a medium for identifying the figure of the sage and the act of Torah study with the symbols of the *lulab, etrog, shofar,* or *menorah.* Quite to the contrary, the example given above from Leviticus Rabbah counterposes the *lulab* with words of Torah. The fact that these are deemed opposites, with the former not invoking but provoking the latter, by itself means little. But it does not sustain the proposition that the combined symbols before us, the *lulab, etrog, shofar,* and *menorah,* somehow mean to speak of Torah study and the sage.

Thus far we see marks of convergence and also of divergence. What happens if we present a sizable repertoire of the combinations of symbols in verbal form that we find in Song of Songs Rabbah? We wonder whether a sizable sample of combinations of symbols in verbal form intersects, or even coincides, with the simple vocabulary, in combination, paramount in iconic representations of symbolic discourse in synagogues. A list drawn from combinations of symbols in verbal form found in Song of Songs Rabbah, already given, must include the following items:

Joseph, righteous men, Moses, and Solomon;
patriarchs as against princes, offerings as against merit, and Israel as against the nations; those who love the king, proselytes, martyrs, penitents;
first, Israel at Sinai; then Israel's loss of God's presence on account of the golden calf; then God's favoring Israel by treating Israel not in accord with the requirements of justice but with mercy;
Dathan and Abiram, the spies, Jeroboam, Solomon's marriage to Pharaoh's daughter, Ahab, Jezebel, Zedekiah;
Israel is feminine, the enemy (Egypt) masculine, but God the father saves Israel the daughter;
Moses and Aaron, the Sanhedrin, the teachers of Scripture and Mishnah, the rabbis;

the disciples; the relationship among disciples, public recitation of teachings of the Torah in the right order; lections of the Torah;

the spoil at the Sea = the exodus, the Torah, the tabernacle, the ark;

the patriarchs, Abraham, Isaac, Jacob, then Israel in Egypt, Israel's atonement and God's forgiveness;

the Temple, where God and Israel are joined, the Temple is God's resting place, the Temple is the source of Israel's fecundity;

Israel in Egypt, at the Sea, at Sinai, and subjugated by the gentile kingdoms, and how the redemption will come;

Rebecca, those who came forth from Egypt, Israel at Sinai, acts of loving-kindness, the kingdoms who now rule Israel, the coming redemption;

fire above, fire below, meaning heavenly and altar fires; Torah in writing, Torah in memory; fire of Abraham, Moriah, bush, Elijah, Hananiah, Mishael, and Azariah;

the Ten Commandments, show-fringes and phylacteries, recitation of the *Shema* and the Prayer, the tabernacle and the cloud of the Presence of God, and the *mezuzah*;

the timing of redemption, the moral condition of those to be redeemed, and the past religious misdeeds of those to be redeemed;

Israel at the Sea, Sinai, the Ten Commandments; then the synagogues and schoolhouses; then the redeemer;

the exodus, the conquest of the Land, the redemption and restoration of Israel to Zion after the destruction of the first Temple, and the final and ultimate salvation;

the Egyptians, Esau and his generals, and, finally, the four kingdoms;

Moses' redemption, the first, to the second redemption in the time of the Babylonians and Daniel;

the litter of Solomon: the priestly blessing, the priestly watches, the Sanhedrin, and the Israelites coming out of Egypt;

Israel at the Sea and forgiveness for sins effected through their passing through the Sea; Israel at Sinai; the war with Midian; the crossing of the Jordan and entry into the Land; the house of the sanctuary; the priestly watches; the offerings in the Temple; the Sanhedrin; the Day of Atonement;

God redeemed Israel without preparation; the nations of the world will be punished, after Israel is punished; the nations of the world will present Israel as gifts to the royal messiah, and here the base verse refers to Abraham, Isaac, Jacob, Sihon, Og, Canaanites;

the return to Zion in the time of Ezra, the exodus from Egypt in the time of Moses;

the patriarchs and with Israel in Egypt, at the Sea, and then before Sinai; Abraham, Jacob, Moses;

Isaac, Jacob, Esau, Jacob, Joseph, the brothers, Jonathan, David, Saul, man, wife, paramour;

Abraham in the fiery furnace and Shadrach, Meshach and Abednego,
the exile in Babylonia, now with reference to the return to Zion

Now let us ask ourselves some very simple questions: Is there a single
combination of symbols in verbal form in this catalogue that joins the
same symbols that are combined in the symbolic vocabulary in iconic
form that we have identified? No, not a single combination coincides. Is
there a paramount role assigned to Tabernacles at all? No, in this cata-
logue the principal holy day must be Passover, commemorating the
exodus, which occurs throughout, and not Tabernacles, commemorat-
ing the life in the wilderness, which occurs not at all. Is there a single set
of symbols in verbal form that can be served by the *shofar*? No, not one.
Whatever the sense or meaning that we assign to the *shofar*, whether the
shofar stands for Isaac on the altar with Abraham ready to give him up,
whether it stands for the New Year and Day of Atonement, or whether it
stands for the coming of the Messiah and the ingathering of the exiles,
makes no difference. On the list before us, I see no point at which the
shofar in any of these senses will have served uniquely well or even
served at all. Whatever the sense of the *menorah*, whether invoking
Hanukkah or an astral ascent, makes no difference; it is not a useful
symbol, in verbal form, for any of the combinations before us; it cannot
have served in a single recombinant statement. The *lulab* and *etrog* so far
as I can see can have claimed no place, in verbal form, in any of our
combinations. While, therefore, at certain points the symbolic discourse
in verbal form surely intersects with the same mode of discourse in
iconic form, in the aggregate, symbolic discourse represented in one
medium bears one set of symbols—singly or in combination!—and sym-
bolic discourse in another medium appeals to a quite different set of
symbols altogether.

WHAT IS AT STAKE IN ANALYZING SYMBOLIC DISCOURSE?

The divergent vocabularies utilized for symbolic discourse point
toward divergent symbolic structures: two Judaisms, one of them repre-
sented by the symbolic discourse in verbal form of the rabbinic Midrash
compilations and the other by symbolic discourse in iconic form repre-
sented by the synagogue ornamentation. That conclusion[3] calls into

3. Goodenough's work, discussed in Appendix II, led to precisely the same
conclusion. But the proposition that "Judaism" was diverse, meaning that there was
more than a single normative Judaism, has been implicit, if not entirely conventional,
even from the late 1940s. The most effective and important statement of the divergence
of literary and iconic evidence in general emerged in the earliest volumes of Good-

question the possibility of describing, on the basis of the written and archaeological evidence, a Judaism that is attested, in one way or another, by all data equally; a Judaism to which all data point; a Judaism that is implicit in, or presupposed by, all data. If there were such a uniform and encompassing Judaic structure, sufficiently commodious to make a place for diverse Judaisms, then it is at the level of symbolic discourse that we should find evidence for its description. For in the preverbal evidence of symbols should emerge messages, at least significations, that can be expressed in the diverse ways that verbal discourse makes possible (and may even require). But, as we have now seen, when we compare the symbols that reach us in two distinct forms, the verbal and the iconic, we find ourselves at an impasse. The verbal symbols serve in one way and the iconic in another, and while they occasionally converge, the points of convergence are few and those of divergence overwhelming.

At stake in these observations is whether we can locate evidence that, beyond any text or artifact, a body of thought—a religious system, encompassing a world view, way of life, and theory of the social group that held the one and realized the other—circulated. What is this "Judaism" to which in my hypothesis makes reference? It is, as a matter of working hypothesis, that set of conceptions and convictions which the generality of Jews took for granted but which no particular group of Jews made distinctively its own. It is the Judaism that all writings, all art, presupposes. And at stake in this analysis of the repertoire of symbols is, Can we claim that a single such structure served to sustain all Judaisms? Is there such a unitary, single, and harmonious "symbolic structure of Judaism" at all? That body of thought, that Judaism—perhaps formed of one Judaism out of many, perhaps identified as what is essential throughout, perhaps defined as the least common denominator among all evidence—is then alleged to be presupposed in all documents and by all artifacts. The answer to that question is simple. No evidence permits us to describe that one Judaism. So far as we are limited to the demonstration made possible by evidence—for example, sources whether in writing or in iconic or other material form, the kind of evidence that is most general, fundamental, and susceptible of homogenization—the picture is clear and one-sided.

Some who posit a "Judaism" of which we are informed appeal not to evidence (e.g., of a given period) but to an a priori: they maintain that

enough's *Jewish Symbols in the Greco-Roman Period.* The recognition that that divergence pointed toward more than a single Judaic system or Judaism, and the specification of the meaning of that fact, derive principally from my *oeuvre.*

there is one Judaism by definition and without demonstration informs all Judaisms, or to which all Judaisms refer or give testimony. Some scholars just now claim that there is a "Judaism out there," beyond any one document, to which in some way or other all documents in various ways and proportions are supposed to attest.[4] They even know how to describe

4. One statement of the matter derives from the British medievalist Hyam Maccoby. Writing in the symposium, "The Mishnah: Methods of Interpretation," *Midstream*, October, 1986, p. 41, he states:

> Neusner argues that since the Mishnah has its own style and program, nothing outside it is relevant to explaining it. This is an obvious fallacy. The Mishnah, as a digest, in the main, of the legal . . . aspect of rabbinic Judaism, necessarily has its own style and program. But to treat it as something intended to be a comprehensive compendium of the Oral Torah is simply to beg the question. Neusner does not answer the point, put to him by E. P. Sanders and myself, that the liturgy being presupposed by the Mishnah, is surely relevant to the Mishnah's exegesis. Nor does he answer the charge that he ignores the aggadic material within the Mishnah itself, e.g., Avot; or explain why the copious aggadic material found in roughly contemporaneous works should be regarded as irrelevant. Instead he insists that he is right to carry out the highly artificial project of deliberately closing his eyes to all aggadic material, and trying to explain the Mishnah without it.

Maccoby exhibits a somewhat infirm grasp upon the nature of the inquiry before us. If one starts with the question, "What does the authorship of this book mean to say, when read by itself and not in the light of other, *later* writings?" then it would be improper to import into the description of the system of the Mishnah in particular (its "Judaism"— hence "Judaism: The Evidence of the Mishnah") conceptions not contained within its pages. Tractate Avot, for one instance, cites a range of authorities who lived a generation beyond the closure of the (rest of the) Mishnah and so is ordinarily dated to about A.D. 250, with the Mishnah dated to about A.D. 200. On that basis, how one can impute to the Mishnah's system conceptions first attaining closure half a century later I do not know. To describe the Mishnah, for example, as a part of "rabbinic Judaism" is to invoke the premise that we know, more or less on its own, just what this "rabbinic Judaism" is and says. But what we cannot show we do not know. And, as a matter of established fact, many conceptions dominant in the final statements of Rabbinic Judaism to emerge from late antiquity play no material role whatsoever in the system of the Mishnah or, for that matter, of Tosefta and Abot. No one who has looked for the conception of "the Oral Torah" in the Mishnah or in the documents that succeeded it, for the next two hundred years, will understand why Maccoby is so certain that the category of "Oral Torah," or the myth of the dual Torah, applies at all. For the mythic category of "Oral Torah" makes its appearance, so far as I can discern, only with the Yerushalmi and not in any document closed prior to that time, although a notion of a revelation over and above Scripture—not called "oral" Torah to be sure—comes to expression in Avot. Implicitly, moreover, certain sayings of the Mishnah itself, for example, concerning rulings of the Torah and rulings of sages, may contain the notion of a secondary tradition, beyond revelation. But that tradition is not called "the Oral Torah," and I was disappointed to find that even in the Yerushalmi the mythic statement of the matter, so far as I can see, is lacking. It is only in the Bavli, for example, in the famous story of Hillel and Shammai and the convert at b. Shab. 30b– 31a, that the matter is fully explicit. If Maccoby maintains that the conception

that Judaism even though no document and no artifact on its own attest to its character. And that Judaism—which I label the "Judaism out there," that is, prior to, encompassing all documents, each with its own distinctive representation of a Judaic system, which I label a "Judaism in here"—is readily defined. Indeed, that Judaism beyond, or beside, all evidences and data is such as to impose its judgment upon our reading of every sentence, every paragraph, every book.[5] As I said, if such evidence

circulated in the form in which we know it, for example, in the Yerushalmi in truncated form or in the Bavli in complete form, he should supply us with the evidence for his position. As I said, what we cannot show we do not know. And most secular and academic scholarship concurs that we have no historical knowledge a priori, though in writing Maccoby has indeed in so many words maintained that we do. In fact, the documents of formative Judaism do yield histories of ideas, and not every idea can be shown to have taken part in the statement of each, let alone all, of the documents. But those who appeal to a Judaism out there, before and beyond all of the documents, ignore that fact.

5. Commenting on this debate with Maccoby and Sanders, William Scott Green says that Sanders "reads rabbinic texts by peering through them for the ideas [presumably ones Jews or rabbis believed] that lie beneath them." This runs parallel to Maccoby's criticism of my "ignoring" a variety of conceptions I do not find in the Mishnah. Both Maccoby and Sanders, in my view, wish to discuss what *they* think important and therefore to ignore what the texts themselves actually talk about, as Green says, "the materials that attracted the attention and interest of the writers" (personal letter, January 17, 1985). In my original review I pointed out that Sanders's categories ignore what the texts actually say and impose categories the Judaic-rabbinic texts do not know. Sanders, in Green's judgment, introduces a distinct premise:

For Sanders, the religion of Mishnah lies unspoken beneath its surface; for Neusner it is manifest in Mishnah's own language and preoccupations. (William Scott Green, in his Introduction, *Approaches to Ancient Judaism* (Brown Judaic Studies; Chicago: Scholars Press, 1980 2:xxi)

Generalizing on this case, Green further comments in those more general terms that bring us into a debate on the nature of religion and culture, and that larger discourse lends importance to what, in other circumstances, looks to be a mere academic argument. Green writes as follows:

The basic attitude of mind characteristic of the study of religion holds that religion is certainly in your soul, likely in your heart, perhaps in your mind, but never in your body. That attitude encourages us to construe religion cerebrally and individually, to think in terms of beliefs and the believer, rather than in terms of behavior and community. The lens provided by this prejudice draws our attention to the intense and obsessive belief called "faith," so religion is understood as a state of mind, the object of intellectual or emotional commitment, the result of decisions to believe or to have faith. According to this model, people have religion but they do not do their religion. Thus we tend to devalue behavior and performance, to make it epiphenomenal, and of course to emphasize thinking and reflecting, the practice of theology, as a primary activity of religious people. . . . The famous slogan that "ritual recapitulates myth" follows this model by assigning priority to the story and to peoples' believing the story, and makes behavior simply an imitation, an aping, a mere acting out.

is to be located, then nonverbal data such as we have examined should have provided it, for here, by definition, in symbols, we should have been able to demonstrate that, whatever verbal explanations people attached to symbols, a fundamentally uniform symbolic structure served all Judaisms that our evidence attests.

To test the proposition that there was one Judaism nourishing all Judaisms, I have proposed to find out whether we may discern *the* symbolic system or structure upon which all Judaic systems relied, with which every system contended (each in its own way, to be sure), and, above all, to which all Jews responded. If we had been able to show that a single symbolic vocabulary and a single syntax and grammar of symbolic discourse served in all extant testimonies to all Judaisms—iconic and literary evidence alike—then we should have begun to pursue the problem of defining that Judaism through the principles of symbolic discourse.

Why choose the symbolic data? Because, it seems to me, it is through the study of what is inchoate and intuitive, a matter of attitude and sentiment and emotion rather than of proposition and syllogism, therefore through the analysis of symbolic structure, that we should be able to discern and set forth the things on which everyone agreed. As a matter of hypothesis, that is the repertoire of conventions and accepted facts that made possible the characteristic disagreements, small and fundamental alike, that until now have required us in studying the formation of Judaism in the first seven centuries A.D. to describe diverse Judaisms and not a single Judaism. All our evidence derives from Judaisms, however, which is to say that every piece of writing speaks for a particular authorship, every work of art met the specifications of a single artist and patron. True, the writings resort to conventions, for instance, the entirety of the Scriptures of ancient Israel known as the Old Testament (for Christianity) or the written Torah (for Judaism). Admittedly, the artists and their patrons implicitly accepted whatever restrictions they recognized, made their selections, as to both themes and representational conventions, from whatever repertoire they deemed self-evident.

Why give privilege to symbolic discourse rather than to the propositional kind? Consider the alternative. Were we to have compiled a list of facts that we must suppose everyone knew, the truths that everyone affirmed, we should still not have an answer to the question of the

As we reflect on Green's observations, we of course recognize what is at stake. It is the definition of religion, or, rather, what matters in or about religion, emerging from one reading of Protestant theology and Protestant religious experience. But in these pages, only a limited aspect of the larger debate is at issue.

character of normative theological statements that all known parties affirmed. True, in the canonical literature of the Judaism of the dual Torah, for one example, we are able to list matters of fact, bearing profound meaning, that all authorships of all documents affirm but that serve to deliver the particular message of none of them in particular. Beyond that important, indeed paramount, corpus of literary evidence for Judaism, moreover, we may take note of beliefs and practices implicit in buildings set aside for cultic purposes—Temple and synagogue before A.D. 70, synagogue afterward—and take for granted that, whatever characterized as special one place or group, all Jews everywhere came to synagogues to do pretty much the same thing, such as say prayers and read the Torah. But our task is not only or mainly to outline the range of agreement, the consensus of practice and belief, that characterized all those Jews represented by the evidence now in our hands. For much that people affirmed was commonplace, and facts, by themselves, do not give us the outlines of a vivid religious system. We saw a case in point when we found that both symbolic vocabularies appealed to the Temple in one way or another. But that proved to be an inert fact, when we proceeded to see the symbolic vocabulary of Song of Songs Rabbah, which proved to have nothing in common with the symbolic vocabulary that dominated in the provenance of synagogue life.

That observation draws us to another initiative in the description of this single prior Judaism, of which we are informed a priori: What are the facts that mattered to everybody, that delivered the same message in behalf of everybody? That is a different question, since it introduces the consideration of consequence. We hardly need to demonstrate that all Jews took as fact the miraculous exodus from Egypt or the giving of the Torah by God to Moses at Sinai. But any supposition that those facts meant the same thing to everybody, that all Judaic systems through the same facts made the same statement, not only is unfounded but also is unlikely. Facts that serve a particular system in a particular way—the revelation of the Torah at Sinai to convey the systemically emblematic myth of the dual Torah, for instance, in the Judaism of the dual Torah we call rabbinic—by definition do not serve any other system in that same way. So when we want to know about consequence we inquire into facts that mattered in all systems in the same way; those are the facts which tell us about the religious and cultural system as a whole that we call Judaism, not a Judaic system or the aggregate of Judaic systems, but simply Judaism, encompassing, ubiquitous, universal, and, as a matter of fact, particular also to every circumstance and system.

A shared symbolic vocabulary can have overcome a further difficulty,

namely, the very particular context to which the evidence in hand attests. The evidence we have, deriving as it does from particular synagogues or distinct books or sets of books, by its nature tells us about not the general but the specific: this place, for synagogues; that authorship, for compilers of books; that authority, for decisors of canonical composites. One authorship then makes the points important to it in its context, for its purpose—by nature, therefore, not merely informative but polemical. And another authorship will speak of what matters in its setting. Drawing two or more documents together not uncommonly yields the impression of different people talking about different things to different people. So too with the art of synagogues: it is by definition local and particular, because a given synagogue, however it may conform to conventions of architecture and decoration we discern throughout, still attests only to what its community—the people who paid for the building, directed its construction and decoration, and contentedly worshiped within it for centuries—desired. If we were to collect all the statements of all the books and homogenize them, we should produce a hodgepodge of contradictions and—more to the point—non sequiturs. And if we were to combine all the representations on all the walls and floors of all the synagogues of late antiquity, what we should have would be a list of everything everywhere. In both cases, the labor of collecting and arranging everything about everything from everywhere yields uninterpretable, indeed, unintelligible facts.

Our task—to define the kind of evidence that forms the *lingua franca* of all documents and all iconic evidence alike—then demanded attention to symbolic discourse. By definition, then, documentary evidence read propositionally will not serve, since that kind of evidence excludes the mute but eloquent message of art, such as we have in abundance. The artistic evidence by itself cannot be read at all, since in its nature it communicates other than propositions and through other than syllogistic media. Arrangements of figures, to be sure, tell stories, and narrative art can be read as to its tale. But the sense and meaning that the tale is meant to convey appeal to representation, and that, by definition, forms a distinctive medium for communication in other than verbal ways.

THE WAY FORWARD: SYMBOLIC DISCOURSE AND THE DESCRIPTION OF THE THEOLOGY OF THE DUAL TORAH

The theology of the Judaism of the dual Torah that took shape in late antiquity comes to expression not only in propositional but also in sym-

bolic discourse.[6] The "another matter" construction constitutes a play on what I have been calling theological "things"—names, places, events, and actions deemed to bear theological weight and to affect attitude and action. The play is worked out by a reprise of available materials, composed in some fresh and interesting combination. When three or more such theological "things" are combined, they form a theological structure, and, viewed all together, all of the theological "things" in a given document constitute the components of the entire theological structure that the document affords. The propositions portrayed visually, through metaphors of sight, or dramatically, through metaphors of action and relationship, or in attitude and emotion, through metaphors that convey or provoke feeling and sentiment, when translated into language prove familiar and commonplace. The work of the theologian in this context is not to say something new or even persuasive, for the former is unthinkable by definition and the latter unnecessary in context. It is, rather, to display theological "things" in a fresh and interesting way, to accomplish a fresh exegesis of the canon of theological "things."

Until now, in my judgment, we have had no method of description of theology in the canonical writings of the Judaism of the dual Torah[7] that is both coherent with the character of the documents and cogent with the tasks of theological description. By theological description I mean the account of the principles and ideas concerning God's relationship with Israel (for we speak of a Judaism) that form the foundation and substrate of the thought that comes to expression in a variety of canonical writings. The problem has been the character of the documents and their mode of theological discourse. It is not that the writers speak only

6. At this point I cannot claim that the principal or the preferred medium is symbolic discourse, but my instinct tells me that that is the case. However, what is required is the analysis of theological discourse in a given, important document and the comparison of what is said in propositional discourse, what in analytical, what in symbolic, and what in narrative. When we have classified and compared the media for theological expression in a given document in which theology forms a principal theme or topic, we shall be able to proceed with this discussion, which is tangential to the argument of this book.

7. I have already pointed to Max Kadushin's pioneering and I think fundamental efforts at defining such a method of theological description. He is the only scholar known to me who did more than collect and arrange and paraphrase sayings on theological topics. All other accounts of rabbinic theology are not only not historical, they also are in no way analytical. The description of what is there, therefore, contributes little more than paraphrase of the sources. The paraphrase is selective, as it must be, but we never are told the principles of selection: why this, not that? Why this first, then that second? So the move from content to analysis of modes of discourse (which begins here) like the move from (mere) content to analysis of the use of language (which Kadushin made) represents a promising route out of the present impasse.

in concrete terms; we could readily move from their detail to our abstraction and speak in general terms about the coherence of prevailing principles of a theological order.

The problem has been much more profound. We face a set of writings that clearly mean to tell us about God and God's relationship to Israel and Israel's relationship to God. The authorships a priori exhibit the conviction that the thoughts of the whole are cogent and coherent, since they prove deeply concerned to identify contradiction, disharmony, and incoherence, and remove it.[8] But we have not known how to find the connections between what they have written and the structure or system of thought that leads them to say, in detail, the things that they say. In working out a theory of the symbolic discourse, I hope to make possible the description of the symbolic structure set forth by that discourse, and thereby I further mean to open the way to the description of the theology.

The reason that I think we must begin with the elementary analysis of how discourse proceeds is simple. The kind of evidence before us offers little alternative. When we propose to describe the theological system to which a piece of well-crafted writing testifies, our task is easy when the writing to begin with discusses in syllogistic logic and within an appropriate program of propositions what we conceive to be theological themes or problems. Hence—it is generally conceded—we may legitimately translate the topically theological writings of Paul, Augustine, or Luther into the systematic and coherent theologies of those three figures, respectively: finding order and structure in materials of a cogent theological character. But what about a literature that to begin with does not set forth theological propositions in philosophical form, even while using profoundly religious language for self-evidently religious purposes? And how shall we deal with a literature that conducts theological thought without engaging in analytical inquiry in the way in which the philosophers and the theologians of Christianity have done, and did in that period?

Surely the canonical literature of this Judaism testifies to an orderly structure or system of thought, for the alternative is to impute to the contents of those writings the status of mere episodic and unsystematic observations about this and that. True, profound expressions of piety may exhibit the traits of intellectual chaos and disorder, and holy simplicity may mask confusion. But, as I have already stressed, such a

8. To prove that proposition, I need merely to point to the Talmud of Babylonia, the triumph of the Judaism of the dual Torah and its definitive and complete statement.

description of the rabbinic literature of late antiquity, which I call the canon of the Judaism of the dual Torah, defies the most definitive and indicative traits of the writings. These are order, system, cogency, coherence, proportion, fine and well-crafted thought.

To begin with, we have to justify the theological inquiry, through analysis of symbolism, into literature that self-evidently does not conform to the conventions of theological discourse to which Western civilization in its Greco-Roman heritage and Christian (and, as a matter of fact, Muslim) civilization in its philosophical formulation have made us accustomed. The Muslim and the Christian theological heritage, formulated within the conventions of philosophical argument, joined by a much smaller Judaic theological corpus to be sure, does not allow us to read as a theological statement a single canonical writing of the Judaism of the dual Torah of late antiquity. So if the literary canons of Western theology are to govern, then to begin with the literature of Judaism in its formative age by definition can present no theological order and system at all.

But that proposition on the face of it hardly proves compelling. For it is difficult for us to imagine a mental universe so lacking in structure, form, and order as to permit everything and its opposite to be said about God, to imagine a God so confused and self-contradictory as to yield a revelation lacking all cogency and truly unintelligible.[9] The very premises of all theology—that there is order, structure, composition, proportion, and form, in God's mind, which in fact is intelligible to us through

9. As a matter of fact, the great Zoroastrian theologians of the ninth century criticized Judaism (and other religions) on just this point; see my "Zoroastrian Critique of Judaism," reprinted in J. Neusner, *History of the Jews in Babylonia* (Leiden: E. J. Brill, 1969) 4:403–23. But not a single Judaic thinker, whether a philosopher or a theologian, whether in the Islamic philosophical tradition or the Western theological and philosophical tradition, has ever entertained the proposition that the God who gave the Torah is confused and arbitrary; and why should anyone have thought so, when, after all, the entire dynamic of Judaic thought embodied within the great halakhic tradition from the Yerushalmi and Bavli forward has aimed at the systematization, harmonization, and ordering of confusing, but never confused, facts of the Torah. There is therefore no possibility of finding in the Judaism of the dual Torah the slightest hint of an unsystematic system, an a-theological corpus of thought. True, a fixed truth of the theological system known as *die Wissenschaft des Judenthums* has maintained that "Judaism has no theology," but that system knew precisely what it meant by "Judaism," even while never explaining what it might mean by the "theology" that "Judaism" did not have. But that is a problem of description, analysis, and interpretation for those who take an interest in the system of thought that underpins "Jewish scholarship" and Reform Judaism in particular, that is, specialists in the history of ideas in the nineteenth century, and of the nineteenth century in the twentieth century. These are not statements of fact that must be taken into account in describing, analyzing, and interpreting documents of the Judaism of the dual Torah.

the medium of revelation properly construed—a priori render improbable the hypothesis that the canonical writings of the Judaism of the dual Torah violate every rule of intelligible discourse concerning the principal and foundation of all being. If, after all, we really cannot speak intelligibly about God, the Torah, holy Israel, and what God wants of us, then why write all those books to begin with?

While theology may comprise propositions well crafted into a cogent structure, about fundamental questions of God and revelation, the social entity that realizes that revelation, the attitudes and deeds that God, through revelation, requires of humanity, there is another way entirely. Theology, the structure and system, the perception of order and meaning of God, in God, through God—these may make themselves known otherwise than through the media of thought and expression that yield belief that theology can deliver its message to and through sentiment and emotion, heart as much as mind; it can be conviction as much as position, and conviction for its part also is orderly, proportioned, compelling of mind and intellect by reason of right attitude rather than right proposition or position. That is to say, theology may set forth a system of thought in syllogistic arguments concerning the normative truths of the world view, social entity, and way of life of a religious system. But theology may speak in other than dynamic and compelling argument, and theologians may accomplish their goal of speaking truth about God through other than the statements made by language and in conformity with the syntax of reasoned thought.

Theology may also address vision and speak in tactile ways; it may utilize a vocabulary of not proposition but opaque symbol (whether conveyed in visual or verbal media), and through portraying symbol, theology may affect attitude and emotion, speak its truth through other media than those of philosophy and proposition. From the time of Martin Buber's *Two Types of Faith*, now nearly four decades ago, people have understood that this other type of theology, the one that lives in attitude and sentiment and that evokes and demands trust, may coexist, or even compete, with the philosophical type to the discourse of which, in general, we are accustomed. Since, as a matter of fact, in the canonical writings of the Judaism of the dual Torah we do not have a single sustained theological treatise, while we do have a monument to a faith that is choate and subject to fully accessible expression, we must teach ourselves how to describe the theology of the Judaism of the dual Torah out of its fully exposed and complete, systemic documents, and, as we shall see, one way of doing so lies in the analysis of symbolism. Some documents utilize certain forms to make theological statements in sym-

bolic discourse, the recombinant symbolic ones such as that which we have now examined. These documents communicate through symbolic discourse. They therefore point toward the symbolic structure that, for the Judaism of the dual Torah, constitutes the theological statement and message.

Now that we recognize the mode of discourse that serves as one principal medium of theological speech, understanding that at stake was the portrayal of God in relationship to Israel, and Israel in relationship to God, rather than dialectical analysis of propositions concerning that relationship and the demonstration thereof, we may begin the task of the description of the theology of the Judaism of the dual Torah —and even contemplate the further task, the theological description of the Judaism of the dual Torah. Each thing will take place in its turn—God willing.

Appendix I

THE INQUIRY OF MAX KADUSHIN

Kadushin tried to show that within the rabbinic canon is present "an articulation of thought and values more complicated than that which can be devised by logic. . . . This type of thinking . . . is universal, whilst local in content and individualistic in configuration. It is not logical but organismic: Each organismic pattern of thought or organic complex has its own distinctive individuality—each social pattern and each individual variation of it." He claimed, in particular, that rabbinic "thought is concerned with numerous rabbinic concepts. . . . These concepts are certainly not united in logical fashion and their relationship with each other defies diagrammatic representation. Instead, every concept is related to every other concept because every concept is a constituent part of the complex as a whole. Conversely, the complex of concepts as a whole enters into the constitution of every concept; and thus every concept is in constant, dynamic relationship with every other concept. Rabbinic thought, hence, is organismic, for only in an organism are the whole and its parts mutually constitutive."[1]

In *Worship and Ethics*, moreover, Kadushin moved directly to define "rabbinic value concepts," such as Torah, religious duty, charity, holiness, repentance, man: "Such terms are noun forms, but they have a different character than other types of terms or concepts. These terms are connotative only, and hence are not amenable to formal definition. Again, they refer to matter which are not objects, qualities, or relations in sensory experience. Their function is to endow situations or events with significance. These value concepts are related to each other not logically but organismically. This means that the value concepts are not deduced from one another and that they cannot be placed in a logical order. Instead, the coherence or relatedness of the value concepts is such that they interweave dynamically."[2]

1. Max Kadushin, *Organic Thinking: A Study in Rabbinic Thought* (New York: Jewish Theological Seminary of America, 1938) v–vi.

2. Max Kadushin, *Worship and Ethics: A Study in Rabbinic Judaism* (Evanston, Ill.: Northwestern University Press, 1964) vii.

In making these statements, Kadushin intended to take up the study of the concepts of what I call the Judaism of the dual Torah and he called "the Rabbis." His intent is to enter into "the great realm of awareness, the realm of ideas that endow life with significance." While in general Kadushin avoided the word "theology," for example, "The values of Rabbinic Judaism consist of ideas,"[3] in fact, his inquiry, in its terms, aimed at elucidating that system and order, that coherence and proportion and composition and cogency, which the description of the theology of a document or a set of documents lays forth. Kadushin, for his part, insisted that we cannot define value terms, over and over again maintaining that these are "undefined concepts," gaining their meaning in context: "We shall find that the value-concepts are not only undefined but non-definable, and that this accords with the dual nature of the task which is accomplished by them. Being non-definable, the value-concepts are extremely flexible, and they can, therefore, respond to and express the *differentia* of human personalities.

"At the same time, the value-term does convey an abstract, generalized idea of the concept it represents, and this generalized idea is common to all the members of the group."[4] Clearly, we have at the same time a definition of the theological task and a denial that it can be done. For Kadushin's acute concern for the social locus of thought and his interest in allowing for individual difference translate theological inquiry into sociological description of the uses, rather than the logic, of language; that would prove quite plausible, if, at the same time, he did not double back and insist that language has no meaning (merely) because different people use different words differently—but we can nonetheless impute to "the value-term" "an abstract, generalized idea of the concept it represents." But that statement sounds very much like the claim that we know the "concept it represents" even though we cannot define any words that express or convey that concept, that is to say, a priori and intuitive definition.

Kadushin took as his task the description of the theology of the canonical documents of Judaism, and that is what makes Kadushin interesting to me, as I reread his corpus: how he addressed the question of descriptive theology of the Judaism of the dual Torah that seems to me urgent. Not only so, but his interest lay in framing a viable method of description; he recognized, as have very few others who have proposed to

3. Max Kadushin, *The Rabbinic Mind* (New York: Jewish Theological Seminary of America, 1952) 1.
4. Ibid, 2.

204 SYMBOL AND THEOLOGY IN EARLY JUDAISM

do the same work, that prior to inquiry we have to solve the methodological problem of how to inquire. He understood full well the need for self-conscious definition of what we wish to know, how we propose to find it out, and why the methods we use in our study prove both congruent to the task and appropriate to the sources. Thus he stated quite explicitly, "Every modern presentation of rabbinic thought is also an interpretation."[5] To those who claimed to give "just the facts," he countered that knowing what we mean by a fact, which is to say, defining taxa and utilizing them, itself represents much more than giving just the facts. He criticized S. Schechter for his pretentious claim: "I considered it advisable not to intrude too much interpretation or paraphrase upon the Rabbis. I let them have their own say in their own words"—as though we could translate into rabbi-talk such categories as "the Kingdom of God (Invisible)," "the Visible Kingdom (Universal)," "the Kingdom of God (Natural)," and on and on; Kadushin insisted in the face of Schechter's anti-intellectual nonsense: "They are interpretative terms."

Then how to proceed? Kadushin framed what he conceived to be a descriptive vocabulary, doing more than merely re-presenting or paraphrasing in translation rabbinic passages: "Once the rabbinic materials are subjected to analysis, an injustice is done if we reckon merely with this or that specific statement; such specific statements then stand unrelated to rabbinic thought as a whole."[6] But the issue then was, How to speak of the whole all together, all at once? And that, of course, forms the centerpiece of theological description: the claim to be able to say, "This is what it was, this is what it meant, and this is what held the whole together: what was important." To solve that problem, Kadushin called upon the concept of "rabbinic value-concepts," as we have already seen. In my judgment, he took a philosophical route to the solution of a theological problem, and that was both sensible and unseemly. It was sensible because of the ultimate goal of the study of a theological system or structure (my concern with the theology of the canon of the Judaism of the dual Torah is to describe the structure, which is choate and stable, rather than the system, which, in the nature of things, proves dialectical and dynamic and hence defies the low-level description of which, at this time, we may with much work prove capable). But it was unseemly because in order to speak of system and to work in an encompassing way, as we have seen, Kadushin defined out of existence the very thing he wished to describe, analyze, and interpret. His error lay in interpreting

5. Kadushin, *Rabbinic Mind*, 8.
6. Ibid, 9.

too soon, describing too little, and analyzing altogether too much out of all context. He missed the specificities, but, alas, that is where God lives: only in the details. That simple fact, after all, is what defines the task to begin with: to find the theology in the literature, God in the details of words.

I believe Kadushin was the only scholar before this writer who took seriously the documentary boundaries of texts. Thus he started with *The Theology of Seder Eliahu* (New York, 1932); he worked on "Aspects of the Rabbinic Concept of Israel in the Mekilta," *Hebrew Union College Annual* 1943–46, 19:57–96; I published his posthumous book, *A Conceptual Commentary on Midrash Leviticus Rabbah; Value Concepts in Jewish Thought* (Atlanta, 1987: Scholars Press for Brown Judaic Studies). Accordingly, we cannot dismiss him as another routine lexical theologian, imputing uniform meanings to words wherever and whenever they occur, at the same time assuming that lexical paraphrase sufficed to represent the logic, order, coherence, and structure of those sets of words, even comprising sentences, which represent (a) theology through description.

This he did not do, but this still is what emerged. He identified four concepts of special interest: God's justice, love, Torah, and Israel, each with its own subconcepts, for example, "God's justice the subconcepts of chastisements, Merit of the Fathers, Merit of the Children, and 'measure for measure'; God's love the subconcepts of prayer, repentance and atonement," and so on. Each of these concepts with their subconcepts he classified and organized and categorized, with this result: "The relation of a general concept to its subconcepts . . . is one form of integration to be found then in the complex of the rabbinic value concepts." Now to what end, and what is at stake? That Kadushin proposed a theological description is beyond any doubt: "Ramified into subconcepts and conceptual phrases, the four concepts . . . play a large role in integrating the entire complex of concepts."[7] The key word here is "integrating," and the main point clear.

The point of relevance to this book comes at the present turning in Kadushin's argument. Kadushin's result, repeated in all of his books, is that the concepts "combine or interweave with *every* value concept of the rabbinic complex of concepts." Lest readers suppose that I have imputed to him this confession of the indeterminacy of all language, I point out that the italics of "every" are his, not mine. Kadushin produces an utter chaos with such hermeneutical positions as this one: "In like

7. Kadushin, *Rabbinic Mind*, 18.

manner the four concepts also interweave with each other and with all their subconcepts and conceptual phases. . . . Apparent now is an all-embracing principle of coherence, making by and large for the organization of the rabbinic value-complex, for, since the four concepts combine with one another and with the rest of the concepts, every concept can interweave with every other concept in the complex."[8] The upshot is that we can never know what anything means in general, because all language is specific to its setting: "The process of integration has enormous bearing on the meaning of the individual concepts. The conceptual term is only suggestive of the meaning of the value concept. The idea content of any particular rabbinic value concept is a function of the entire complex of concepts as a whole, more specifically, of the process of the integration of the particular concept with the rest of the concepts of the complex. Depending on how we view the process, we can say, therefore, either that a value concept takes on idea content, or that its idea content becomes explicit only as it interweaves with other concepts of the complex."[9] Again and again Kadushin insists that fixed combinations will not serve to impute the meaning of a value concept: "There is no way to predict, on the basis of the particular concepts involved, precisely what idea any given combination of concepts may be made to express." Then what of coherence, logic, order? Kadushin answers that question, and with this answer we conclude our survey of his method:

What is the principle of coherence or order which governs the concepts? We have to do here not with a fixed, static form of unity but with a dynamic process. It is a process of integration, on the one hand, in which the four fundamental concepts combine with each other and with the rest of the concepts so that each individual concept is always free to combine with any other concept of the complex; and it is also a process of individuation, on the other hand, in which any particular concept takes on meaning or character in the very process whereby it combines with the other concepts of the complex. . . . The rabbinic complex of value concepts is an organism. . . . The rabbinic value-complex, since it is composed of concepts and ideas, is a mental organism.[10]

The organization of the rabbinic value concepts is . . . a highly complicated affair, complex enough because of the constant interweaving of all the concepts in their organismal relationship and made still more complex because of further, supplementary types of relationship permitted by the

8. Ibid, 22.
9. Ibid, 23.
10. Ibid, 24–25.

organismic integration. . . . The rabbinic value-complex functions easily, simply, often almost casually. . . . The rabbinic value concept is not a meaning added or applied to objective facts or situations but inherent in the situations and as easily apprehended.[11]

It now suffices to repeat that Kadushin has taken a philosophical route to the solution of what is, to begin with, a literary problem—even while, as I said, identifying the importance of the literary evidence read *in situ*. He has taken the language of the rabbinic writings as the probative evidence, the meanings of words read at one and the same time essentially out of all specific context and also wholly and only in discrete and specific context alone. In my view, the result is wholly negative. Kadushin did not succeed in describing the theology of the Judaism of the dual Torah, because he identified as the appropriate evidence the wrong data, words read pretty much every which way; and furthermore, having focused upon the right question—the character of documents and the message of documents—he turned away from his own results. What did Kadushin do wrong? Despite his own good method he ignored the bounds of the documents, treating the canon as essentially uniform and limited only by its outer frontiers. So he leapt directly into words and their definition. That accounts for the unnuanced character of his results.

Kadushin most certainly identified as his quest a theological description problem, so he knew precisely the problem he wished to solve. What makes me sure it was the problem of the description of theology? I find ample justification in his own words (even while he did not like the word "theology" at all):

The problem of the coherence of rabbinic theology [to which he appends the footnote, p. 267 n. 2: "the term 'rabbinic theology' is not an appropriate designation for rabbinic thought"] appears to be precisely that which we have just raised with regard to values in general. Any representation of rabbinic theology as a logical system . . . is bound to be a distortion. Careful scholars agree with Schechter who says, "that any attempt at an orderly and complete system of Rabbinic theology is an impossible task." Instead they aim at "letting Judaism speak for itself in its own way," to use Moore's words, and therefore, for the most part, merely offer collected data on rabbinic concepts or attitudes in the form of centos of rabbinic passages on these themes drawn from various sources. The very fact however that disparate passages drawn from rabbinic sources that were composed at

11. Ibid, 30.

208 SYMBOL AND THEOLOGY IN EARLY JUDAISM

different periods and under divergent circumstances can yet be brought together so as to elucidate a rabbinic concept—that fact is proof positive that rabbinic theology possessed some kind of unity, some sort of coherence.[12]

There we have it: what is the logic of this logical system? How is it systemic at all? Not only so, but, Kadushin points out, all those who have worked in the Western academic idiom have concurred that we may ask such a question of consensus, logic, order, and coherence. He points out, for instance, that Schechter insisted on the presence of "consensus of opinion," and points to remarkable agreement in doctrine; Bacher in his time stressed that both in method and in content (in Kadushin's words) "haggadic literature was already well developed at a very early period and that therefore it is more correct to speak of the enlargement rather than the development of the Haggadah." From this, Kadushin concluded, "The principle of coherence of rabbinic theology . . . must have been such as made for unity of thought over great stretches of time and still gave room for differences due to changed circumstances and to the divergent proclivities of individuals."[13] And that ends up with his organismic thinking, in which we cannot define anything but know what everything means.

While among philosophically engaged colleagues, Kadushin quite justifiably retains more than antiquarian interest, for the study of religion, his *oeuvre* marks only an experiment that failed. He asked the right question; his criticism of his predecessors hit the mark. But in asking questions of coherence and logic, he denied that these questions could be answered; that is, I think, because he did not know how to answer them. He tried to cover everything all at once, even while correctly working through specific documents in concrete ways; it was, then, a failure of nerve. He wanted too much too soon, and he did not do the detailed work that would have yielded results commensurate to the inquiry: what holds the whole together is a question he never in the end answered at all, and the answers that he did give underlined his own failure.

And yet—and yet, for the sheer wit and intelligence, the effort, and the courage and the nobility of the enterprise as he undertook to realize it, Kadushin stands pretty much all by himself. He is the only scholar who has forthrightly and articulately asked the theological question of

12. Kadushin, *Organic Thinking*, 2.
13. Ibid, 2–3.

Judaism in the correct, academic mode.[14] He is the only scholar who has undertaken to set forth a well-crafted method. And he is the only scholar who has provided sustained and well-articulated results. I cannot (yet) describe "the rabbinic mind," but, like Kadushin, I am confident that unless and until we can make sense of that mind (I should prefer the word "theology"), we shall have attained only a very partial, and not a very persuasive or compelling, description of Judaism.

14. Theologians who have offered normative statements of course are not subject to judgment here. True, I cannot point to theologies of Judaism that have exhibited profound grasp and appreciation of the rabbinic corpus, which commonly serves only to supply undifferentiated proof texts for propositions formulated not within the dual Torah but within other realms of thought and discourse entirely; to the discourse of theology of Judaism, therefore, the canonical books, while authoritative and critical, prove peripheral and ancillary. The sole exception in any language is Abraham J. Heschel, but his *Torah min hashshamayim*, on the theology of revelation of the sages Ishmael and Aqiba, the one immanental and the other transcendental (and for Heschel these words bear rather particular and possibly idiosyncratic meanings), cast in merely descriptive language what is, in fact, a prescriptive and normative theory of revelation in the Judaism of the dual Torah; he mixed academic scholarship with theology, and whether the result was theology, as I should claim, certainly it was not scholarship. But beyond Heschel, the theological scene proves barren indeed to those who take their sight by the fixed star of the dual Torah. And, it goes without saying, when the theologizing of avatars of "the tradition," that is, people educated in the Yeshiva world, gets translated into English, we are presented with either confused meanderings (J. B. Soloveichik's *Halakhic Man* is the outstanding example) of a pseudo-philosophical order or sheer platitude and banality (the cult figure, Adin Steinsaltz, provides the best instance among a great many).

Appendix II

GOODENOUGH'S CONTRIBUTION
TO THE STUDY OF JUDAISM

THE PROBLEM OF SYNAGOGUE ART
IN THE STUDY OF ANCIENT JUDAISM

What we learn about Judaism from the art of the ancient synagogues has been debated for most of the twentieth century. When we follow those debates, we shall understand how the visual arts—with stress on the problem of interpreting the meaning of art and symbolism—affect our understanding of the religious life of people we know, otherwise, only from holy books. The particular case at hand brings us to the critical issue in the study of ancient Judaism, from the first to the seventh century. The literary evidence overall portrays that Judaism in one way and the artistic evidence in a quite different way. That is why synagogue art presents a problem in the study of ancient Judaism.

Most ancient synagogues, both in the Land of Israel and abroad, reveal important decorations on their walls. The decorations turn up fairly consistently. Some symbols recur nearly everywhere. Other symbols never make an appearance at all. A *shofar*, a *lulab* and *etrog*, a *menorah*, all of them Jewish in origin, but also such pagan symbols as a zodiac, with symbols difficult to find in Judaic written sources—all of these form part of the absolutely fixed symbolic vocabulary of the synagogues of late antiquity. By contrast, symbols of other elements of the calendar year, at least as important as those which we do find, turn out never to make an appearance. And, obviously, a vast number of pagan symbols proved useless to Judaic synagogue artists. It follows that the artists of the synagogues spoke through a certain set of symbols and ignored other available ones. That simple fact makes it highly likely that the symbols they did use meant something to them, represented a set of choices, delivered a message important to the people who worshiped in those synagogues.

Because the second commandment forbids the making of graven images of God, however, people have long taken for granted that Judaism should not produce an artistic tradition. Or, if it does, it should be essentially abstract and nonrepresentational, much like the rich decorative tradition of Islam. But from the beginning of the twentieth century, archaeologists began to uncover in the Middle East, North Africa, the Balkans, and the Italian peninsula synagogues of late antiquity richly decorated in representational art. For a long time historians of Judaism did not find it possible to accommodate the newly discovered evidence of an ongoing artistic tradition. They did not explain that art, they explained it away. One favorite explanation was that "the people" produced the art, but "the rabbis," that is, the religious authorities, did not approve it or at best merely tolerated it. That explanation rested on two premises. First, because talmudic literature—the writings of the ancient rabbis over the first seven centuries A.D.—made no provision for representational art, therefore representational art was subterranean and "unofficial." Second, rabbis are supposed to have ruled everywhere, so the presence of iconic art had to indicate the absence of rabbinic authority.

Aware of the existence of sources that did not quite fit into the picture that emerged from talmudic literature as it was understood in those years or that did not serve the partly apologetic purposes of their studies, scholars such as George Foot Moore in his *Judaism: The Age of the Tannaim*[1] posited the existence of "normative Judaism," which is to be described by reference to talmudic literature and distinguished from "heretical" or "sectarian" or simply "non-normative" Judaism of "fringe sects." Normative Judaism, exposited so systematically and with such certainty in Moore's *Judaism*, found no place in its structure for art, with its overtones of mysticism (except "normal mysticism"), let alone magic, salvific, or eschatological themes except within a rigidly reasonable and mainly ethical framework; nor did Judaism as these scholars understood it make use of the religious symbolism or ideas of the Hellenistic world, in which it existed essentially apart and at variance.

Today no informed student of Judaism in late antiquity works within the framework of such a synthesis, for this old way is no longer open. The testimony of archaeology, especially of the art of the synagogues of antiquity, now finds a full and ample hearing. In understanding the way

1. George Foot Moore, *Judaism: The Age of the Tannaim* (Cambridge: Harvard University Press, 1927).

in which art contributes to the study of the history of a religion, we find in Judaism in late antiquity a fine example of the problems of interpretation and how they are accommodated and solved. To trace the steps by which people began to accept the importance of art—symbolic, representational, abstract, iconic—is to follow one career above all, and that is Erwin R. Goodenough's.

ERWIN R. GOODENOUGH AND THE SYMBOLISM OF JUDAISM

In studying about ancient Judaism through reference to the art of the synagogue, we deal with one towering figure. Erwin Ramsdell Goodenough was the greatest historian of religion that America ever produced, and his *Jewish Symbols in the Greco-Roman Period* is his major work.[2] Goodenough provided for the artistic remains of the synagogue a complete and encompassing interpretation, and, to the present time, his view remains the principal theory by which the art of the synagogue is approached.

Writing about his *Jewish Symbols in the Greco-Roman Period,* Goodenough stated:

> I am bold enough to hope not only Judaism and the origin of Christianity may be illumined by the present undertaking, but I may also offer suggestions for a new methodology applicable to the whole spiritual history of the civilizations behind us. . . . I have slowly been forced to suspect that the spiritual history of the development of Western man cannot be written as a set of disjunctive essays on the religion of each successive people and civilization, from Babylonia to the present. Rather it must be seen to be a continuous adaptation of certain basic symbols. These volumes are then submitted ultimately as a contribution to a field in which no one is as yet an expert. That field is symbolism in the most general and contemporary sense.

So Goodenough explains his purpose in the study of Jewish symbols in particular. Indeed, as we see, his vision encompassed the whole of

2. The complete bibliography of Goodenough's writings, by A. Thomas Kraabel, appears in J. Neusner, ed., *Religions in Antiquity: Essays in Memory of Erwin Ramsdell Goodenough* (Leiden: E. J. Brill, 1968) 621–632. My abridged edition of his *Symbols* was published in 1988 by Princeton University Press. In what follows, I have drawn on parts of my introduction to that book and on my introduction to the literature on Goodenough's work, printed in the appendix of the same book. All of Goodenough's articles are now in print in the following: J. Neusner and E. S. Frerichs, eds., *Goodenough on History of Religion and on Judaism* (Brown Judaic Studies; Atlanta: Scholars Press, 1986); and A. Thomas Kraabel, ed., *Goodenough on Christianity* (Brown Judaic Studies; Atlanta: Scholars Press, 1990).

human spiritual history. That explains Goodenough's greatness, why he deserves a hearing for a long time to come. Because, along with his teacher, George Foot Moore, Erwin Ramsdell Goodenough was the greatest historian of religion produced in America, his work retains abiding interest.

Erwin Ramsdell Goodenough was born in Brooklyn, New York, raised in a theologically conservative Methodist family, studied at Hamilton College, Drew Theological Seminary, and Garrett Biblical Institute, from which he received his bachelor's degree in theology in 1917. He then spent three years studying at Harvard with George Foot Moore, the first important historian of religion in America, and another three years at Oxford. He received his D. Phil. from Oxford in 1923 and in the same year became instructor in history at Yale University. He spent his entire career at Yale, being named Professor of the History of Religion in 1934 and John A. Hoober Professor of Religion in 1959. He retired in 1962 and spent a post-retirement year teaching at Brandeis University.

Goodenough spent much of his life working on Jewish art and symbolism. In his reading of these symbols, we meet Goodenough's basic notion of Philo's Judaism, for he interprets the symbols by reference to Philo's writings and proposes to describe a mystical, Greek-speaking Judaism, represented by both Philo and the artists who decorated the ancient synagogues. We see in this book how Goodenough debated a different reading of Philo. By simply reviewing the finds, Goodenough forced the scholarly world to reconsider its consensus and to come to a thoughtful reappraisal of its earlier position. Goodenough's essential contribution is to be measured by evaluating, not his "proof" of any of his theses, but rather his method and its *cumulative* consequences. Goodenough forced some of us to take seriously the question posed by the Jewish symbolic vocabulary yielded by ancient synagogues and sarcophagi. With reference to both Philo and synagogue art Goodenough does not claim to "prove" anything, for if by proof one means certain and final establishment of a fact, there can be no proof in the context of evidence such as this.

At the period between the first and the sixth century, the manifestations of the Jewish religion were varied and complex, far more varied, indeed, than the extant talmudic literature would have led us to believe. Besides the groups known from this literature, we have evidence that "there were widespread groups of loyal Jews who built synagogues and buried their dead in a manner strikingly different from that which the men represented by extant literature would have probably approved, and, in a manner motivated by myths older than those held by these

men." The content of these myths may never be known with any great precision, but comprehended a Hellenistic-Jewish mystic mythology far closer to the Qabbalah than to Talmudic Judaism. In a fairly limited time before the advent of Islam, these groups dissolved. This is the plain sense of the evidence brought by Goodenough, not a summary in any sense of his discoveries, hypotheses, suggestions, or reconstruction of the evidence into a historical statement.

Along with Moore's *Judaism* and Goodenough's *Jewish Symbols* no other single work has so decisively defined the problem of how to study religion in general and, by way of example, Judaism in particular. Goodenough worked on archaeological and artistic evidence, so took as his task the description of Judaism out of its symbolic system and vocabulary. Moore worked on literary evidence, so determined to describe Judaism as a systematic theological structure. Between the two of them they placed the systematic study of Judaism in the forefront of the academic study of religion and dictated the future of the history of religion in the West. It would encompass the religions not only of nonliterate and unfamiliar peoples but also of literate and very familiar ones. In all, Moore and Goodenough have left a legacy of remarkable power and intellectual weight. Through the study of Judaism they showed how to describe, analyze, and interpret religious systems, contexts and contents alike.

In 1963 Goodenough asked me what I thought he had contributed. I turned the question on him and now report his answer: What do you think? I recall my surprise at how he understated his contribution. Goodenough was a great man, one of the few truly great human beings I have known in scholarship. The modesty of his assessment of his own work strikes me as evidence of that fact. At the same time, let it now be said that he had a sense of not having been adequately appreciated in his day. Even when he lay dying, Goodenough expressed a sense of disappointment and hurt. Academic life sometimes turns paranoia into understatement. But Goodenough's continuing influence, the keen interest in his work two decades after his death, surely vindicates him and marks him as one of the giants of his age.

Goodenough does not claim to "prove" anything. The stones are silent; Goodenough has tried to listen to what they say. He reports what he understands about them, attempting to accomplish what the evidence as it now stands permits: the gradual accumulation of likely and recurrent explanations derived from systematic study of a mass of evidence and the growing awareness that these explanations point to a highly probable conclusion. That is not a "demonstration" in the sense that a geometrical proposition can be demonstrated, and for good reason are

the strictly literal (and, therefore, philological) scholars uncomfortable at Goodenough's results. But all who have worked as historians even with literary evidence must share Goodenough's underlying assumption that nothing in the endeavor to recover historical truth is in the end truly demonstrable or positive, but significant statements about history may nonetheless be made.

GOODENOUGH'S REVIEW OF THE ARCHAEOLOGICAL EVIDENCE FOR JEWISH ART IN THE SYNAGOGUE

The first three volumes of Goodenough's *Jewish Symbols* collect the Jewish realia uncovered in the past by archaeologists working in various parts of the Mediterranean basin. Goodenough's interest in these artifacts began, he reports, with the question of how it was possible, within so brief a span as fifty years, that the teachings of Jesus could have been accommodated so completely to the Hellenistic world. Not only central ideas but even widespread symbols of early Christianity appear in retrospect to have been appropriated from an environment alien to Jewish Palestine. "For Judaism and Christianity to keep their integrity, any appropriations from paganism had to be very gradual" (1:4). Yet within half a century of Jesus' death, Christian churches were well established in Hellenistic cities, and Christian teachings were within the realm of discourse of their citizens. If the "fusion" with Hellenistic culture occurred as quickly as it did, then it seems best explained by reference to an antecedent and concurrent form of Hellenistic Judaism that had successfully and naturally achieved a comfortable accommodation with Hellenism. Why so? Goodenough maintains that the Judaism known from the writings of the ancient rabbis, hence "rabbinical Judaism," could not accommodate itself to Hellenism. Goodenough's main point follows: "While rabbinical Judaism can adjust itself to mystic rites . . . it would never have originated them."

That is to say, we should look vainly in the circles among whom talmudic literature developed for the origins of the various symbols and ideas of Hellenistic Judaism. It follows that evidences of the use of the pagan inheritance of ancient civilization for the specifically Jewish purposes derives from Jews whose legacy is not recorded in the pages of the Talmud. So Goodenough's first question is, If the rabbis whose writings we possess did not lead people to use the symbols at hand, then who did? If, as Goodenough contends, not all Jews (perhaps, not even many Jews) were under the hegemony of the rabbis of the Talmud, who did not lead the way in the utilization of pagan symbols in synagogue decoration, then what shall we think if we discover substantial, identifiably Jewish

purposes of forms we should expect to uncover not in a Jewish but rather in a pagan setting?

One conclusion would render these finds insignificant. If illegal, symbolic representations of lions, eagles, masks, victory wreaths, not to mention the zodiac and other astral symbols, were made for merely ornamental purposes, "the rabbis" may not have approved of them but had to "reckon with reality" and "accepted" them. That view was commonly expressed but never demonstrated. For his part, Goodenough repeats litanously, symbol by symbol and volume by volume (see 1:108), that it is difficult to agree that the handful of symbolic objects so carefully chosen from a great variety of available symbols, so frequently repeated at Dura, Randanini, Bet Alpha, Hammam Lif, and elsewhere, used to the exclusion of many other symbols, and so sloppily drawn that no ornamental artist could have done them, constituted mere decoration. Furthermore, it begs the question to say that these symbols were "merely" ornamental: why specifically these symbols and *no others?* Why in these settings?

Goodenough attempts to uncover the meaning of various symbols discovered in substantial quantities throughout the Jewish world of antiquity. His procedure is, first, to present the finds *in situ;* second (and quite briefly), to expound a method capable of making sense out of them; and, third, to study each extant symbol with the guidance of this method. Goodenough presents a majestic array of photographs and discussion, for the first time presenting in one place a portrait of Jewish art in antiquity, one as magnificent as will ever appear. The Bollingen Foundation deserves credit for making possible Goodenough's remarkable edition of the art. Nothing like it has been done in the thirty years since the first three volumes made their appearance.

In his survey Goodenough begins with the art of the Jewish tombs in Palestine and of their contents, studying the remains by chronological periods and thus indicating the great changes in funerary art that developed after A.D. 70. Goodenough proceeds (1, ch. 5) to the synagogues of Palestine, their inscriptions and contents, describing (sometimes briefly) more than four dozen sites. He concludes (1:264):

> In these synagogues certainly was a type of ornament, using animals, human figures, and even pagan deities, in the round, in deep relief, or in mosaic, which was in sharp distinction to what was considered proper for Judaism. . . . The ornament we are studying is an interim ornament, used only after the fall of Jerusalem, and before the completion, or reception, of the Talmud. The return to the old standards, apparently a return to the halachic Judaism that the rabbis advocated, is dramatically attested by the

destruction, obviously by Jews themselves, of the decorative abominations, and only of the abominations, in these synagogues. Only when a synagogue was abandoned as at Dura . . . are the original effects preserved, or the devastations indiscriminate.

The decoration in these synagogues must have seemed more than merely decorative to those who destroyed them so discriminatingly.

Goodenough argues that distinction between fetishistic magic and religion is generally subjective and imposed from without by the embarrassed investigator. He points out (2:156) that magical characteristics, such as the effort to achieve material benefits by fundamentally compulsive devices are common (whether we recognize them as such or not) in the "higher" religions. It is certainly difficult to point to any religious group before the present time that did not quite openly expect religion to produce some beneficial consequence and if that consequence was to take place after death, it was no less real. Hence Goodenough concludes that "magic is a term of judgment," and thus the relevance of charms and amulets is secured. Goodenough summarizes the consequences of his evidence as follows (2:295):

> The picture we have got of this Judaism is that of a group still intensely loyal to Yao Sabaoth, a group which buried its dead and built its synagogues with a marked sense that it was a peculiar people in the eyes of God, but which accepted the best of paganism (including its most potent charms) as focusing in, finding its meaning in, the supreme Yao Sabaoth. In contrast to this, the Judaism of the rabbis was a Judaism which rejected all of the pagan religious world (all that it could). . . . Theirs was the method of exclusion, not inclusion.

The problem is, then, how to establish a methodology by which material amassed in the first three volumes may be studied and interpreted.

GOODENOUGH'S INTERPRETATION
OF SYMBOLS: THE METHOD

Goodenough argues that the written documents, particularly the talmudic ones, do not suffice to interpret symbols so utterly alien to their spirit and, in any case, so rarely discussed in them. Even where some of the same symbols inscribed on graves or synagogues are mentioned in the Bible or in the Talmud, it is not always obvious that those textual references engage the mind of the artist. Why not? Because the artists follow the conventions of Hellenistic art, and not only Hellenistic art but the conventions of the artists who decorated cultic objects and places in

the same locale in which, in the Jewish settings, the symbols have turned up. Goodenough asks for a general theory to make sense of all the evidence, something no one else gives, and asks (4:10):

> Where are we to find the moving cause in the taking over of images, and with what objective were they taken over? . . . It seems . . . clear to me that the motive for borrowing pagan art, and integrating it into Judaism throughout the Roman world, can be discovered only by analyzing the art itself.

An interpretive method needs to be devised. Goodenough succinctly defines this method (4:10–11):

> The first step . . . must be to assemble . . . the great body of evidence available, . . . which, when viewed as a whole, demands interpretation as a whole, since it is so amazingly homogeneous for all parts of the Empire. The second step is to recognize that we must first determine what this art means in itself, before we begin to apply to it as proof texts any possibly quite unrelated statements of the Bible or the Talmud. That these artifacts are unrelated to proof texts is a statement which one can no more make at the outset than one can begin with the assumption of most of my predecessors, that if the symbols had meaning for Jews, that meaning must be found by correlating them with talmudic and biblical phrases. . . . The art has rarely, and then only in details, been studied for its possible meaning in itself; this is the task of these volumes.

If the succeeding volumes exhibit a monotonous quality, as one symbol after another comes under discussion and produces an interpretation very close to the ones already given, it is because of Goodenough's tenacious use of a method clearly thought through, clearly articulated, and clearly applied throughout. What is this method? The problem here is to explain how Goodenough determines what this art means in itself. He begins by asking (4:27):

> Admitting that the Jews would not have remained Jews . . . if they had used these images in pagan ways and with pagan explanations, do the remains indicate a symbolic adaptation of pagan figures to Judaism, or merely an urge to decoration?

Goodenough (4:28) defines a symbol as "an image or design with a significance, to one who uses it, quite beyond its manifest content, . . . an object or a pattern which, whatever the reason may be, operates upon men, and causes effect in them, beyond mere recognition of what is literally presented in the given form." Goodenough emphasizes that most important thought is in "this world of the suggestive connotative

meaning of words, objects, sounds, and forms." He adds (4:33) that in religion a symbol conveys not only meaning but also "power or value." Further, some symbols move from religion to religion, preserving the same "value" while acquiring a new explanation. In the long history of Judaism religious "symbols" in the form of actions or prohibitions certainly endure through many, varied settings, all the while acquiring new explanations and discarding old ones, and perpetually retaining religious "force" or value or (in more modern terms) "meaning." Hence Goodenough writes (4:36):

> Indeed, when the religious symbols borrowed by Jews in those years are put together, it becomes clear that the ensemble is not merely a "picture book without text," but reflects a lingua franca that had been taken into most of the religions of the day, for the same symbols were used in association with Dionysus, Mithra, Osiris, the Etruscan gods, Sabazius, Attis, and a host of others, as well as by Christianity later. It was a symbolic language, a direct language of values, however, not a language of denotation.

Goodenough is far from suggesting the presence of a pervasive syncretism. Rather, he points to what he regards as pervasive religious values applied quite parochially by various groups, including some Jews, to the worship of their particular "Most High God." These values, while connotative and not denotative, may nonetheless be recovered and articulated in some measure by the historian who makes use of the insights of recent students of psychology and symbolism. Goodenough says (4:42):

> The hypothesis on which I am working . . . is that in taking over the symbols, while discarding the myths and explanations of the pagans, Jews and Christians admitted, indeed confirmed, a continuity of religious experience which it is most important to be able to identify . . . for an understanding of man, the phenomenon of a continuity of religious experience or values would have much more significance than that of discontinuous explanations.

Goodenough therefore must state carefully where and how each symbol occurs, thus establishing its commonplace quality; he must then show the meaning that the symbol may have had *universally,* indicating its specific denotative value in the respective cultures which used it. He considers its broader connotative value, as it recurs in each culture, because a symbol evokes in man, not only among specific groups of men, a broader, psychologically oriented meaning. Goodenough notes that the formal state religions of Athens, Rome, and Jerusalem had a quite different basis and had little (if any) use for the symbols at hand. These symbols, he holds, were of use "only in religions that engendered deep

emotion, ecstasy, religions directly and consciously centered in the renewing of life and the granting of immortality, in the giving to the devotee of a portion of the divine spirit of life substance."

At the end these symbols appear to indicate a type of Judaism in which, as in Philonic Judaism, the basic elements of "mystery" were superimposed upon Jewish legalism. The Judaism of the rabbis has always offered essentially a path through this present life the father's code of instructions as to how we may please him while we are alive. To this, the symbols seem to say, was now added from the mystery religions, or from Gnosticism, the burning desire to leave this life altogether, to renounce the flesh and go into the richness of divine existence, to appropriate God's life to oneself.

These ideas have as little place in normative, rabbinic Judaism as do the pictures and symbols and gods that Jews borrowed to suggest them. That such ideas were borrowed by Jews was no surprise to me after years of studying Philo.

What is perplexing is the problem of how Jews fitted such conceptions into, or harmonized them with, the teachings of the Bible.

THE MEANING OF THE ARTISTIC SYMBOLS

In volumes 4–8, Goodenough turns back to the symbols whose existence he traced in volumes 1–3. Now he attempts a systematic interpretation according to the method outlined in volume 4, part 1. In his discussion of symbols from the Jewish cult, Goodenough attempts to explain what these symbols may have meant when reproduced in the noncultic settings of synagogue and grave, specifically, the *menorah,* the Torah Shrine, *lulab* and *etrog, shofar,* and incense shovel. These symbols are, of course, definitely Jewish. But they seem to have been transformed into symbols (4:67), "used in devotion, to have taken on personal, direct value," to mean not simply that the deceased *was* a Jew but to express a "meaning in connection with the death and life of those buried behind them." It would be simple to assign the meaning of these symbols to their biblical or cultic origins, except for the fact that they are often represented with less obviously Jewish or biblical symbols, such as birds eating grapes and the like.

Rather, Goodenough holds that these devices may be of some direct help in achieving immortality for the deceased, specifically

the *menorah* seems to have become a symbol of God, of his streaming light and Law . . . the astral path to God. the *lulab* and *etrog* carried on the

association of Tabernacles as a festival of rain and light, but took on mystical overtones, to become a eucharist to escape from evil and of the passing into justice as the immaterial Light comes to man.

He concludes:

> They could take a host of pagan symbols which appeared to them to have in paganism the values they wanted from their Judaism and blend them with Jewish symbols as freely as Philo blended the language of Greek metaphysics with the language of the Bible.

In *Fish, Bread and Wine,* Goodenough begins by discussing the Jewish and pagan representations of creatures of the sea, in the latter section reviewing these usages in Egypt, Mesopotamia, Syria, Greece, and Rome (a recurrent inquiry), then turns to the symbolic value of the fish in Judaism, finally, to bread. The representations of "bread" often look merely like "round objects," however, and if it were not for the occasional representation of baskets of bread, one should be scarcely convinced that these "round objects" signify anything in particular. The section on wine is the high point of these volumes, both for its daring and for its comprehensive treatment of the "divine fluid" and all sorts of effulgences from the godhead, from Babylonia and Assyria, Egypt (in various periods), Greece, Dionysiac cults in Syria and Egypt, as well as in the late syncretistic religions. Goodenough finds considerable evidence in Jewish cult and observance but insists that fish, bread, and wine rites came into Jewish practice during and not before the Hellenistic period, and hence must be explained by contemporary ideas. Wine, in particular, was widely regarded as a source of fertility, but its mystic value was an expression of the "craving for sacramental access to Life."

Pagan symbols used in Jewish contexts include the bull, lion, tree, crown, various rosettes and other wheels (demonstrably not used in paganism for purely decorative purposes), masks, the gorgoneum, cupids, birds, sheep, hares, shells, cornucopias, centaurs, psychopomps, and astronomical symbols. Goodenough treats this body of symbols last because while some may have had biblical referents, the symbolic value of all these forms seems to him to be discovered in the later period. Of the collection, Goodenough writes (8:220–21):

> They have all turned into life symbols, and could have been, as I believe they were, interpreted in a great many ways. For those who believed in immortality they could point to immortality, give man specific hopes. To those who found the larger life in a mysticism that looked, through death, to a final dissolution of the individual into the All, . . . these symbols could

have given great power and a vivid sense of appropriation. . . . The invasion
of pagan symbols into either Judaism or Christianity . . . involved a modifi-
cation of the original faith, but by no means its abandonment. Symbolism is
itself a language, and affected the original faith much as does the adopting
of a new language in which to express its tenets. Both Christians and Jews
in these years read their Scriptures, and prayed in words that had been
consecrated to pagan deities. The very idea of a God, discussion of the
values of the Christian or Jewish God, could be conveyed only by using the
old pagan *theos;* salvation, by the word *sōtēria;* immortality, by *athanasia.*
The eagle, the crown, the zodiac, and the like spoke just as direct, just as
complicated, a language. The Christian or Jew had by no means the same
conception of heaven or immortality as the pagan, but all had enough in
common to make the same symbols, as well as the same words, expressive
and meaningful. Yet the words and the symbols borrowed did bring in
something new.

Goodenough continues (8:224): "When Jews adopted the same lingua
franca of symbols they must . . . have taken over the constant values in
the symbols."

Finally, Goodenough reviews the lessons of the evidence. From the
cultic objects we learn that the Jews used images of their cultic objects in
a new way, in the pagan manner, for just as the pagans were putting the
mythological and cultic emblems of their religions on their tombs to
show their hope in the world to come, so too did the Jews. From fish,
bread, and wine, we learn that the Jews were thus partaking of immortal
nature. In reference to the symbols that had no cultic origins (vols. 7 and
8) and, on the face of it, slight Jewish origins (apart from the bull, tree,
lion, and possibly crown, which served in biblical times), Goodenough
proposes that the value of these objects, though not their verbal explana-
tions, were borrowed because some Jews found in them "new depths for
[their] ideas of . . . [their] own Jewish deity, and [their] hope of salvation
or immortality."

THE DEBATE ON THE ART OF THE SYNAGOGUE AT
DURA EUROPOS: GOODENOUGH AND KRAELING

When the painted walls of the synagogue at Dura-Europos emerged
into the light of day in November 1932, the modern perspective on the
character of Judaism in Greco-Roman times had to be radically refo-
cused. Until that time, it was possible to ignore the growing evidence,
turned up for decades by archaeologists, of a kind of Judaism substan-
tially different from that described in Jewish literary remains of the

period. It is true that archaeological discoveries had long before revealed in the synagogues and graves of Jews in the Hellenistic worlds substantial evidences of religious syncretism and of the use of pagan symbols in identifiably Jewish settings. But before the Dura synagogue, these evidences remained discrete and made slight impact. They were not explained; they were explained away.

After the preliminary report, the Dura synagogue was widely discussed, and a considerable literature developed, mostly on specific problems of art but partly on the interpretation of the art; in the main, the Dura synagogue was studied by art historians, and not, with notable exceptions, by historians of religion or of Judaism. But, as I said, from 1932 to 1956 Goodenough was prevented by colleagues from discussing the finds at Dura, since the final report on the excavation was still in preparation. In 1956, Carl H. Kraeling published *The Synagogue.*[3] Then the issue could be fairly joined. In no way can Goodenough's vols. 9–11 be considered in isolation from the other and quite opposite approach to the same problem. So as we take up Goodenough on the Dura synagogue, we deal with Goodenough only in the context of the debate with Kraeling.

Let me state the issue in a general way. Under debate is how we make use of literary evidence in interpreting the use of symbols and, further, which evidence we consider. Goodenough looks at the symbols in their artistic context, hence in other settings besides the Jewish one, and he invokes literary evidence only as a second step in interpretation; Kraeling starts with literary evidence and emphasizes the Jewish meanings imputed in literary sources to symbols found in Jewish settings. This he does to the near exclusion of the use and meaning of those same symbols in non-Jewish settings in the same town, indeed on the same street. Goodenough reads Hellenistic Jewish writings at his second stage; Kraeling reads rabbinic and related writings at his first stage. Now to make the matter concrete.

Kraeling opened the Talmud and Midrash and related writings and then looked at the walls of the synagogue. He argued that the paintings must be interpreted for the most part by reference to the so-called rabbinic literature of the period, and he used the Talmudic, Midrashic, and Targumic writings for that purpose. He writes (pp. 353–54):

3. A. R. Bellinger, F. E. Brown, A. Perkins, and C. B. Welles, eds., *The Excavations at Dura-Europos Conducted by Yale University and the French Academy of Inscriptions and Letters. Final Report* 8, pt. 1: *The Synagogue,* by Carl H. Kraeling, with contributions by C. C. Torrey, C. B. Welles, and B. Geiger (New Haven: Yale University Press, 1956).

The Haggadic tradition embodied in the Dura synagogue paintings was, broadly speaking, distinct from the one that was normative for Philo and for that part of the ancient Jewish world that he presents. . . . This particular cycle [of paintings] as it is known to us at Dura moves within a definable orbit of the Haggadic tradition. . . . This orbit has Palestinian-Babylonian rather than Egyptian relations.

Goodenough took the opposite position. Characteristically, he starts with systematic statement of method, only then proceeding to the artifacts that demand interpretation.

Kraeling argues that the biblical references of the Dura paintings are so obvious that one may begin by reading the Bible and proceed by reading the paintings in the light of the Bible and its Midrashic interpretation in the Talmudic period. He says:

Any community decorating its House of Assembly with material so chosen and so orientated cannot be said to have regarded itself remote from religious life and observance of the Judaism that we know from the Bible and the Mishnah. . . . It would appear [p. 352] that there is a considerable number of instances in which Targum and Midrash have influenced the pictures (p. 351).

Kraeling provides numerous examples of such influence. He qualifies his argument, however, by saying that the use of Midrashic and Targumic material is "illustrative rather than definitive." While he makes reference, from time to time, to comparative materials, Kraeling does not in the main feel it necessary to examine the broad iconographic traditions operating in Dura in general and most manifestly in the synagogue art. Whatever conventions of pagan art may appear, the meaning of the synagogue art is wholly separated from such conventions and can best, probably only, be understood within the context of the Judaism known to us from literary sources.

Goodenough's argument, repeated in the later volumes from the earlier ones, is that literary traditions would not have led us to expect any such art as this. We may find statements in talmudic literature that are relevant to the art, but we must in any case after assembling the material determine:

what this art means in itself, before we begin to apply to it as proof texts any possibly quite unrelated statements of the Bible or the Talmud. That these artifacts are unrelated to proof texts is a statement which one can no more make at the outset than one can begin with the assumption of most of my predecessors, that if the symbols had meaning for Jews, that meaning must be found by correlating them with talmudic and biblical phrases [4:10].

Even though the art of the Dura synagogue may at the first glance seem to be *related* to Midrashic ideas, even found in a few cases to reflect Midrashic accounts of biblical events, nonetheless one is still not freed from the obligation to consider what that art meant to a contemporary Jew, pagan, or Christian who was familiar with other art of the age. Since both the architectural and the artistic conventions of the Dura synagogue are demonstrably those of the place and age, and not in any way borrowed from preexistent "rabbinic" artistic conventions—because there weren't any!—one must give serious thought to the meaning and value, or the content, of those conventions elsewhere and assess, so far as one can, how nearly that value and meaning were preserved in the Jewish setting.

Both Kraeling and Goodenough agree that there was a plan to the art of the synagogue. All concur that biblical scenes are portrayed not only as mere ornament or decoration but as a means of conveying important religious ideas, so that the walls of the sanctuary might, in truth, yield sermons. So we may now turn away from the argument that, anyhow, symbols are not always symbolic. *These* symbols were symbolic. One may continually say that the use of pagan art is wholly conventional, just as the critics of Goodenough's earlier interpretations repeat that the symbols from graves and synagogues were "mere ornament" and imply nothing more than a desire to decorate (none surely can say this of Dura, and no one has, for the meaningful character of Dura synagogue art is self-evident). But having asserted that pagan art has lost its value and become, in a Jewish setting, wholly conventional, we have hardly solved many problems. For by saying that the "art has lost its value," we hardly have explained *why* pagan conventions were useful for decoration.

Let us let the scholars speak for themselves, first, on the general meaning that emerges from the paintings as a whole and, second, on the nature of Judaism at Dura. While both scholars interpret the pictures in detail, each provides a summary of the meaning of the art as a whole. Kraeling's is as follows (pp. 350–51):

A closer examination of the treatment of Israel's sacred history as presented in the Synagogue painting leads to a number of inferences that will help to appraise the community's religious outlook. . . . These include the following:
a. There is a very real sense in which the paintings testify to an interest in the actual continuity of the historical process to which the sacred record testifies. This is evidenced by the fact that they do not illustrate interest in the Covenant relationship by a combination of scenes chosen from some one segment of sacred history, but provide instead a well-organized

progression of scenes from the period of the Patriarchs and Moses and Aaron, from the early days of the monarchy, through the prophetic period, the exile, the post-exile period, to the expected Messianic age as visualized by prophecy. . . .

b. There is a very real sense in which the history portrayed in the paintings involves not only certain individuals, but concretely the nation as a whole, and in which the course of events in time and space are for the individuals and the nation a full and completely satisfactory expression of their religious aspirations and ideals. . . .

c. There is a very real sense in which the piety exhibited in, and inculcated by, the paintings finds a full expression in the literal observance of the Law. This comes to light in the effort to provide the historical documentation for the origin of the religious festivals . . . in the attention paid to the cult and its sacra, including the sacrifices: and in the opposition to idolatry.

d. Because they have this interest in the historical process, in the people of Israel, and in the literal observance of the Law, the paintings can and do properly include scenes showing how those nations and individuals that oppose God's purposes and His people are set at naught or destroyed. . . . In other words, the religious problem which the synagogue paintings reflect is not that of the individual's search for participation in true being by the escape of the rational soul from the irrational desires to a higher level of mystical experience, but rather that of faithful participation in the nation's inherited Covenant responsibilities as a means of meriting the fulfillment of the divine promises and of making explicit in history its divinely determined purpose.

Since the West Wall contains the bulk of the surviving fresco, we turn to Goodenough's interpretation of that wall (10:137–38):

The west wall of the synagogue as a whole is indeed coming to express a profoundly consistent Judaism. On the left side a miraculous baby is given by Elijah, but he ties in with the temporal hopes of Israel, exemplified when Persian rulership was humiliated by Esther and Mordecai. Divine intervention brings this about, but, here, brought only this. Above is the cosmic interpretation of the temple sacrifice of Aaron, and Moses making the twelve tribes into the zodiac itself.

On the right, just as consistently, the immaterial, metaphysical, values of Judaism are presented. Moses is the divine baby here, with the three Nymphs and Anahita-Aphrodite. Kingship, as shown in the anointing of David by Samuel, is not temporal royalty, but initiation into the hieratic seven. Above these, the gods of local paganism collapse before the Ark of the Covenant, the symbol of metaphysical reality in Judaism, which the three men beside the Ark also represented, while that reality is presented in a temple with seven walls and closed inner sanctuary, and with symbols from the creation myth of Iran. At the top, Moses leads the people out to true spiritual Victory.

In the four portraits, an incident from the life of Moses is made the culmination of each of these progressions. He goes out as the cosmic leader to the heavenly bodies alongside the cosmic worship of Aaron, the *menorah*, and the zodiac. He reads the mystic law like the priest of Isis alongside the Closed Temple and the all-conquering Ark. He receives the Law from God on Sinai beside a Solomon scene which we cannot reconstruct; but he stands at the Burning Bush, receiving the supreme revelation of God as Being, beside the migrating Israelites, who move . . . to a comparable, if not the same, goal.

The reader must be struck by the obvious fact that, in the main, both scholars agree on the substance of the paintings, but they disagree on both their interpretation and their implications for the kind of religion characteristic of this particular synagogue.

Concerning Dura Judaism, Kraeling argues that the Jews of Dura had fallen back "visibly" upon the biblical sources of religious life (p. 351). Kraeling says throughout that the Jews in Dura were, for the most part, good, "normative," rabbinic Jews:

> If our understanding of the pictures is correct, they reveal on the part of those who commissioned them an intense, well-informed devotion to the established traditions of Judaism, close contact with both the Palestinian and the Babylonian centers of Jewish religious thought, and a very real understanding of the peculiar problems and needs of a community living in a strongly competitive religious environment, and in an exposed political position [p. 353].

Goodenough, in his description of Judaism at Dura (10:196–209), holds that these were not participants in the "established traditions of Judaism" and that they did not have close contact with Babylonian or Palestinian Judaism. The walls of the synagogue are not, he argues, representations of biblical scenes but *allegorizations* of them (as in the specific instances cited above). The biblical scenes show an acceptance of mystic ideas which the symbolic vocabulary of Jews elsewhere in the Greco-Roman world, studied in the first eight volumes, suggested. Goodenough says (10:206):

> While the theme of the synagogue as a whole might be called the celebration of the glory and power of Judaism and its God, and was conceived and planned by men intensely loyal to the Torah, those people who designed it did not understand the Torah as did the rabbis in general. Scraps stand here which also appear in rabbinic haggadah, to be sure. . . . But in general the artist seems to have chosen biblical scenes not to represent them, but, by allegorizing them, to make them say much not remotely implicit in the texts. . . . On the other hand, the paintings can by no means be spelled out

from the pages of Philo's allegories, for especially in glorifying temporal Israel they often depart from him altogether. Kraeling astutely indicated . . . that we have no trace of the creation stories, or indeed of any biblical passages before the sacrifice of Isaac, sections of the Bible to which Philo paid almost major attention. This must not blind us, however, to the fact that the artist, like Philo, presumed that the Old Testament text is to be understood not only through its Greek translation, but through its re-evaluation in terms of Greek philosophy and religion. Again, unlike Philo in detail but like him in spirit, the artists have interpreted biblical tradition by using Iranian costumes and such scenes as the duel between the white and black horsemen. . . . The Jews here, while utterly devoted to their traditions and Torah, had to express what this meant to them in a building designed to copy the inner shrine of a pagan temple, filled with images of human beings and Greek and Iranian divinities, and carefully designed to interpret the Torah in a way profoundly mystical.

Goodenough takes account of the high probability that, under such circumstances, Jews learned from their neighbors and commented, in a way they found appropriate, on their neighbors' religions. Kraeling's approach rests on the premise of a group of Jews quite separate from the diverse world around them. Yet so far as we know, there was no ghetto in Dura, and neither physical nor cultural isolation characterized the Jews' community there. They assuredly spoke the same language as others, and they knew what was going on.

The notion, moreover, of an "Orthodoxy" surely applies to the third century a conception invented in the nineteenth (a point that students of religion will find particularly suggestive), and that anachronism has confused many, not only Kraeling, in reading the artistic and literary sources at hand. There was no single Judaism, there was never an Orthodoxy, any more than today there is a single Judaism, Orthodox or otherwise. That conception is a conceit of Orthodoxy. Indeed, throughout Babylonia (present-day Iraq) Jews lived in the same many-splendored world, in which diverse languages and groups worshiped different gods. And Jews themselves prove diverse: there were many Judaisms. And the art, properly interpreted, forms the principal testimony to the most widespread of the Judaisms of late antiquity. That is why the study of the art is essential for the study of ancient Judaism.

THE DEBATE ON GOODENOUGH'S INTERPRETATION: NOCK AND SMITH

A clear picture of the difficulty of interpreting the religious life emerges from reviewing the debate that Goodenough precipitated. That

will show us how to differentiate the main point from matters of detail. Anyone with an interest in symbolism will follow that debate with intense interest. A mark of the success of scholarship, particularly in a massive exercise of interpretation such as the one at hand, derives from how a scholar has defined issues. Did Goodenough succeed in framing the program of inquiry? Indeed he did. Nearly all critics concede the premise of his work, which, when he began, provoked intense controversy. Goodenough demanded that the Jewish symbols be taken seriously, not dismissed as mere decoration. That view formed the foundation of his work, and he completely succeeded in making that point stick. Few today propose to ignore what, when Goodenough began work, many preferred to explain away. So Goodenough's greatness begins in his power to reframe the issues of his chosen field. In his day in his area few scholars enjoyed equivalent influence and, in ours, none in the field at hand.

But that fact should not obscure differences of opinion, both in detail and in general conclusions. Goodenough would not have wanted matters any other way. Teachers of ancient Judaism through art will find useful an account of two interesting approaches—those of Morton Smith and Arthur Darby Nock—to the criticism of Goodenough's *Jewish Symbols*.

Arthur Darby Nock (1902-1963)

In *Gnomon* 27 (1955), 29 (1957), and 32 (1960), Nock presented a systematic critique of vols. 1–8, under the title "Religious Symbols and Symbolism." Now reprinted in Zeph Stewart, ed., *Arthur Darby Nock: Essays on Religion and the Ancient World* (Oxford: Clarendon Press, 1972) 2:877–918, Nock first summarizes the main lines of Goodenough's approach to the interpretation of symbols. He then expresses his agreement with what I regard as the principal result of Goodenough's work for the study of Judaism (pp. 880–82, *passim*):

> G[oodenough] has made a good case against any strong central control of Judaism: it was a congregational religion and the local group or, in a large city such as Rome, any given local group seems to have been largely free to follow its own preferences. Again, in art as in other things, Judaism seems to have been now more and now less sensitive on questions of what was permissible. From time to time there was a stiffening and then a relaxing: down into modern times mysticism and enthusiasm have been recurrent phenomena; so has the "vertical path" as distinct from the "horizontal path." To speak even more generally, from the earliest times known to us there has been a persistent quality of religious lyricism breaking out now here, now there among the Jews.

The point conceded by Nock is central to Goodenough's thesis: that Judaism yielded diversity and not uniformity. Again, since Goodenough repeatedly turns to Philo for explanation of symbols, it is important to see that Nock concedes how Philo may represent a world beyond himself:

> So again, in all probability, Philo's attitude was not unique and, deeply personal as was the warmth of his piety and his sense of religious experience, we need not credit him with much original thinking. The ideas which he used did not disappear from Judaism after 70 or even after 135. Typological and allegorical interpretation of the Old Testament continued to be common. G.'s discussion of the sacrifice of Isaac is particularly instructive; so are his remarks on the fixity and ubiquity of some of the Jewish symbols and (4.145ff.) on *lulab* and *etrog* in relation to the feast of Tabernacles, "the culminating festival of the year" with all that it suggested to religious imagination.
>
> *Menorah, lulab, etrog,* Ark and incense-shovel were associated with the Temple and as such could remain emblems of religious and national devotion after its destruction; the details of the old observances were discussed with passionate zeal for centuries after their disuse. G. has indeed made a strong case for the view that, as presented in art, they refer to the contemporary worship of the synagogue (as he has produced serious arguments for some use of incense in this). It may well be that they suggested both Temple and synagogue.

But Nock provided extensive and important criticism of Goodenough's ideas. He expresses his reservations on detail (pp. 882–83):

> The improbability of many of G.'s suggestions on points of detail does not affect his main theses, but those theses do themselves call for very substantial reservations. Thus the analogy between Isis and Sophia is more superficial than real, and so is that between allegorical explanations of the two types of religious vestments used by Egyptians and the two used by the High Priest. No these are not minor matters; the first is one of the foundations of what is said about the "saving female principle" and the second is made to support the supposition of Lesser and Greater Mysteries of Judaism.
>
> The crucial question is: was there a widespread and long continuing Judaism such as G. infers, with something in the nature of a mystery worship? Before we attack this we may consider (a) certain iconographic features regarded by G. as Hellenistic symbols—in particular Victories with crowns, Seasons, the Sun, and the zodiac; (b) the cup, the vine and other motifs which G. thinks Dionysiac; (c) the architectural features which he interprets as consecratory.

The important point to observe is how Nock calls into question not only detail but the general approach: the main results. That is how scholarly debate should go forward. But Nock concludes (p. 918):

> Once more such points do not destroy the essential value of the work. I have tried to indicate . . . what seem to be the major gains for knowledge which it brings and naturally there are also valuable details.

In the balance, Nock's systematic critique confirms Goodenough's standing as the scholar to insist that the symbols matter. More than that Goodenough could not have asked. More than that Nock did not concede.

Morton Smith (1915-)

Smith's "Goodenough's Jewish Symbols in Retrospect" (*Journal of Biblical Literature* 86 [1967] 53–68) provides a list of reviews of Goodenough's work, which he compiled from *L'Année philologique,* as well as a systematic reconsideration of the work as a whole. As a statement of an experienced scholar of the history of Judaism and Christianity in the formative age, Smith's essay stands as the definitive account of his own viewpoint on Goodenough's work. Smith first calls attention to the insistence on distinguishing the value of a symbol from its verbal explanation (p. 55):

> The fundamental point in Goodenough's argument is his concept of the "value" of a symbol as distinct from the "interpretation." He defined the "value" as "simply emotional impact." But he also equated "value" with "meaning" and discovered as the "meaning" of his symbols a complex mystical theology. Now certain shapes may be subconsciously associated with certain objects or, like certain colors, may appeal particularly to persons of certain temperaments. This sort of symbolism may be rooted in human physiology and almost unchanging. But such "values" as these do not carry the theological implications Goodenough discovered.

The premise of a psychic unity of humanity, on which Goodenough's insistence on the distinction at hand must rest, certainly awaits more adequate demonstration. Smith proceeds (pp. 55–56):

> After this definition of "value," the next step in Goodenough's argument is the claim that each symbol always has one and the same "value."
>
> Goodenough's position can be defended only by making the one constant value something so deep in the subconscious and so ambivalent as to be compatible with contradictory "interpretations." In that event it will also be compatible with both mystical and legalistic religion. In that event the

essential argument, that the use of these symbols necessarily indicates a mystical religion, is not valid.

So much for the basic theory of symbolism. Smith proceeds (p. 57) to the specific symbolism at hand:

> The lingua franca of Greco-Roman symbolism, predominantly Dionysiac, expressed hope for salvation by participation in the life of a deity which gave itself to be eaten in a sacramental meal. This oversimplifies Goodenough's interpretations of pagan symbolism; he recognized variety which cannot be discussed here for lack of space. But his thesis was his main concern, and drew objections from several reviewers, notably from Nock, who was the one most familiar with the classical material.
>
> It must be admitted that Goodenough's support of this contention was utterly inadequate. What had to be established was a probability that the symbols, as *commonly* used in the Roman empire, expressed this hope of salvation by communion. If they did not *commonly* do so *at this time,* then one cannot conclude that the Jews, who at this time took them over, had a similar hope. But Goodenough only picked out a scattering of examples in which the symbols could plausibly be given the significance his thesis required; he passed over the bulk of the Greco-Roman material and barely mentioned a few of the examples in which the same symbols were said, by those who used them, to have other significance. These latter examples, he declared, represented superficial "interpretations" of the symbols, while the uses which agreed with his theory expressed the symbols' permanent "values." The facts of the matter, however, were stated by Nock: "Sacramental sacrifice is attested only for Dionysus and even in his cult this hardly remained a living conception"; there is no substantial evidence that the worshipers of Dionysus commonly thought they received "his divine nature in the cup." So much for the significance of the "lingua Franca" of Greco-Roman Dionysiac symbolism.

Smith then points out that Goodenough "ruled out the inscriptional and literary evidence which did not agree with his theories." He maintains that Goodenough substituted his own intuition, quoting the following: "The study of these symbols has brought out their value for my own psyche." By contrast, Smith concurs with Goodenough's insistence on the hope for the future life as a principal theme of the symbols. Still, Smith maintains that Goodenough failed "to demonstrate the prevalence of a belief in sacramental salvation" (p. 58). In Smith's view, therefore, "the main structure of his argument was ruined."

In reviewing the Goodenough debate, students will learn from examples of how not to pursue an argument. Smith provides a fine instance of a mode of discourse that students will recognize as inappropriate. For,

as is his way in general, Smith makes a long sequence of *ad hominem* points about Goodenough's background, upbringing, religious beliefs, and the like, for example, "He is the rebellious son of G. F. Moore" (p. 65). In this way he personalizes and trivializes scholarship. He lays down such judgments as "enormous exaggerations," "his pandemic sacramental paganism was a fantasy," and on and on. Smith underscores his views with lavish use of italics. He declares Goodenough's views nothing less than "incredible." He leaves in the form of questions a series of, to him "self-evident," claims against Goodenough's views. These claims in their form as rhetorical questions Smith regards as unanswerable and beyond all argument. For example: "But the difficulties in the supposition of a *widespread, uniform* mystical Judaism are formidable [italics his]. How did it happen that such a system and practice disappeared without leaving a trace in either Jewish or Christian polemics? We may therefore turn from the main argument to incidental questions" (p. 59). Those three sentences constitute Smith's stated reason for dismissing Goodenough's principal positions and turning to minor matters. Personalizing, then trivializing issues of scholarly interpretation forms a common mode of debate, and students will benefit from a direct encounter with this debate, since, after all, the evidence—the art itself—is there for them to interpret as well. Goodenough, for his part, had worked out answers to these questions, which he recognized on his own, and, had he lived, had every capacity of dealing with them to (at least) his own satisfaction.

Still Smith's criticism cannot be dismissed as that of a mere self-important crank. Nor should we wish to ignore his positive assessment (p. 61):

> Goodenough's supposition that the Jews gave their own interpretations to the symbols they borrowed is plausible and has been commonly accepted. His reconstructions of their interpretations, however, being based on Philo, drew objections that Philo was an upper-class intellectual whose interpretations were undreamt of by the average Jew. These, however, missed Goodenough's claim: Philo was merely one example of mystical Judaism, of which other examples, from other social and intellectual classes, were attested by the monuments. For this reason also, objections that Goodenough misinterpreted Philo on particular points did not seriously damage his argument; it was sufficient for him to show that Philo used expressions suggestive of a mystical and sacramental interpretation of Jewish stories and ceremonies. The monuments could then show analogous developments independent of Philo. Some did, but most did not.

The single most important comment of Smith is as follows (p. 65):

> Goodenough's theory falsifies the situation by substituting a single, anti-rabbinic, mystical Judaism for the enormous variety of personal, doctrinal, political, and cultural divergencies which the rabbinic and other evidence reveals, and by supposing a sharp division between rabbinic and anti-rabbinic Judaism, whereas actually there seems to have been a confused gradation.

Declaring Goodenough to have failed, Smith concludes (p. 66): "Columbus failed too. But his failure revealed a new world, and so did Goodenough's." For more than that no scholar can hope. For learning is a progressive, an ongoing process, an active verb in the continuing and ever-present tense.

Index of Names
and Subjects

Index of Biblical and Rabbinic References